A Treasury of African Art
from the
Harrison Eiteljorg Collection

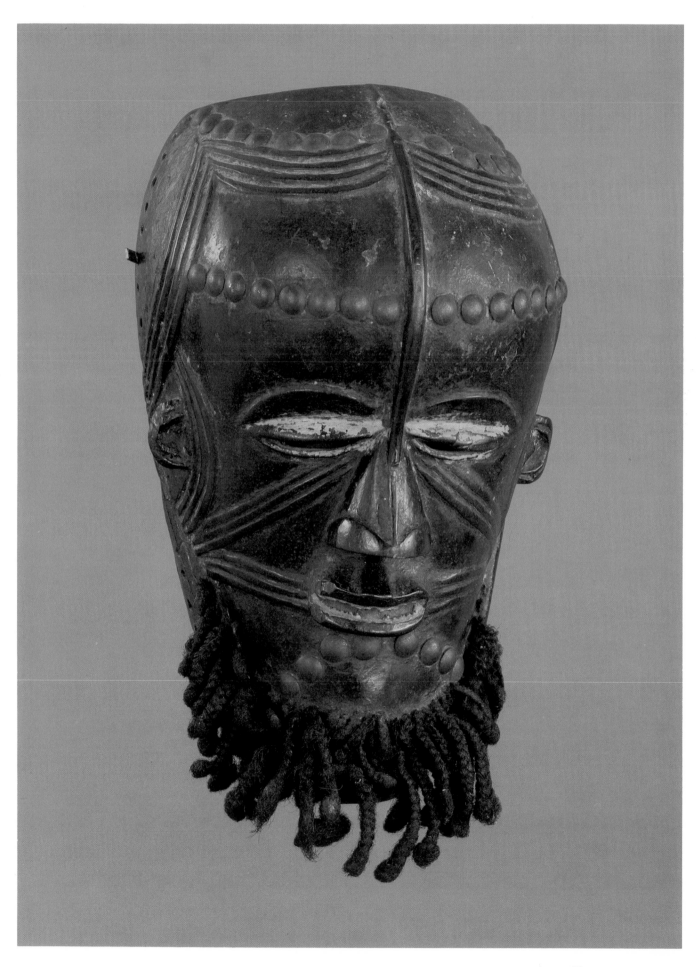

cat. no. 60
Bete(?) face mask, Ivory Coast

A Treasury of African Art from the Harrison Eiteljorg Collection

Theodore Celenko

Foreword by Roy Sieber
With Commentaries by Harrison Eiteljorg

Indiana University Press
Bloomington

Research Assistant: Catherine L. Ricciardelli
Photographer: Robert Wallace (except cat. nos.
61-62, 103, 145-47, 165, 175 and as noted in text)
Designer: Marcia K. Hadley
Printer: Allied Printing Service, Inc.
Indianapolis, Indiana

Manufactured in the United States of America

Library of Congress Cataloging in Publication
Data

Celenko, Theodore.
 A treasury of African art from the Harrison
Eiteljorg Collection.

 Bibliography: p.
1. Sculpture, Black — Africa, Sub-Saharan —
Catalogs.
2. Sculpture, Primitive — Africa, Sub-Saharan —
Catalogs.
3. Eiteljorg, Harrison — Art collections — Catalogs.
I. Eiteljorg, Harrison. II. Title.
NB1091.65.C46 1983 730'.0967'074013 82-
47954
ISBN 0-253-11057-2
1 2 3 4 5 87 86 85 84 83

Contents

Foreword

Nearly twenty years ago, shortly after I had arrived at Indiana University, a well-known New York dealer told me that a Dogon staff I had admired in his gallery had been purchased by an Indianapolis collector. Had I met him? I had not. About two years later I was invited to visit the Harrison Eiteljorg Collection of African sculpture. Is it necessary to relate that there I rediscovered the Dogon staff? (cat. no. 5) Long a collector of the art of the American West Harry had become enamored of African art. I should like to think that the staff might have been the bait.

In the early days a good number of pieces were acquired from itinerant African dealers who would check into a motel for a night or two with a roomful of masks and figures; some were genuine pieces in traditional style, some good, some bad; others were highly inventive forms and styles clearly made for export; yet others were mystery pieces, possibly real, possibly fake. Harry often bought a dealer's entire stock-in-trade. As he explained it, it was easier and usually less expensive than trying to buy a few carefully selected pieces at highly inflated prices after much haggling. The result, inevitably, was uneven and he was quite willing to be ruthless on two counts: to prune all but the best pieces and to seek out works with increasing care and discrimination to balance the collection.

Thus, as any collector must, Harry attended to both the style range and the aesthetics of the collection. But, again as any collector must, he had to decide on its perimeter. Unlike museums, the private collector has several choices: he may choose to acquire only a few pieces, aiming for the classical masterpieces, textbook examples of type and style; or the collector may decide to acquire however many pieces are needed to echo variations on a single theme (as with *ibejis* or *Sande* masks, for example), or to focus on a country or a single ethnic group, or to look for unusual pieces or less well-known styles and types. Harry chose all, to range over the variations of styles and types from the entire subcontinent, Africa south of the Sahara. The result is documented by the works of art illustrated in this volume.

It has frequently been suggested that surveys of African sculpture (or its presentation in a museum setting) falsify the dynamic spirit of the art. This charge is not without some validity for the object has been removed from its normal life cycle which would have seen its creation in a traditional culture and its use in that setting until it was, in a very real sense, used up, destroyed by insects or climate or accident. Then it would, in the normal pattern of things, have been replaced. Thus the exhibition, or even the photograph, of a work of African art interrupts its life cycle and to some degree falsifies it, just as exposing an Egyptian tomb relief to general view in a museum falsifies its original state hidden away from human eyes. Or indeed, as a photograph or an instant replay of a dramatic sports moment — the end of a race, a touchdown run — freezes a moment which from one point of view was meant to exist only in and for that particular moment.

Thus we have brought to these African objects an alien and possibly a warped view — the preservation and display of that which was not meant to be so protected or isolated. Whatever an object might have been in its original setting — aesthetically, meaningfully, usefully — it is now no longer. In a sense it has become a symbol of what it was; a symbol that now exists in and for our world. At the same time it may be that only by freezing the object, by taking it out of context are we able to experience it at all. Further we can now review it, contemplate it, in the end better understand it. We do this routinely with art objects from the more familiar settings of Greece, Rome and Medieval and Renaissance Europe. Although the worlds of African cultures and the forms of their art are less familiar, we should try to understand them.

The Harrison Eiteljorg Collection allows us to seek that understanding, to explore at our leisure the breadth and complexity of African art, its rich variety of forms and styles and aesthetics. Theodore Celenko has written the text and notes which put the collection into historical, ethnic and cultural perspective. It is a rich experience. To the new visitor, the landscape may seem a bit breathtaking, but be assured it is well worth the trip.

Roy Sieber

Collector's Statement

For centuries African art has been living art, part of the fabric of African life. Every item in this book served a purpose, whether as a symbol of royalty, as an emblem of social prestige, as a device for communicating with the spirit world or merely as a utilitarian object. Perhaps it is the social, political and religious character of African art, even more than its inherent aesthetic merit, that intrigues me the most. My first acquisition of African art, many years ago, was a handsome Dogon staff (cat. no. 5). I admired its classic beauty. As I studied the use of this staff and of other early acquisitions I became interested in the cultural role of African sculpture and began seriously to collect African art. In the early days I bought indiscriminately, sometimes whole collections from traders, dealers, and collectors. Some of the pieces were very good, some good, some ordinary. I eventually realized that I needed professional help and some twelve years ago contacted a prominent authority, Dr. Roy Sieber, Rudy Professor of Fine Arts at Indiana University. His wise and gracious counsel over the years has significantly improved the scope and quality of my collection. It was through him that I acquired the good services of Theodore Celenko who has been the curator of my collection for the past six years. He has been largely responsible for organizing the collection, weeding out the ordinary and the questionable, and acquiring pieces to round out my holdings. In the process of upgrading the collection we have given many pieces to schools and universities and even created African art collections in several instances. That too, has given me a great deal of satisfaction.

I am frequently asked which are my most treasured objects. Naturally, I do have a few favorites. Certainly one of them is the lovely little figurine, probably Fang (cat. no. 159), on the jacket of this book. Also among my prized objects are the impressive Yoruba *Magbo* mask (cat. no. 100) illustrated on the front cover of *African Arts*, May 1981 (which included an article highlighting my collection) and the Wee mask (cat. no. 57) so terrifyingly ugly that it is beautiful. Some pieces are special because of the circumstances of their acquisition. The two Vai figures (cat. nos. 47-48), for example, were personally acquired from the late Professor George Herzog, formerly of Indiana University, who collected them in 1930. Other objects are important to me because of their rarity and age, such as the "Jenne" terra-cottas (cat. nos. 1-2) and Benin brasses (cat. nos. 109-10). Throughout the book I have made comments about these pieces as well as many others. It was a difficult process selecting from my entire collection the pieces for this book; however, in the process I have been amazed anew by the vigor and diversity of African art.

Harrison Eiteljorg

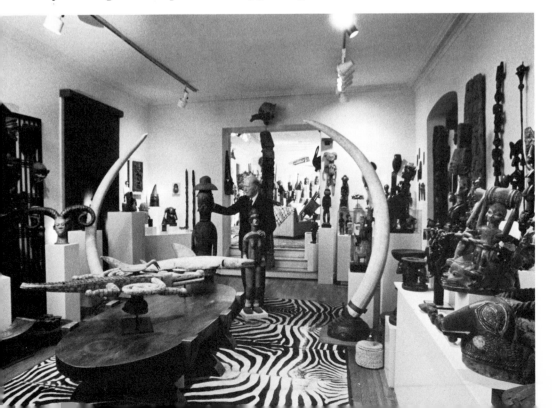

Harrison Eiteljorg (pictured in one of his office galleries) is also a prominent collector of the art of the American West. His book, Treasures of the American West *(New York, 1981) presents selections from his extensive holdings. He also collects American Indian and Oceanic art.*

Acknowledgments

Mr. Eiteljorg and I are deeply indebted to Roy Sieber, Associate Director of Collections and Research, National Museum of African Art, Washington, D.C., and Rudy Professor of Fine Arts, Indiana University, who has played an important role over the past dozen years in helping to shape the Eiteljorg collection. His input into many aspects of this catalog is gratefully acknowledged. Peggy S. Gilfoy, Curator of Textiles and Ethnographic Art, Indianapolis Museum of Art, has worked closely with the Eiteljorg collection over the years and has given generously of her time in the catalog's preparation. Catherine L. Ricciardelli, Registrar of the Eiteljorg collection, served as research assistant, and together we created the maps which were executed by John M. Hollingsworth, Staff Cartographer, Geography Department, Indiana University. Hazel Sizemore, secretary to Mr. Eiteljorg, graciously assisted with the typing of drafts. Many authorities have freely shared their opinions and research data and in some cases have provided field photographs placing objects in their cultural setting. Their contributions are acknowledged throughout the catalog. Former and present staff members of the Indianapolis Museum of Art have provided assistance. In particular, I cite Robert Wallace, the Museum's photographer, who is responsible for all but a few of the photographs; Marcia K. Hadley, Assistant Director of Public Relations, Publications, who designed the catalog; and Martin J. Radecki, Lance Mayer, Linda E. Merk, Catherine M. Collins and Richard W. Sherin of the Conservation Department who provided technical assistance in the analysis of many objects.

Theodore Celenko

Key to Captions

In addition to the text each caption includes the following categories of information:

Zone, and where applicable, region and subregion

Ethnic group which manufactured and used the object:

> In some instances another name (or names) by which a people is known follows in parentheses. The texts elucidate those few cases where it can be determined that an object was made by one ethnic group but used by another. Where possible an ethnic subgroup, specific locale, school of carvers or carver is cited.

The familiar name of the present-day nation (or nations) within which an ethnic group lives:

> Where it can be established that an object from a people located in more than one nation comes from a particular nation or nations, only that nation or those nations are listed. Ethnic locations on the maps follow the same rule.

Object identification and, where possible, its name in local language:

> Diacritical markings of African words in the caption headings and texts are not included, and the singular and plural of African terms are not always distinguished. Certain African words, for example, those identifying deities, cults, societies and some types of objects, are capitalized.

Materials of construction:

> The predominant material is listed first. In most instances substances (e.g., wood, glass) rather than objects (e.g., beads, earrings) are listed. Among the exceptions are cloth, (woven fibers); basketry (plaited, wickerwork or other construction of vegetable fibers); mastic, (hardened plastic substances such as resin); incrustation, and diverse medicinal and sacrificial substances (e.g., blood, eggs, chalk) whose accurate identification requires laboratory analysis. The term pigment indicates an intentional coloring of the surface with any local or foreign coloring. Altered surfaces which are the result of scorching or years of oiling, smoking, oxidation and handling are not cited. The term fiber designates all non-constructed vegetable fibers.

Dimensions:

> Except in a few obvious instances the largest dimension, height (h.), length (l.), width (w.), is listed in inches and centimeters. Measurements for non-rigid objects are cited as approximate (approx.) or a measurement of a rigid element of the item is cited.

Dating:

> A date of manufacture is offered for a few objects about which sufficient evidence exists. Unless specified otherwise dates are assumed to fall within this century.

Collection, exhibition and publication history:

> Following the text, available collection, exhibition and publication history is listed. In most instances commercial exhibitions and publications such as those associated with auction houses and art dealers are not included.

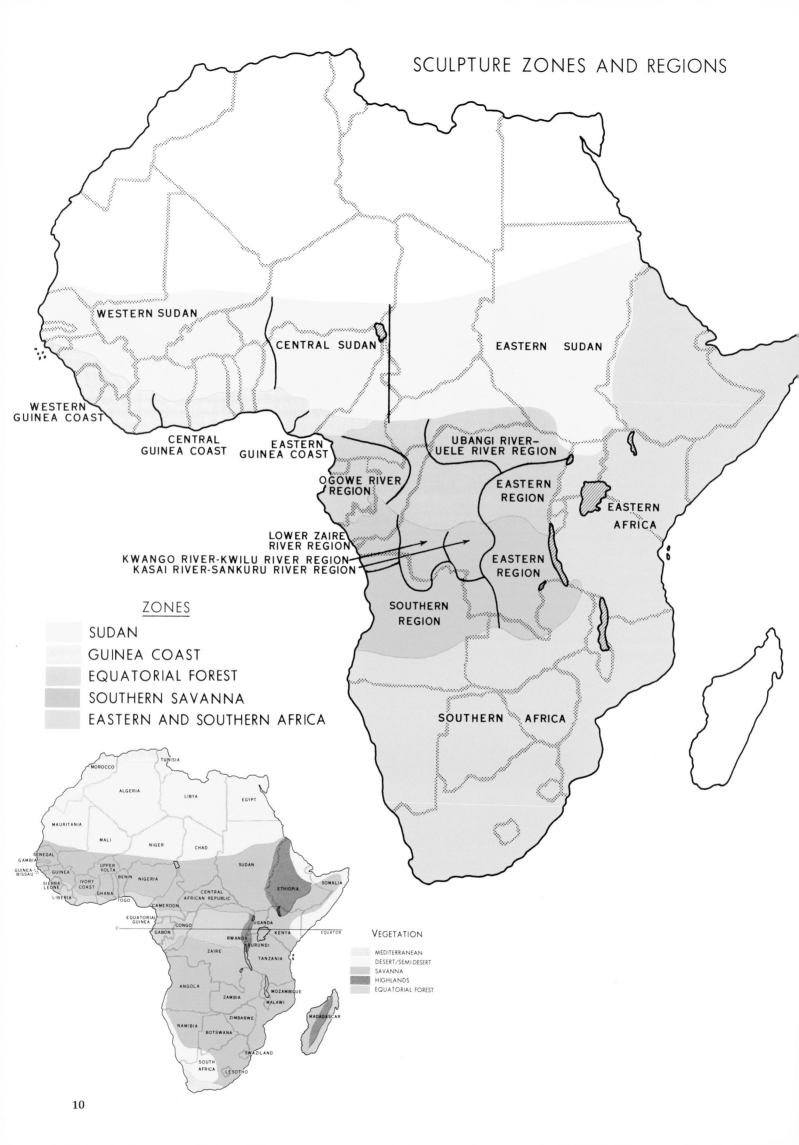

SCULPTURE ZONES AND REGIONS

WESTERN SUDAN

CENTRAL SUDAN

EASTERN SUDAN

WESTERN
GUINEA COAST

CENTRAL
GUINEA COAST

EASTERN
GUINEA COAST

UBANGI RIVER-
UELE RIVER REGION

OGOWE RIVER
REGION

EASTERN
REGION

EASTERN
AFRICA

LOWER ZAIRE
RIVER REGION

KWANGO RIVER-KWILU RIVER REGION
KASAI RIVER-SANKURU RIVER REGION

EASTERN
REGION

SOUTHERN
REGION

SOUTHERN AFRICA

ZONES

SUDAN
GUINEA COAST
EQUATORIAL FOREST
SOUTHERN SAVANNA
EASTERN AND SOUTHERN AFRICA

MOROCCO
TUNISIA
ALGERIA
LIBYA
EGYPT
MAURITANIA
MALI
NIGER
CHAD
SENEGAL
GAMBIA
GUINEA-
BISSAU
GUINEA
UPPER
VOLTA
NIGERIA
SUDAN
SIERRA
LEONE
IVORY
COAST
BENIN
SOMALIA
LIBERIA
GHANA
TOGO
ETHIOPIA
CENTRAL
AFRICAN REPUBLIC
CAMEROON
EQUATORIAL
GUINEA
UGANDA
CONGO
GABON
KENYA
EQUATOR
0°
RWANDA
BURUNDI
ZAIRE
TANZANIA
ANGOLA
MOZAMBIQUE
ZAMBIA
MALAWI
MADAGASCAR
ZIMBABWE
NAMIBIA
BOTSWANA
SWAZILAND
SOUTH
AFRICA
LESOTHO

VEGETATION

MEDITERRANEAN
DESERT/SEMI-DESERT
SAVANNA
HIGHLANDS
EQUATORIAL FOREST

10

Introduction

In terms of styles, functions, materials and techniques, the items presented here offer an ample overview, though by no means a comprehensive survey, of traditional sub-Saharan sculpture. A handful of centuries-old objects provides a chronological dimension to the catalog. The stylistic and functional diversity of the catalog entries reveals that generalizations about African sculpture are difficult. Its study encompasses hundreds of ethnic groups inhabiting a vast region and a history extending back more than two thousand years. Perhaps the only universal feature of traditional African sculpture is its functional nature. Unlike the "art-for-art's sake" of our own culture, African masks, figures, staffs and other objects, which we regard as "art," fulfill a host of religious, social, political and utilitarian needs.

The organization of this catalog into geographic-cultural units follows a method first established by Carl Kjersmeier (1935-38) almost half a century ago and refined by Eckart von Sydow (1954), Frans Olbrechts (1959), Elsy Leuzinger (1960) and Denise Paulme (1962a), among others, during the subsequent quarter century. The zones, regions and smaller areas designated in this catalog stem from a scheme in this tradition established by Roy Sieber and Arnold Rubin (1968) which utilizes linguistic relationships as well as the geographic, stylistic and historical factors considered by earlier writers. This approach has been modified by René Bravmann (1970), Arnold Rubin (1976a), Christopher Roy (1979a) and Maude Wahlman (1979; 1980). In addition to the above references and those dealing with specific areas (cited in the catalog, e.g., Wittmer and Arnett [1978] and Siegmann [1981]), sources which have aided in the organization of the catalog and the production of maps include Maes (1921), Maes and Boone (1935), Herskovits (1945), Baumann and Westermann (1948), Murdock (1959), Boone (1961; 1973), Gunn (1962), Greenberg (1966), Cornet (1971; 1978), Baumann (1975), François Neyt (1981) and the International African Institute's Ethnographic Survey of Africa edited by Daryll Forde.

Although partitioning of the continent in this fashion provides a convenient means of dealing with the complexity of Africa and its arts, any such scheme is to some extent arbitrary. The maps in particular, despite their definitive borders, should be viewed as cartographic abstractions. For example, the placement of the Urhobo and Ijo shrines (cat. nos. 121-22), a shared tradition of neighboring peoples, in two distinct areas and even regions (the Edo of the Central Guinea Coast and the Delta area of the Eastern Guinea Coast) is one of a number of instances in the catalog which illustrates the problems inherent in pigeonholing African peoples and their arts. Although each of the four principal sculpture-producing zones, the Sudan, the Guinea Coast, the Equatorial Forest and the Southern Savanna, is partitioned into regions and in some cases into smaller areas, no such attempt is made for Eastern and Southern Africa. The relative paucity of sculpture from this vast segment of the continent does not permit meaningful subdivision.

SUDAN

"Sudan," which derives from an Arabic term for "land of the blacks," refers to a broad swath of territory between the Sahara Desert to the north and the forest areas to the south spanning the continent from the Atlantic coast to the Red Sea. The desert-like terrain of the northern perimeter gradually becomes grassy as one moves south, and in its most southerly extensions the Sudan becomes a wooded savanna. Most areas experience a long dry season briefly interrupted by a few months of rain. Here, in contrast to the forested, tsetse fly-infested areas to the south, cattle and horses play important roles in economic and prestige systems. Grain crops supplemented with hunting and fishing provide the primary means of subsistence for most peoples.

Well before European penetration of the Sudan, and both before and during Islamization, great empires arose in the Sudan such as Ghana (8th-11th centuries), Mali (13th-16th centuries) and Songhai (15th-16th centuries) which encompassed vast territories. Unfortunately almost no record of the visual arts contemporary with these states survives, with the exception of minimal archaeological evidence (cat. nos. 1-2) and reports of early Islamic writers. In recent times political authority in most areas has seldom extended beyond the village.

Islam is a pervasive cultural feature throughout the Sudanic zone. From North African bases it first gained a foothold south of the Sahara a millennium ago, initially through trade and later, and more substantially, through religious conversion, political alliance and warfare. With few exceptions the Koranic prohibition against figurative arts had a deleterious effect on indigenous, religious-oriented carving, and almost all Sudanese items in the catalog represent traditions which are outside of, and which have managed to exist despite, Islam. However, North African and Mediterranean influences accompanying the spread of Islam provided an influx of new techniques, object-types, motifs and ideas which in many ways enriched the arts of the Sudan as well as more southerly areas. Throughout the Sudan Islamic peoples such as the Fulani (Peul), Wolof, Tuareg and Hausa have sophisticated weaving, leatherworking and metalworking tradi-

tions (cat. nos. 26-31) which are neglected in sculpture-oriented surveys.

Sudanic sculpture exhibits broad typal, stylistic and contextual similarities which may have resulted from common or related origins or from similar environmental and historical factors. Human figures are characterized by abstracted, often attenuated forms. Although the Dogon (cat. no. 3), Mumuye (cat. no. 37) and Eastern Sudan (cat. no. 204) figures represent distinct styles separated by thousands of miles, they all exhibit Sudanic approaches to human form which contrast with more naturalistic styles to the south (e.g., cat. nos. 79-81). Human figures frequently embody ancestral or other spirits. Masks commonly assume stylized animal forms and are usually controlled by men's societies within which they play diverse roles, most notably in agricultural and funerary activities.

The Sudanic zone can be viewed as Western, Central and Eastern regions; the latter is dealt with together with Eastern and Southern Africa (p. 224). The Western Sudan, which consists largely of areas of the present-day nations of Senegal, Guinea, Mali, Upper Volta, Ghana and Ivory Coast, is to a great extent populated by peoples who speak either Gur or Mande languages. This linguistic dichotomy provides a tentative means of dealing with the region's sculpture, since styles coincide to some extent with language. The stylistic differences between the two traditions are most clearly demonstrated through masks. Those of the Gur speakers, such as the Bwa (cat. no. 6) and Nuna (cat. no. 8) are characterized by geometric forms and polychromed surfaces and often have superstructures. In contrast, masks of the Bamana (cat. nos. 19-20) and other Mande speakers usually have blackened surfaces and lack significant superstructures. In very general terms Mande-speaking carvers incorporate more curved forms and more complex sculptural arrangements than are exhibited by carvings of the Gur speakers.

The Central Sudan, which encompasses northern Nigeria and parts of neighboring nations, is inhabited by a diverse mosaic of peoples. Although

Islamic influence was evident along the northern perimeter of the region at an early date, it was not until the 19th century that holy wars pushed Islam south to the very fringes of the forested areas. However, many peoples, especially those living within the Benue River Valley, have in large measure maintained their belief systems and associated carving traditions. The corpus of terra-cottas identified as Nok was unearthed in this region, providing the earliest (5th century B.C.-3rd century A.D.) figurative sculptural tradition yet established for sub-Saharan Africa.

WESTERN SUDAN
CENTRAL SUDAN

See p. 224 for map of Eastern Sudan

Western Sudan

inland Niger delta
area of Mopti, Jenne and Ke-Macina towns

unidentified ethnic group, Mali

1
female figure
clay
h. 10¹/₄ in. (26 cm.)

15th-16th centuries (?)

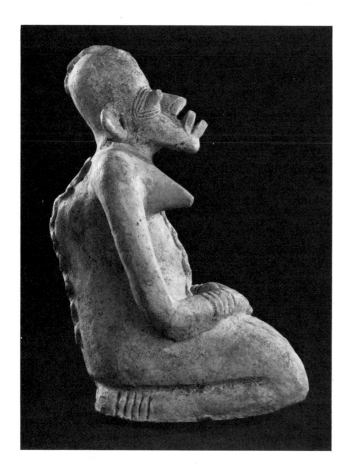

Within the last forty years a growing corpus of centuries-old clay figures has been discovered in the inland delta of the Niger River in Mali. The delta was centrally located in relation to the series of Sudanic empires of the past millennium; however, the place of these figures within the cultures making up these states is unknown. Terracottas like this example and cat. no. 2 are often identified as Jenne (Djenne) because they were first discovered in the vicinity of the ancient and present sites of Jenne, an important town dating from about 200 B.C. Both Eiteljorg figures are stylistically linked with others identified with an area bordered by Mopti in the north, Jenne in the south and Ke-Macina in the west. Radiocarbon and thermoluminescence dates for a limited number of these figures generally fall within the 11th to 17th centuries A.D., making them one of the earliest yet identified figurative traditions south of the Sahara (McIntosh and McIntosh 1979:52, de Grunne 1980:26-27; 57-135).

This example, which has been dated by thermoluminescence testing to the 15th-16th centuries (Oxford University, Research Laboratory for Archaeology and the History of Art, sample no. 281r18-15), belongs to a style of delta terra-cottas sometimes identified as "classic Jenne," characterized by bulging eyes often encircled by parallel grooves, jutting mouth and chin, and in single figures a kneeling, upright posture with arms on the knees or crossed over the chest. This figure's rigid posture, columnar limbs and torso, and angular facial features appear to reflect a wood carving tradition similar to some recent wood carving modes of the Western Sudan (cat. no. 3). This relationship allows speculation about the region's past carving styles. The red slip found on many of these images is still evident on some areas of the surface. The hunchback, bracelets, anklets, apron and zigzag relief on the head and torso are common iconographic elements. The zigzag motif probably depicts snakes; its frequent appearance on figures and the occurrence of terra-cotta snakes suggest a cult significance (de Grunne 1980:27-34).

exhibited: African-American Institute, New York,
 1981-82
 Chicago Public Library Cultural Center,
 1982

published: de Grunne and Preston 1981, no. 23, fig.
 21

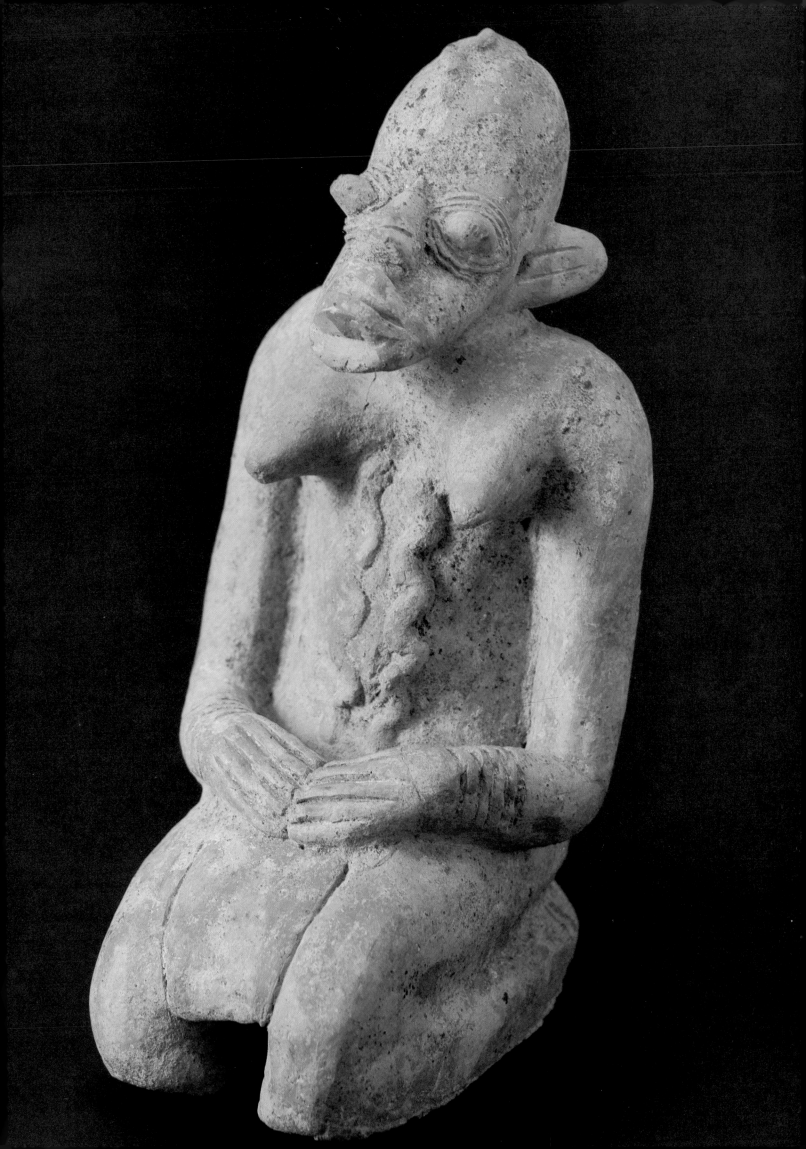

inland Niger delta
area of Mopti, Jenne and Ke-Macina towns

unidentified ethnic group, Mali

2
female figure
clay
h. 8⁵/₈ in. (21.9 cm.)

15th-17th centuries (?)

Informal, asymmetrical postures typified by this figure with tilted head resting on one knee are characteristic of some inland delta terra-cottas. The significance of such postures, as with almost everything else about these figures, is unknown. Like cat. no. 1 the figure is hunchbacked, wears bracelets and bears relief imagery of snakes (on head, upright forearm, lower rear torso). Unlike cat. no. 1, whose angular, rigid forms reflect Sudanic wood carving styles, this example is rendered in a softer, more amorphous manner associated with modeling in clay. Thermoluminescence testing indicates a late 15th to early 17th century date (Oxford University, Research Laboratory for Archaeology and the History of Art, sample no. 281w18).

Unfortunately, little is known about the cultural context of these figures, in part because almost all examples have been surface finds or unearthed without archaeological supervision. Despite speculation, their significance, use, and the ethnicity of their makers are uncertain. Archaeological work in the delta has revealed an urban occupation of over two thousand years evidenced by foundations of mudbrick construction, large burial urns and other pottery, and cuprous, silver and iron materials. Iron and slag at the earliest levels of the ancient site of Jenne (beginning about 200 B.C.) are evidence of one of the earliest iron industries of sub-Saharan Africa (McIntosh and McIntosh 1980; de Grunne 1980:11-24).

Only one archaeological endeavor, that of the McIntosh team at the old site of Jenne, has uncovered a figure in a datable, secure context (McIntosh and McIntosh 1979). The figure, similar to the Eiteljorg example, was found with charcoal radiocarbon dated to 1000-1300 A.D. It had not been buried, but rather, along with other material including clay vessels containing food formed part of the contents of a building. The McIntoshes speculate that the figure was part of an ancestral shrine. Shrines with ancestor figures were still used at the present site of Jenne early in this century. Two other figures were recovered by this team within wall foundations at a site near old Jenne, and may relate to a practice of embedding images in walls as protection against annual flooding. Considering practices of present Sudanic populations, it is reasonable to conjecture that these figures embodied ancestral or other spirit forces.

This and the preceding clay figure are among the oldest pieces in my collection. The informal posture of this one appears whimsical, although we will probably never know its significance. H.E.

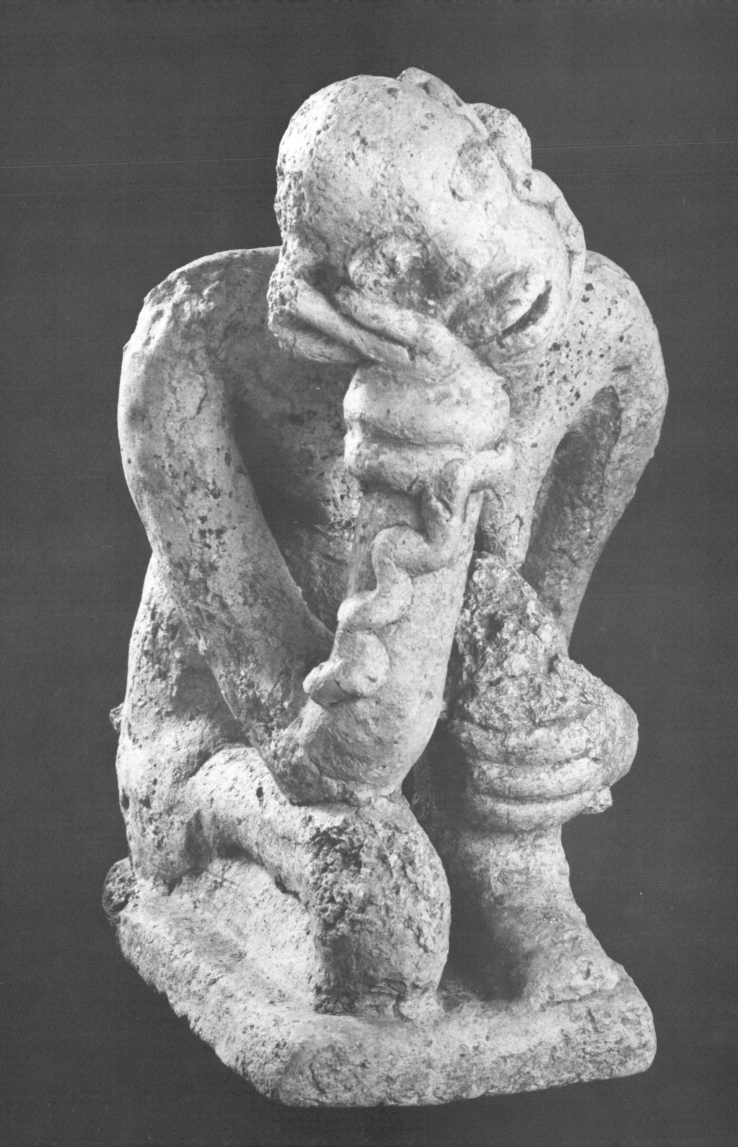

Dogon, Mali

3
female figure
wood, incrustation
h. 29^1/$_{16}$ in. (73.8 cm.)

The Dogon live in rocky country south of the
bend of the Niger River. Over the centuries they
have resisted Islam and other outside influences
to a greater extent than most peoples of the re-
gion and consequently have retained much of
their traditional way of life. Despite the ample re-
search among and writing about the Dogon there
is relatively little available field data concerning
the identification and ritual context of carved
figures, which are assumed to function as a link
with ancestors or other forces in the supernatural
world. Barbara DeMott (1982:18-38), in a review of
writings on the Dogon, points out the dearth of
field data regarding the relationship of specific
sculptural themes with particular ritual contexts.
For example, the frequent interpretation (Leu-
zinger 1963:no. 12; Laude 1971:125; Newton
1978:141) of raised arms like those on this exam-
ple with a supplication for rain is apparently not
supported by field data. Weathering has eroded
most of the surface of this old carving including
layers of sacrificial incrustation, suggesting that
the figure was ritually unattended for a number
of years before its removal from Dogon country.

exhibited: Indiana Central University, Indianapolis,
 1980

published: Celenko 1980, no. 1, ill.

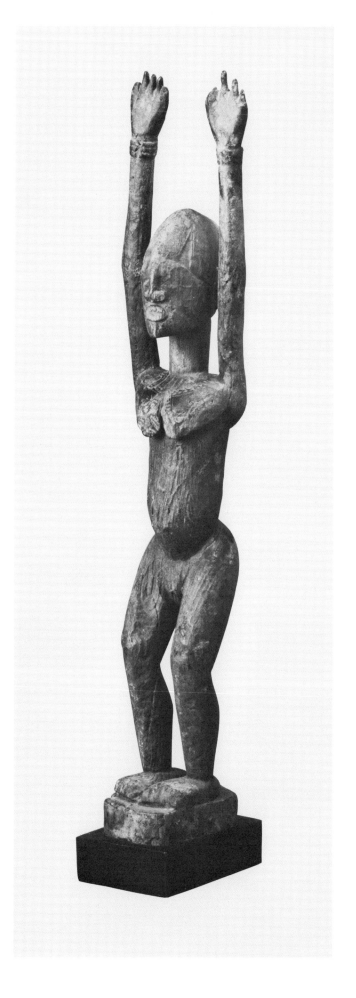

Dogon, Mali

4
face mask for *Awa* society
wood, pigment
h. 15¹³/₁₆ in. (40.2 cm.)

Dogon masks are controlled by the *Awa*, a men's initiatory society whose "... primary ritual function is to conduct public rites that insure the ordered passage of the dead into the supernatural world" (De-Mott 1982:62). This example, which depicts a hyena, is of a type worn by *Awa* members during a *Dama*, a masking ritual conducted every two or three years to deal with the spirits of persons who have died since the last *Dama*. Rituals for an important man may last up to six days and involve over a hundred maskers. The spirits of the dead wander about the community as a potential danger, and the primary purpose of the *Dama* rite is to drive these souls from the world of the living to the realm of ancestral spirits.

Over seventy Dogon masquerades are documented, each with a particular fiber or wooden mask, costume and individual mode of behavior. Maskers generally impersonate beings which represent supernatural forces. For example, the hyena, which is depicted by this carving, is associated with a hyena-man monster believed to prey on humans at night. The hyena's reputation for abnormal, malicious behavior is paralleled by the maskers' threatening gestures during *Dama* performances. The animal's head is characteristically depicted with bulging forehead, prominent snout, short, upright ears and red, black and white spots (Griaule 1963:466-68, fig. 107Y; De-Mott 1982:62-68, 75-87, 107-108, fig. 38).

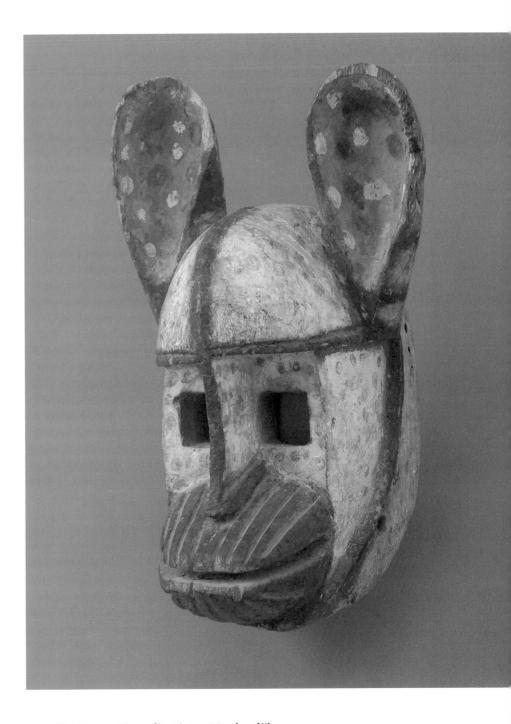

ex-collection: Cornelis Pieter Meulendijk

published: Wassing 1968, pl. XV

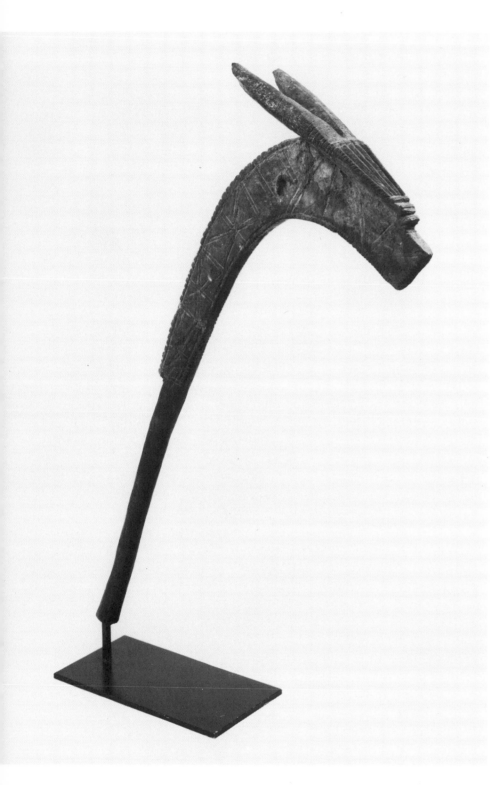

Dogon, Mali

5
staff for thief masker (*Yo Dommolo*)
wood, iron, incrustation
l. 28¹/₈ in. (71.4 cm.)

In his classic study of Dogon mask-
ing Marcel Griaule illustrates an
animal-headed staff similar to this
example which is carried on the
shoulder of a *Yona*, or thief masker.
These masqueraders wear a dis-
tinctive fiber headpiece and appear
at funerals of fellow *Yona* and other
public gatherings. During the funer-
ary period they conduct ritually
sanctioned and communally ac-
cepted thievery of animals which
are later eaten during feasts. They
also steal clothing and other items
from spectators in order to receive
payment upon return of the stolen
goods (Griaule 1963:332, 562, fig.
131B, pl. XX). The form of such staffs
may derive from hunters' throwing
sticks (Fagg 1968:no. 4).

exhibited: Herron Museum of Art,
 Indianapolis, 1965

published: Herron Museum of Art,
 Indianapolis, 1965, no. 5

*This graceful carving, acquired some
twenty years ago during a visit to
New York, was one of the very first
African pieces in my collection. H.E.*

Western Sudan — Gur

Bwa, Upper Volta
area of Houndé town

6
face mask
wood, pigment
h. 87⁹/₁₆ in. (222.5 cm.)

Bwa masks with tall, plank-like superstructures exemplify the preference of Gur-speaking groups for abstract, geometric forms and bold use of color. The animal imagery incorporated into these masks is difficult to identify. A bird beak overhanging a round face is typical. Available field data does not indicate a symbolic significance for the characteristic checkerboard designs which embellish the superstructure. The mask probably functioned within the *Dwo* society as a manifestation of a bush spirit which intercedes with the spirit world on behalf of the living. It would have appeared at periodic, communal festivals, at harvest celebrations and at funerals of important individuals (Skougstad 1978:15-24; Roy 1979a:nos. 14, 18; Fagg 1980:50-51). The neighboring Ko, one of the so-called Gurunsi peoples, make similar masks, and Guy Le Moal (in Fagg 1980:50) reports that Bwa masks of this type were copied from the Ko.

The field photograph, taken by Nancy Mickelsen (overseas Art and Photoservice) in 1972, depicts a Bwa masker at Ouagadougou during a state ceremony honoring Georges Pompidou. Throughout West Africa greeting important visitors with masquerades is a centuries-old practice.

exhibited: Indiana Central University, Indianapolis, 1980

published: Celenko 1980, no. 4

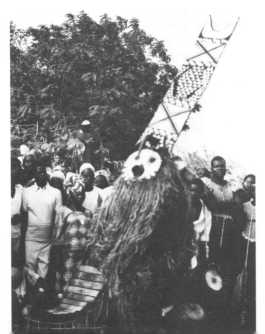

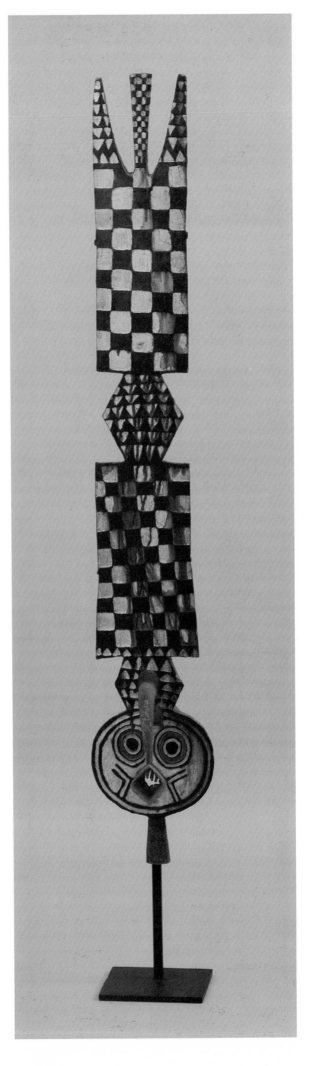

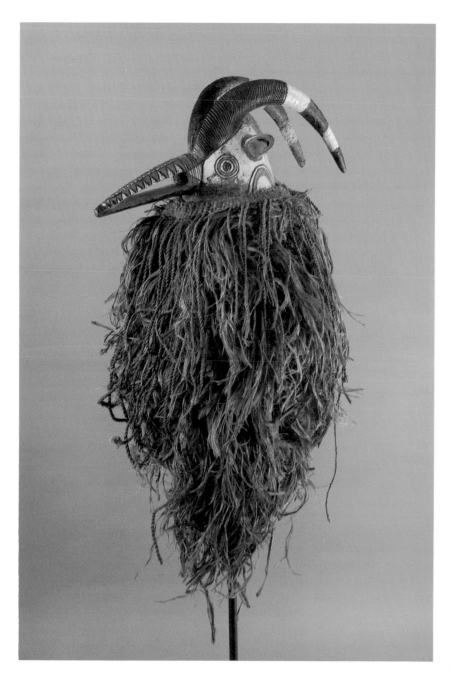

Mossi, Upper Volta
area south and west of the White
Volta River

7
cap mask (*Wan-pesego*)
wood, pigment, fiber, fur, mastic
l. 23¹/4 in. (59.1 cm.)

Christopher Roy (1979b:50-53, 68-71,
pls. 1-32) reports that relatively
small zoomorphic masks covered
with red, white and black geometric
patterns and lacking superstruc-
tures belong to the Ouagadougou
style area which encompasses the
Mossi living south and west of the
White Volta River. This example is
identified by Roy (1981) as a *Wan-
pesego* (*wango*, mask; *pesego*, ram),
ram mask, from the southwestern
Ouagadougou style area. The *Wan-
pesego*, which is worn on top of the
head, is distinguished by thick,
crescent-shaped horns and a prom-
inent "snout." The particular animal
or other entity depicted is a clan's
totem, a sacred being who played a
major role in the origin myth of the
clan. Furthermore, these carvings
embody the collective spirits of the
ancestors of a clan. The primary
function of Mossi maskers is to es-
cort the souls of the deceased into
the world of ancestral spirits during
funerals held some time after inter-
ment. They take part in burials and
agricultural rites, and protect the
community's wild fruit trees. Be-
tween appearances, a *Wan-pesego*,
which has had its fiber attachments
removed, may also serve as an an-
cestral altar within the owner's
house or family spirit house (Roy
1979b:71-102).

Nuna, Upper Volta

8
cap mask
wood, pigment, fiber, gourd,
 feathers, incrustation
l. 22$^{1}/_{2}$ in. (57.1 cm.)

The Nuna, Ko, Kasena, Lela, Sisala
and other related peoples of south
central Upper Volta and parts of
neighboring northern Ghana are col-
lectively referred to as Gurunsi by
their neighbors. Only recently have
attempts been made to properly
identify the carving styles of these
groups (Skougstad 1978:15-23;
Museum of African Art 1979; Roy
1979a:no. 14; Wahlman 1980:nos.
34-36). Christopher Roy (1981) attri-
butes this zoomorphic headpiece to
the Nuna, whose masks share some
features with those of the neighbor-
ing Mossi (cat. no. 7). It was worn on
top of the head with a viewing plane
below the snout. The surface shows
signs of sacrificial offerings. Accord-
ing to Norman Skougstad (1978:23)
Nuna masks are manifestations of
bush spirits which can intercede
with other divinities for the benefit
of humans. Maskers appear at fu-
nerals and during festivals held
every three years.

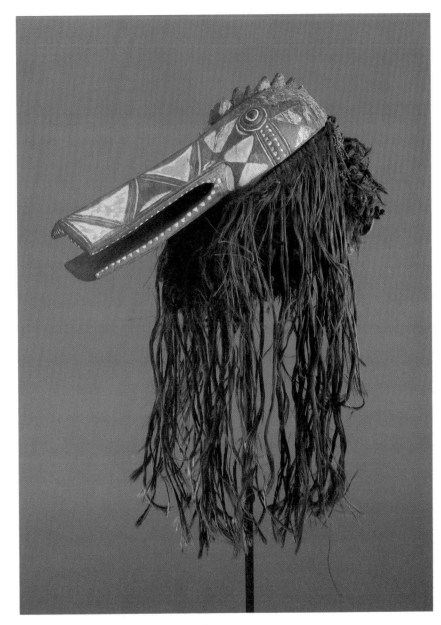

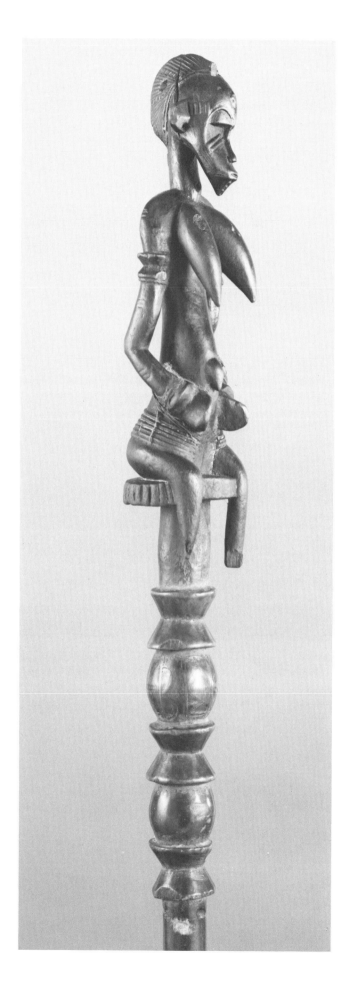

Senufo, Ivory Coast

9
staff for *Poro* association
wood, iron, fiber, cloth, mastic
h. 39¹⁵/₁₆ in. (101.5 cm.)

Staffs surmounted by female figures are awarded to young men of the male *Poro* association for outstanding hoeing ability. During communal hoeing the staffs are carried by champion cultivators as indicators of their status. They are also displayed at funerals of champion cultivators and other men and women. On such occasions the staff, with its pointed iron base, is implanted in front of the deceased's house as a tribute and as a reminder of the ancestral aspect of these carvings which pass from generation to generation. The female images on these staffs depict young maidens at the height of their physical beauty and promise both human and agricultural increase (Glaze 1981a:8-10, 161-65; 1981b). The figures are usually seated on a stool, the legs of which are missing in this carving, and are ". . . presented in the traditional gesture of serene repose, designed as a dramatic contrast to the cultivator's striving in the fields" (Glaze 1981a:164). These staffs are commonly identified in the literature as *daleu* (Goldwater 1964:26), a term which simply means "figurative sculpture" (Glaze 1981b:49). Anita Glaze (1981a:165) reports the terms *Tefalipitya,* "hoe-work-girl," and *Tyakparipitya,* respectively, among some central and southern Senufo.

exhibited: Indianapolis Museum of Art, 1976
 Indianapolis Museum of Art at
 Columbus, 1977

published: Gilfoy 1976, no. 86, ill.

Senufo, Ivory Coast
central area

10
helmet mask (*Kunugbaha?*) for *Poro*
 association
wood, pigment, brass, iron, fiber
l. 15¼ in. (38.7 cm.)

Various animal-headed wooden helmet masks are worn by the highest-ranking masqueraders of the men's *Poro* association. This example, which may depict a hyena, probably originates from an artisan group such as the Fono or Tyeduno living in the Kafiri or Kufuru dialect area to the south of Korhogo. It may be a *Kunugbaha* anti-witchcraft mask which comes out during funerals for elders. Two consistent features of the *Kunugbaha* are the absence of antelope horns and the inclusion of boar tusks and teeth, which in this carving are reduced to angular forms at the corners of the mouth. Red and white pigmentation, brass eyes and chameleon imagery are frequently found on these masks. The chameleon, believed to be one of the first creatures to inhabit the earth, is associated with primordial knowledge and mysterious

powers. A small hole on top of the carving probably once held quills, feathers or other items. Maskers typically carry drums and are enveloped with garments, feathers, fibers, animal skins and other elements (Glaze 1981a:1-6, 137-42, 207-209, 213-216, pls. 8, 64; 1982). Anita Glaze (1981a:208) summarizes the significance of *Poro* helmet masks, which appear at both funerals and initiations:

> They are the embodiment of supernatural powers and knowledge of magical formulae, expressed through aggressive forms and symbols, including the adjunctive accumulation of signifying natural material to the carved zoomorphic head. These powers are augmented by age and validated by the accretion of magical substances and blood sacrifices to . . . [deities], the ancestors, and the bush spirits. The masquerade incarnates powers that may be directed against lawbreakers (felons) and sorcerers and against negative spirit forces, such as witches, wandering dead, and malevolent bush spirits.

published: Celenko 1981, fig. 8

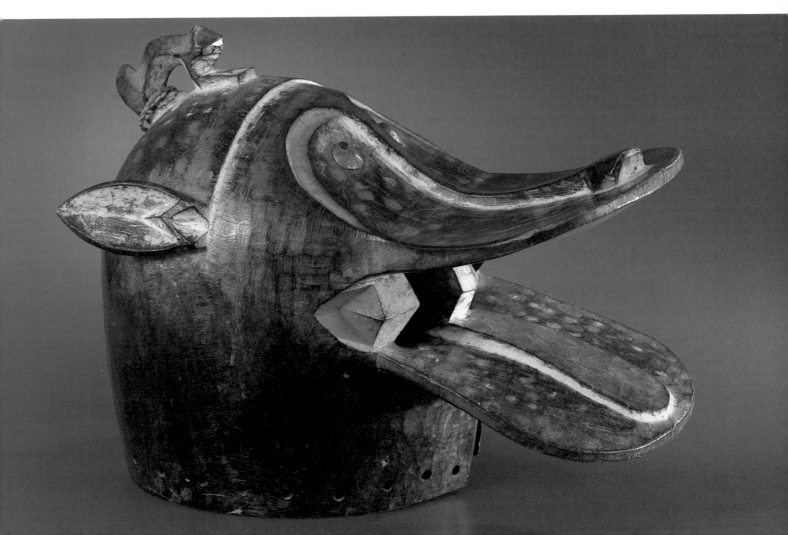

Nafana, Kulango or Degha,
Ghana/Ivory Coast

Cercle de Bondoukou

11
face mask (*Bedu*)
wood, pigment, iron
h. 71¹/₂ in. (181.7 cm.)

René Bravmann's research (1973:18, fig. 20; 1974:101-18) of the *Bedu* masking tradition provides valuable lessons on aspects of African arts which are often neglected. Firstly, the *Bedu* and other masks of the Cercle de Bondoukou in east central Ivory Coast and neighboring Ghana demonstrate that masking is not necessarily incompatible with Islam. For example, although the *Bedu* masquerade of the Nafana, Kulango and Degha (Mo) is non-Muslim in ownership and use, the Islamized Mande in the area not only tolerate *Bedu* but participate in certain of its activities. Another point to be gleaned from Bravmann's research is that African sculptural traditions are not timeless or without history; the *Bedu*, for instance, originated among the Nafana only about forty years ago. Lastly, the tradition is of note because it is one of the better documented examples of a mask type used by more than one ethnic group.

Bedu masks come out during an annual, month-long festival and at funerals of important elders. They are universally regarded as embodying protective forces which have a positive effect on concerns such as illness, human fertility and agricultural success. Unlike many African masking traditions there is little secrecy about the *Bedu*; even women take part in the preparation of the masquerade. The masks, all worn by men, appear in male-female pairs. Bravmann's informants usually identified carvings such as this one with disc-like superstructures as female. The masquerader, whose body is concealed in a fiber gown, views through holes in the lower half of the mask. The back of the mask has a wooden projection and iron rods for tying the mask to the dancer. The geometric designs, which are newly painted for each appearance, apparently have no documented significance.

exhibited: Indianapolis Museum of Art, 1976
 Indianapolis Museum of Art at
 Columbus, 1977

published: Gilfoy 1976, no. 62, ill.

This mask is as large as the man who wears it. H.E.

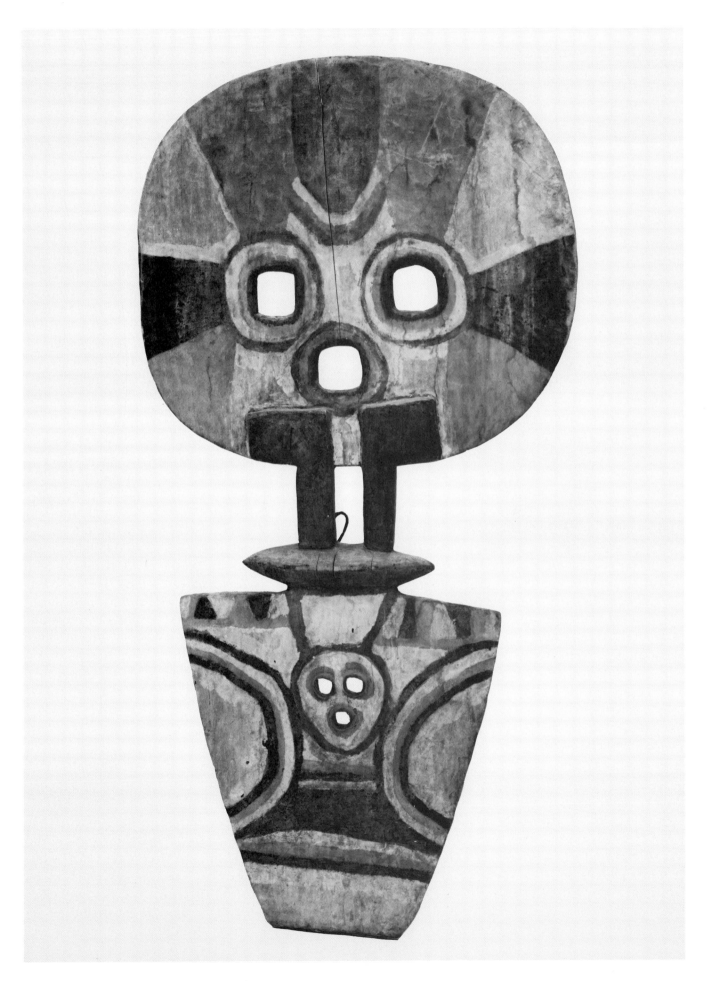

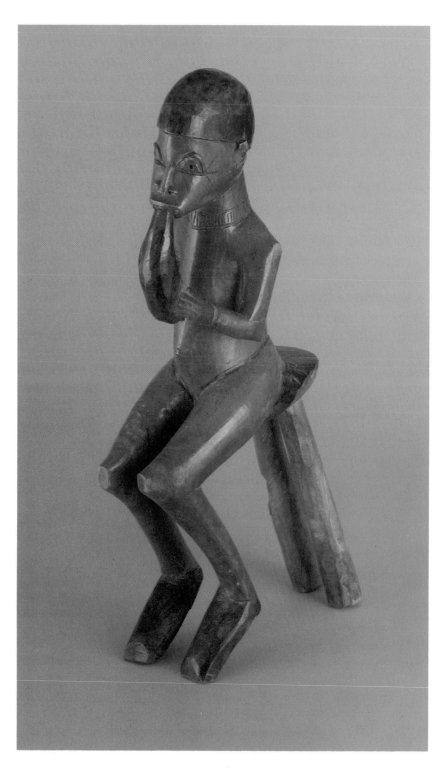

exhibited: Indianapolis Museum of Art, 1976

published: Gilfoy 1976, no. 83
 Meyer 1981a, no. 182, ill.

Western Sudan — Gur

Lobi, Upper Volta
Gaoua town
school of Sikire Kambire

12
figure (*bateba*)
wood, iron
h. 27³/₁₆ in. (69.1 cm.)

The Lobi, whose carvings exhibit a range of styles, live in southwestern Upper Volta and parts of neighboring Ivory Coast and Ghana. There is some contradiction in the literature, perhaps due to local variation within Lobiland, as to whether figures embody ancestral, bush or other local spirits, spirit helpers or deities (Labouret 1931:188, 405-408; Goody 1962:224, 226; Himmelheber 1966a; Meyer 1981a; 1981b; 1981c). According to Piet Meyer (1981a), carved human figures known as *bateba* are not merely inanimate objects representing spirits, but are viewed as living beings which act as intermediaries between humans and the spirit world. For example, they protect against witches and sickness, help women conceive, and mourn for the dead. *Bateba*, which vary greatly in form and gesture, function within shrines and as instruments of divination. Generally, the larger carvings, a foot or more high, are shrine objects, and seated figures similar to this example have been photographed in shrines. This figure, whose ray-like markings at the corners of the eyes relate to Lobi scarification patterns (Himmelheber 1966a:87), holds what may be a wind instrument or tobacco pipe. Piet Meyer attributes this carving to a pupil of Sikire Kambire of the town of Gaoua in southwestern Upper Volta (Meyer 1981a:57, 127-41, no. 182, ills. 95, 102; 1981c; for other examples see Guimiot and Van de Velde 1977:no. 7; Cole and Ross 1977:117, fig. 245 [reattributed by Sieber 1978:10]).

Bobo (?), Upper Volta/Mali

13
female figure
wood, incrustation
h. 19 in. (48.2 cm.)

The attribution of this figure rests on the stylistic relationship of its head with Bobo *Bole* masks (cat. no. 14) documented by Guy Le Moal (1980:230, figs. 14c-d). Although both Le Moal (1980:230) and Norman Skougstad (1978:24) refer to Bobo figures, they do not illustrate them or report on their use. Indeed, there is apparently very little published on the styles and functions of Bobo figures. Jürgen Zwernemann (1962), writing about the neighboring Bwa, illustrates two figures which are carried as fertility images during masquerades. One of these carvings (Zwernemann 1962:ills. 1-2), although exhibiting a differently styled head, has flat shoulder tops, arm conventions and other formal features which relate to the Eiteljorg figure. The incrusted surface of this figure suggests repeated applications of offerings.

exhibited: Indiana Central University, Indianapolis, 1980

published: Celenko 1980, no. 7

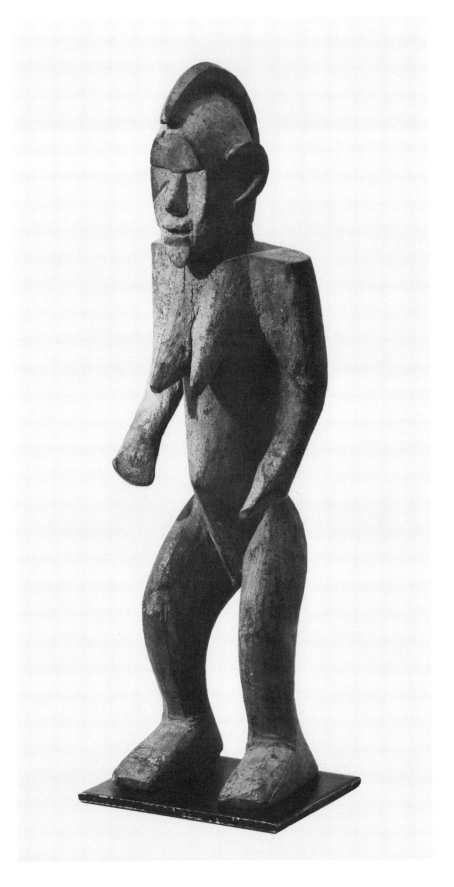

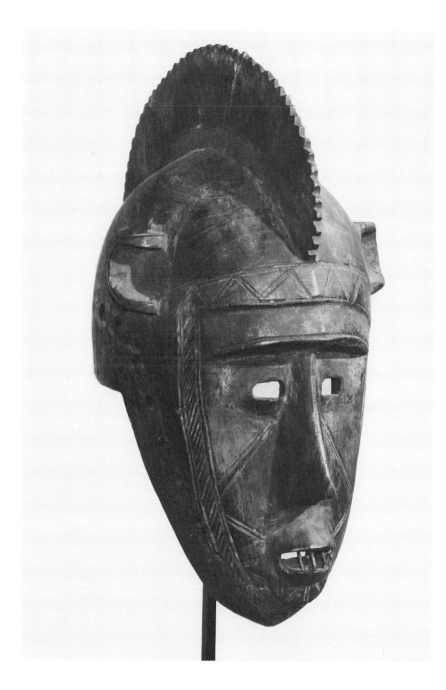

Bobo, Upper Volta
area of Taguna village

14
helmet mask (pseudo *Bolo*)
wood, pigment
h. 15 in. (38.1 cm.)

Guy Le Moal's recent book (1980) provides a thorough study of Bobo masking, which in addition to well-known wooden headpieces, includes a host of cloth, fiber and leaf varieties. These helmet masks are typical of Bobo carving in their hemispherical tops, prominent brows, saggital crests and painted geometric surfaces. The latter trait is also prevalent on masks of neighboring Gur-speaking groups.

According to Le Moal (1980:216, 230, 333) some kinds of wooden masks like cat. no. 14 were invented in recent times for maskers who entertain during public festivities, and subsequently were carved for the art market. Le Moal (1980:230, 243-46, figs. 14c-d; see also Kamer 1973:nos. 1, 4) documents masks in the style of the head of cat. no. 13 among smiths at the village of Taguna in northeastern Bobo country. He identifies them as pseudo *Bole* (sing., pseudo *Bolo*) since they have been transformed completely in both form and function from *Bole*, ritual fiber masks which the smiths acquired from the Zara, a Bobo subgroup. No ritual function is reported for the pseudo *Bolo*.

In contrast, *Molo* masks (cat. no. 15) are ritually important since they are regarded as spiritual entities, incarnations of the deity *Dwo*. Use of the *Molo* and other wooden masks is the prerogative of smiths, although today these artisans also produce them for farmers. During dry season activities of the *Dwo* society smiths wear the *Molo* at initiations and fu-

Bobo, Upper Volta
area of Kurumani or
 Taguna villages (?)

15
**helmet mask (*Sibe Molo* or
 So Molo) for *Dwo* society**
wood, pigment
h. 58¹/₂ in. (148.6 cm.)

nerals. Cat. no. 15 is either a *Sibe Molo* or *So Molo*, indistinguishable mask forms whose ritual contexts differ. *Sibe Molo* maskers wear leaf costumes, whereas the wearer of the *So Molo* is completely naked. The *Molo* depicts an elongated human head surmounted by horns and has a rectangular, rather than trapezoidal, face below the brow. Le Moal distinguishes two styles of *Molo*, one from the Kurumani village area in central Boboland, and another from farther north in the Taguna village area. This example has features from both areas; the angular eye openings and navel form in the mouth area are in the Taguna style, while the long nose and straight horns suggest an origin in the Kurumani area. Although Le Moal distinguishes male and female *Molo* masks, the hybrid nature of this carving permits only a tentative male identification (Le Moal 1980:222-26, fig. 18, passim).

cat. no. 14
exhibited: Indiana Central University,
 Indianapolis, 1980

published: Celenko 1980, no. 6, ill.

cat. no. 15
exhibited: Indiana Central University,
 Indianapolis, 1980

published: Celenko 1980, no. 5
 Celenko 1981, fig. 9

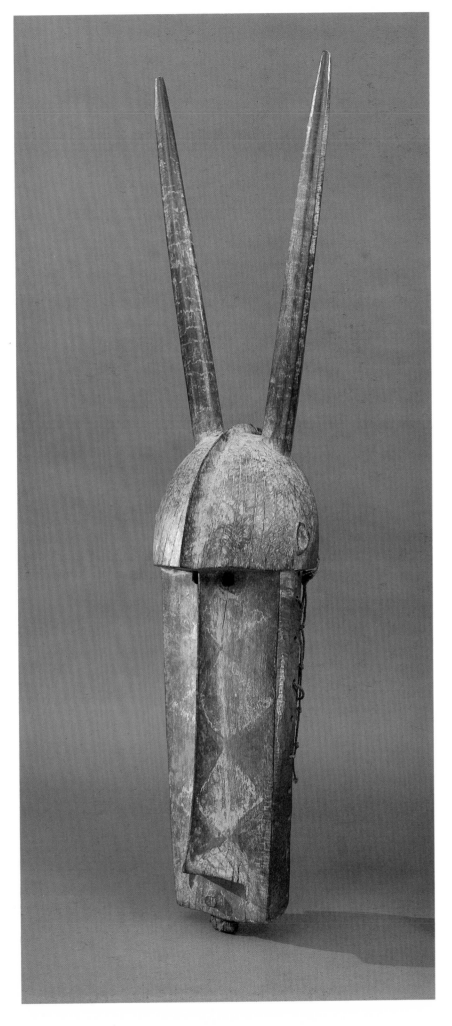

Maninka (Malinke), Ivory Coast
area of Korhogo town

16
hunter's shirt
cloth, leather, fiber, fur, mirror, animal teeth,
 claws, horn
approx. h. (excluding fringe): 33 in. (83.8 cm.)

Among Mande and neighboring peoples, proven hunters own prestige shirts made of woven cotton strips. Integral to these garments are magic charms, which in this example include animal teeth, claws, horns, and leather amulets containing Koranic inscriptions. Charles Bird (1974:viii) elucidates the intimate relationship between Maninka hunters and the occult, manifested, in part, by shirt charms:

> The hunter, being a man of action, a performer of deeds, must necessarily become a specialist in occult science. His talismans are vital to his ability to perform and they protect him from acts that enemies or evil spirits would do to him. . . . What is important in performing any deed whether it be the killing of a lion or the vanquishing of an enemy king has nothing to do with the individual's physical attributes or prowess, but rather with the knowing of the secret to the antagonist's *nyama* [the energy of action]. Once this has been determined and the appropriate sacrifice made to counteract it, the outcome of the conflict is determined.

exhibited: Museum of Modern Art, New York,
 1972-73
 Los Angeles County Museum of Art, 1973
 M.H. de Young Memorial Museum, San
 Francisco, 1973
 Cleveland Museum of Art, 1973
 Creative Arts Department, Purdue
 University, West Lafayette, Indiana,
 1975

published: Sieber 1972a, 46, ill.
 McNaughton 1975, no. 34

Medicinal and magical elements are also found on some hunter-warrior garments in my American Indian collection. H.E.

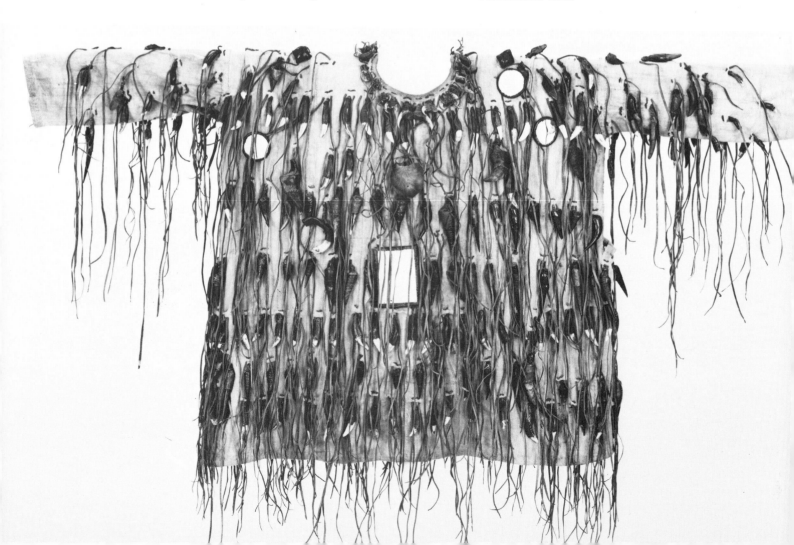

Maninka (Malinke), Mali
western Mali (?)

17
helmet mask
fiber, cloth, wood
approx. h. 28 in. (71.1 cm.)

Masks of fiber, cloth, feathers, leather or other non-wood construction are widespread in sub-Saharan Africa, but because of ethnocentric relegation to the category of minor or craft-oriented forms they have often been neglected by collectors as well as researchers. This example, consisting largely of dyed and natural fibers built around a net framework, was collected in Bamako by Professor Charles Bird of Indiana University. According to Bird (1979), the mask may represent a lion and was said to have come from the extreme western portion of Mali where it was used by a Maninka youth association. In neighboring southeastern Senegal different types of fiber masks, associated with agricultural and initiation activities, have been documented among the Bassari and Fulani (Gessain 1963a:fig. 5, 1963b:figs. 6-8; 1968:147, 149; figs. 1-3).

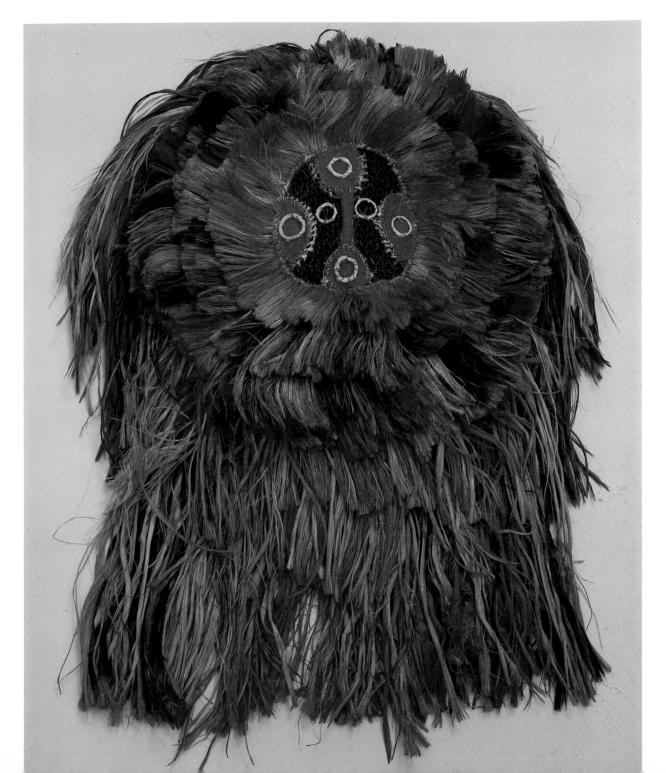

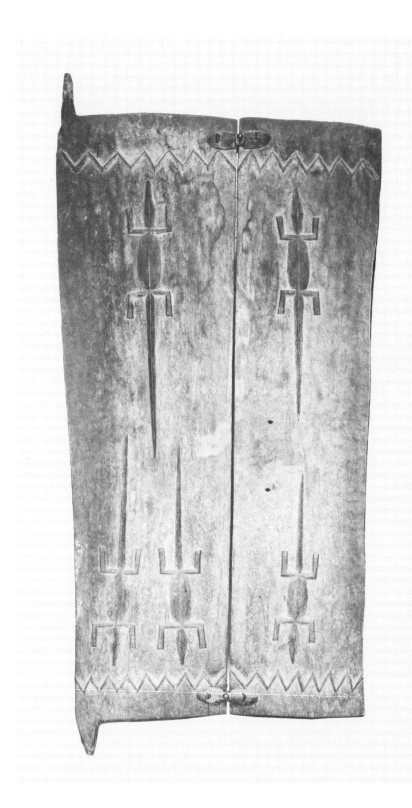

Bamana, Mali

18
door
wood, iron
h. 63⁷/₈ in. (162.3 cm.)

This two-paneled door was collected in Segou by Professor Charles Bird (1979) of Indiana University. Its large size and imagery indicate that it was probably used on a house or shrine, rather than on a granary or chicken coop. The reptilian figures in relief are probably lizards, certain varieties of which are considered protection against thieves; their inclusion here may be apotropaic (Imperato 1972). The zigzag relief bordering the top and bottom of the door may depict snakes. The two holes in the panel to the viewer's right are for the attachment of a lock.

Decorated doors denote prestige among many West African peoples and exemplify an important social dimension of African art. H.E.

Bamana, Mali
eastern area, area of Segou town (?)

19-20
pair of head crests for *Chi Wara* association
left (female): wood, pigment, glass, fiber
 h. 33³/₄ in. (85.7 cm.)
right (male): wood, pigment, glass, fiber, brass,
 iron, cowrie shell
 h. 36¹/₂ in. (92.7 cm.)

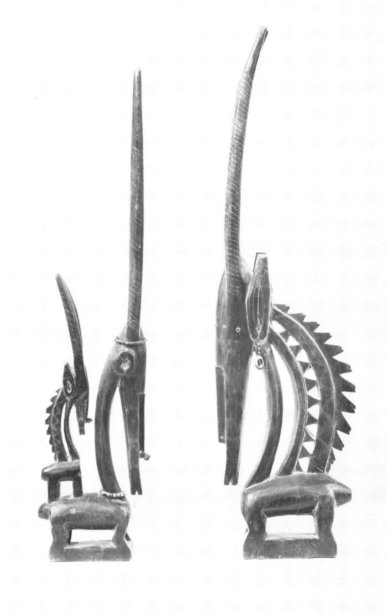

The *Chi Wara (Ci Wara, Tyi Wara)* association is one of six initiatory societies once prevalent among the Bamana. Because of Islamic and Western influence, traditional religious beliefs have been undermined, and in recent decades the association's masquerade has for the most part evolved into secular entertainment. In the past, field preparation and other agricultural work coincided with ceremonies which celebrated *Chi Wara*, a mythic creature who first taught man farming. These ceremonies honored farmers and acknowledged the crucial nature of their work. Wooden crests worn by paired maskers, one depicting a male antelope and the other a female, preserved the memory of the beast and served as emblems of the association (Imperato 1970; Zahan 1980:17-24, passim).

According to Dominique Zahan (1980:63-99; 1981) the crests' components refer to elements necessary for successful farming. For example, the antelope horns of both headpieces represent the growth of millet, the grain staple. Water is denoted by the maskers' fiber costumes. The zigzag pattern of the mane of the larger, male crest symbolizes the path of the sun between the solstices, while the female antelope and child symbolize, respectively, earth and humankind. The union of male (sun) and female (earth) is reinforced during masquerade preparation which involves both sexes, although only men perform (Brink 1981:25).

The paired maskers dance bent-over with animal-like movements. Each carries two sticks in his hands in simulation of antelope's forelegs, and perhaps as an allusion to *Chi Wara's* original digging sticks. Although a literal translation of *Chi Wara* is "farming beast" or "beast who labors" the term has come to signify ". . . an excellent farmer a man who spends his entire day, from sunrise to sunset, bending over his *daba* [hoe], never straightening up, not even for a moment, either to rest, drink or eat, and hoeing with joy, perseverance and pride" (Imperato 1970:8). Such an ideal is impossible to attain, but it indicates the respect given to farm work among many African peoples.

exhibited: Indiana Central University,
 Indianapolis, 1980

published: Celenko 1980, nos. 2-3

The distinctive profiles of Chi Wara *crests have become hallmarks of African art. H.E.*

Marka, Mali
area of San town

21
antelope head for puppet stage
wood, brass, iron
h. 17³/₁₆ in. (43.7 cm.)

An ongoing tradition of theater exists among the Bozo, Bamana, Maninka, Marka and other Malian peoples. The theater is conducted by secular youth groups, *Kamalen Ton*, village-based, some-times multi-ethnic associations of men and

Bamana (?), Mali
area of Segou town

22-23
pair of antelope heads for puppet stage
wood, pigment, cloth, iron
female (left): h. 37³/₈ in. (95.1 cm.)
male (right): h. 40¹/₂ in. (102.9 cm.)

women ranging in age from early teens to mid-forties. *Kamalen Ton* coordinate and provide labor for communal projects such as road repair and collective farming, and provide public entertain-

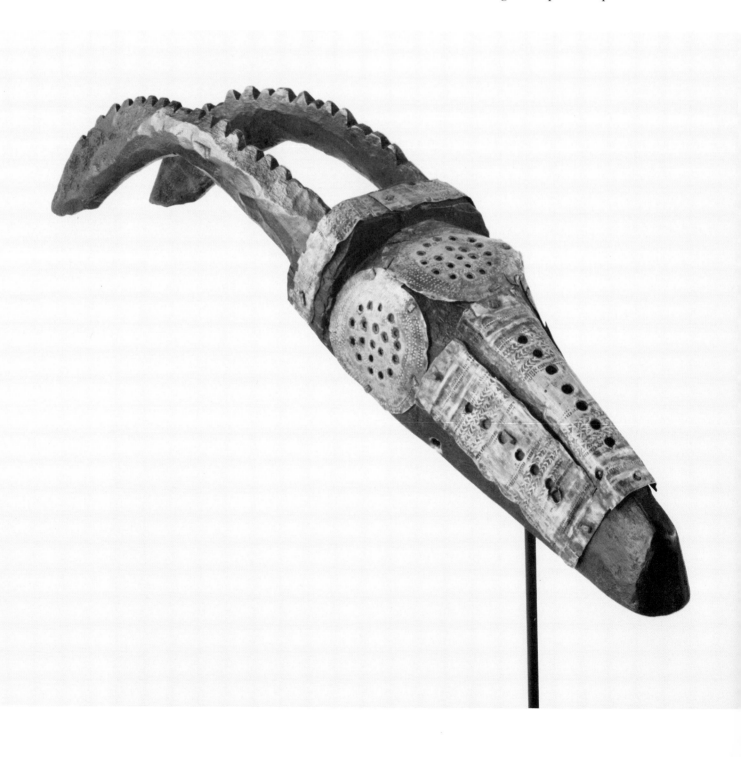

ment in the form of local theater prior to the planting season and after the first harvest.

Some performances include masking, puppetry, music and singing. Puppet shows satirize or honor contemporary and mythological characters and are often moralistic. Puppeteers are hidden behind a movable stage which consists of a wooden frame, often in the form of an animal, draped with cloth or fiber. These three carvings are not puppets, but rather heads which are attached to the zoomorphic stages. The male-female pair depicts heads of the dwarf antelope (*mankalani kun*); they were once affixed to separate stages presented together. During the performances the symbolic significance of the various animals depicted by the puppets and stages is revealed through praise songs (Arnoldi 1976; 1982). One song refers to the dwarf antelope's tough skin as a metaphor for the animal's protective power (Arnoldi 1976:n.p.):

> E! Little antelope!
> You're not worth a damn!
> But you've got a tough skin!
> Ah! Little antelope!
> You're too small!
> But you've got a tough skin!
> Ah! Little antelope!
> What can you do?
> But you've got a tough skin.

In contrast to the blackened surfaces of secret society masks and figures, the surfaces of theater carvings are often brightly colored and embellished with cloth, metal and other non-wooden materials. The pair of antelope heads is boldly colored with orange and blue oil-based paints. The metal appliqué on the older, unpainted mask represents a longstanding Marka tradition.

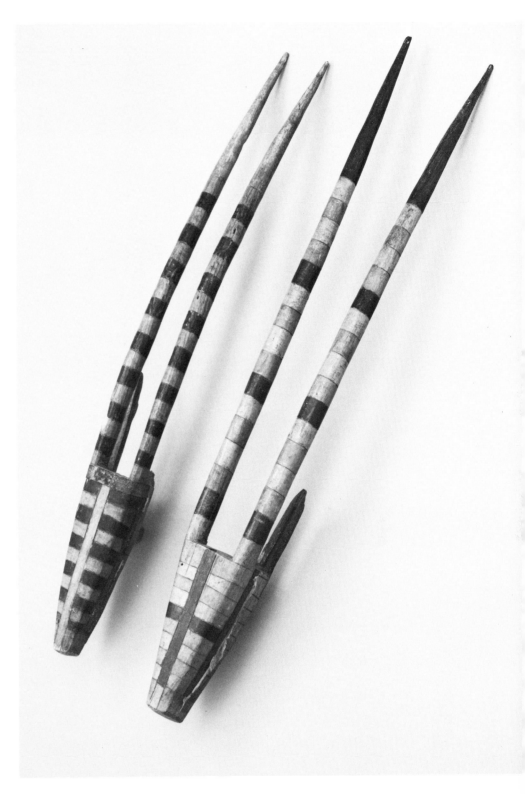

cat. nos. 22-23

exhibited: Creative Arts Department, Purdue University, West Lafayette, Indiana, 1976

published: Arnoldi: 1976, no. 39, ill.

Bamana, Mali

24
altar figure (*Boli*)
wood, fiber, sacrificial materials
l. 47 in. (62.9 cm.)

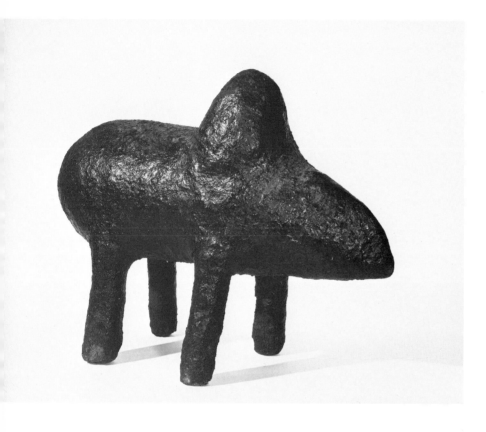

Boli are animal, human or unidentifiable forms placed on altars in the sanctuaries of a number of men's societies. These assemblages are composed of diverse materials which may include wood, roots, clay, wax, honey, blood, alcoholic beverages, chewed kola nuts, claws, horns and metal (Goldwater 1960:10; Zahan 1974:29; McNaughton 1979:26). A *Boli* is viewed as an embodiment of spiritual forces and as such provides a reservoir of power which can be harnessed at appropriate times (McNaughton 1979:27). According to Germaine Dieterlen (in Goldwater 1960:10) these altars, because of their composite nature, summarize the universe. They are also a summary of society; each member contributes a part of himself by covering the *Boli* with saliva while pronouncing his name.

A radiograph of this *Boli* reveals a wooden framework consisting of a torso and four limbs nailed together; the hump is built around a spherically shaped entity of an undetermined radiopaque substance, perhaps a clay vessel. This construction corroborates reports of the composite aspect of these objects and contrasts with at least one radiographed example whose core was monoxylous (Sieber and Celenko 1977:20-21). Substances such as blood which may be present have been "burned out" during the radiographic process and are not visible. Radiography provides a non-destructive, readily available and low cost analytical technique which in addition to the investigation of construction methods can be useful in the detection of damage and repair, cavity contents (cat. no. 170) and heavily incrusted, hidden contours (Sieber and Celenko 1977; radiograph taken on T.F.I. Hotshot; Kodak Industrex AA film; 50kV, 3 mA, 3 min.; Conservation Department, Indianapolis Museum of Art, 1978).

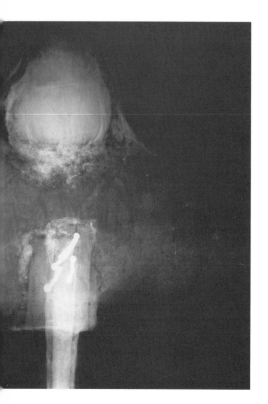

exhibited: Indianapolis Museum of
Art, 1976
Indianapolis Museum of
Art at Columbus, 1977

published: Gilfoy 1976, no. 98, ill.

Although the construction and contents of this piece were analyzed through radiography, understanding its innermost secrets requires a thorough knowledge of a complex social and religious system. H.E.

unidentified ethnic group

25
headpiece
basketry, cowrie shells, seeds,
 metals, wood, animal horns, fiber,
 hair, glass, mastic
w. of base: 17$\frac{1}{8}$ in. (43.5 cm.)

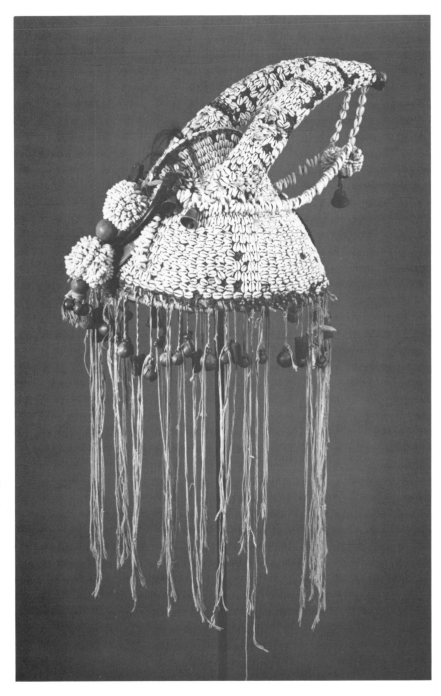

This large headdress consists of a
coiled, basketry cap embellished
with an assortment of shells, seeds,
brass bells, animal horns and other
ornaments. There appears to be
nothing quite like it in the literature,
and the origin of the piece is uncer-
tain. However, its similarity to pub-
lished headpieces from some West-
ern Sudanic peoples such as the
Senufo of Ivory Coast (Glaze 1981a:
pl. 45), the Konkomba (Froelich
1954:fig. 108) and the Moba of Togo
(Mullen:n.d.) suggests that it comes
from this region. The source of the
headpiece claims that it is a type
associated with hunters and that it
originates among the Koranko of
south central Guinea at or near the
town of Faranah.

exhibited: Indianapolis Museum of
 Art, 1976
 Indianapolis Museum of
 Art at Columbus, 1977

published: Gilfoy 1976, no. 61, ill.
 Saturday Evening Post
 1975, p. 52, ill.

*Headpieces of basketry, leather,
cloth and other "soft" materials are
usually neglected in surveys and dis-
cussions of African art because of
the abundance of wood carving. But
this headdress, completely covered
with cowrie shells, is truly a work of
art. H.E.*

Toucouleur or Wolof, Senegal/Gambia

26 (top left)
woman's necklace bead (?)
gilded silver-copper alloy
w. 1¹⁵/₁₆ in. (4.9 cm.)

Toucouleur or Wolof, Senegal/Gambia

27 (top right)
woman's necklace bead (?)
gilded silver-copper alloy
w. 1⁷/₈ in. (4.8 cm.)

Toucouleur (?), Senegal

28 (center left)
woman's hair ornament
gilded silver-copper alloy
h. 1⁷/₈ in. (4.8 cm.)

Toucouleur (?), Senegal

29 (center middle)
woman's hair ornament or necklace bead
gilded silver-copper alloy
h. 2 in. (5.1 cm.)

Wolof (?), Senegal/Gambia

30 (center right)
woman's earring
gilded silver-copper alloy
w. 1¹/₂ in. (3.8 cm.)

Toucouleur (?), Senegal

31 (bottom)
woman's necklace
gilded silver-copper alloy
l. of large bead: 3¹⁵/₁₆ in. (10 cm.)

Although figurative sculpture is almost nonexistant among Muslim peoples such as the Toucouleur, Wolof, Fulani (Peul) and Tuareg, their accomplishments in other arts such as weaving, leatherwork, gourd decoration and jewelry are noteworthy. The technique and style of these prestige ornaments from the Senegambian area indicate Wolof and Toucouleur work. They were made by smiths who work exclusively with non-ferrous metals, employing techniques which are still the subject of some confusion. These examples, which were analyzed by the Detroit Institute of Arts (Research Laboratory, L81.2075-78, L81.2080, L81.2082), are of silver-copper alloy components covered with a gold wash. The precise method of gilding, which gives the jewelry its characteristic yellow-orange color, is uncertain. An autocatalytic process without electric current was probably used, although a "mise-en-couleur" technique is also known from this area. Most components have probably been assembled with solder, while the granulation and perhaps the filigree, which give these ornaments a distinct character, have most likely been affixed with a gum arabic-borax glue. Stylistically and technically this jewelry represents part of a centuries-old tradition also found in North Africa and the Mediterranean world (Baldwin 1978).

cat. no. 29
exhibited: Indiana Central University, Indianapolis, 1980

published: Celenko 1980, no. 10

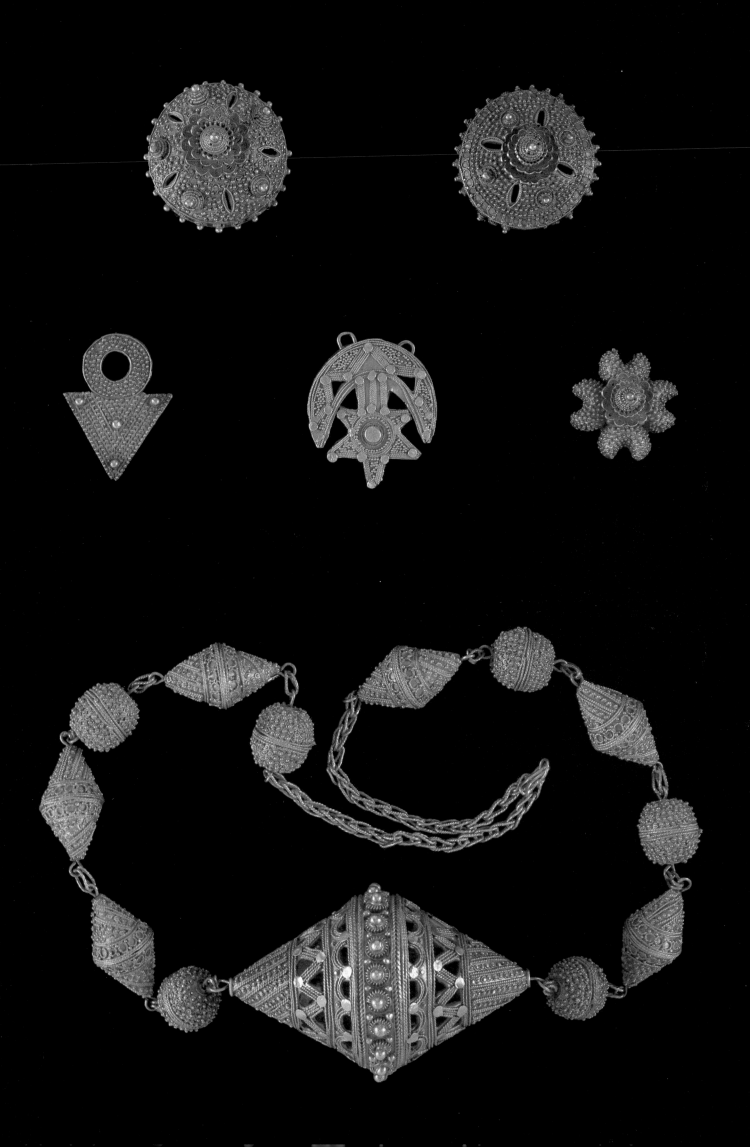

Nupe, Nigeria
Lapai town (?)

32
door
wood
h. 64^{15}/$_{16}$ in. (164.9 cm.)

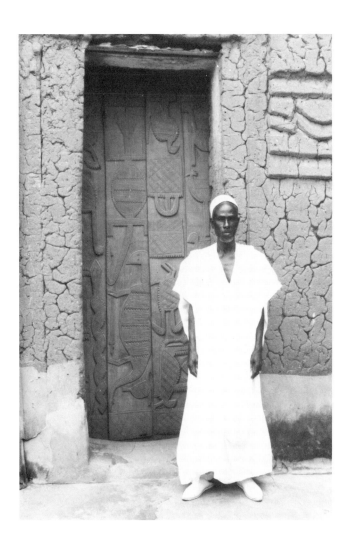

As a result of Fulani incursions during the last century, the Nupe and other peoples of the Central Sudan adopted Islam to varying degrees which resulted in the elimination or adaptation of figurative wood carving associated with pre-Islamic religious practices. Although some mask making still exists among the Nupe, it is because of their metalworking, weaving, leatherworking, wood carving and other crafts focused on utilitarian objects that they have established themselves among the most admired artisans of the Central Sudan.

Doors with elaborate relief are the prerogative of the wealthy, but due to changing fashion they have not been made for traditional use during the past four or five decades. The relief imagery of this example, which may be essentially decorative, is dominated by birds, lizards, sandals and airplanes. The door probably originates from the town of Lapai, a carving center about forty miles east of Bida. Iron staples originally held the four panels together (Perani 1978).

The field photograph was taken by Judith Perani in 1973 in Agaie, a town between Lapai and Bida, and depicts the Emir, or paramount leader, before his palace. The palace is of mud construction and rectangular in ground plan. The four-paneled door was commissioned by the Emir about twenty years ago (Perani 1978).

exhibited: Indianapolis Museum of Art, 1976
 Leigh Yawkey Woodson Art Museum,
 Wausau, Wisconsin, 1983

published: Gilfoy 1976, no. 92, ill.
 Aronson 1983, no. 47, fig. 15

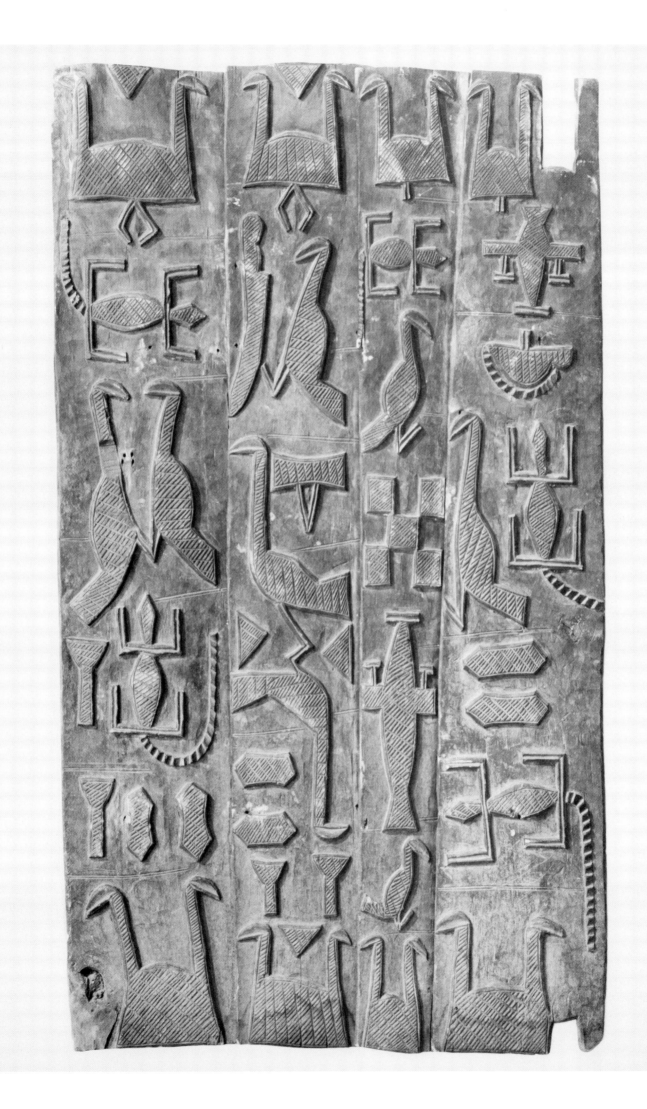

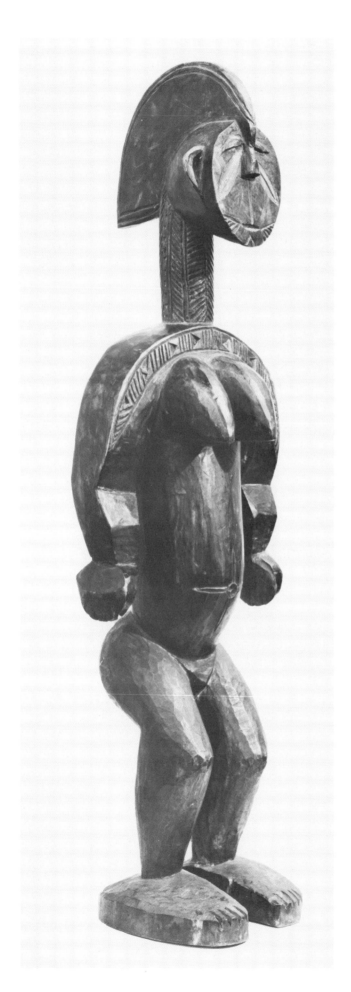

Igala, Nigeria
area of Dekina town, Ukuaja village
carver: Umale

33
female figure
wood, pigment
h. 21 in. (53.3 cm.)

The carvings of the Igala, who live in an area of mixed forest and savanna, are related to those of both the Central Sudan and the Eastern Guinea Coast. This example from northern Igala country has affinities with Sudanic forms in the bold curves of the head crest and shoulders, the cylindrical neck and the hard-edged, flat face. Based on Susan Connell's field data, William Fagg (1970a:no. 47; Christie 1978a:lot 246) attributes this figure to Umale, a living self-taught carver. His distinctive style has permitted identification of a number of other carvings which include figures, stools, masks and mirror cases (Van de Velde-Caremans 1976; Christie 1979b:lot 244; Foss 1980:no. 121; *African Arts* 1980:17). This example has geometric incisings on the face, neck, shoulders and torso, and an incised lizard on its back, some of which may depict scarification or other skin markings. Curiously, the legs and upper feet have not been scorched like the rest of the figure's surface. The significance and use of this figure are uncertain; it may have embodied a spiritual force associated with protection and fertility (Van de Velde-Caremans 1976:139).

exhibited: Edna Carlsten Gallery, University of
Wisconsin at Stevens Point, 1983

published: Aronson 1983, no. 89

The attribution of this figure to a specific carver represents attempts to identify individual carving styles, and belies the popular assumption that African artists are anonymous. H.E.

Koro or Ham (Jaba), Nigeria

34
drinking vessel *(Gbene?)*
wood, iron
h. 17⁵/₈ in. (44.8 cm.)

Roy Sieber (1961:12-13) reports that anthropomorphic drinking vessels of this type are for the most part carved for the Ham by the neighboring Koro, and it is uncertain to which group this example should be attributed. Such instances point out the problems of automatically associating a particular sculptural type or style with a single ethnic group. Due to trade, warfare, political alliances, migrating craftsmen and other cultural interactions it is not uncommon for a number of peoples to share art forms. Palm wine was drunk from the vessel on rare occasions of annual sacrifices and important funerals, and staining from wine is evident at the bottom of the cup.

published: Celenko 1981, fig. 1

It is important to know the original use of an object; at first glance this carving might be taken for a standing figure, although it is actually a wine cup. H.E.

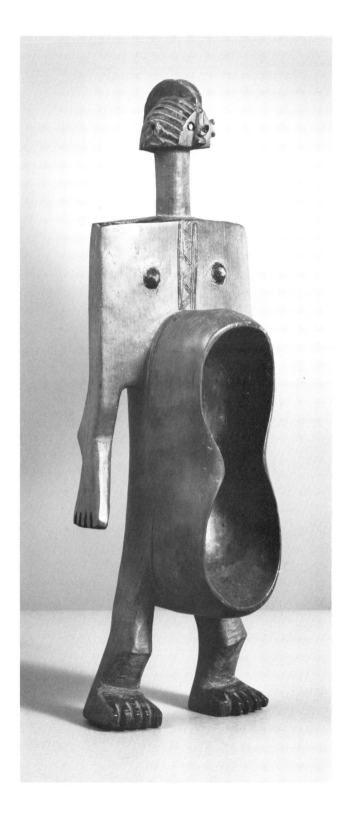

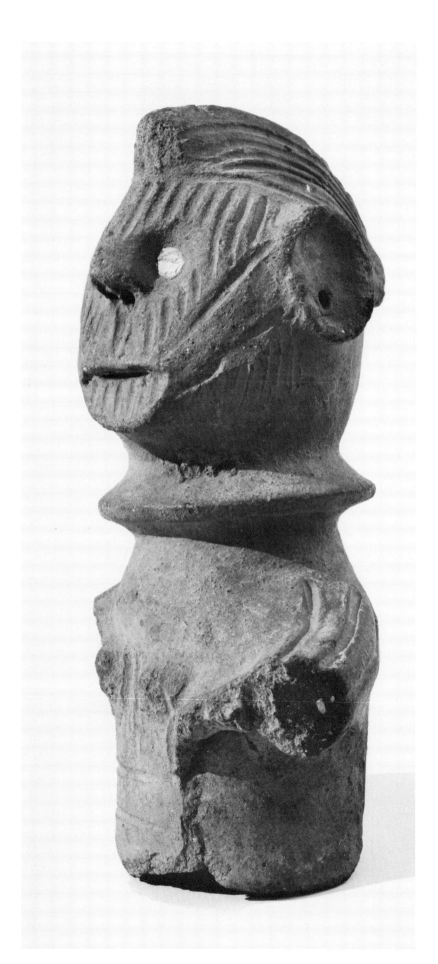

unidentified ethnic group,
Nigeria

35
human figure fragment
clay, mica
h. 8⁵/₁₆ in. (21.2 cm.)

Archaeological work in the Central
Sudan has uncovered a number of
figurative clay traditions, such as
Nok (5th century B.C.-3rd century
A.D.), Yelwa (2nd-7th centuries A.D.)
and Sao (10th-16th centuries A.D.),
which are among the earliest yet
documented sub-Saharan art. Some
northern Nigerian peoples still make
terra-cotta images, or have done so
in the recent past, and some of
these sculptures may be historically
linked to older traditions. Ther-
moluminescence testing of this hol-
low fragment dates it within this
century (Los Angeles County
Museum of Art, Conservation Cen-
ter, 1979, TR 3190-1). In its stylized
features and facial markings of par-
allel grooves this piece bears some
resemblance to terra-cotta grave im-
ages of the Dakakari people of
northwestern Nigeria, and to a
terra-cotta hut finial attributed to
the Gwari of north central Nigeria
(Christie 1976:lot 63).

Mama, Nigeria

36
cap mask
wood, pigment, feathers, incrustation
l. 16¹/₂ in. (41.9 cm.)

Carved headpieces of the Mama and other Benue River Valley peoples frequently take the form of a Sudanic type zoomorphic helmet or cap mask with prominent horns and snout. (cat. nos. 7-8, 10). Mama masks depicting bush cows or other horned animals are among the more abstract and simplified figurative headpieces of Africa. Information regarding Mama masks is sketchy. An early report by Temple (1919:269) sheds some light on the subject:

> . . . men don carved wooden masks, with long horns, in representation of some animal, and fringes of dried grass depending therefrom effectually conceal the countenance of the wearer, who is thought to represent some person or thing long since dead. It seems

probable that the Mama observe ancestor worship, as the skulls of deceased relatives are preserved in the compounds.

Later references indicate that Mama masqueraders, as embodiments of ancestral or other supernatural forces, take part in funerals and agricultural rites (Murray and *Annual Report of the Antiquities Service of Nigeria*, 1952-53 in Rubin 1969:110-12; Leuzinger 1972:210; *Nigerian Museum*, n.d.:25; Eyo 1977:206; Fagg 1980:98). Although Mama masks are commonly attributed to the *Mangam* cult, some references identify them as *Kambon* masks of the *Udawaru/Ubawaru* society (Leuzinger 1972:210; *Nigerian Museum* n.d.:25).

exhibited: Leigh Yawkey Woodson Art Museum,
 Wausau, Wisconsin, 1983

published: Aronson 1983, no. 44

The abstract simplicity of Mana masks brings to mind works of Brancusi and other twentieth century European sculptors. H.E.

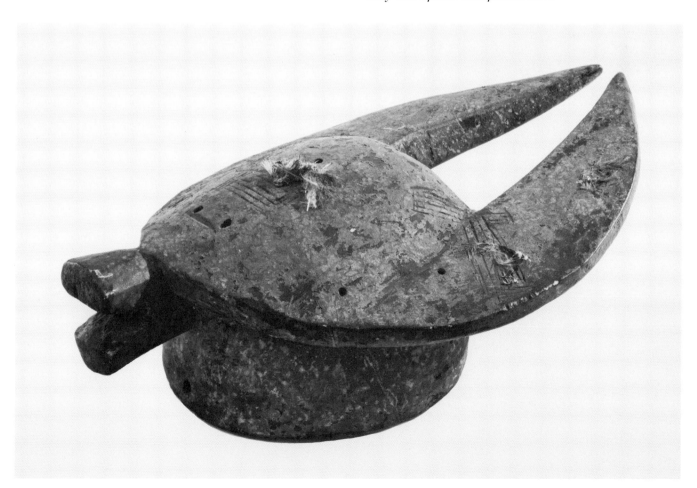

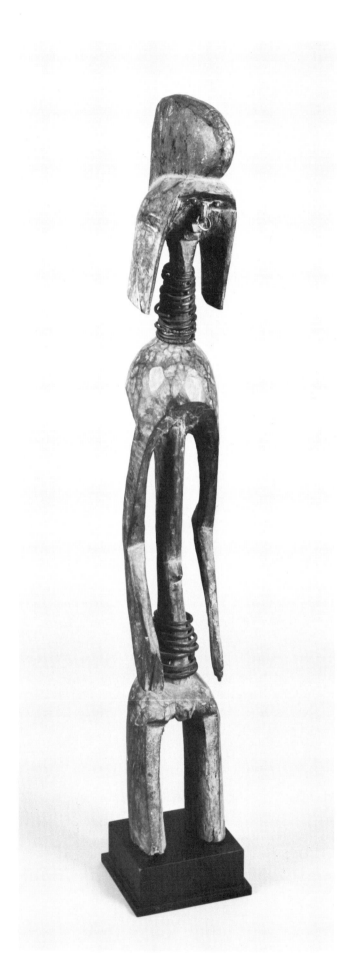

Mumuye, Nigeria

37
male figure
wood, brass
h. 42³/₄ in. (108.5 cm.)

Mumuye figures in a wide variety of styles are characterized by a lack of naturalism with jutting forms, elongated torsos and flipper-like arms that curve inward. Heads typically include a coiffure crest and lateral flaps which may depict coiffure elements or distended earlobes. A number of uses, which are not necessarily mutually exclusive for a particular figure, have been reported for Mumuye statuary. They serve as instruments for diviners and medicinal specialists, and as embodiments of guardian spirits associated with important elders (Fry 1970; Rubin 1978; 1981).

Mambila (?), Nigeria/Cameroon

38
male figure
wood, pigment
h. 10¹/₄ in. (26 cm.)

Figures in this style are generally attributed to the Mambila, and published carvings collected among these people relate formally to this example (Schwartz 1976:figs. 10-13, 40; Gebauer 1979:M22, M23, M28). However, such attributions must remain tentative since carving styles of the Mambila, Mfumte, Mbembe and other groups of the Upper Benue River Valley to the north of the Cameroon Grasslands have not been adequately distinguished. For instance, Paul Gebauer (1979:M20, M25, M27; Vogel 1981b) collected figures among the Mfumte with depressed heart-shaped faces, angular legs and other features usually associated with Mambila work. The light wood and red, white and black pigments of this example are characteristic of Mambila carvings. Among the Mambila such figures ara receptacles for ancestral spirits and are called *Tadep* and *Tadob* among other names. They serve primarily as protective devices in palm groves and on huts maintained for the storage of ritual items (Schwartz 1976:19-22; Gebauer 1979:185-87, 317).

exhibited: Indiana Central University,
 Indianapolis, 1980

published: Celenko 1980, no. 40

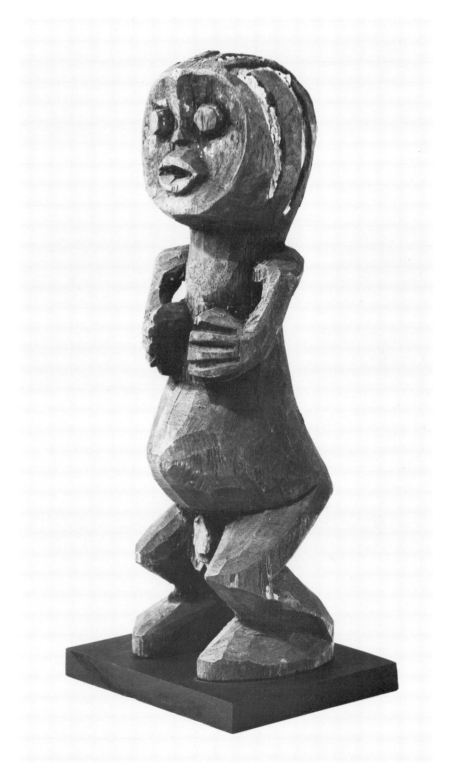

GUINEA COAST

The Guinea Coast is that part of West Africa lying below the Sudanic zone. The term "Guinea" may have come from a North African, specifically Berber, term for the "homeland of the blacks," later applied by the Portuguese to the West African coast (Balandier 1974:162). Alternatively, "Guinea" may be a corruption of "Ghana," the medieval Sudanic empire known to the Mediterranean World centuries before the European "Age of Exploration." The Guinea Coast is densely populated relative to other parts of the continent. Most terrain along the coast is rain forest; inland areas are mixed woodland and savanna. Subsistence agriculture is based primarily on root crops such as yams and cassava.

From the standpoint of sculptural form and function, as well as other cultural factors, the Guinea Coast zone can be divided into Western, Central and Eastern regions. The Western region lacks large-scale political institutions and the

prestige and leadership arts characteristic of some peoples of the Central and Eastern Guinea Coast. Masks rather than figures are the predominant sculptural form. According to a scheme proposed by William C. Siegmann (1981; see also Fischer 1981b), based on style, use and geographic origin of carvings, the Western Guinea Coast is here partitioned into the Atlantic Coast, the Mano River, the Makona River and the Cavalla River areas.

The Atlantic Coast, which encompasses northern Sierra Leone and the coastal areas of Guinea-Bissau and Guinea, is the most arbitrary and most sculpturally heterogeneous of the four areas. Carvings of the Nalu, Landuma and Baga of Guinea relate to the abstract, geometric forms of the Western Sudan, and figures and masks of the Bidjogo of Guinea-Bissau have stylistic affinities with both the abstraction of the Sudan (cat. no. 41) and the naturalism of the Guinea Coast (cat.

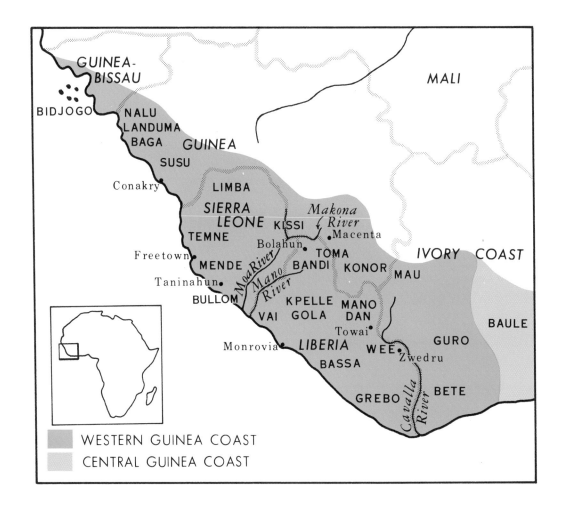

no. 39). Perhaps the only prevalent, although not universal, feature of the Atlantic Coast's sculpture is polychromed sufaces.

The most representative carvings of the Mano River area, which includes the southern half of Sierra Leone and neighboring Liberian territory, are blackened helmet masks used within the *Sande* women's society of the Mende (cat. nos. 45-46), Vai, Gola and other peoples. Indeed, most wooden headpieces from this area belong to women; the relatively few men's wooden masks function within the men's *Poro* society. Siegmann (1981) reports that the widespread use of fiber masquerade costumes distinguishes masking of the Mano River area from that of the Makona and Cavalla River areas.

The Toma, Bandi, Kissi, Kpelle and other peoples of northwestern Liberia, southeastern Guinea and eastern Sierra Leone living in the vicinity of the Makona River, a tributary of the Moa, have headpieces resembling the bold, abstract forms of the Western Sudan. The predominant sculptural expression is masks, which function within the men's *Poro* society.

The Cavalla River area encompasses eastern and southern Liberia and parts of neighboring Guinea

and Ivory Coast. The area is inhabited by the Dan, Mano, Grebo, Wee, Guro, Bete and other groups who do not have *Poro*, an institution which is prevalent in the Mano and Makona River areas. However, the functions of Cavalla River area masks are similar to those of *Poro* masks. Although the Bassa are included within the Cavalla River area on the basis of linguistic relationships, absence of *Poro*, and other cultural features, their female helmet masks (cat. no. 54) are closely related to and surely derived from those of the Mano River area. Masks from this area range from relatively naturalistic, restrained forms (cat. nos. 53, 56) to more expressionistic modes (cat. nos. 55, 57).

The Central Guinea Coast is populated almost exclusively by the Kwa-speaking Akan, Fon, Yoruba and Edo peoples. In contrast to the egalitarian Western Guinea Coast societies, those of the central region are generally hierarchical and politically centralized. Leadership regalia and prestige items for royals and others of high status constitute an important part of artistic expression. Because such objects (e.g., cat. nos. 66-71, 78, 85, 109-11, 113) are often produced by full-time specialists, they are sometimes marked by a technical sophistication infrequently encountered elsewhere in Africa.

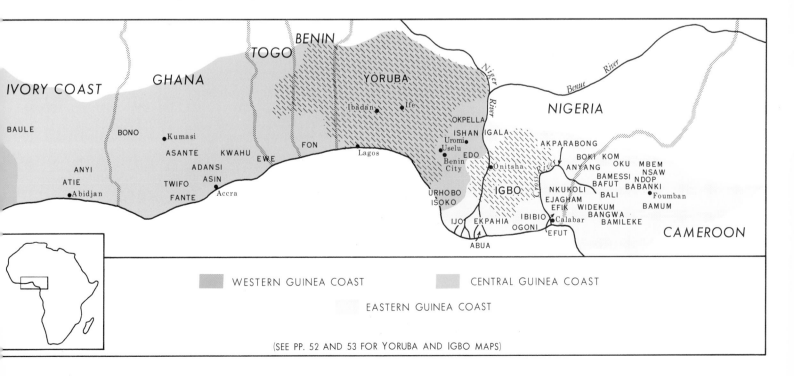

WESTERN GUINEA COAST CENTRAL GUINEA COAST

EASTERN GUINEA COAST

(SEE PP. 52 AND 53 FOR YORUBA AND IGBO MAPS)

The Asante, Dahomean, Yoruba and Edo kingdoms, all of which flourished prior to this century, are among Africa's most well known states. To a great extent, Guinea Coast states derived their power and wealth from coastal trade with Europeans, beginning, in some areas, with the Portuguese in the 15th century. Europeans traded for gold, ivory, spices and other products, and later, with the establishment of plantations in the Americas, slaves became a major export. The importance of trade is reflected in the European names given to various parts of the West African coast, for example, "Gold Coast" and "Ivory Coast." The centuries of European influence had a profound effect on Guinea Coast peoples which in many ways paralleled the influence of Islam on Sudanic populations. The European presence affected the arts of the Guinea Coast through the introduction of objects (e.g., European-type chairs and clothing), motifs (e.g., Christian cross) and materials (e.g., new or greater availability of certain metals).

The Central Guinea Coast catalog entries come from three major cultural spheres, the Akan, the Edo and the Yoruba. The Akan and Edo complexes are each made up of distinct ethnic groups who speak related languages, in many instances have related sculptural styles, and share a common cultural base. The Yoruba, on the other hand, are considered a single people with subgroups who speak dialects of one language. The sculpture of these subgroups is marked by variations of stylistic and iconographic features shared throughout Yorubaland. In the past the subgroups were organized into independent states, of which Oyo and Ife are perhaps the most well known. The Yoruba are among the more populous, urbanized and prolific art-producing peoples of Africa. Although their visual arts are well represented by the catalog entries, there is no sampling here of the centuries-old (12th-15th centuries A.D.) Yoruba sculptures in terra-cotta and metal from Ife, Owo and other cities.

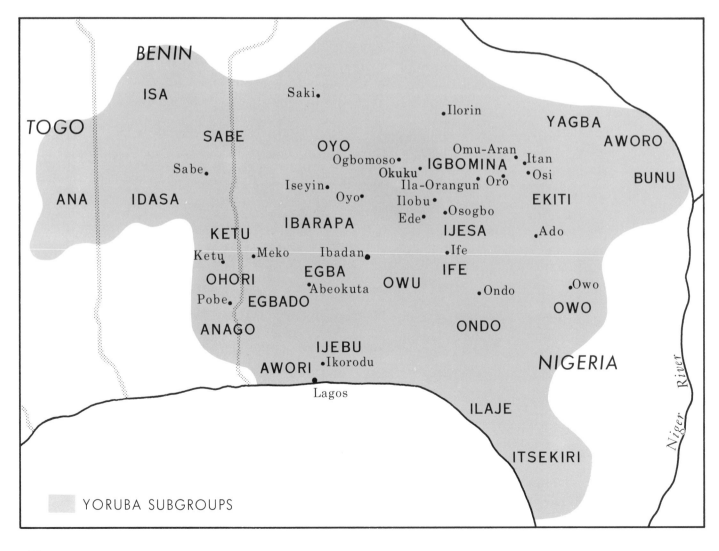

YORUBA SUBGROUPS

The Eastern Guinea Coast is treated here as four principal art-producing areas: the Niger River Delta, the Igbo, the Cross River and the Cameroon Grasslands. The populations of the first three areas, who occupy the southeastern quadrant of Nigeria, are politically decentralized with authority largely in the hands of men's societies. Unlike the Central Guinea Coast, leadership-related arts are not prominent. Men's society masks and head crests constitute the major art form of these sculpturally rich areas. Polychromed surfaces are prevalent, and, as elsewhere in the Guinea Coast, carving styles are more naturalistic than in the Sudan. The populous Igbo with their numerous subgroups are the dominant group in southeastern Nigeria, and the diversity of their carving styles reflects in part their interaction with neighboring peoples. There are broad parallels of sculptural forms and functions between southeastern Nigeria and the Equatorial Forest zone.

The Cameroon Grasslands, in contrast to surrounding areas, consists of a series of chiefdoms and kingdoms which recall the hierarchical societies of the Central Guinea Coast. There is an abundance of leadership-associated carvings, castings, textiles and beadwork, and with the exception of cat. no. 145, all catalog entries relate to leaders and other important individuals. Despite the diversity of populations, the Grasslands can be considered a single cultural and stylistic complex. For example, most carving styles are characterized by bold, dynamic, expressive forms. Because of trading, borrowing, inter-ethnic commissioning of sculpture, and other means of transmitting styles, it is often impossible to identify the origin of a particular sculpture without field documentation.

NSUKKA
• Nsukka
AYAMELUM
ANAM
UMUERI •Enugu Abakaliki• IZI
UMUIGWEDO NGWO
 •Awka EZZA
Onitsha• AGULU IKWO
ADAZI-ANI
NENI ORERI Cross River
 •Okigwi AFIKPO
 •Orlu

KWALE •Umuahia
 •Owerri
OKOBA OWERRI
 NGWA

 •Aba

Niger River

NIGERIA

IGBO SUBGROUPS

Bidjogo, Guinea-Bissau
Bissagos Islands

39
helmet mask *(Dugn'be?)*
wood, horn, pigment, glass, iron, mastic
horn span: 20$^1/_4$ in. (51.4 cm.)

The Bidjogo, a small group who have resisted
Islam, inhabit a group of islands off the coast of
Guinea-Bissau. Their masks and figures constitute
a unique corpus of carving distinct in many ways
from nearby mainland traditions of both the
Sudan and Guinea Coast.

Bissagos Islanders of both sexes wear headpieces
during initiation activities and other communal
festivities. Costumes and wooden headgear aid in
distinguishing age-grades, that is, groups of simi-
larly aged persons of one sex at the same level of
advancement. Bovine masks are perhaps the most
representative of the zoomorphic headpieces,
which also include fish, shark, bird and hip-
popotamus images. This example, which prob-
ably depicts an ox raised in a village *(dugn'be)*,
was worn by pre-initiates (Gallois-Duquette 1981).
Although masks and crests are used by both
sexes, field photographs show this type worn
only by men. This mask is worn over the head
with the animal's face pointing upward; however,
the masker sometimes assumes the stance of the
animal and lowers the mask into a life-like posi-
tion. It is of interest to note that Hugo Adolph
Bernatzik documents bovine heads similar to this
one used as adornments for prows of war canoes
(Bernatzik 1944:passim; Gallois-Duquette 1976:
30-31; 1979; 1981).

The mask is of composite construction with neck,
ears, horns and glass eyes affixed to the head
with a mastic. The naturalism of the mask, for
example, the gathered skin of the neck and the
wrinkles encircling the eyes, is enhanced by the
real horns. The result is a remarkable likeness of
an ox, an important sacrificial animal for the is-
landers.

exhibited: Indiana Central University, Indianapolis,
 1980

published: Celenko 1980, no. 15
 Celenko 1981, fig. 5

*This head brings to mind range cattle depicted in
my collection of Western American art. H.E.*

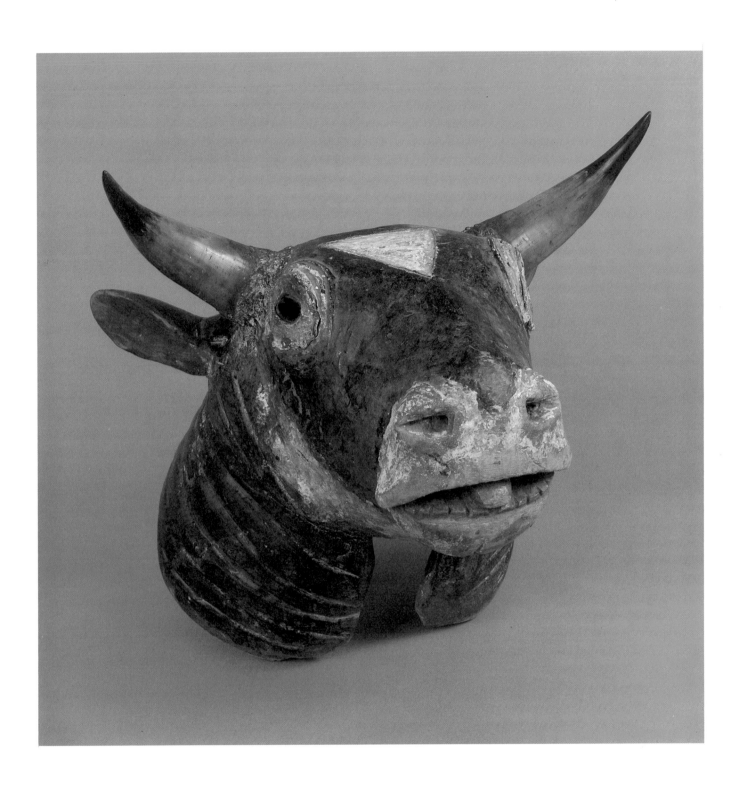

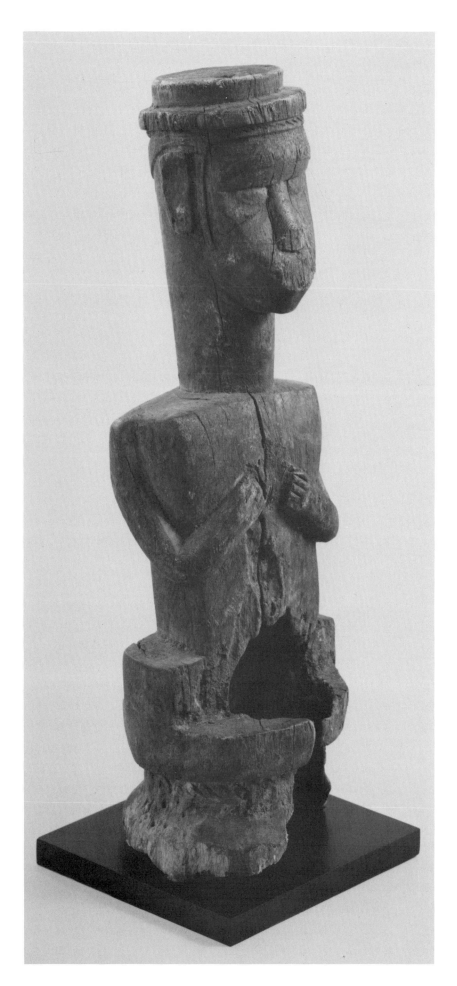

Bidjogo, Guinea-Bissau
Bissagos Islands

40
male figure *(iran)*
wood, pigment
h. 14¹/₈ in. (35.9 cm.)

The general term for these Bidjogo
figures is *iran*, a Creole word, al-
though each such image also bears
a more specific name. These images,
as well as other non-figurative ob-
jects such as balls of plants which
bear the same name, provide the liv-
ing with a means of communicating
with the supreme deity and with
ancestors. An *iran* can belong to an
individual or to an entire village. In
either instance it is given offerings
and appealed to for a wide range of
personal and communal concerns
such as bountiful crops, civil dis-
putes and illness (Helmholz 1972;
Gallois-Duquette 1976:37-43; 1978).

Bidjogo, Guinea-Bissau
Bissagos Islands

41
male figure *(iran)*
wood
h. 16¼ in. (41.3 cm.)

Bidjogo figures are rendered in
rigid, upright postures, often as in
these termite-eaten, weathered
examples, with the lower torso inte-
grated into a stool or base. These
two carvings only reveal in part the
great stylistic range of Bidjogo
statuary. Cat. no. 40, with a Euro-
pean hat, represents a tendency to
naturalism which is evident in the
rounded, somewhat fleshy face. In
contrast, cat. no. 41, without arms,
typifies more abstract, minimal
styles which relate to Sudanic
forms.

exhibited: Indianapolis Museum of
 Art, 1976

published: Gilfoy 1976, no. 82, ill.

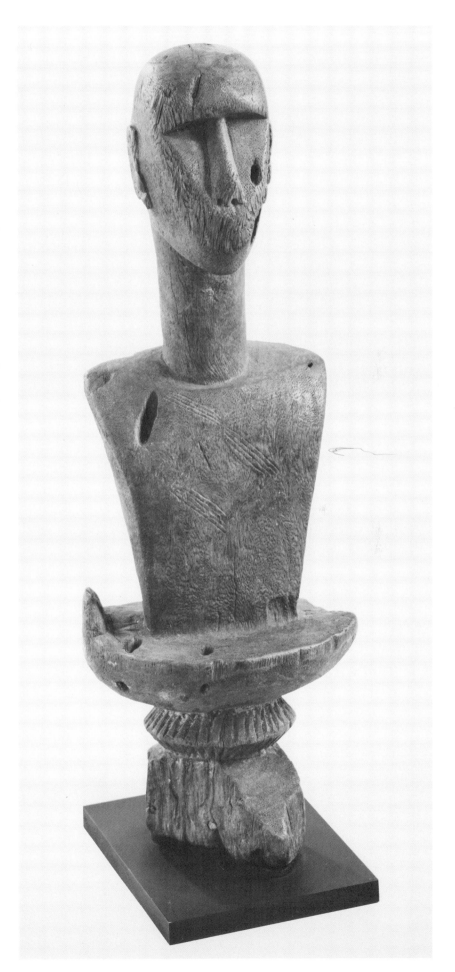

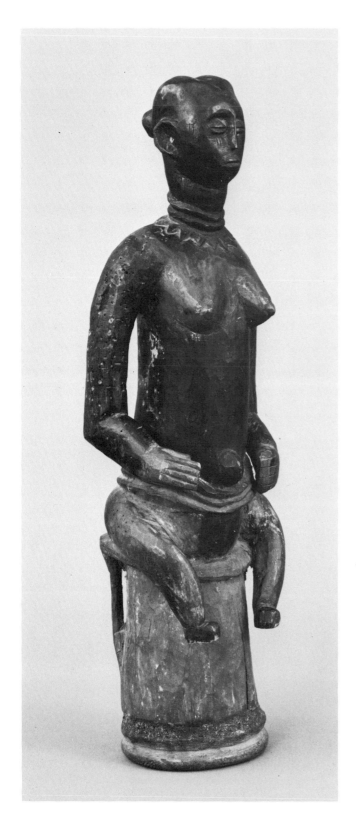

exhibited: Cranbrook Academy of Art,
 Bloomfield Hills, Michigan, 1975
 Indianapolis Museum of Art, 1976

published: Mato 1975, no. 2, ill.

Limba (?), Sierra Leone

42
trumpet for *Gbangbani* society
wood, pigment, mastic, iron
h. 25¹³/₁₆ in. (65.3 cm.)

Gbangbani (Anggbanggbani) is a men's anti-witchcraft society which probably originated among the Limba and spread to the Temne, Mende and other peoples of the area. The society has not been adequately studied, but Frederick Lamp (1978:43-45) reports that the *Gbangbani*, through a patron spirit of the same name, protects young men from malevolent forces during their initiations. A ritual item of central importance to the society is an anthropomorphic trumpet whose vindictive "breeze" is capable of catching witches. The female images of these carvings may symbolize fertility as a positive force against witchcraft. The color red, which covers much of this trumpet, is abhorrent to witches. Charms in the form of waist beads or necklaces are commonly added; in this example they are incorporated in relief (Lamp 1978:43-45).

These hollow carvings typically have a blowing hole in the upper back of the figure and an open end under the stool or base upon which the image sits. A curious feature of the Eiteljorg example is the stopper affixed to the open end. Lamp (1980) has encountered unattached stoppers on other trumpets and speculates that they may have been corked when not in use to prevent both the uncontrolled leakage of the vindictive "breeze" and the contamination of the spiritual body through the orifices. Simon Ottenberg (1981), who also worked in the area, did not encounter *Gbangbani* trumpets with stoppers, but does not rule out the possibility that the plugs helped contain sacrificial or other materials. This stopper, however, is attached with mastic, and even secured with iron nails which are visible in radiographs. The heads of some of the nails have been cut off, perhaps to conceal them. Furthermore, laboratory tests indicate that the wood type, and the oil-based paint of the stopper differ from those of the trumpet (Indianapolis Museum of Art, Conservation Department, 1980). The evidence suggests that the stopper may not be original despite its worn condition.

unidentified ethnic group,
Liberia/Sierra Leone/Guinea

43-44
side-blown trumpets
ivory, mastic
top, l. 20³/₁₆ in. (51.3 cm.)
bottom, l. 22⁹/₁₆ in. (57.3 cm.)

Side-blown trumpets of ivory, horn and wood are found among the Mende, Grebo, Bullom, Kpelle, Toma (Loma) and other peoples of the region. The rich brown patination of these examples suggests years of handling and the high degree of embellishment, including openwork finials, associates them with an important individual or individuals. William Hommel (1980), who thinks these examples are probably Mende, suggests that they were prestige objects of a paramount chief which were sounded to announce his approach to a village or town. Such trumpets are documented as accompaniments for entertainments and activities of men's societies. They also announce public gatherings, welcome visitors, convey messages and serve as beacons for those lost in the forest (Schwab 1947:154;Schmidt in Siegmann 1977:85, 96-97).

exhibited: Indianapolis Museum of Art, 1976
 Indianapolis Museum of Art at
 Columbus, 1977

published: Gilfoy 1976, no. 23, ill.

Ivory becomes more beautiful with age and handling, as these dark, lustrous trumpets show. H.E.

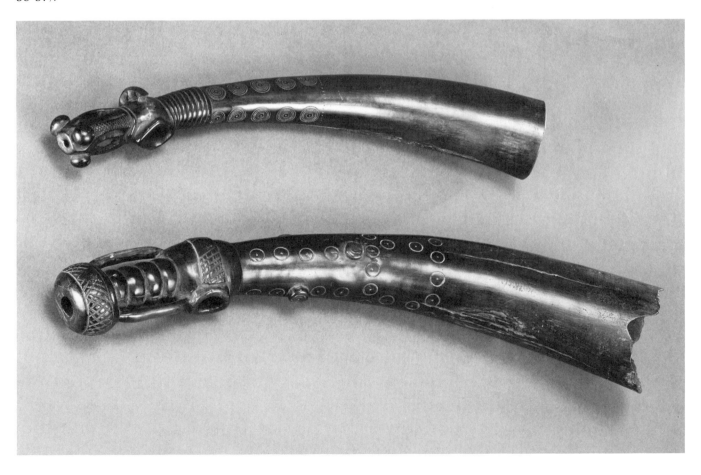

cat. no. 45
exhibited: Indianapolis Museum of Art, 1976
 Indianapolis Museum of Art at Columbus, 1977
 Indiana Central University, Indianapolis, 1980

published: *Saturday Evening Post* 1975, p. 51, ill.
 Gilfoy 1976, no. 12, ill.
 Celenko 1980, no. 16, ill.

Mende, Sierra Leone

45
helmet mask (*Sowei*) for *Sande* society
wood, pigment, aluminum, fiber, cowrie shells, claws, mastic
h. 16¹/₈ in. (41 cm.)

Helmet masks of the Mende, Vai, Gola, Bassa (cat. no. 54) and other peoples of the Western Guinea Coast are the most well documented instance of women's masking in Africa. European reports as early as the 16th century mention women's societies (Richards 1970:33-35), and it is possible that the use of masks is also centuries old. Young women who have reached puberty are taken to a "bush school" for a number of months where they learn the secrets of the *Sande* women's society and acquire the skills and knowledge necessary for womanhood. It is primarily during this initiation process that maskers appear. William Hommel's 1973 photograph taken at Taninahun village, Bumpe chiefdom in south central Sierra Leone, documents a *Sowei* masker enveloped in the customary blackened raffia fibers.

Mende, Sierra Leone

46
helmet mask (*Sowei*) for *Sande*
 society
wood, pigment, mastic
h. 14³/₄ in. (37.5 cm.)

Although men carve these head-
pieces, women own and use them.
They are normally commissioned by
middle level *Sande* members and
embody personal protective spirits
known as *Sowie, Sowo, Nowo* and a
host of other terms (Hommel
1974:n.p.; Siegmann 1977:7-12; Lamp
1979:21). Since the helmets are
meant to attract spirits they are
made as beautiful as possible, with
shiny black surfaces, neck rings and
elaborate coiffures. The blackened
coloring may allude to the mysteri-
ous, river-dwelling spirit probably
identified with *Sowei* maskers (Phil-
lips 1980:114). The significance of
the neck rings is uncertain. The
often repeated view that, as exag-
gerations of fat, they symbolize
well-being and fecundity, may be
unfounded (Lamp 1979:25, 28; Phil-
lips 1980:115). Instead they may ex-
press a Mende admiration of neck
lines on individuals (Phillips
1980:115), or allude to water ripples
as a mask emerges from the water
when presented by the water spirit
(Hommel 1978:11; Hinckley 1980:6).
The masker views through slits in
the rings (cat. no. 46) or through
slits in the eyes (cat. no. 45). When a
woman retires from masking her
helmet is no longer considered to
embody a spirit. The metal embel-
lishments on cat. no. 45 may indi-
cate that, after its ritual life was over,
it was presented to a chief as a
prestige object (Hommel 1974:n.p.).

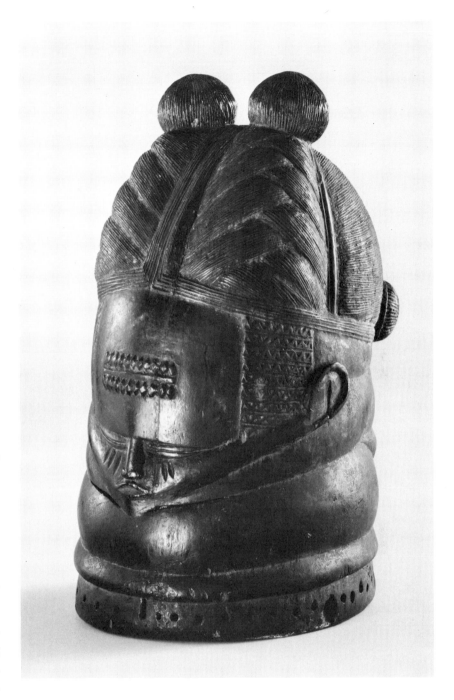

cat. no. 46
exhibited: Indianapolis Museum of Art, 1976
 Indianapolis Museum of Art at Columbus, 1977

published: Gilfoy 1976, no. 10, ill.
 Celenko 1980, no. 17

*Perhaps I am so attracted to Mende masks because they are worn
by women. I have a complete "wardrobe" of them in every size and
shape, and with every type of coiffure. H.E.*

Vai, Liberia

47 (left)
female figure
wood, pigment
h. 34^1/$_{16}$ in. (86.6 cm.)

48 (right)
male figure
wood, pigment
h. 32^3/$_{16}$ in. (81.7 cm.)

These figures, probably by the same hand, were collected among the Vai of western Liberia over fifty years ago by George Herzog (1975), a former professor at Indiana University. They belong to a figure style complex shared by the Mende, Temne, Vai and other groups. The delicate facial features, set low on the face, and the ringed necks relate to helmet masks of the region's women's societies. The Vai and other peoples of western Liberia are expert silversmiths, and a silver chest pendant is probably depicted on the female (Siegmann 1981). The male is represented with an embroidered fez. The significance and use of these carvings is uncertain. Similar curative and protective images are documented among the neighboring Mende.

exhibited: Indianapolis Museum of Art, 1976

published: Gilfoy 1976, no. 18, ill.

These handsome figures always remind me of Professor Herzog who collected them in Liberia in 1930. I acquired them from this kindly gentleman when he entered a nursing home. H.E.

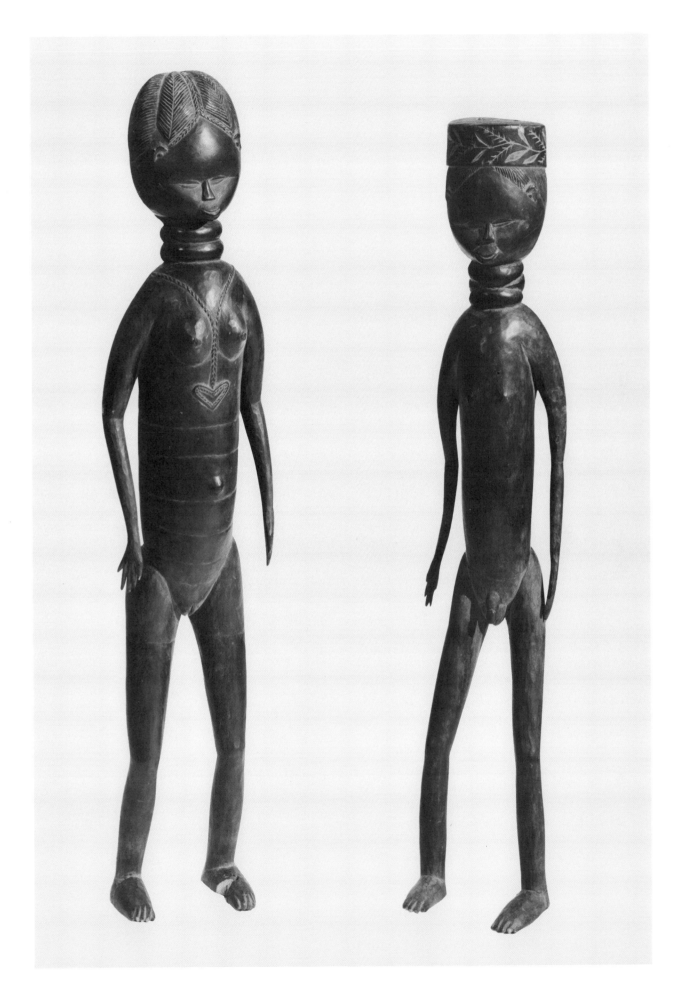

Toma (Loma), Bandi (Gbande) or Kissi,
Guinea/Liberia/Sierra Leone

49
helmet mask (*Landai/Dandai*) for *Poro* society
wood, pigment, feathers, fiber, cloth, fur, hair,
 skin, aluminum
approx. l. 65 in. (165.1 cm.)

Landai (Dandai) headpieces have been reported from the Toma (Loma), Bandi (Gbande), Kissi and Mende living in northwestern Liberia, southeastern Guinea and eastern Sierra Leone (Eberl-Elber 1937:42-45; Allen 1939:opposite p. 42; Harley 1941:27-28; Dittmer 1966:38, pl. 11; Dennis 1972:138-41, 189-90; Rubin 1974:no. 19; Hildebrand in Fraser 1974:40; Fraser 1974; Atmore and Stacey 1979:110-11; Siegmann 1981; see also Fagaly 1978:25). William Siegmann (1981) is of the opinion that the *Landai* mask originated among the Bandi and is probably most widespread today among the Toma (Loma) on both sides of the Guinea/Liberian border. His 1973 photograph depicts a Kissi *Landai* masker at rest at the town of Bolahun in northwestern Liberia. It illustrates the size of these masks, which together with their feather superstructures, measure over five feet in length, and shows how the dancer is concealed in cloth and fiber. Not apparent in this photograph is the normally horizontal position of the mask with the wearer's plane of vision extending through the snout.

The *Landai* mask appears during initiation activities of the men's *Poro* society. George Harley (1941:27), writing about the Gbande of Liberia, reports that the masquerader calls the boys to the initiation school in the bush and announces and accompanies their return to the village. As spiritual overseer of the proceedings, the masker "...pretends to devour the youths, thus providing an excuse for their long absence during the period of indoctrination in the bush. Later they are believed to be reborn from his stomach as though through a womb" (Hildebrand in Fraser 1974:40). The prominent teeth and red mouths of these masks may allude to this ritual devouring.

Douglas Fraser (1974:38-54) discusses the dual aspect of the *Landai*, which synthesizes the opposing forces of nature and civilization. Natural forces of the universe are symbolized by the "great bush spirit," manifested in the *Landai* by its great size and crocodile-like mouth with movable lower jaw. Civilization is symbolized by "the legendary first ruler," an ancestral aspect indicated by the nose and other human facial features, and the beard, bushy eyebrows, nose and ear hair of an elder.

exhibited: Indianapolis Museum of Art, 1976
Indianapolis Museum of Art at
 Columbus, 1977
Indiana Central University, Indianapolis,
 1980

published: Gilfoy 1976, no. 3, ill.
Celenko 1980, no. 21, ill.

This imposing headpiece may be my most dramatic and fearsome mask. We have displayed it with the related feather costumes (overleaf) at a number of exhibitions. H.E.

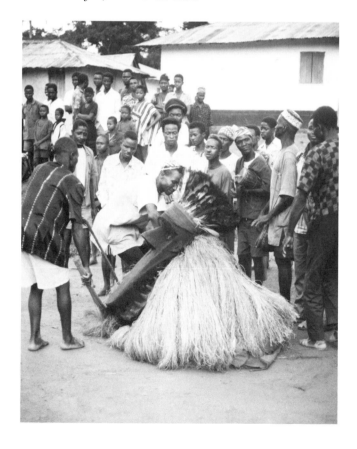

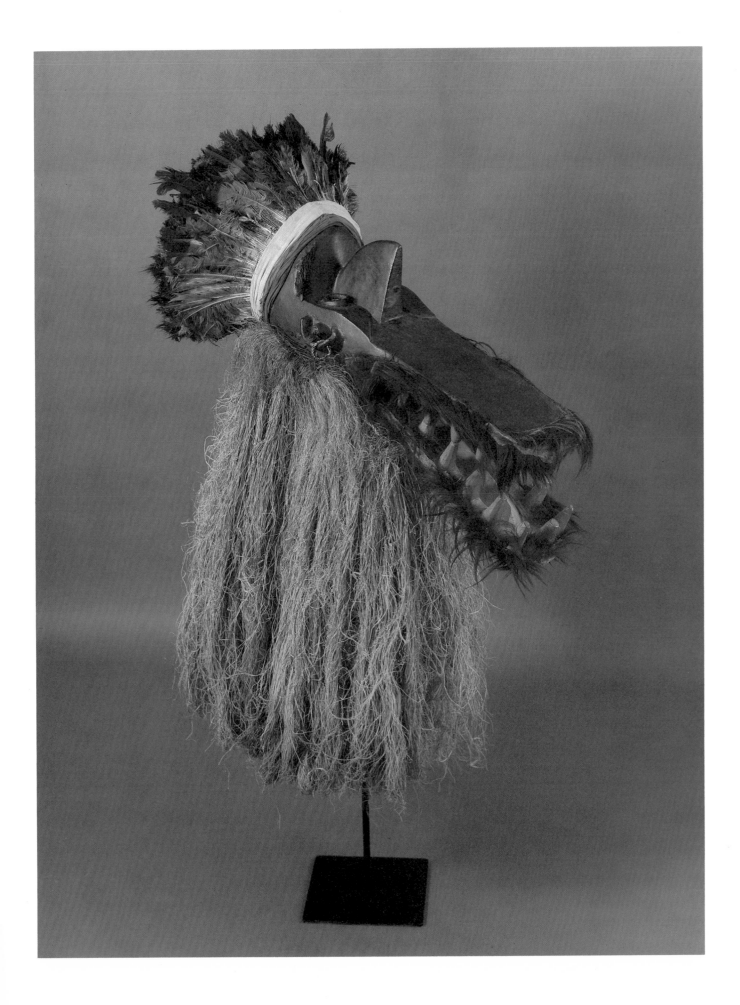

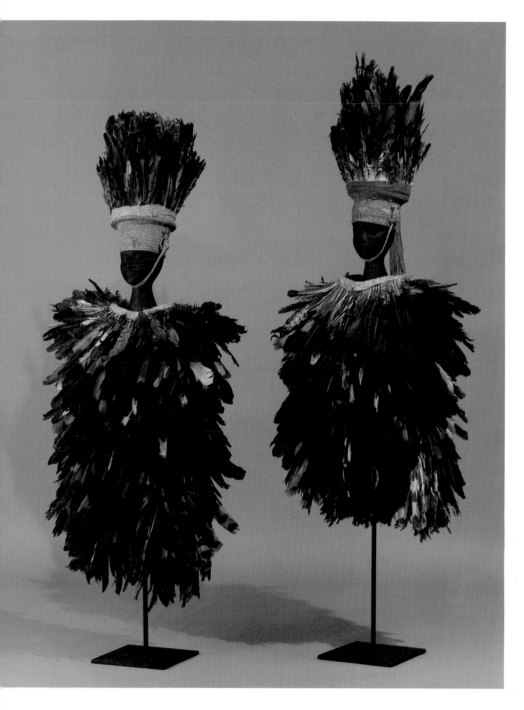

Toma (Loma) (?), Guinea/Liberia

50-51
cloaks and headdresses for *Poro* society *Wenilegei* dancers
feathers, fiber
left: cloak, approx. l. 44 in. (111.8
cm.)
headdress, approx. l. excluding
chin strap: 22 in. (55.9 cm.)
right: cloak, approx. l. 38 in. (96.5
cm.)
headdress, approx. l.
excluding chin strap and
cloth trailer: 26^1/$_2$ in. (67.3
cm.)

Costumes adorned with feathers from the touraco or "blue wing" are documented among the Toma (Loma) on both sides of the Guinea/Liberia border (Gaisseau 1954:109, 140, 143, opposite p. 152, passim; Huet 1978:26, pl. 35; Siegmann 1977:73; see also Allen 1939:opposite p. 42). They are worn by a *Wenilegei* or "bird man" who appears during initiations, funerals and secular dances of the *Poro* society. According to Jean-Louis Paudrat (1978:26) the ". . . costume refers to the bird of the original myth, a bird that brought power to human society." The dancer, whose body is covered with white clay, wears anklets and carries a staff. *Wenilegei* may accompany the *Landai* (cat. no. 49) and other *Poro* maskers.

exhibited: Indianapolis Museum of
Art, 1976

published: Gilfoy 1976, no. 3, ill.

These costumes are even more elaborate than some of the feather garments in my American Indian collection. H.E.

Toma (Loma),
Guinea/Liberia/Sierra Leone

52
mask for *Poro* society
wood, pigment, fiber, cloth, animal
 hide, horn, iron, brass, clay,
 mastic
approx. h. 49³/₈ in. (126.1 cm.)

The Toma speak a Mande language
like the Bamana and other groups of
the Western Sudan. Although their
masks relate functionally to the
Poro complex to the south, they are
Sudanic in form. This exceptionally
large example exhibits typical Toma
features in the flat face and promi-
nently projecting nose and fore-
head. Animal hide, which would
have concealed a masker, covers the
back of the carving; fibers, cloth
amulets, animal horn, a brass bell,
iron money bars and two clay pots
are affixed to the top of the mask.
The pots, nestled between the
horns, probably once contained
ritual substances. The eyes are
marked with metal discs. Appar-
ently, the masker looked through
the open mouth.

There is little available information
about the function of Toma masks.
They embody spirit forces and are
used during initiations, funerals and
other activities of the men's *Poro*
society (Gaisseau 1954; cat. no. 49).
According to William Siegmann
(1977:15; 1981) many masks of this
type, which may also be used by the
neighboring Kissi, are not danced
with publicly but rather are used
within the sacred forest of the *Poro*.
The large size and clay pots of this
example suggest that it may have
functioned outside of a masking
context for at least part of its his-
tory.

exhibited: Indianapolis Museum
 of Art, 1976

published: Gilfoy 1976, no. 9, ill.

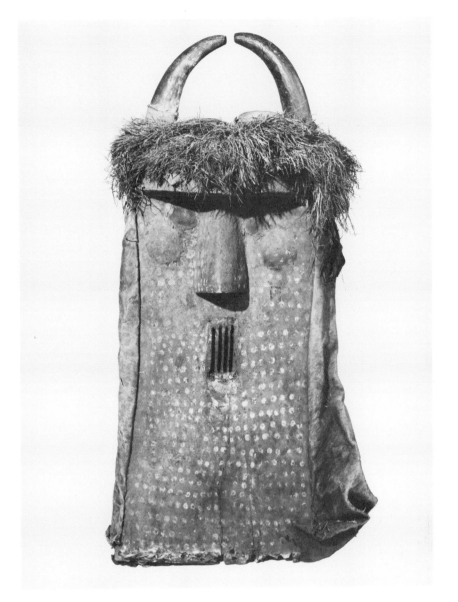

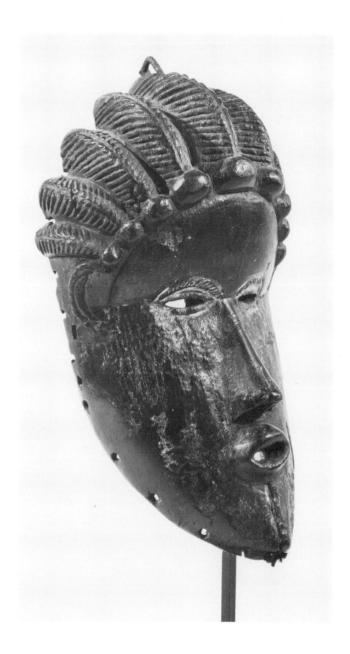

Bassa, Liberia

53
head crest (*Gela*) for *Nor* society
wood, pigment, iron
h. 9¹/₂ in. (24.2 cm.)

Gela, which represent nonhuman spirits, are senior entertainment masks of the men's *Nor* society. The masker is completely enveloped in cloth and fibers and performs a smooth, gliding dance. The masks are not worn over the face as is common in the region, but rather are attached to basketry caps worn on top of the dancer's head. The *Gela's* distinctive features include the concave profile, the pointed chin and the incorporation of a coiffure as part of the carving (Siegmann 1977:25-27; 1981).

Bassa, Liberia

54
helmet mask
wood, pigment
h. 13¹¹/₁₆ in. (34.8 cm.)

Bassa helmet masks embody personal spirits and like similar masks among the Mende and other peoples of the region (cat. nos. 45-46) function within a women's society. The names for the society and its masks, and specifics about use are not well documented. Features which distinguish these carvings from similar masks of other groups are the vertically lobed hair style and the relief treatment of the face in styles similar to those of *Gela* masks (cat. no. 53).

exhibited: Indianapolis Museum of
 Art, 1976
 Indianapolis Museum of
 Art at Columbus, 1977

published: Gilfoy 1976, no. 15

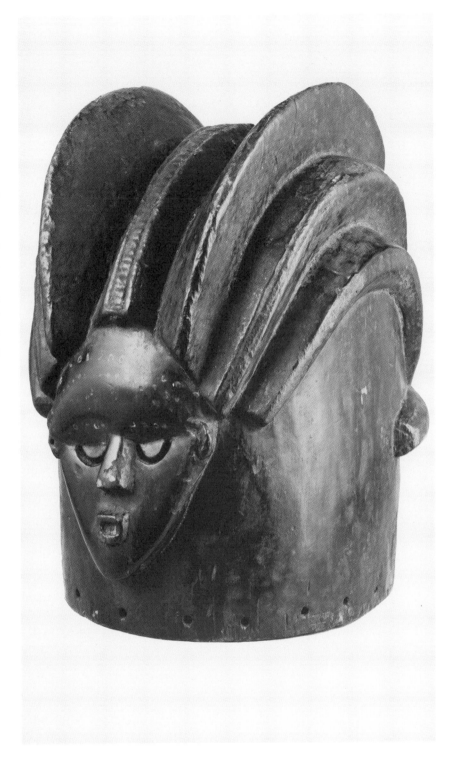

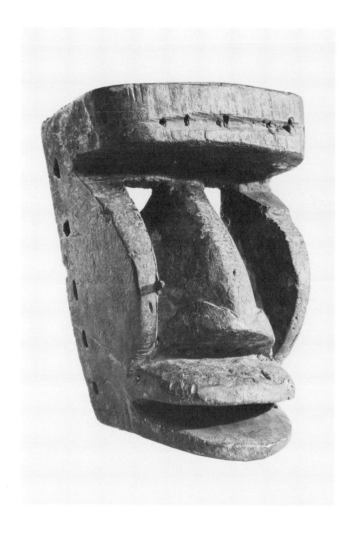

exhibited: Indianapolis Museum of Art, 1976

published: Gilfoy 1976, no. 6

The abstract shape and the play of positive and negative space recall the sculpture of Henry Moore. H.E.

Dan, Liberia/Ivory Coast

55
face mask for *Kaogle* or *Kagle* masker
wood, pigment, iron
h. 9⅝ in. (24.5 cm.)

Dan masks are used in initiation, war, social control and entertainment activities. Their authority stems from the belief that they embody powerful forest spirits:

> These spirits, even though invisible, have names, personalities and definite characteristics. Many of these, however, are not pleased with their bodiless nature and wish to participate in the human world by helping, entertaining and teaching the village people. The spirit then appears in a dream to a sympathetic person. It can give its human friend (man or woman) future-telling powers, animal strength or political sway, among other capabilities. In return, the spirit dictates the manner in which it should be manifested and sustained. Its appearance can be static, in the form of a bundle of fur, antelope horns or a small snail shell filled with various ingredients — what is often called a "fetish." At other times a spirit may ask for a mobile, living materialization and urge the chosen person to incarnate him, to perform him, with a mask (Fischer 1978:18).

Kaogle, chimpanzee maskers, and *Kagle*, hooked-stick maskers, wear masks with angular cheeks, prominent noses and brows, and large chinless mouths. In former times they came out to incite young men to war, and more recently they have provided entertainment and a means for youths to vent their aggression through dance. Perhaps the most important attributes of these masquerades are the hooked sticks which the masker throws at spectators (Fischer and Himmelheber 1976:104-112; Fischer 1978:22; Siegmann 1977:20). The monkey-like features of these masks parallel the unpredictable, animalistic actions of the performer. By acting in a socially unacceptable manner the masker ". . . illustrates how the unfettered individual is a destructive force in the community and that only socialization and ritual create and reinforce the necessary order in human life" (Siegmann 1977:3).

Dan, Liberia/Ivory Coast

56
face mask for *Zakpai Ga* (?) masker
wood, pigment, fiber, iron
h. of wood portion: 9⁹/₁₆ in. (24.4 cm.)

This carving relates formally to those worn by *Zakpai Ga*, "fire-extinguishing," maskers. They go about during the dry season at midday to make certain that women extinguish their fires before the potentially dangerous afternoon winds begin. The fiber beard and metal teeth of these masks (missing from the upper lip of this example) and the bold movements of the masker are masculine, aggressive features characteristic of the *Zakpai Ga* (Fischer and Himmelheber 1976:73-85; Fischer 1978:21). However, it is difficult to establish a direct relationship of form to function in masks from this region. For example, differently functioning masks of the Dan and neighboring peoples have similar facial features.

exhibited: Indiana Central University, Indianapolis, 1980

published: Celenko 1980, no. 22

This mask typifies the expressive, dramatic qualities I prize in African carvings. H.E.

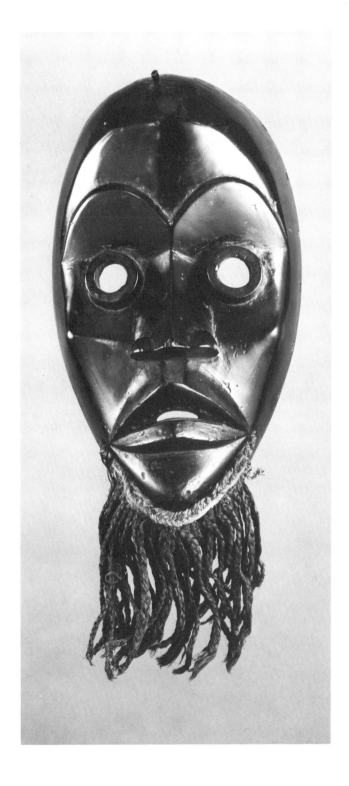

Wee, Liberia/Ivory Coast

57

face mask *(Begla?)*

wood, pigment, shells, cloth, fiber, fur, paper,
 metals, feathers, quills, incrustation
approx. h. 17 in. (43.2 cm.)

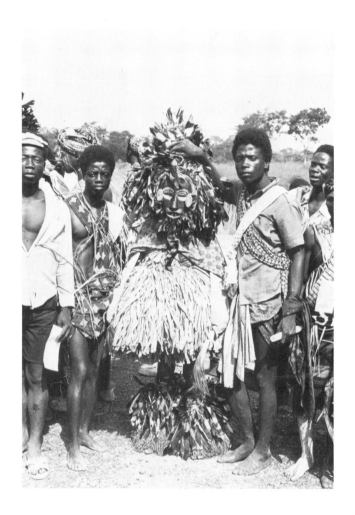

The term Wee (We), which has recently gained acceptance, refers to linguistically related populations of eastern Liberia and western Ivory Coast (Holsoe 1979). Previously the most common of a host of names used to identify these peoples were Kran in Liberia and Ngere (Gere, Guéré, Nguéré) in the Ivory Coast. The Wee are noted for the distorted and accumulative nature of their masks which contrast dramatically with the relative naturalism and simplicity of some Dan styles. However, the significance of masks among the Wee parallels that among the Dan. They are regarded as spiritual entities and are worn during the settlement of disputes and other social control activities, as well as during public entertainments in which moral lessons are sometimes taught. According to Hans Himmelheber masks can be identified as male or female, and the cartridge shells and wooden leopard's teeth of this example indicate that it is probably a male known by the general term *Begla* (Vandenhoute in Gerbrands 1957:78-93; Himmelheber 1963; 1966b; Siegmann 1977:1-3).

The field photograph, taken by William Siegmann at the eastern Liberian town of Zwedru, depicts a Wee masker posed with dancers and musicians on Liberia's Independence Day celebration of 26 July 1977.

exhibited:　Indianapolis Museum of Art, 1976
　　　　　　Indianapolis Museum of Art at
　　　　　　　　Columbus, 1977

published:　Gilfoy 1976, no. 2, ill.

This mask is so hideous, so fierce that it has an unexplainable attraction for me. H.E.

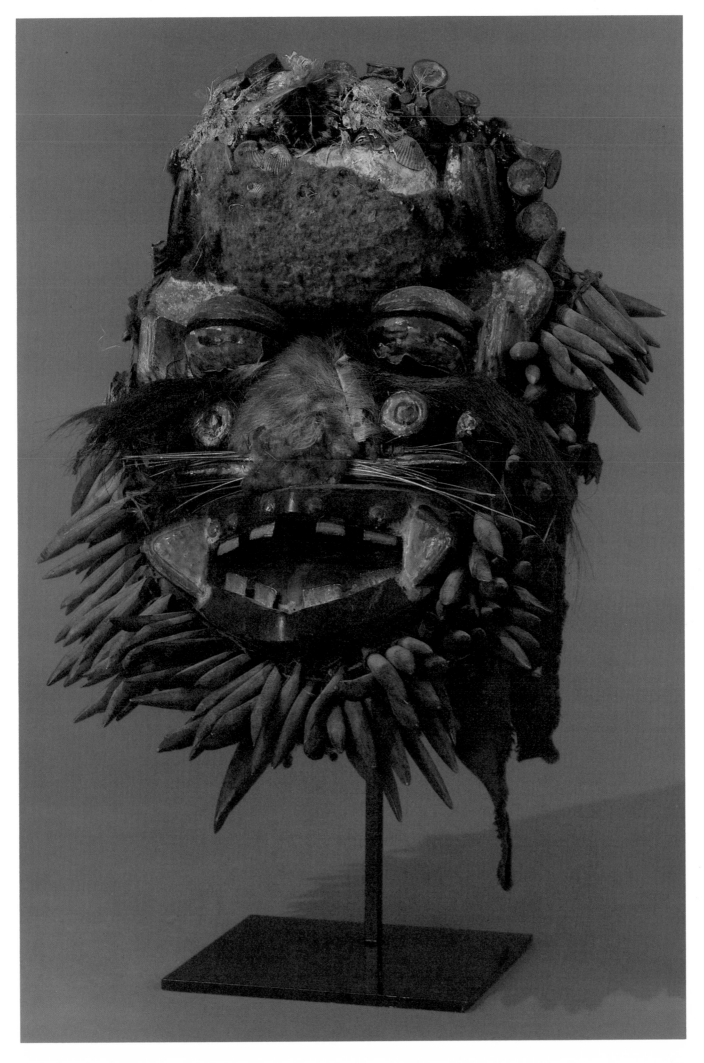

Dan or Wee, Liberia/Ivory Coast

58
female figure
brass
h. 8 in. (20.3 cm.)

Small, freestanding figures of cast brass, like larger figures of wood, are prestige objects without religious import (Fischer and Himmelheber 1976:177; Siegmann 1977:49). They portray both sexes in scenes from everyday life such as a man with gun, or a woman with child or mortar. This example, which was acquired in Liberia about sixty years ago (Gant 1981), depicts a woman carrying a staff. Brass images in related styles are found among a number of peoples of eastern Liberia and parts of neighboring Ivory Coast. Consistent features of standing figures are bowed legs, arms set free of the torso and large hands and feet.

This charming small brass figure was collected in the 1920s by an American working in Liberia for Firestone Rubber. I subsequently acquired it from his widow. H.E.

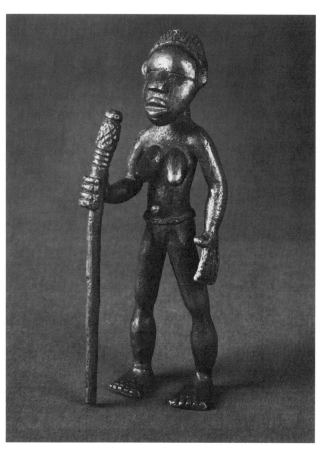

Dan or Wee, Liberia

59
female figure (lu me)
wood, pigment, monkey fur, hide, metals, glass, fiber
h. 37¹/₂ in. (95.2 cm.)

This figure is reported to have been collected near Towai, a village in Nimba County, northeastern Liberia (Kitnick 1980). Its style relates to both Dan and Wee carving (Siegmann 1981). Most wooden figures from this area are simply portraits of living individuals, usually women, which are commissioned by men who could afford them. Except on rare occasions when they are publically displayed, these status objects are maintained in a domestic setting where they are shown to important guests. Although an image may serve as a remembrance of someone after his or her death, it does not function as an ancestor figure (Siegmann 1977:37, 42-43; Fischer 1981a).

The figure is embellished with glass beads, metal earrings, brass anklets, wooden teeth and monkey hair. The relatively light coloring of the loins indicates that a skirt was once present. The composite construction, which includes movable arms joined to the torso at the shoulders, jointed thighs and breasts, and removable navel and genital plugs, may reflect the influence of Euro-American carpentry.

ex-collection: Katherine C. White

exhibited: Los Angeles County Museum of Art,
 1974-75
 M.H. de Young Memorial Museum, San
 Francisco, 1975-76
 Indiana Central University, Indianapolis,
 1980

published: Siroto 1976, no. 72
 Celenko 1980, no. 23, ill.
 Celenko 1981, fig. 3

The relatively large size of this figure and its separately carved parts, including movable arms, are unusual for figures from this area. H.E.

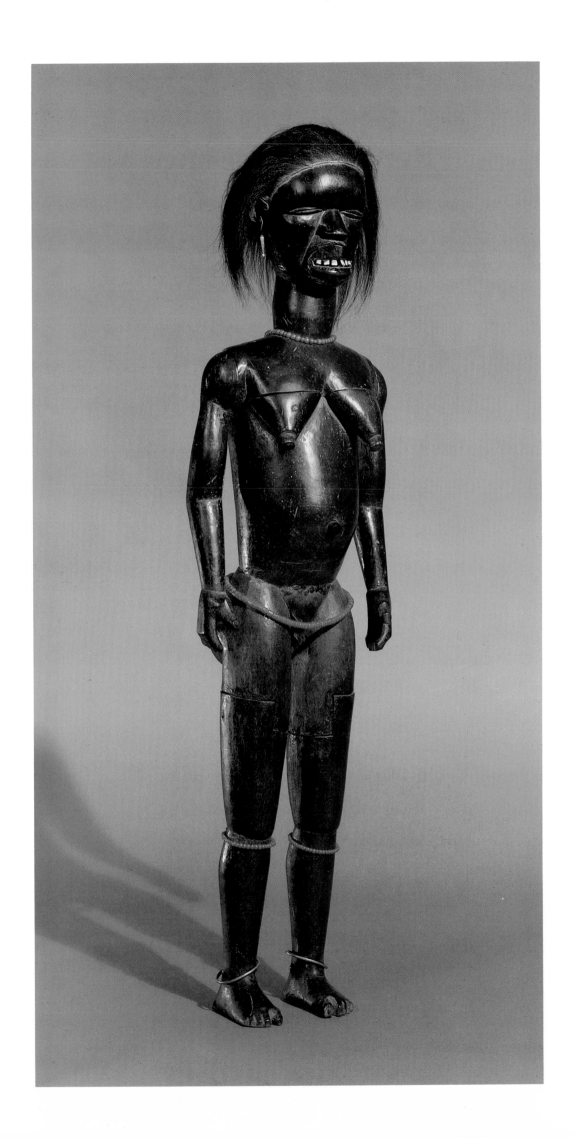

Bete (?), Ivory Coast

60 (see frontispiece)
face mask
wood, pigment, leather, hair, iron
h. 10⁹/₁₆ in. (26.9 cm.)

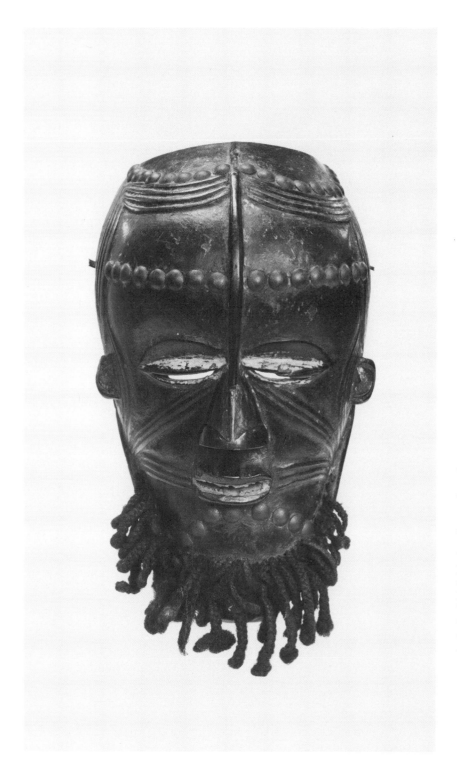

This fine carving, illustrated in the frontispiece, is among Professor Roy Sieber's favorites in my collection. H.E.

Masks similar to this one have been attributed to the Guro or Bete, neighboring peoples of southwestern Ivory Coast who speak, respectively, Mande and Kwa languages. Unfortunately, their arts have not been adequately studied. A handful of published masks that relate to this example are assigned to the Guro (Fagg 1965:no. 15; 1970a:no. 125; Herold 1967:nos. 21, 23; Quinn 1978:60), and the S-curve profile and prominent hairline of this carving suggest Guro work. However, the mask's relatively broad face, wide nose, large eyes, scarification, vertical forehead ridge and metal tacks and fiber beard are not common to Guro face masks but suggest rather a Bete origin. Masks and figures with elements relating to the Eiteljorg mask are attributed to the Bete (Holas 1960:pl. 22; 1967:pls. 3, 9; 1968:pls. III, X; 1969a:pl. 13; 1969b:pls. 1, 31; Leuzinger 1972:F24; see also Newton 1978:62). Bete carving comprises a number of substyles that have not yet been identified. Unlike this relatively naturalistic example, the most widely known Bete masks have distorted features, often with facial projections, and resemble those of the Wee and other groups to the west.

The role of Bete masking is not well documented. Maskers, who are viewed as protective agents generally embodying spiritual forces, appear at entertainments and other public festivals, funerals, trials, inter-village treaty ceremonies and during hunting and war activities (Paulme 1962b:134, 148; Holas 1968:120-30; Rood 1969).

exhibited: Indianapolis Museum of
Art, 1976
Indianapolis Museum of
Art at Columbus, 1977

published: Gilfoy 1976, no. 51, ill.
Celenko 1981, fig. 10

Guro, Ivory Coast

61
face mask
wood, pigment
h. 19¹/₄ in. (48.5 cm.)

Although the Guro live next to linguistically related peoples of the Western Guinea Coast, their carving styles have much in common with those of the Baule, an Akan group who immigrated into what is now central Ivory Coast two centuries ago. The cultural interaction between these two peoples has resulted in related, yet distinct, mask and figure styles characterized by a degree of naturalism, and an elegance and refinement of form. One prevalent feature of Guro carving, exemplified by this buffalo head mask, is prominently curved contours. The little that is understood about anthropomorphic and zoomorphic masks of the Guro suggests uses within men's societies similar to those of the *Poro* to the west. Reported functions include roles in agricultural, funerary, antiwitchcraft and entertainment activities (Tauxier 1924:253-54; Elisofon and Fagg 1958:no. 113; Sieber and Rubin 1968:no. 52; Bascom 1973:65; Vogel in Roy 1979a:no. 61).

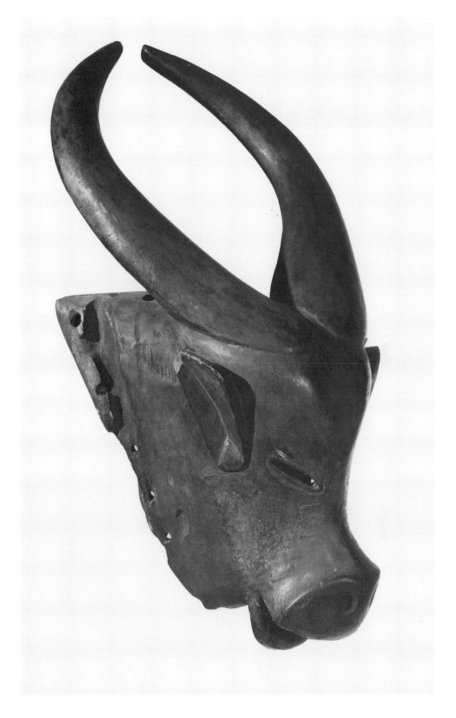

exhibited: Indianapolis Museum of
 Art, 1976

published: Gilfoy 1976, no. 30, ill.

The graceful contours of this mask typify the elegant nature of much Guro carving. H.E.

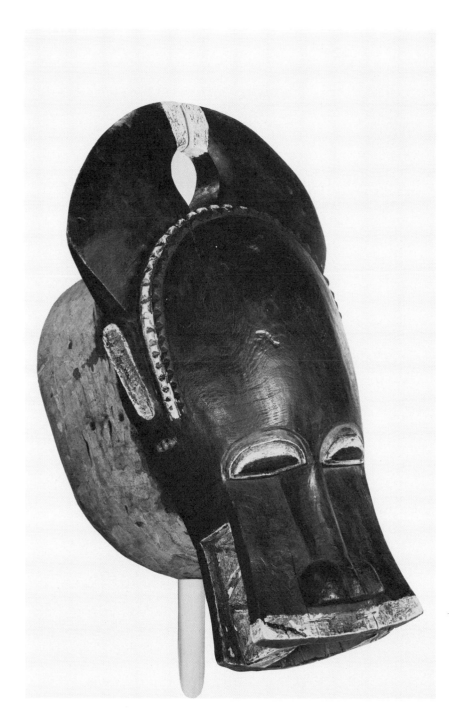

Baule, Ivory Coast

62
helmet mask *(Bonu Amuen)*
wood, pigment, iron
l. 18¹/₄ in. (46.4 cm.)

The Akan are a culturally related cluster of peoples distributed throughout the southern half of Ghana and southeastern Ivory Coast. Akan societies are organized into states, of which the Asante confederation is the best known. The Baule, the westernmost Akan group, migrated to Ivory Coast from the core Akan area in Ghana over two centuries ago. Unlike most Akan peoples they have varied masking traditions which at least in some instances were adopted from non-Akan groups such as the Wan, Guro and Senufo with whom the Baule came into contact after their migration. Helmet masks of horned animal heads with squared-off snouts and prominent teeth are called *Bonu Amuen* or "gods in the bush." Such masks are strictly male in orientation and are danced with during funerals of important men and in ceremonies to discipline women and protect villages. Women are forbidden to observe these masquerades, which are associated with such qualities of the bush and maleness as aggressiveness, violence and unpredictability. This example may represent *Do* or *Dye*, two of the oldest and most widespread of the *Bonu Amuen*. Fibers or leaves to help conceal the dancer originally hung from the unpainted neck (Vogel 1977:71-101; 1979).

Baule, Ivory Coast

63
face mask (*Kpan Pre*)
 for *Goli* dance
wood, pigment
h. 12¹/₁₆ in. (30.7 cm.)

During the early years of this cen-
tury the Baule adopted the *Goli*
dance from the Wan, a Mande-
speaking people to the northwest.
Goli is widespread throughout
Bauleland, and unlike some mask-
ing activities, it involves all elements
of the village community during a
day-long spectacle. *Goli* is a dance
of rejoicing performed as enter-
tainment during days of rest, har-
vest celebrations and visits of impor-
tant individuals. Maskers also ap-
pear at men's funerals to honor the
deceased and to provide a diversion
for mourners. The performance in-
cludes four pairs of wooden masks,
two face and two helmet types. The
Kpan Pre is identified by its black-
ened human face and curved goat
horns. Despite the almost wholesale
borrowing of *Goli* mask types, the
conventions of the *Kpan Pre*, for
example, small pouting mouth and
long slender nose joined to closely
placed eyes, are characteristically
Akan. All *Goli* masks have a raffia
cape tied to a flange. The costume
also includes a ram skin nailed to
the upper part of the flange. *Goli*
masks are atypical of Baule masks in
that they often lack eye openings
and have a stick in the lower part of
the flange which the wearer can
hold in his teeth to help support the
headpiece (Vogel 1977:124-51; 1980).

*I admire the delicate beauty and rich
patina of this mask. H.E.*

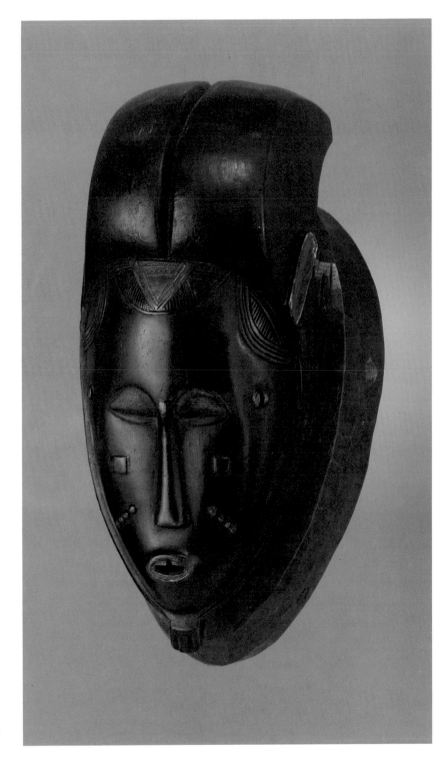

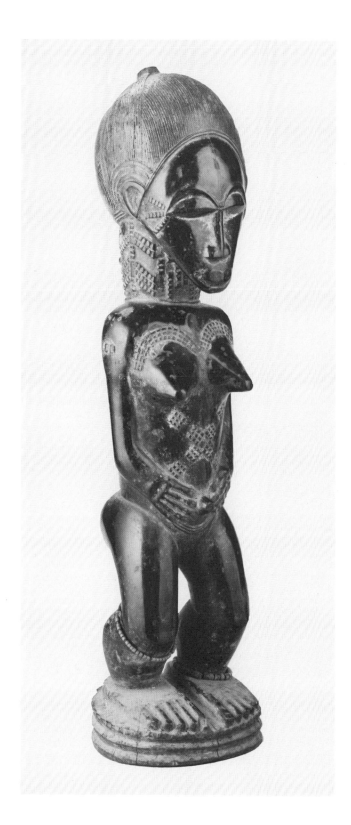

Baule, Ivory Coast

64
female figure (*Blolo Bla* or *Asie Usu*)
wood, pigment, incrustation, glass, fiber
h. 16¹/4 in. (41.3 cm.)

The long held view that Baule figures are ancestral is refuted by Susàn Vogel (1973; 1977:152-74; 1981a) who reports that carved human figures fall into two categories: spirit lovers (*Blolo Bla*, "spirit wife;" *Blolo Bian*, "spirit husband") or nature spirits (*Asie Usu*). Individuals with marital or fertility problems may be advised by a diviner to acquire a wooden image representing the husband or wife that everyone has in the other world. These spirit mates may sometimes interfere maliciously with their earthly counterparts, and the wooden figures provide a means of contact through which the spirit wives and husbands can be appeased. The figures are fondled, rubbed and cared for tenderly; they are even "slept" with periodically. Such treatment usually results in a lustrous surface. Nature spirits (*Asie Usu*), which reside in natural phenomena like trees and rocks, may also cause misfortune such as crop failure or sickness. A diviner may advise a troubled individual to acquire a wooden human figure for appeasing the spirit. *Asie Usu* figures, which are essentially similar in form to spirit lover figures, are not fondled but receive offerings of eggs, blood and other substances which leave them incrusted and dirty. Unfortunately, the identity of a particular Baule figure cannot always be determined by its surface condition since some, like this example, were cleaned and polished after removal from their original context.

The refined quality of this figure and the abstract forms of the baboon on the facing page illustrate the considerable variation of style sometimes found in the carvings of a single ethnic group. H.E.

Baule, Ivory Coast

65
baboon figure
wood, incrustation, cloth
h. 24³/₈ in. (61.9 cm.)

Various functions and names have been reported
for baboon-like figures carved in styles distinct
from those of Baule human images. Characteristic
of these figures is a baboon or monkey head with
open mouth and bared teeth, hands raised in an
offering gesture, prominent genitals and surfaces
incrusted with sacrificial substances. Such figures
are communal in orientation and protective in
nature; appeals are made to supernatural forces
embodied within them in order to combat witch-
craft and insure success in hunting, farming and
disease control (Himmelheber and Holas in Ger-
brands 1957:71; Vogel 1977:90-92).

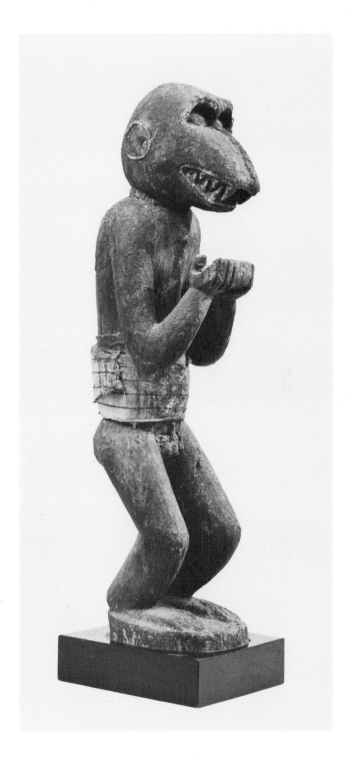

Baule, Ivory Coast

66 (top)
chest pendant
gilded cuprous alloy
w. 4¹/₂ in. (10.8 cm.)

Asante (?), Ghana

67 (left top)
ring
gilded alloy
l. 2³/₈ in. (6 cm.)

Asante (?), Ghana

68 (left bottom)
ring
gilded alloy
l. 2⁵/₈ in. (6.7 cm.)

unidentified ethnic group, Ghana/Ivory Coast

69 (center)
necklace beads
gold
l. 5¹¹/₁₆ in. (14.4 cm.)

Asante, Ghana

70 (right)
armlet
gold, leather, fiber, unidentified internal material
l. of leather packet: 3¹³/₁₆ in. (9.7 cm.)

Asante (?), Ghana/Ivory Coast

71
crown (bottom)
cotton, wood, gold, paper, mastic
approx. w. 7¹/₂ in. (19.1 cm.)

For centuries gold has played an important role in the social and economic life of the Baule, Asante and other Akan peoples, and the prosperity of some states was due largely to trade in this metal. The status and wealth of chiefs, title holders and other important people were indicated, in part, by their gold holdings. The metal became symbolic of leadership, and on formal occasions leaders displayed a dazzling array of cast gold and gold-covered items as part of their dress and regalia.

The chief's crown (cat. no. 71) is made of imported velvet and gold leafed wood ornaments. The use of an adhesive rather than tiny gold staples indicates a post-19th century date (Himmelheber 1972:191; Ross 1983). The ornaments depict sea shells, prestige objects acquired from the coast. The large and small shells placed side by side probably refer to an Akan proverb, "everyone has a senior" (Ross 1983). The circular pendant (cat. no. 66) resembles those worn by Asante priests concerned with the purity of chiefs' souls. It may have served a similar function among the Baule. In relief, along the tube used for suspension, are two beasts of prey about to pounce on an antelope, referring, perhaps to a proverb. Technically the pendant is of interest because it is made of a cast cuprous alloy gilded by an unidentified non-gold leaf technique (cat. nos. 26-31). Unlike the Asante, who in recent centuries controlled most of the gold supply, the Baule had relatively little gold, which may explain their use of gilding. The spiral design, also apparent in the necklace disc beads (cat. no. 69) results from the thin wax threads of the original model. The rings (cat. nos. 67-68) are also gilded by an unidentified technique. The bird mounted on one of these rings (cat. no. 67) is laden with power imagery: cannons on the wings and powder kegs in the beak and on the tail. The body of the bird is in a knot form symbolizing wisdom. The armlet (cat. no. 70.) is of a type normally worn at the elbow of a chief. The rectangular, leather, gold leafed packet probably contains Koranic inscriptions or other protective elements. The attached ornaments, some probably missing, are both non-figurative and figurative. Among the figurative ones are representations of human incisors symbolic of military prowess.

cat. no. 66
exhibited: Indiana Central University, Indianapolis, 1980

published: Celenko 1980, no. 14

Nowhere else in Africa does goldworking reach such spectacular heights as among Akan peoples.
H.E.

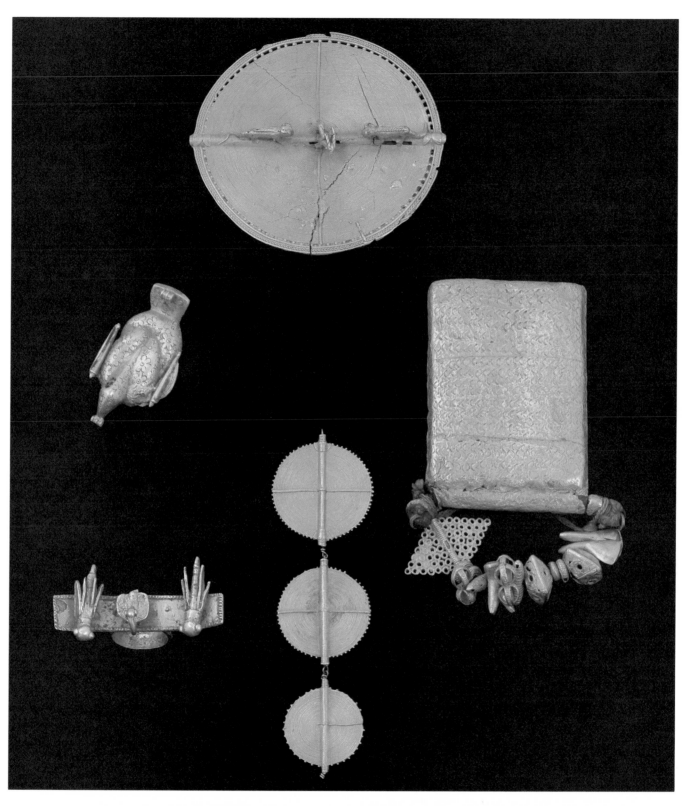

Baule, Ivory Coast

72
stool
wood, pigment
l. 48^{13}/$_{16}$ in. (124 cm.)

Unlike Akan stools associated with an individual's soul, this type is purely secular. Reserved for men of high status, it was a prestige object for special occasions (Vogel 1978). Power-oriented imagery, a common feature of Akan leadership arts, is here manifested by a leopard devouring a small animal, perhaps a goat.

exhibited: Indianapolis Museum of Art, 1976

This is one of my earliest acquisitions, collected before my serious involvement with African art. I admired it as a piece of sculpture and still prize it. H.E.

Asante (?), Ghana

73
woman's comb
wood, pigment, brass
h. 11 in. (27.9 cm.)

Baule, Ivory Coast

74
heddle pulley
wood, iron, fiber
h. 5¹³/₁₆ in. (14.8 cm.)

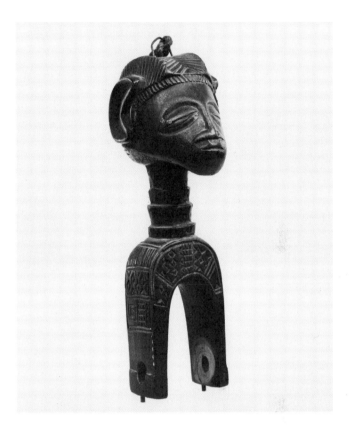

Although a good deal of Akan art relates to leadership and religion, there are many utilitarian carvings such as game boards, pulleys and combs, found at all societal levels. On special occasions such as weddings and births women receive combs from male friends and relatives. Although the combs are utilitarian they also serve as mementos and could be displayed in the home or worn as hair ornaments. Incised or relief carving, in a wide variety of figurative and non-figurative motifs, typically adorns both sides. Figurative motifs frequently relate to friendship; an example is the stylized heart shape between what are probably profile views of chairs on top of the comb. Sometimes the handle carries a date or the name of an individual, as on this example (Cole and Ross 1977:48-53).

Throughout West Africa men's horizontal strip weaving looms include one or more pulleys to manipulate opposing heddle frames. The abraded inner surfaces of the pulley's "feet" and the oblong shape of the axle holes, created by the pull of the heddles, are evidence of the missing wheel. Ornamentation of Akan pulleys has not been thoroughly studied and the significance of this head is uncertain. While some embellishments are purely decorative, other iconographic elements may be protective or have some other significance for the weaver.

ex-collection: Josef Herman

Pulleys and combs are among the everyday utilitarian objects that Africans transform into art. H.E.

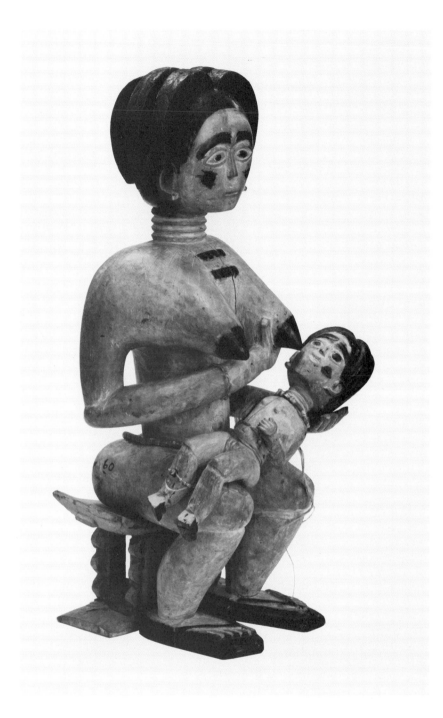

Fante, Ghana

75
female figure with child
wood, pigment, glass, metal,
 plastic, fiber
h. of female figure: 20 in.
 (50.8 cm.)

Female figures, particularly those
nursing children, are associated
with human fertility and are kept in
shrines dedicated to various deities.
They sometimes have white surfaces
(largely worn away in this example)
which imitate the whitened skins
adopted by devotees. This as-
semblage consists of a separately
carved stool, child and female figure
whose sandaled feet may identify
her as a queen mother (Warren 1976;
Cole and Ross 1977:107-117). The
stool is typically Akan in config-
uration with horizontal base, verti-
cal supports and concave seat.
Among Akan peoples stools have a
special significance, and an individ-
ual keeps the same one throughout
his or her life. After death they serve
as repositories for the souls of the
deceased, a role often filled by an-
cestral images among other peoples.

exhibited: Indianapolis Museum of
 Art, 1976
 Indianapolis Museum of
 Art at Columbus, 1977

published: Gilfoy 1976, no. 90, ill.

Asante, Ghana

76
female fertility figure (akuaba)
wood, pigment
h. 10¹⁵/₁₆ in. (27.9 cm.)

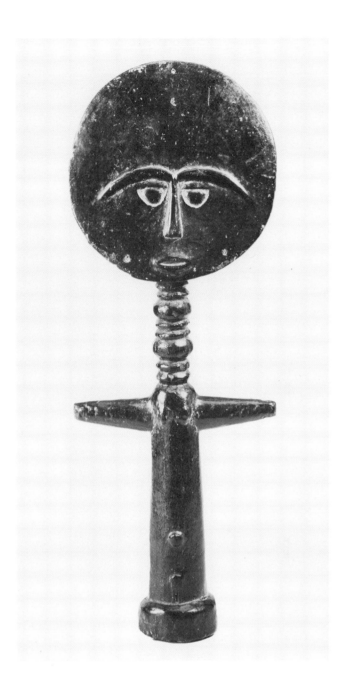

The term *akuaba* (Akua's child) relates to various versions of a legend of a barren woman, Akua, who on the advice of a priest had a carver make a small image which she cared for as if it were a real child. Akua subsequently became pregnant and gave birth to a beautiful daughter which inspired other childless women to follow her practice. Among Akan peoples *akuaba* figures are thought to insure the birth of beautiful and healthy children, and even already pregnant women acquire them. The figures are carried about by women and cared for as if they were children. After childbirth an *akuaba* is retained by a mother as a memento and sometimes as a teaching device for girls or placed in the shrine of the priest who consecrated it (Cole and Ross 1977:103-104).

Akuaba usually have simplified cylindrical torsos, often with projecting horizontal arms and large flattened heads. The high foreheads relate to an Akan practice of modeling the pliable crania of infants. The ringed neck characteristic of these figures is an exaggerated rendering of neck fat and alludes to beauty and well-being. Akan stylization of the human face in sculpture, which includes prominent, semi-circular eyebrows meeting at the bridge of the nose and a small mouth, are epitomized in *akuaba*. With rare exceptions these carvings depict females. According to Herbert Cole and Doran Ross (1977:104) this may relate to three factors: the sex of Akua's first child, the need for domestic help and the desire of women in a matrilineal society to perpetuate the family line.

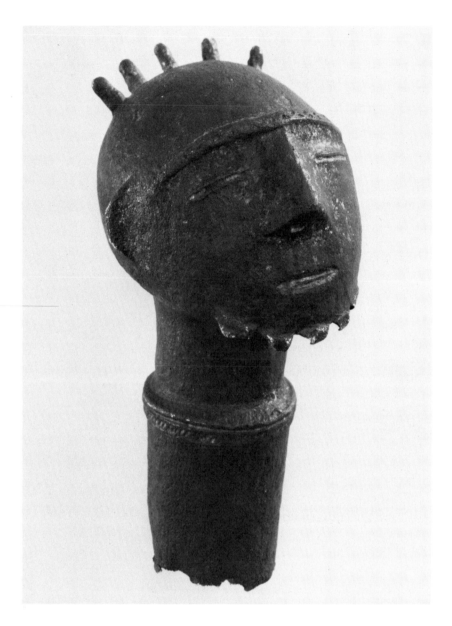

unidentified ethnic group,
Ghana/Ivory Coast

77
finial head
brass, clay
h. 3^{15}/$_{16}$ in. (10 cm.)

17th century (?)

Thermoluminescence testing dates the clay core of this Akan casting to a period between the early 15th and late 18th centuries, with an early 17th century date most probable (Daybreak Nuclear and Medical Systems, Inc.; Guilford, Conn.; sample 10A14, 1982). The broken bottom of the cylindrical support indicates that this bearded head was a finial for a staff (Garrard 1983:48, fig. 55) or some other object. Doran Ross (1983) speculates that it came from a lid of an early variety of *kuduo* (Cole and Ross 1977:fig. 135, see also fig. 139), cast brass prestige and ritual vessels.

published: Garrard 1983, fig. 55

unidentified ethnic group,
 Ghana
southern Akan area

78
commemorative head
clay
h. 10³/₈ in. (26.4 cm.)

17th century (?)

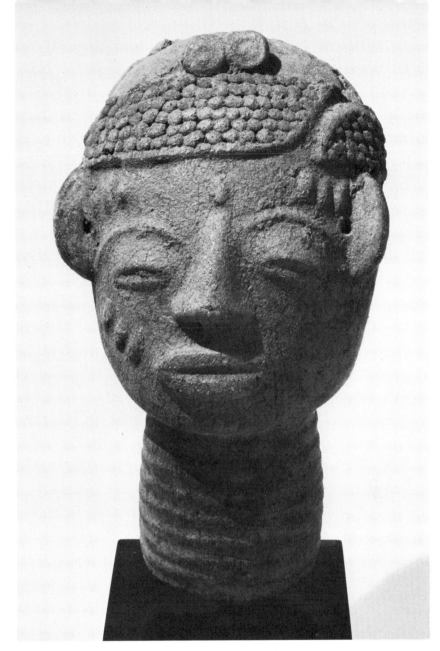

Among Akan peoples terra-cotta heads and figures serve as memorials for deceased royals. These images, often painted and adorned with clothing and other articles, can be viewed as surrogates for the dead and are the focal point of formal funerals. After the funeral, which, following common African practice, may take place long after interment, the terra-cottas are placed on or near graves or in shrine rooms where they receive prayers and sacrifices. Manufacture of commemorative heads, figures and figurative vessels is normally the responsibility of women, contradicting the assumption that in Africa women produce only utilitarian pottery while men make figurative, ritual terra-cottas. Archaeological endeavors and early European reports have placed the tradition as far back as the 17th century, although it is almost certainly older (Sieber 1972b:175-79; 1973:71-75; Cole and Ross 1977:117-27; Preston 1981). These images may represent the oldest documented figurative tradition still functioning in a traditional African context (Sieber 1972b:182).

Heads exhibit a wide range of styles, from flat, disc-like faces with stylized features to more naturalistic renderings. However, even relatively naturalistic heads such as this example should probably not be considered physiognomic portraits in the Western sense, but rather idealized portrayals which are particularized through association with a specific family, grave or shrine. Scarification, coiffure or jewelry also aids in determining the sex, age, status and identity of the commemorated individual. The tufted coiffure and the absence of earring holes in the earlobes indicates that this example probably depicts a male (Preston 1970:nos. 29, 37; 1981; Sieber 1973:71-72; Cole and Ross 1977:125).

Stylistically this head resembles others identified with the Twifo, Asin, Adansi and other southern Akan groups. The 17th century date tentatively assigned to this piece is based on dates variously arrived at for similar heads (Preston 1970:nos. 30-32; Sieber 1973:74-75; de Grunne 1980:145-217) and on a thermoluminescence analysis (Los Angeles County Museum of Art, Conservation Center, 1979, TR 3190-5) which indicates a time of manufacture between the late 15th and early 17th centuries. However, this early test date may say more about the potential shortcomings of the thermoluminescence technique as applied to isolated, post-field samples than it does about the age of the head (cat. nos. 1-2, 35, 77, 114).

Centuries-old objects like this head reveal the long history of African art. H.E.

Ibarapa subgroup (?), Nigeria

79 (left)
staff *(ose Sango)* for *Sango* cult
wood, pigment
h. 19¹/₄ in. (48.9 cm.)

Ketu subgroup, Nigeria
Meko town
carver: Duga or his school

80 (middle)
staff *(ose Sango)* for *Sango* cult
wood, glass, fiber
h. 18³/₄ in. (47.7 cm.)

Igbomina subgroup, Nigeria
Ila-Orangun town
carver: Fakeye family (?)

81 (right)
staff *(ose Sango)* for *Sango* cult
wood
h. 20¹³/₁₆ (52.9 cm.)

Various legends recall *Sango*, a great warrior, re-knowned magician and early king of Oyo, who was tragically compelled to commit suicide because of a misuse of power. He was subsequently deified and attracted devotees in many parts of Yorubaland. *Sango* is intimately associated with fire, lightning and thunder, and it is believed that he terrifies enemies by emitting fire and smoke through his mouth. His primary attribute and the focal point of ritual activity on his altars are stone celts which are regarded as "thunderbolts" the deity hurls from the sky (Lawal 1970:15-24). During rituals cult priests and priestesses carry wooden staffs *(ose Sango)* whose imagery includes celts in the form of double-headed axes. As emblems of the cult these staffs are symbols of devotion and protective in nature. However, they are also symbols of the deity's destructive power, for example, to invoke lightning, and are ". . . used most expressively when a priest possessed by the god dances with . . . [one], wielding it violently in simulation of *Sango's* violence" (Lawal 1981).

Cat. no. 81 was photographed by William Fagg in 1950 in a *Sango* shrine within the king's palace at Ila-Orangun, and was probably carved by a member of the Fakeye family around the turn of the century (Fagg 1975). The depiction of twin images on the double-axe form surmounting the head of a kneeling female worshiper probably relates to the belief among some Yoruba that *Sango* is the ultimate source of twins (Thompson 1971:ch. 12:6). The phallus handle and female worshiper with child of cat. no. 79 may make reference to the sexuality and fertility associations of the deity (Lawal 1970:99-100; Thompson 1971:ch. 12:4). Cat. no. 80 relates stylistically and iconographically to examples by Duga, a master carver at Meko, documented by William Bascom in 1950. The central figure depicts a cult priest who carries an *ose Sango* under his right arm and wears a ritual cape laden with cowrie shells and bells. His left hand rests on the head of a female worshiper of *Oya*, goddess of the Niger River and *Sango's* most loyal wife. The man to his right is beating *Sango's* drum (Bascom 1969a:85, 104-105; 1973:88). The double-axe form surmounting the priest's head bears two additional celt forms.

cat. no. 79
exhibited: Donald Morris Gallery, Detroit, 1971
 Indianapolis Museum of Art, 1976
 Indianapolis Museum of Art at
 Columbus, 1977
 Leigh Yawkey Woodson Art Museum,
 Wausau, Wisconsin, 1983

published: Donald Morris Gallery 1971, no. 28, ill.
 Gilfoy 1976, no. 108, ill.
 Aronson 1983, no. 12

cat. no. 80
published: Armstrong 1981, pl. 11

cat. no. 81
exhibited: Indianapolis Museum of Art, 1976
 Indianapolis Museum of Art at
 Columbus, 1977

published: Gilfoy 1976, no. 109, ill.

Yoruba craftsmen are prolific workers and talented carvers who sometimes use pronounced erotic imagery (cat. no. 79). The three staffs illustrate the technical mastery and subtle variation of style that mark Yoruba sculpture. H.E.

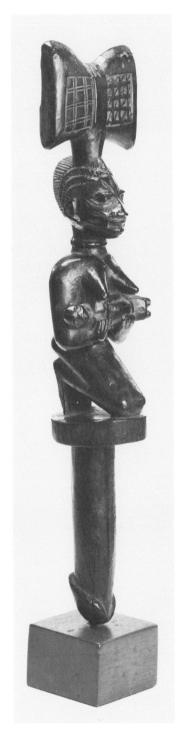
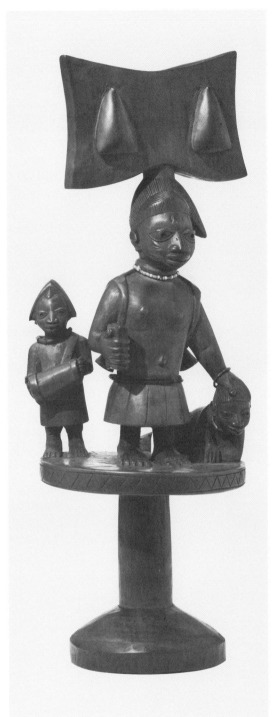
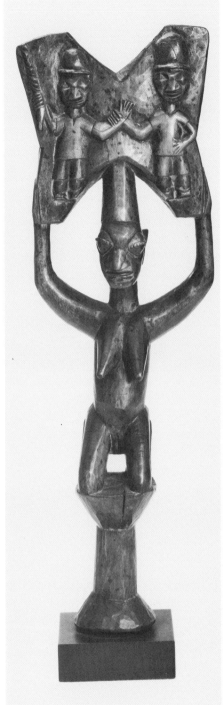

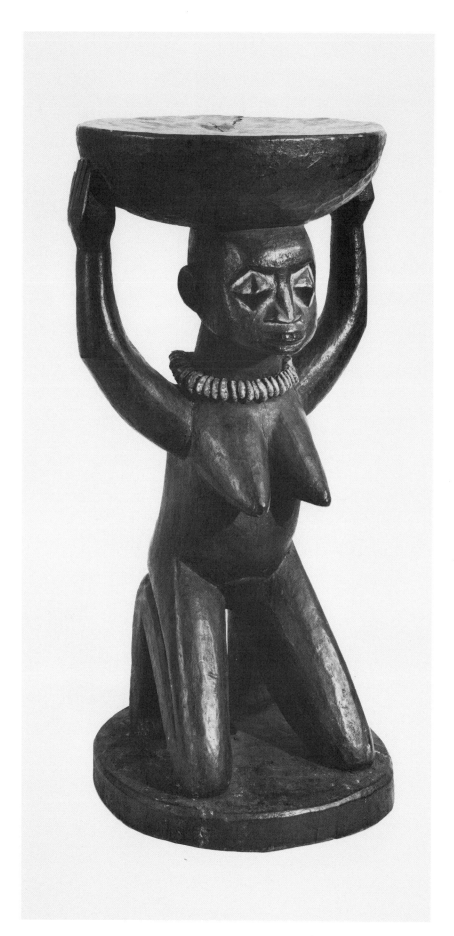

Igbomina subgroup, Nigeria

82
altar pedestal *(arugba)*
wood, pigment, fiber, leather,
 cowrie shells
h. 22³/₈ in. (56.9 cm.)

Pedestals with figurative supports are prominent components of cult altars, where they serve as display platforms for ritual items. In the Igbomina area *arugba* are prevalent in *Sango* shrines. If this example were part of a shrine dedicated to the deity it would have supported a calabash containing his "thunderstones," the shrine's focal point. The hemispherical support held by the caryatid, which depicts a female devotee, probably derives from a calabash form (Drewal 1977:22-23; 1980a:48-49; Picton 1981). The prevalence of female images on stools, pedestals, staffs and other cult paraphernalia probably alludes to fertility and ". . . the soothing presence of women, [as a] source of concern and coolness, . . ." (Thompson 1971:ch. 19:1).

Oyo subgroup (?), Nigeria
Ede town

83
altar figure depicting *Sango* priest
wood, pigment
h. 38³/₁₆ in. (97 cm.)

Figures depicting drummers, gift bearers, priests and even the deity sometimes form part of the paraphernalia of *Sango* shrine altars. This large carving is revealed as a priest by the double-headed axe wand (*ose Sango*, cat. nos. 79-81.) held in each hand and by one of a number of types of female hair styles worn by the cult's priests and priestesses. On a man, such a coiffure alludes to the role of a priest, when possessed by the deity, as *Sango's* wife. Such figures are not essential to shrines; however, their presence further honors the deity (Beier 1958:32-34; Lawal 1970:37-46; Houlberg 1981). "They help the worshiper to achieve the calm state of concentration, and the condition of receptiveness that is necessary if the god is to manifest himself during the ceremonies" (Beier 1958:32). Furthermore, this particular figure, which brings to mind a priest in a state of possession, of communication with the deity, serves as a religious sign "linking the visible world of the living with the invisible realm of *Sango"* (Lawal 1970:42-43). The distinctive style of this carving with massive features and thrusting, somewhat disjointed shoulders, relates to shrine figures documented at Ede (Beier 1958:pls. I-II, VII; Lawal 1970:pls. 24, 45-46, 48).

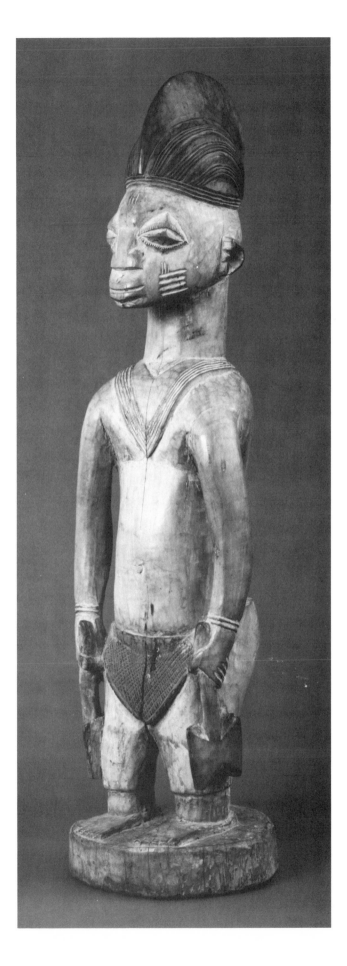

unidentified subgroup, Nigeria

84
***Sango* priest's shirt** *(ewu Sango)*
cloth, glass, fiber
approx. h. 41 in. (104.2 cm.)

The beadwork on both sides of this shirt is extraordinarily complex in design and imagery. The garment is comparable to some heavily beaded vests in my American Indian collection. However, unlike the secular nature of much Indian beadwork, this shirt is a ritual garment. H.E.

This elaborately beaded shirt was worn during rituals by a *Sango* priest, who, because his deity was a king, was allowed to own beaded objects. The bead embroidery which covers both sides of the garment is iconographically complex. On the front of the shirt (left) a pair of human heads predominate and may allude to the deity's role as creator of twins (Thompson 1971:ch. 13:3-4). Although some of the beadwork is missing from this side, including most of one of the faces, enough of it is extant to ascertain that the composition exhibits a bilateral symmetry, a mirroring of elements, which reinforces the concept of twinning. Depictions of celts or "thunderstones," the primary attribute of *Sango*, appear throughout both embroidered sides as triangular, often paired, elements or as rounded shapes. The interlace and snake motifs, which are also found on both sides, and the zigzag motif encompassed within rectangular panels on the back probably have royal associations. The zigzag may also allude to lightning which *Sango* hurls from the sky (Thompson 1971:ch. 8:2-3). Other elements such as the floral motifs may be purely decorative.

The composition on the shirt's back (right), in its profusion of elements and complexity of design, evokes the erratic nature of the deity (Gilfoy 1976:71). At the same time, as on the front side, the composition reveals an implicit bilateral symmetry which may refer to twinning. The colors associated with *Sango* are red and white, and their use in the beadwork and cloth backing may allude to the dual nature of the deity: red to fire, lightning and violence; white to calm and kingly presence (Thompson 1971:ch. 12; ch. 13:3-4).

exhibited: Indianapolis Museum of Art, 1976
Indianapolis Museum of Art at
Columbus, 1977

published: Gilfoy 1976, no. 111, ill., cover ill.

Egba subgroup (?), Nigeria
area of Abeokuta town (?)

85
royal cap (ori-ko-gbe-ofo)
cloth, glass, fiber
approx. h. 8 in. (20.4 cm.)

In traditional times, only kings and devotees of certain cults such as those of *Ifa* and *Sango* (cat. no. 84) had the prerogative to own beaded items, which were commissioned from male embroiderers. Royal beadwork includes slippers, pillows, flywhisks, gowns, caps and crowns. Caps such as this one serve as informal headgear for a king and are not worn during rituals. They are distinct from the sacred veiled crowns which epitomize divine kingship. Embroiderers have a relatively free hand in the determination of design elements on these informal caps, and the fleur-de-lis and other motifs on the bottom of this example may be purely decorative (Beier 1982:85). However, these caps often include birds and other imagery found on the more elaborate crowns. Birds are a prevalent symbol of witches, but in a royal context refer to kingly mastery over evil (Thompson 1971:ch. 8:1). They allude to the "miracle of divine kingship," the ability of royals to communicate "with the spirits of departed kings" (Thompson 1972:256) and ". . . with the gods through aerial flight, connecting the aspirations of heaven and earth" (Thompson 1971:ch. 8:1). The knob-like projection at the top of the cap is one variation of a recurring Yoruba motif which alludes to divine presence (Drewal, M. 1977).

unidentified subgroup, Nigeria/Benin

86
bottle with kneeling figure
glass, wood, fiber, cloth, leather
h. 12⁷⁄₈ in. (32.7 cm.)

This unusual assemblage consists of a beaded commercial glass bottle with bird-finialed stopper, a beaded wooden figure made of several pieces, and a base of cloth and leather. Its surface shows use and the lavish application of beadwork suggests a prestige or ritual function. Henry Drewal (1981c) speculates that it probably held medicines or other ritual preparations and was kept in a shrine or palace. Ulli Beier (1982:35) publishes a beaded glass bottle with bird finial but without a supporting figure which was made for Oba Oyewusi II of Okuku.

The art of covering glass bottles with beads is also found among some California and Northwest Coast American Indians. H.E.

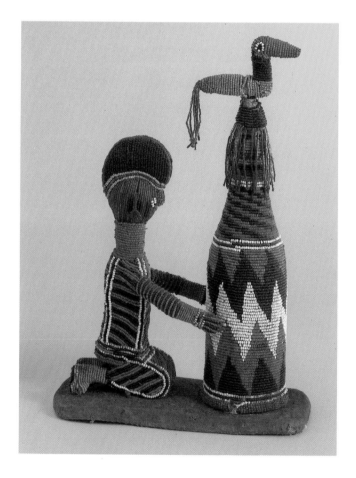

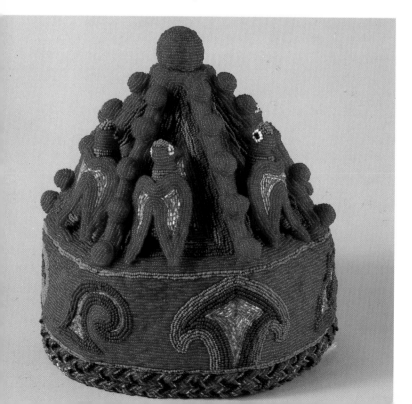

unidentified subgroup, Nigeria
northeastern area (?)

87
ritual dance panel *(yata)*
cloth, fiber, glass
h. of panel without shoulder strap:
 12¹⁵/₁₆ in. (32.9 cm.)

Beaded dance panels, which are not
well documented, are part of the
ritual attire of devotees of various
deities. They are usually worn in
pairs suspended from the shoul-
ders. A handful of published exam-
ples are documented among or at-
tributed to the northern or eastern
Yoruba (Bascom 1969a:86-87, ill. a;
Thompson 1971:ch. 8:3, pls. 5a, 5b, 6;
Pemberton 1980:fig. 11, pls. 6, 12,
15-16, 21-22, 25). John Pemberton
(1980:pls. 12, 16, 21) attributes panels
with motifs similar to this one, and
with a predominance of blue, gold
and white beads to the cult of *Osun,*
a major river deity of the Igbomina
and other northeastern Yoruba sub-
groups. Pemberton (1980:pl. 6)
further indicates that a human face
such as the one on this example re-
fers to the "inner head" *(ori inun),* or
spiritual power of the devotee.

cat. 85
exhibited: Indianapolis Museum of
 Art, 1976
 Indianapolis Museum of
 Art at Columbus, 1977

published: *Saturday Evening Post*
 1975, p. 52, ill.
 Gilfoy 1976, no. 113

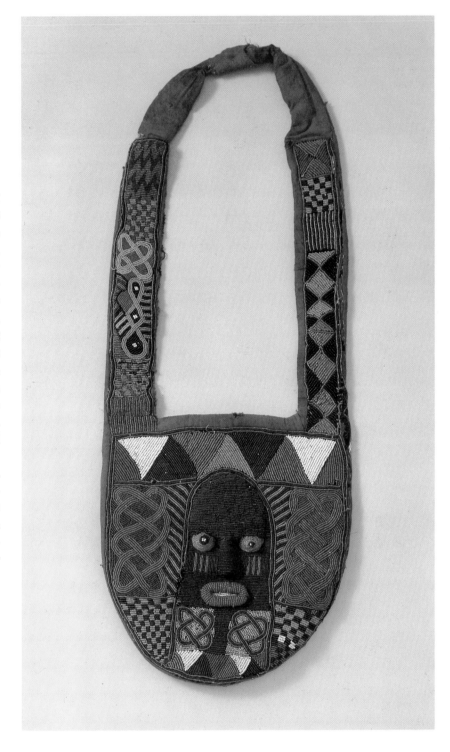

cat. 86
exhibited: Indianapolis Museum of Art, 1976

published: Gilfoy 1976, no. 114

cat. 87
exhibited: Indiana Central University, Indianapolis, 1980

published: Celenko 1980, no. 24

Oyo subgroup, Nigeria

88-89
pair of dance staffs for *Esu/Elegba* cult (*ogo Elegba*)
wood, pigment, fiber, glass, cowrie shells
left: h. 17¹/₄ in. (43.9 cm.)
right: h. 17³/₈ in. (44.2 cm.)

Esu (Elegba, Elegbara), messenger of the gods, is associated with uncertainty, and his unpredictable, unrestrained and mischievous behavior parallels similar aspects of human nature. In his capacity as "divine enforcer" he causes misfortune, manifested in accidents and detrimental behavior, for those who have neglected or offended the gods. Regardless of what deity a Yoruba follows, it is likely that he or she will pray and sacrifice to *Esu* in order to avoid misfortune. Although the deity is often viewed as a negative force there is a positive aspect to his actions associated with productivity, change and growth (Wescott 1962; Bascom 1969a:79).

Among the paraphernalia associated with the worship of *Esu* are paired, male and female figured staffs which are either carried by devotees or worn suspended upside down from their necks by leather thongs. This characteristically kneeling pair of figures hold calabash medicine containers and incorporate the deity's most prevalent attribute, a tail-like extension of the head sometimes similar to a coiffure affected by *Esu* priests. This protruding, curved element has phallic associations which relate to the deity's sexually aggressive, libidinous nature and more generally to male potency. Cowrie shells, a traditional form of money, which are included in the added necklaces and depicted on the coiffure of these examples, relate to *Esu's* involvement with the marketplace where money transactions are a potential source of conflict. The dark, often indigo, coloring which covers much of the cult's equipment has contradictory associations with, for example, the evil, dark side of *Esu* or with wealth, prestige and kingship. Furthermore, the dramatic contrast of a blackened surface and white cowrie shells is symbolic of the deity's activities in the world of extremes (Wescott 1962; Thompson 1971:ch. 4).

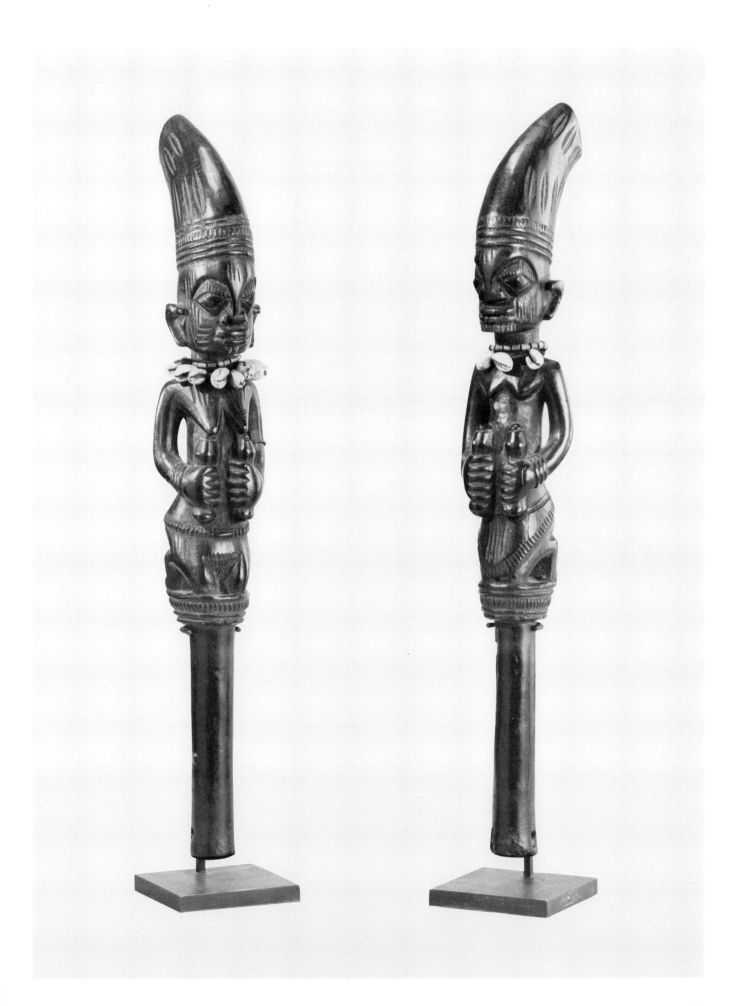

unidentified subgroup, Nigeria

90
divination tray *(opon Ifa)*
wood
h. 16 in. (40.6 cm.)

Ifa, god of divination, is associated with order, stability and knowledge. Through highly trained diviners, *babalawo*, he transmits to mankind the will of the gods, most importantly that of *Olorun*, god of the sky and destiny and father of all deities. Clients beset with problems or facing important decisions seek out *babalawo* in order to learn the proper, divinely established course to follow. The divining procedure, which varies according to the particular *babalawo* and area, includes prayers, sacrifices and other rituals. A consistent feature of the procedure entails repeated throws of palm nuts or a divining chain of seed pods. The result of each throw dictates the series of lines which the diviner makes on a divining tray, *opon Ifa*, which has been dusted with wood powder or flour. The configuration of lines corresponds to a corpus of *Ifa* verses, of which there are thousands, which are then recited by the diviner. These verses, which include myths, folktales, praise names, incantations, songs, proverbs, and riddles relating to the Yoruba pantheon, offer the client solutions to his or her problem (Bascom 1969b).

Ifa's friend *Esu*, as messenger of the gods, plays a vital role in the divination process, and occupies a prominent place among imagery which is carved in relief on the borders of divination trays. This example is exceptional in the number of times (six) the deity's face is depicted. There are also a dozen human figures. One rides a horse; others play a flute or gong, smoke a pipe, or carry a staff or weapon. While these figures may depict worshipers of *Esu*, the long-tailed headdresses worn by two of the figures (flanking one head of *Esu*, top of ill.) suggest that the deity himself may be represented. Other iconographical elements, which include snakes and birds, are difficult to interpret since the imagery of *opon Ifa* may relate to various deities.

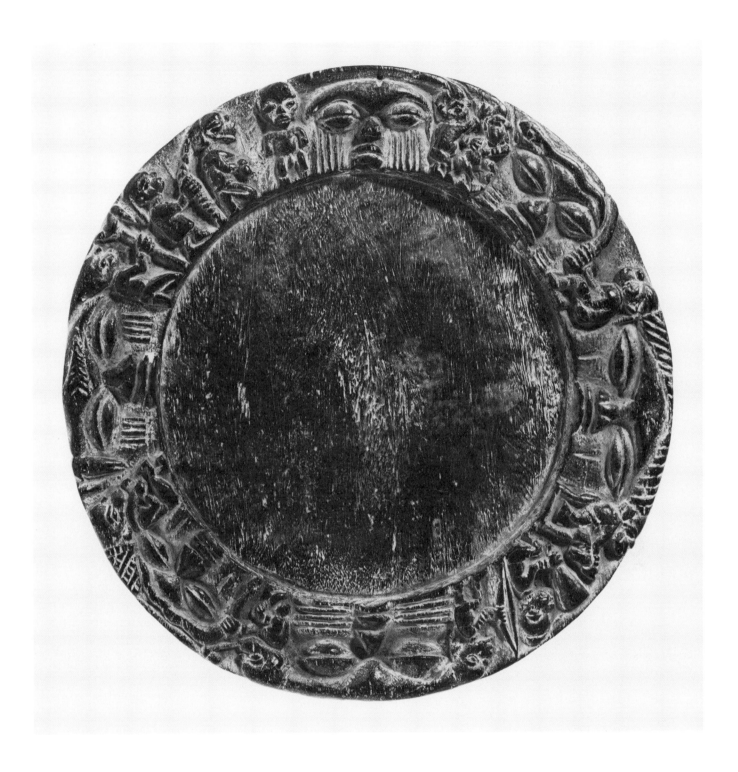

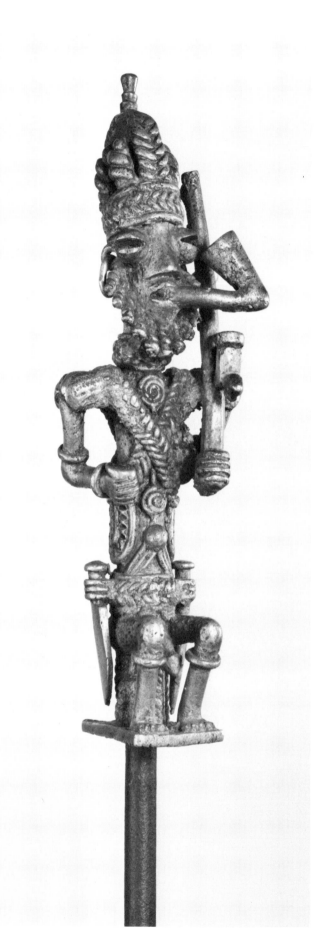

Egbado or Egba subgroup (?), Nigeria

91
staff for head of blacksmiths *(iwana Ogun)*
brass, iron
h. 22¹/₈ in. (56.2 cm.); h. of figure: 8³/₈ in. (21.3 cm.)

The hooked bottom of this staff is like those of smiths' pokers. That feature and the prominence of iron weaponry depicted with the finial figure identify the staff with the cult of *Ogun,* the god of iron. The deity brought knowledge of iron to the Yoruba and is the patron of blacksmiths, warriors, hunters, wood-carvers, barbers and others who depend on ferrous implements. These staffs serve as title indicators for the heads of smiths' groups and are carried by messengers to validate oral messages among senior smiths (Thompson 1971:ch. 7:1-2, pls. 6-10). The cast brass finial probably depicts a bearded title-holder who wears an openwork crown, shoulder bags, armlets, bracelets and leglets. Other attributes include a tobacco pipe which has probably been bent to the side, bladed weapons suspended from a belt and a musket. An element broken off the figure's right hand probably represented a flywhisk. Four published brass figures iconographically and stylistically similar to this casting all carry whisks. Two of these, in the Museum of Ethnic Arts, Los Angeles (Thompson 1971:ch. 7:pl. 10) and a private collection (Adams 1982:no. 80) are on *iwana Ogun;* the latter was acquired at Ibadan in 1963. The other two figures, in the Museum für Völkerkunde, Berlin (Krieger 1969:nos. 174-75), are parts of other types of objects and were collected in 1909.

Many African peoples have had longstanding and sophisticated traditions of working iron, brass and other metals. H.E.

Ijebu subgroup, Nigeria

92
**staff for *Osugbo* society
 *(edan Osugbo)***
brass, iron
h. 10¼ in. (26 cm.)

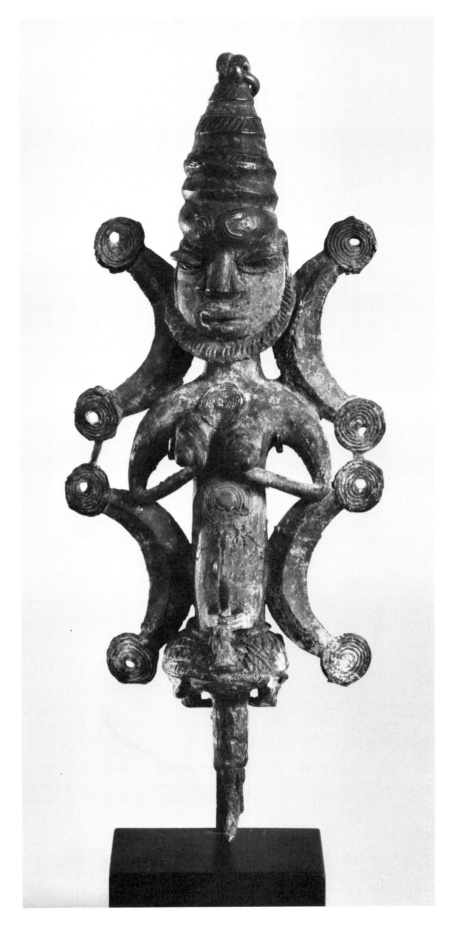

The *Osugbo* society, also known as *Ogboni* and *Mole* outside of the Ijebu area, worships *Onile*, "mother earth," ". . . as the source of life and the judge of all human actions" (Drewal 1981a:90). The society's title holders are community elders whose primary role within *Osugbo* is ". . . reconciling and adjudicating differences among persons and atoning for the violation of the earth" (Pemberton 1982:186). This ancient, secretive institution has the power to judge royals as well as commoners.

An *edan Osugbo,* paired male and female brass figures cast onto iron rods and joined by a brass chain, is usually commissioned when an initiate enters the society, and forms an important part of the cult's ritual paraphernalia. Perhaps the most often cited of the host of functions for these staff assemblages is their placement at the site of a serious crime calling the involved parties to the cult house (Bascom 1969a:36-37; Drewal 1981a:90). The hermaphroditic aspect of this kneeling figure with both beard and breasts, but with concealed genital area, is not uncommon and may allude to the extraordinary, supernatural powers of the society. The figure may wear a crown (Thompson 1971:ch. 6:4, pl. 19) and is laden with such avian imagery as the bird pecking the abdomen and the crescent forms, possibly a cryptic reference to bird profiles (Dobbelmann in Drewal 1981a:91), in relief on the forehead and in the openwork flanking the figure. Birds refer to the spiritual powers of "our mothers," elderly women and female ancestors (cat. no. 94) and in this specific context the pecking bird may allude to ". . . the spirit bird of 'our mothers' consuming an offering [and] may be a metaphor of judgements or rituals carried out to ensure the continuity and stability of society" (Drewal 1981a:91).

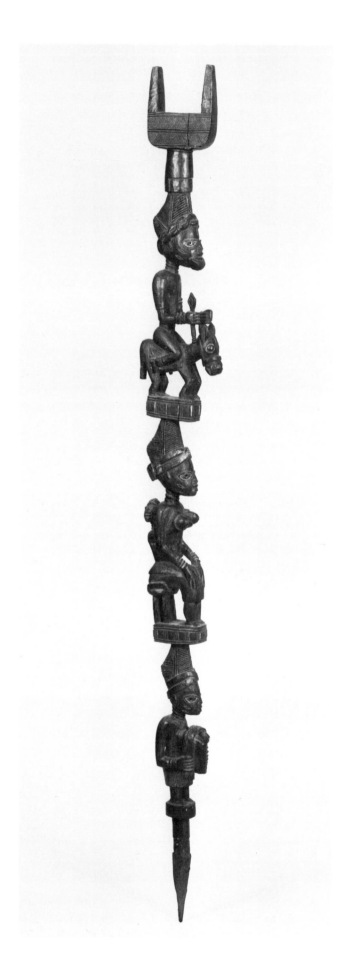

unidentified subgroup, Nigeria/Benin
western area

93
staff
wood, pigment, iron
h. 53¹/₂ in. (136 cm.)

Multi-figured staffs of this type, which are carried
by women in the rituals of various cults, have
been documented among the Ketu and other
subgroups living along the Nigeria/Benin border
(Carroll 1967:pls. 30, 36; Christie 1979a:lot 91; Fagg
1979). This example comes from the border area
or from a subgroup a little to the east. Its imagery
consists of a mounted man holding a spear or
staff, a mother and child, and a standing woman.
The bright pigments which once covered the
carving have been largely obliterated from han-
dling.

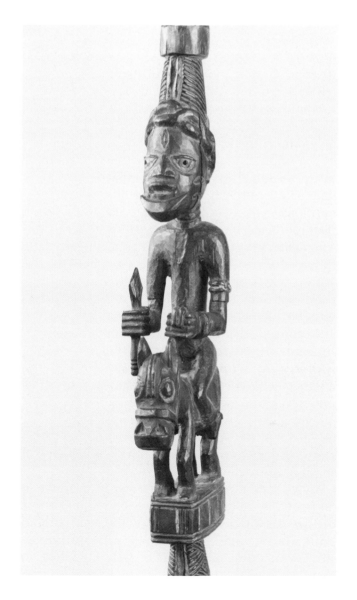

Oyo subgroup (?), Nigeria

94
staff for *Osanyin* or *Erinle* (*opa Osanyin* or *opa Erinle*)
iron
h. 24⁷/₁₆ in. (62.2 cm.)

Iron staffs with multiple bird images serve as standards for medicinal specialists who are followers of the herbalism gods, *Osanyin* and *Erinle*. These specialists, because of their knowledge of prayer, sacrifice and medicine, are consulted by individuals seeking protection against witches, believed to be the source of human pathology. During the dark hours, witches materialize as "night birds" to work their evil. They are called "our mothers," "owners of the world" and "mothers who are birds" and are thought to be senior to all deities except *Ifa*, the god of divination. It is not surprising that "At the head of virtually every Yoruba cult, even those termed 'male dominated,' is an elder female without whose presence and authority ritual would be ineffectual" (Drewal 1977:29). Although witches are viewed as essentially dangerous, if properly dealt with, their awesome powers can be neutralized and made to benefit mankind (Thompson 1971:ch. 11:2-3; Drewal 1977:29).

The iconography of staff mounts is usually characterized by birds, which symbolize witches, encircling a larger, more prominently situated bird which epitomizes *Osanyin*, *Ifa* or other medicine related deity. It was from *Ifa* that the gods acquired the knowledge necessary to overcome witchcraft. The arrangement of the birds has been interpreted as ". . . a metaphor for the control of deadly power by the human mind" (Thompson 1971:ch. 11:2-3). The number of birds, sixteen, is fundamental to Yoruba numerology; it is basic to *Ifa* divination and is the original number of Yoruba kings.

exhibited: Indianapolis Museum of Art, 1976
Indianapolis Museum of Art at
 Columbus, 1977
Indiana Central University, Indianapolis,
 1980

published: Gilfoy 1976, no. 107, ill.
Celenko 1980, no. 26

This iron staff suggests that African art may have influenced modern abstract sculpture. H.E.

Ketu or Egbado subgroup, Benin/Nigeria

95

cap mask for *Gelede (Efe/Gelede)* cult
wood, pigment
h. 18¹/₈ in. (46 cm.)

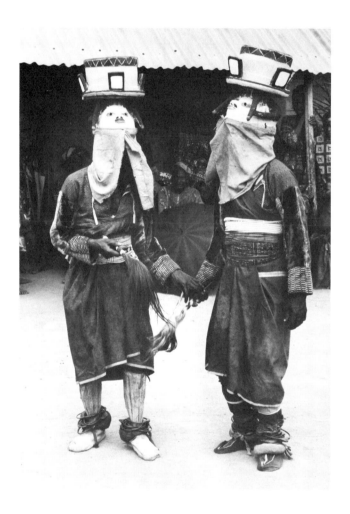

Among the southwestern Yoruba the pervasive *Efe/Gelede* cult acknowledges and honors "the mothers," elderly women, female ancestors and female deities. Large-scale public festivals, held at the start of the farming season, during funerals of cult members and on other occasions, include colorfully costumed maskers accompanied by music. Such festivals, in addition to honoring "the mothers," entertain, educate, provide an outlet for artistic expression and exercise social control through public criticism. The ceremonies involve two distinct, yet related activities, *Efe*, which takes place at night, and *Gelede*, which follows the next day. A central element of the festivals is masqueraders, who are all male, but usually perform in male-female pairs (Drewal 1974a; 1974b).

The cult's headpieces take the form of wooden cap masks which fit on top of the head. A dancer looks out from behind a cloth suspended from the mask as illustrated in Eliot Elisofon's 1971 photograph (National Museum of African Art, Washington, D.C.) of a pair of *Gelede* maskers taken at the Ketu town of Meko. Human-headed caps usually support superstructures which vary widely in complexity and subject matter. The imagery of *Efe* masks tends to be more cryptic than that of *Gelede* examples, which draw on themes from everyday life (Thompson 1978b:63). The superstructure of the *Gelede* mask, cat. no. 95 (right), consists of two chained slaves, one carrying a cask, the other a tusk, who are held captive by an armed guard whose fez, with a crescent and star, suggests an Islamic northerner. The openwork nature of this monoxylous carving attests to the technical competence of Yoruba carvers. Cat. no. 96 (overleaf, left) is identified by Henry Drewal (1981c) as an *Efe* mask, probably from the Ohori or Ketu subgroup. He further comments that the beard and spiraling, tube-like element, which depicts a turban with triangular amulets attached, are Islamic motifs. The snakes held by the figure atop the mask and the ritual knives at the back of the superstructure refer to *Ogun*, the god of iron (Drewal 1981b; 1981c). A second *Efe* mask, cat. no. 97 (overleaf, right), is tentatively attributed by Drewal (1981c) to the Ketu workshop of Otooro, but not to Otooro himself. Like the preceding example, the face is whitened, a feature typical of *Efe* headpieces. The crescent moon above the forehead may refer to the supernatural powers of kings to uncover plots and disorders within their realms (Drewal 1974a:58). The balance of the superstructure consists of a female head-wrap, phalluses and sheathed knives; the latter probably allude to *Ogun*.

exhibited: Indiana Central University, Indianapolis, 1980

published: Celenko 1980, no. 27

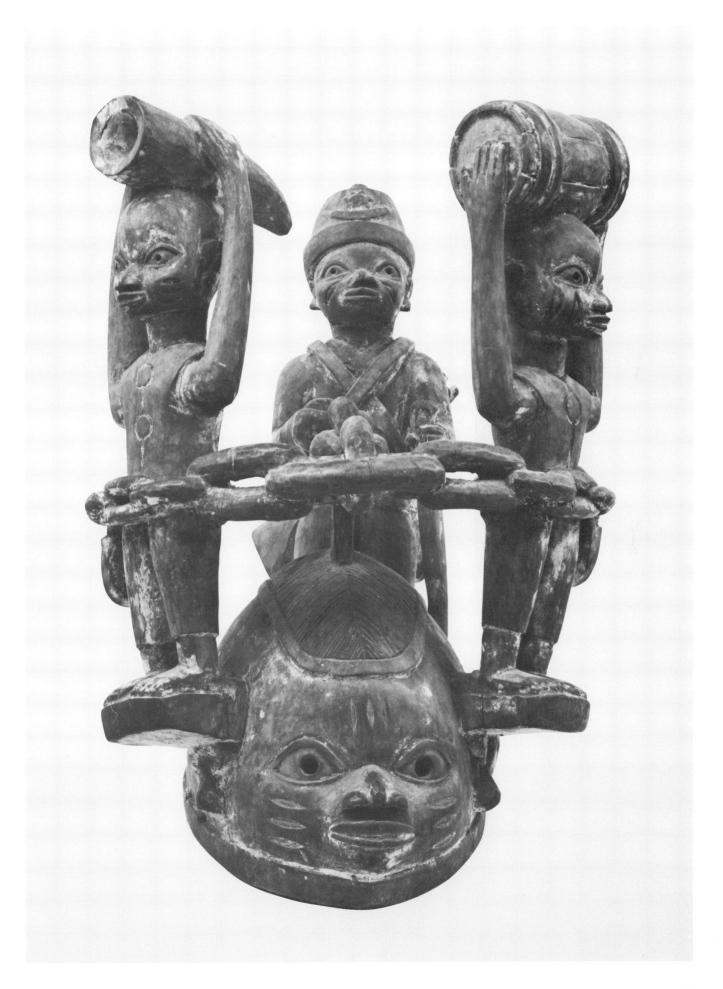

Ohori or Ketu subgroup (?), Benin/Nigeria

96
cap mask for *Efe (Efe/Gelede)* cult
wood, pigment, iron
h. 13¹/₈ in. (33.4 cm.)

The inventiveness of Yoruba carvers is perhaps best exemplified in the varied and elaborate superstructures of Efe/Gelede headpieces. Cat. no. 97 (right) is a particular favorite that I collected in a Chicago antique shop years ago. I loved its masterful carving and muted coloring. H.E.

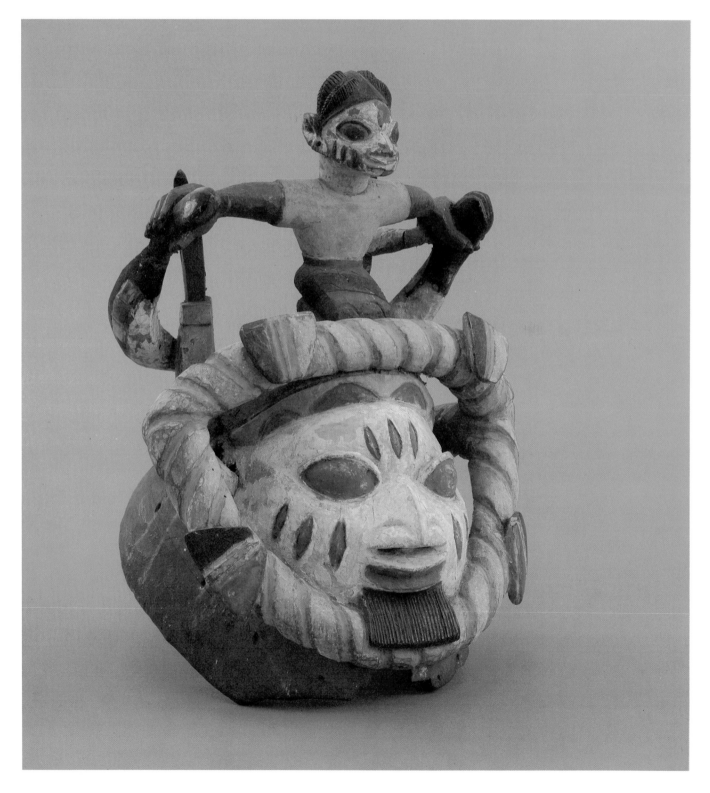

Ketu subgroup, Benin
Ketu town
school of Otooro (?)

97
cap mask for *Efe (Efe/Gelede)* cult
wood, pigment
h. 11¹⁵/₁₆ in. (30.4 cm.)

cat. no. 97
exhibited: Indianapolis Museum of Art, 1976
Indianapolis Museum of Art at
Columbus, 1977

published: Gilfoy 1976, no. 115, ill.

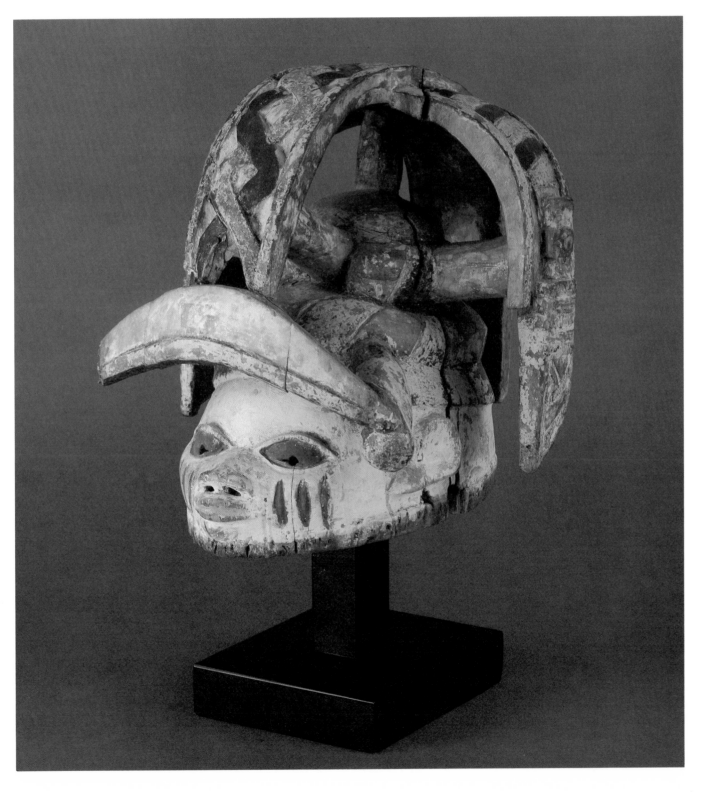

Ohori, Anago, Ketu, Sabe or Egbado subgroup, Benin/Nigeria

98
body mask for *Gelede* cult
wood, pigment, iron, fiber
h. excluding arms: 41^{11}/$_{16}$ in. (105.9 cm.)

A large, seldom published type of *Gelede*-related mask which envelops the dancer's head, arms and torso has been identified with the western Yoruba living within or near the People's Republic of Benin (Fagg 1951:126, pl. 33; Northern and Goldwater 1969:no. 360; Drewal 1974a:19, fig. 16; Gillon 1979:pl. XV; Drewal and Drewal 1983:162, 209, pls. 86-87, 139-40). Henry Drewal (1980b) tentatively attributes the Eiteljorg example to the Ohori subgroup. Such masks have movable arms, which in this example can be manipulated with ropes by the dancer. The little that has been pub-lished about these imposing carvings relates to gorilla-headed examples from the Egbado sub-group which may be associated with *Odua*, the earth mother (Fagg 1951:126; Thompson in Drewal 1974a:19). However, there seems to be no published data regarding the significance and use of human-headed masks. The coiffure of the Eitel-jorg carving, with one side of the head shaved, is also depicted on another mask of this type (Gillon 1979:pl. XV), and suggests that the image portrays a female *ilari*, or royal slave (Johnson 1921:60-62, 67; Drewal 1980b). The significance of the promi-nent "arrow," in relief on the shaved portion of the head is uncertain.

This large "mask" entrances me with its boldly carved features and imposing structure, so differ-ent from many of the refined, delicate Yoruba pieces in my collection. H.E.

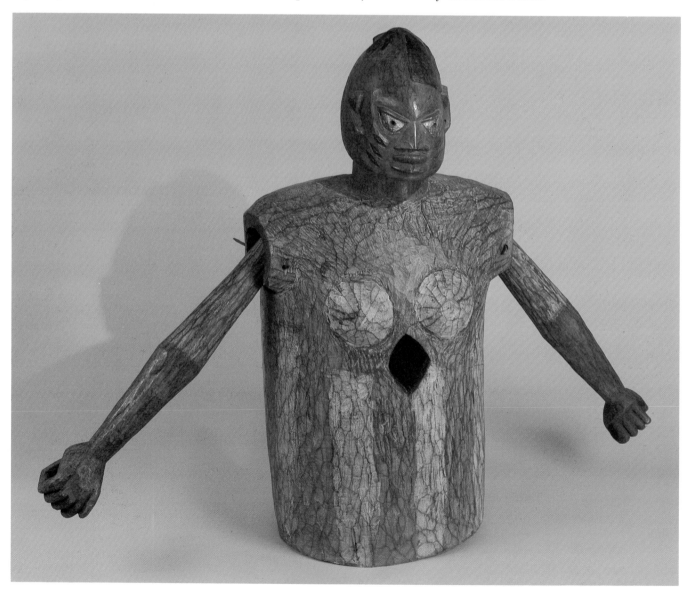

Anago subgroup, Benin
area of Pobe town (?)

99
body mask for *Gelede* cult
wood, pigment
h. 44¹/₈ in. (112.2 cm.)

Another variation of a *Gelede* body mask is also attributed to a western subgroup, the Anago, probably from an area south of Pobe town on the Benin side of the border (Drewal 1980b; Thompson 1980; Drewal and Drewal 1983:162, pl. 86). A woman holding what appears to be a shawl is depicted on a similar *Gelede* body mask (Leuzinger 1972:L7). Henry Drewal (1980b) reports that this shawl-like element suggests the depiction of a priestess or ritual dance contestant. Some of these body masks are not large enough to accommodate most men. For example, the bottom opening of this one is only about thirteen inches wide. According to Drewal (1981c), such masks are worn by boys.

published: Drewal and Drewal 1983, pl. 86

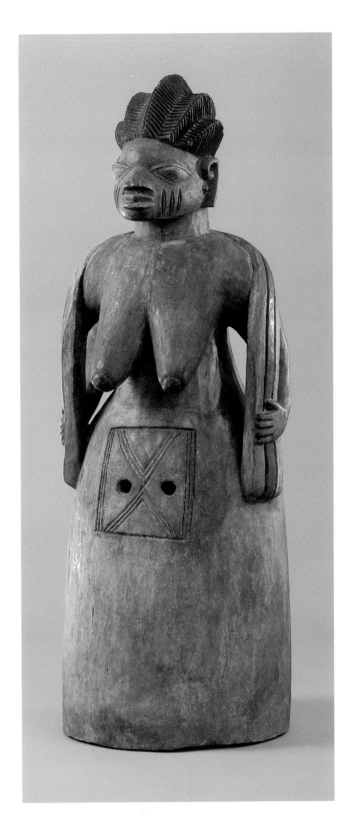

Ijebu subgroup, Nigeria
Ikorodu town
carver: Onabanjo (Konkorugudu) of Itu Meko
 quarter (?)

100
helmet mask for *Magbo (Agbo)/Ekine* cult
wood, pigment, cloth, iron, metal foil, mastic
h. 28⁵/₁₆ in. (72 cm.)

The *Magbo (Agbo)/Ekine* water spirit cult is prevalent among Ijebu Yoruba. The inspiration for the cult and its headpieces is assumed to have come from the Kalabari Ijo, who have a rich tradition of masquerades honoring water spirits and who have long had contact with Yoruba coastal groups. Aspects of the cult may also derive from the Ilaje Yoruba, who have had considerable cultural interaction with neighboring Ijo and Edo

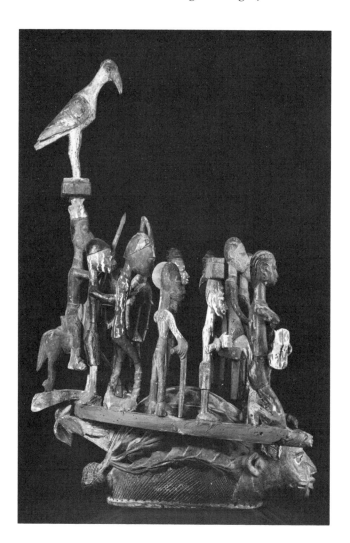

(Bini); the latter group is also a possible source of some elements of the cult (Thompson 1971:ch. 9:3; de la Burde 1973; Drewal 1980a:92-93). Unlike many *Magbo* headpieces that relate to the stylized imagery of Kalabari Ijo carvings, this example relates closely in conception and style to Yoruba *Gelede* masks. However, the elongated bodies and hooked noses of the superstructure figures, and their semicircular arrangement around the supporting head clearly identify the headpiece as a *Magbo* mask from southern Ijebuland in the Ikorodu area just to the northeast of Lagos (Fagg 1979; Thompson 1979; Drewal 1980a:92-93). Indeed, Henry Drewal (1980a:92-93; 1980b) tentatively attributes the headpiece to the master Onabanjo (Konkorugudu) of Itu Meko quarter, Ikorodu.

The impressive superstructure consists of thirteen separately carved images mounted on a U-shaped bar whose ends terminate in human heads. Additional figures were probably once affixed to the double-voluted element above the face of the helmet portion. It is likely that these scroll-like forms and the floral cluster protruding from the back of the head derive from "Brazilian Baroque" motifs brought back to Yorubaland by repatriated slaves (Fagg 1952; 1979). The group of figures suggests a procession and includes a mother suckling a child, an accordian player, a churchman at pulpit, a prisoner, a palm wine tapper and a farmer. The superstructure is dominated from the rear by a mounted king who carries a spear and wears a crown and boots; his head is surmounted by a prominent bird. The mask may embody *Igdo*, the bird, a major *Magbo* water spirit, as a manifestation of kingship. Robert Thompson (1971:ch. 9:3-4) reports that among *Agbo (Magbo)* cults of central Ijebuland some masks with royal imagery allude to the crown of King Igodo *(Igdo)*.

published: Armstrong 1981, pls. 63, 63a
 Celenko 1981, cover ill.

How this fragile piece survived is a mystery. Evidently it was handled with great care. I remember carrying it home on my lap. It was illustrated on the cover of the May 1981 issue of African Arts. *H.E.*

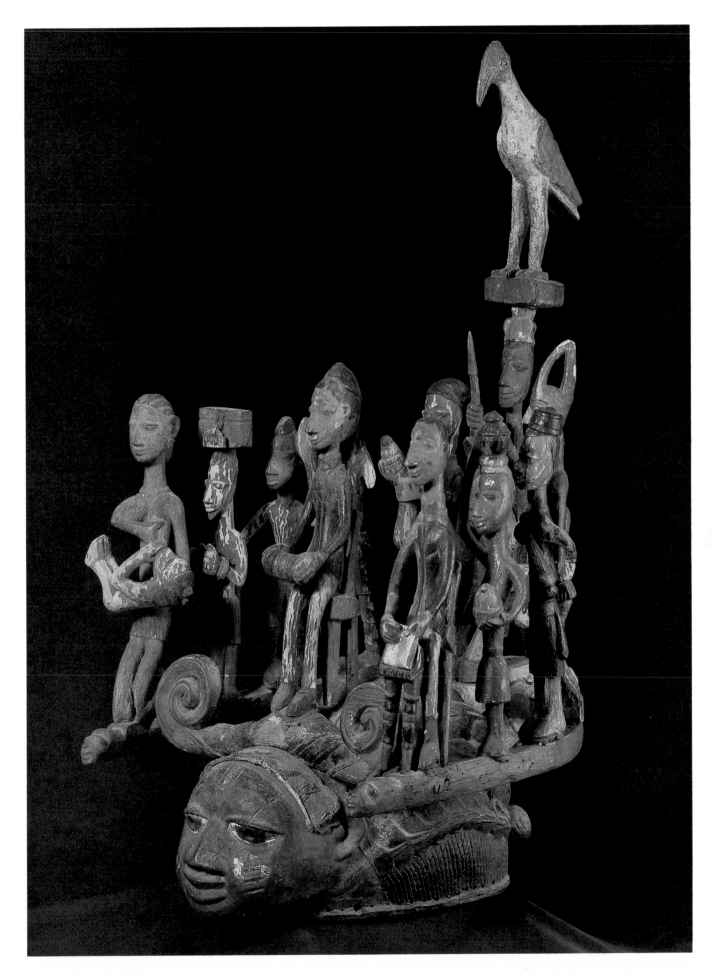

Oyo subgroup, Nigeria

101
headpiece *(Eleru/Alate)* for *Egungun* cult
wood, iron
h. 14¹/₄ in. (36.9 cm.)

The *Egungun* cult is widespread and probably had its origins among the Oyo subgroup. The cult's primary role is to honor ancestors and to worship certain deities (Bascom 1969a:93; Drewal 1978:18; Fagg in Sotheby 1980:lot 58). *Egungun* maskers appear at annual festivals and at funerals of cult members where they serve as a link between the living and the dead. Among their duties are consoling loved ones of the deceased and providing entertainment and crowd control (Gilliland 1961:124-25). The maskers wear a variety of wooden or cloth headpieces and elaborate costumes with decorated cloth, mirrors, feathers and jewelry which display their wealth and dedication in honoring the ancestors (Drewal 1980a:19-20).

Cat. no. 101 belongs to a category of *Egungun* headpieces known as *Eleru/Alate* (*eleru*, owner of load; *alate*, owner of tray) which is documented among the Oyo Yoruba (Maesen 1972:pl. 11; Schiltz 1978:52, fig. 10; Houlberg 1978:56, 58, fig. 3). These headpieces consist of a tray-like form supporting images, in this example two human and two simian heads. The animal heads probably refer to the mythical union of a woman and an ape which resulted in the patas monkey, the first *Egungun* masquerader (Drewal and Drewal 1978:28). The combination of human and animal forms in this carving suggests that it belongs to the *Molomole* variety of the *Eleru/Alate* mask type (Schiltz 1978:54).

Cat. no. 102 is similar to a ram-horned mask with a human mouth rather than a snout, documented by William Gilliland (1961:55, no. 14) at the town of Ado in the Ekiti area of northeastern Yorubaland. Henry Drewal (1981c), citing style and pigmentation, attributes this carving to the eastern or northeastern Yoruba. Furthermore, its speckled surface and large eyes bring to mind

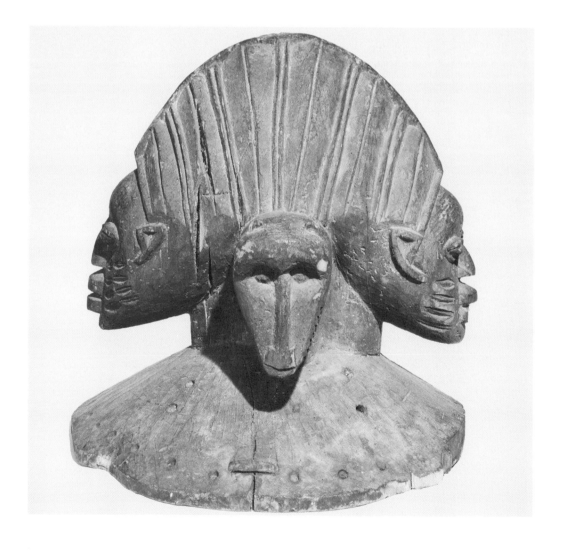

similar features on *Epa* masks of the northeast Yoruba, and a photograph taken by Robert Thompson (in Fagg 1968:opposite nos. 114-15) in the northern Ekiti town of Itan illustrates an *Epa* mask with similar pigmentation and eye configuration. Another example of a ram *Egungun* mask, from outside the Ekiti area in Ibadan, has a more defined, human face (Lawal 1970:pl. 67). According to Gilliland's (1961:55-56) information this type of *Egungun* mask is known as *Agbo*, "ram." The masquerader views through a hole beneath the snout and wears a floor-length cape of unshredded palm leaves. As the masker dances and sings to the music provided by his male followers, the close proximity of women indicates his friendliness and their belief in his aid in fertility.

cat. no. 101
exhibited: Indianapolis Museum of Art, 1976

published: Gilfoy 1976, no. 119, ill.

unidentified subgroup, Nigeria
eastern or northeastern area

102
helmet mask for *Egungun* cult
wood, pigment
l. 19⁷/₈ in. (50.5 cm.)

cat. no. 102
exhibited: Indianapolis Museum of Art, 1976
 Indianapolis Museum of Art at
 Columbus, 1977

published: Gilfoy 1976, no. 120, ill.

The diverse forms of Egungun headpieces are demonstrated by these two carvings. H.E.

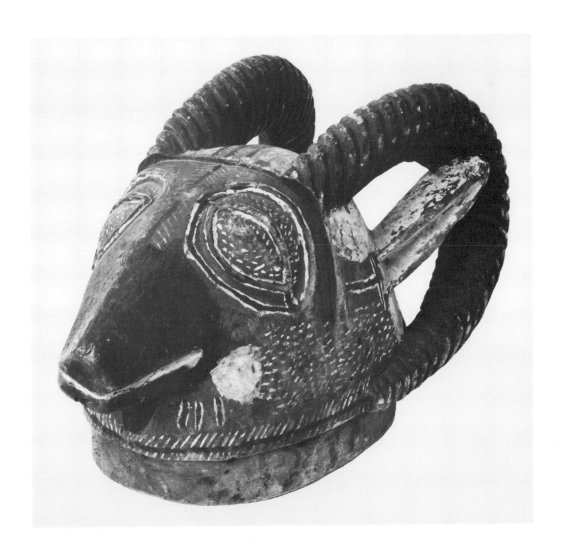

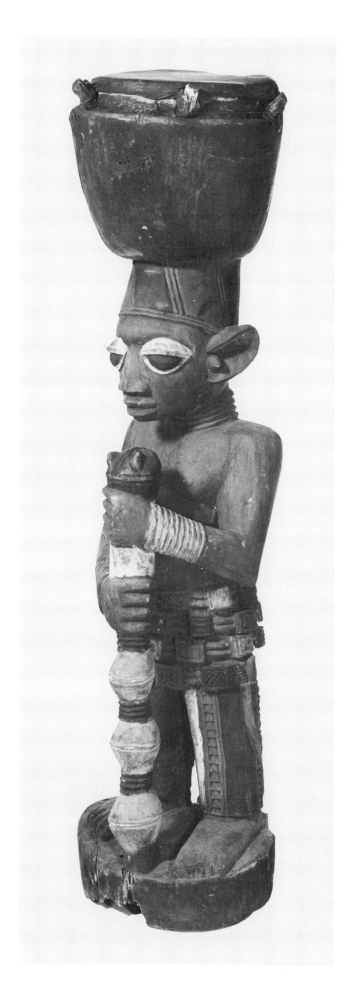

Ekiti subgroup, Nigeria
Osi town
school of Arowogun (Areogun)

103
drum
wood, pigment, skin
h. 48^{11}/$_{16}$ in. (123.7 cm.)

Drums similar to this example carved by Arowo-
gun are documented in the town of Osi, among
the northern Ekiti Yoruba (Carroll 1967:79-90, pl.
34). This example is attributed by William Fagg
(1979) to the school of this master carver or
possibly his son, Bandele, who was trained by
Osamuko, an apprentice of Arowogun (Carroll
1967:91-100). The support figure, who wears a tas-
seled fez and European-type trousers, probably
depicts a worshiper or priest of an unidentified
deity. The prominent staff, whose finial may be an
animal head, suggests the drum's use in a cult
context. The figure's belt, which is covered with
what are probably protective amulets, holds a pis-
tol and sheathed knife; these elements suggest a
hunter or warrior association.

exhibited: Indianapolis Museum of Art, 1976

published: Gilfoy 1976, no. 124, ill.

*In Africa, musical instruments are often so embel-
lished that they are transformed into works of art.
H.E.*

Oyo subgroup (?), Nigeria

104
bowl supported by mother with child
(*olumeye*)
wood, pigment, glass, fiber, iron
h. 12¼ in. (31.1 cm.)

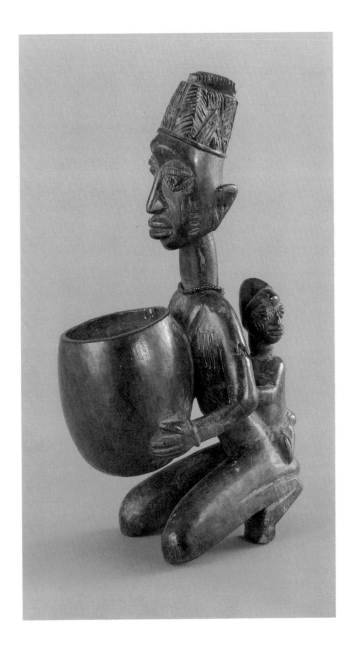

Vessels with figurative supports, called *olumeye*, are shrine paraphernalia of various cults. They typically depict a female devotee, often with a child. The cups hold kola nuts or other offerings. *Olumeye* are also carried by women during religious festivals (Carroll 1967:159, pl. 28; Thompson 1971:ch. 19, pl. 18; Drewal 1977:27). Robert Thompson's (1971:ch. 3) interpretation of Yoruba aesthetics is the basis for a previous analysis of this masterful carving (Gilfoy 1976:78-79):

> The gesture of the body is one of submission, kneeling and offering. However, the body is not in repose but seems rather to be ready to spring, and in this position actively offers the cup as a gesture which ultimately demands a response from the spirit world. The sculptor has balanced a number of active elements and oppositions through the use of strong vertical and horizontal alignments which are mitigated by subtle curves which enliven the whole . . . the visibility and clarity of form and line are strongly rendered, balanced by the treatment of the surface which alternates gloss with strong shadows created by deep incisions establishing a luminosity which seems to emanate from within the figure; the attention paid to symmetry, positioning, delicacy and straightness is varied and played upon by the skill of the carver and ultimately, the figure herself is represented at the height of her powers, with her young, a perfect balance, or "relative mimesis" as Thompson describes it, of elements important to the Yoruba.

exhibited: Indianapolis Museum of Art, 1976
Indianapolis Museum of Art at
Columbus, 1977
Indiana Central University, Indianapolis,
1980

published: Gilfoy 1976, no. 129, ill.
Celenko 1980, no. 28, ill.

This fine carving was featured in my first exhibition of African art at the Indianapolis Museum of Art in 1976. H.E.

unidentified subgroup, Nigeria
northern area

105-106
female and male twin figures (*ere ibeji*)
wood, pigment, glass, fiber
female: h. 10¹⁵/₁₆ in. (27.8 cm.)
male: h. 10¹/₂ in. (26.7 cm.)

The Yoruba regard twins as special phenomena. Small wooden figures, *ere ibeji* (*ere*, image; *ibeji*, twin), are commissioned by parents upon the death of one or both twins to serve as repositories for the souls of the deceased. Such carvings are common due to the high incidence of twinning among the Yoruba and because infant mortality, especially in multiple births, takes a heavy toll in traditional societies. The figures are usually cared for by a mother or by a surviving twin who is believed to share a soul with the deceased. Except when they are danced with in public, *ere ibeji* are maintained in a domestic setting. The figures are treated with reverence since the soul of the deceased twin can aid a family or, if not cared for properly, can cause illness, sterility or other mis-

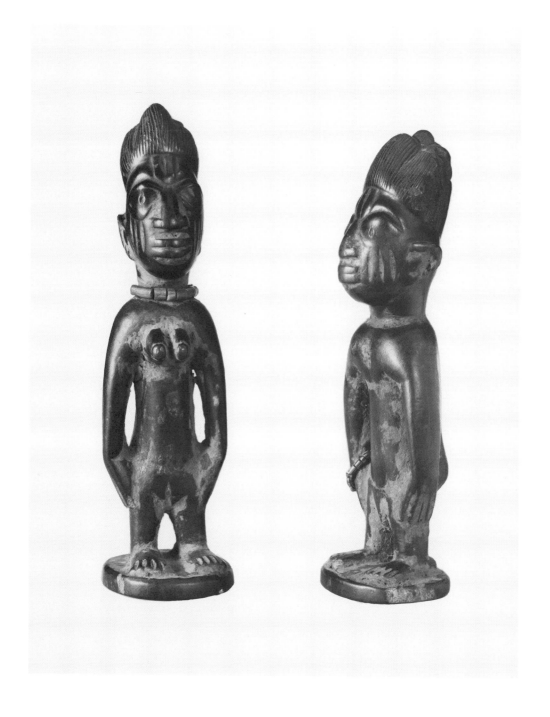

Igbomina subgroup, Nigeria
area of Ila-Orangun town

107 (top)
female twin figure *(ere ibeji)*
wood, pigment, glass, fiber
h. 10¹⁵/₁₆ in. (27.8 cm.)

Igbomina subgroup, Nigeria
area of Oro or Omu-Aran town (?)

108 (bottom)
male twin figure *(ere ibeji)*
wood, pigment, iron, glass, fiber
h. 9⁵/₈ in. (24.5)

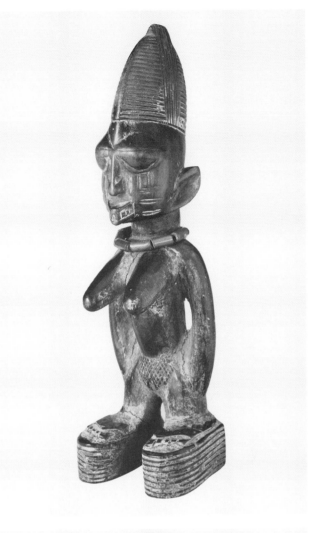

fortune (Thompson 1971:ch. 13; Houlberg 1973;
Stoll and Stoll 1980:36-53).

The frequent washing, feeding, rubbing and
fondling which these figures receive accounts for
their worn surfaces. The facial features of cat. no.
107, for example, have been partially obliterated
from handling over a long period. Among the em-
bellishments of *ere ibeji* are indigo or other blue
coloring applied to the hair and other areas, and
a reddish wood paste rubbed on the torso. Addi-
tions of beads or other jewelry or dress items are
common. A typically African feature of these
figures is that they are not portraits in the sense
of depicting physiognomy. Despite the associa-
tion of *ere ibeji* with particular infants or chil-
dren, they are idealized adults with fully devel-
oped sexual attributes. Carving styles, facial scar-
ification, coiffures and dress items usually allow
attribution of an *ere ibeji* to a particular sub-
group, area, town, village, family or carver. These
four *ere ibeji* exhibit the prominent eyes, rela-
tively large heads, and arms merging with the
thighs characteristic of northern Yoruba carving.
Cat. nos. 107-108 wear high sandals and exhibit
facial and torso styles characteristic of the Ig-
bomina subgroup of northern Yoruba country.
The Islamic amulet worn around the neck of cat.
no. 108 indicates the adoption of Islam by many
Yoruba, particularly in northern areas.

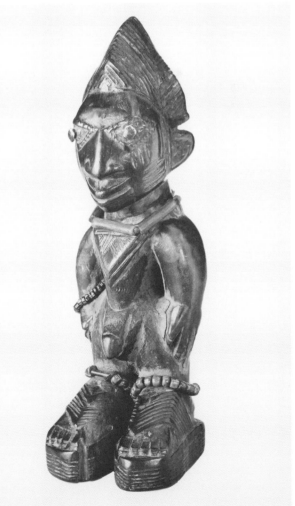

*Ibejis are so very personal. They are held, ca-
ressed, nurtured and embellished over the years
as their worn surfaces, and beads and other or-
naments indicate. H.E.*

Edo (Bini), Nigeria
Benin City court

109
commemorative plaque
brass
h. 21⅛ in. (53.7 cm.)

17th century (?)

The Edo-speaking peoples of southern Nigeria are known primarily through the Edo of the Benin City area who erroneously have been labeled Bini by Europeans. Benin City was the center of one of the more powerful and long-lived states of West Africa. It probably began more than a millennium ago as a small Edo kingdom which by the 15th century had developed into an empire encompassing other peoples and extending over much of what is now southwestern Nigeria. The centuries of prosperity which this forest kingdom enjoyed rested largely on its control of the coastal trade with Europeans. Slaves and African products such as ivory, animal skins, vegetable gums and palm oil were traded for salt, metals, cloth, guns and other manufactured goods. Political and religious life was centered around the *Oba*, a divine king who ruled through an hierarchical system of court officials and local chiefs. The Benin kingdom remained viable until 1897 when the British took Benin City, the capital, during a punitive expedition.

Court art was intimately related to the *Obas*, who controlled the distribution of prestige substances such as brass and ivory, with which many royal items were made. Guilds of specialists provided the court with ritual and ceremonial paraphernalia which included staffs, bells, containers, weapons, altar heads, commemorative plaques and articles of dress. After their capture of the palace the British removed thousands of these artifacts, which were later sold in Europe.

Plaques made by the "lost-wax" casting process were probably once displayed within the palace complex at Benin City. This assumption is based in part on a 17th century Dutch account (Dapper in Roth 1903:160) which describes cast brass panels with images adorning wooden pillars within the palace courtyard. At a later date the plaques were stored away, perhaps as a result of civil disturbances, and at the time of the British

capture of the city in 1897 they were found in storage. According to one informant the castings had been used by Edo officials as a reference to earlier court customs (Willett 1967:154).

The subject matter of all but a handful of approximately nine hundred plaques is commemorative and symbolic and typically includes formally posed *Obas*, chiefs, attendants and animals. A small number are multi-figured and in some cases depict battle scenes, hunting parties or court ceremonies. Unfortunately it has been impossible in most instances to link a particular individual or historic event with a given plaque, or to ascertain the original arrangement of the plaques relative to one another. This example depicts a warrior chief of high status. The ceremonial sword, *eben*, (damaged hilt) in his left hand (cat. no. 119), anklets, bracelets and collar assembly of coral beads, leopard teeth and brass bell (cat. no. 112) indicate rank. The barbed spear (bent upper portion) in his right hand and the sheathed sword at his waist are typical Edo weapons. He wears a garment perhaps made of parrot feathers, which are apotropaic (Ben-Amos 1982), or of rolls of braided rope from which beads or bells are suspended. His hat has leather or cloth side pieces and a front panel possibly of metal. The curved form extending from behind his left shoulder represents a stiffened projection characteristic of some garments. The background surface of the plaque is adorned with two frequently occuring elements, leaf designs and, in relief, rosettes (Dark 1973:73-74, pl. 79, ill. 201), which in present-day Benin City are called "design of the sun" or "the sun never misses a day" (Ben-Amos 1980:28-29; 1982). Another common motif, the guilloche, covers the plaque's side panels.

A number of attempts have been made to establish a relative chronological framework for the thousands of pre-1897 Edo court artifacts through studies of oral histories, early European reports, iconography, style, material and technique. Philip Dark's scheme (1973; 1975) stands as perhaps the most widely accepted chronology, assigning plaques of this type to the first quarter of the 17th century. However, there are no data which permit absolute dating, and Dark (1980:introduction) himself points out that "not one piece of traditional art can be exactly dated before 1890."

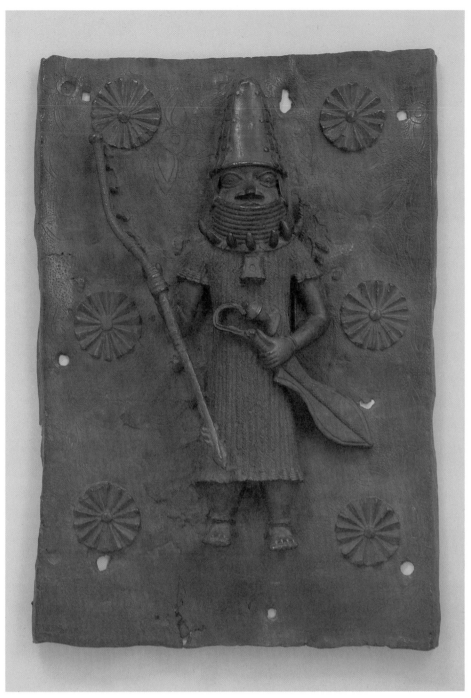

In recent years researchers have attempted to gain insight into the chronology of Edo court objects through metallurgical analysis. Testing of this plaque [copper, 74.1 % (± .5 %); zinc, 15 % (± .5 %); lead, .84 % (± .05 %); iron, .74 % (± .05 %); tin, if present, is less than the lower detection limit of 2 %] and the Eiteljorg queen mother head (cat. no. 110) proved compatible with the brass nature of most other objects tested for elemental percentages. Furthermore, the percentages of copper, zinc and tin for the plaque and head are generally consistent with the limited number of published analyses of other zinc-brass items presumed to date to the 17th and 18th centuries (Werner 1970; Werner and Willett 1975; Willett 1981; tested at Atomic Absorption Spectroscopy Laboratory of Eli Lilly and Company, Indianapolis, in conjunction with the Conservation Department, Indianapolis Museum of Art, 1979).

ex-collections: Pitt-Rivers Museum (Farnham, Dorset, England)
Jay C. Leff

exhibited: Department of Fine Arts, Carnegie Institute, Pittsburgh, 1959-60
Museum of Primitive Art, 1964
Indianapolis Museum of Art, 1977
Indiana University Art Museum, Bloomington, 1980
Indiana Central University, Indianapolis, 1980

published: Pitt-Rivers 1900, pl. 19, figs. 113-14
Fairservis 1959, no. 299
Museum of Primitive Art 1964, fig. 30
Indiana University Art Museum, Bloomington, 1980, no. 9, ill.
Celenko 1980, no. 29, ill.
Celenko 1981, fig. 6
Dark 1982, no. 0/56, p. 2.1.2

Edo (Bini), Nigeria
Benin City court

110
commemorative head of queen mother
brass, iron
h. 17¹/₈ in. (43.5 cm.)

18th century (?)

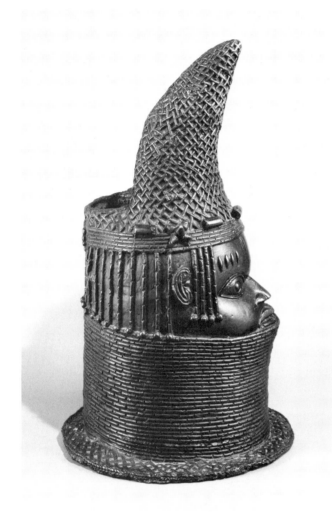

ex-collections: W. D. Webster
Pitt-Rivers Museum (Farnham,
Dorset, England)
Charles Ratton

exhibited: Indiana University Art Museum,
Bloomington, 1980
Indiana Central University, Indianapolis,
1980

published: Pitt-Rivers 1900, pl. 20, figs. 119-20
Dark 1975, no. 0/61, p. 88
Indiana University Art Museum,
Bloomington, 1980, ill. no. 4
Celenko 1980, no. 30, ill.
Dark 1982, no. 0/61, p. 2.1.2

According to oral history it was not until the 16th century that the *Obas'* mothers, *Iye Oba*, were elevated to a special status (Egharevba 1968:27). Altars were maintained in their memory at Uselu, a village near Benin City where the royal women resided, and at the palace in Benin City as long as an *Iye Oba's* son reigned (Ben-Amos 1982). These mud platform altars supported a variety of ritual paraphernalia, such as human heads of cast brass which were the focus of periodic rituals. The practice imitated similar ancestral cults at Benin City dedicated to past *Obas*. The royal family was a pervasive religious and political force, and the welfare of the state and its people were intimately related to the well-being and beneficence of deceased, as well as living, royals. The altar heads served as a spiritual link between these ancestors and the Edo people. Portraiture in the Western sense was not attempted; rather, such heads were generalized conceptions which were particularized by association with specific altars.

All queen mother heads include a distinct cone shaped crown, a beaded collar and a hole at the top which may have facilitated the placement of an elephant tusk, a royal attribute. In life, the beaded collar and crown were composed of imported prestige materials, red coral, and, near the crown's edge, five cylindrical stone beads. Over the eyes are scarifications, and between these are two marks indicating smears of sacrificial blood. The forehead marks and the pupils of the eyes are pieces of iron which were set into the original wax model.

The large size and thickness of this casting, stylized facial features, collar height and base flange suggest a relatively late date in court history. Philip Dark (1975:32, 88) attributes the head to the reign of Oba Eresonye (c. 1735-50). However, as with all pre-1897 Edo court objects, precise dating is impossible.

Metallurgical analysis of this brass casting revealed the following: copper, 66.7 % (± .5 %); zinc, 28% (± .5 %); lead, 2.16% (± .05%); iron, .28% (± .05 %); tin, if present, is less than the lower detection limit of 2 % (Atomic Absorption Spectroscopy Laboratory of Eli Lilly and Company, Indianapolis, in conjunction with the Conservation Department, Indianapolis Museum of Art, 1979; cat. no. 109).

This head and the preceding plaque, both taken by the British during their 1897 expedition, are among the older pieces in my collection. The technical sophistication of these castings is comparable to the work being done in our modern foundries. H.E.

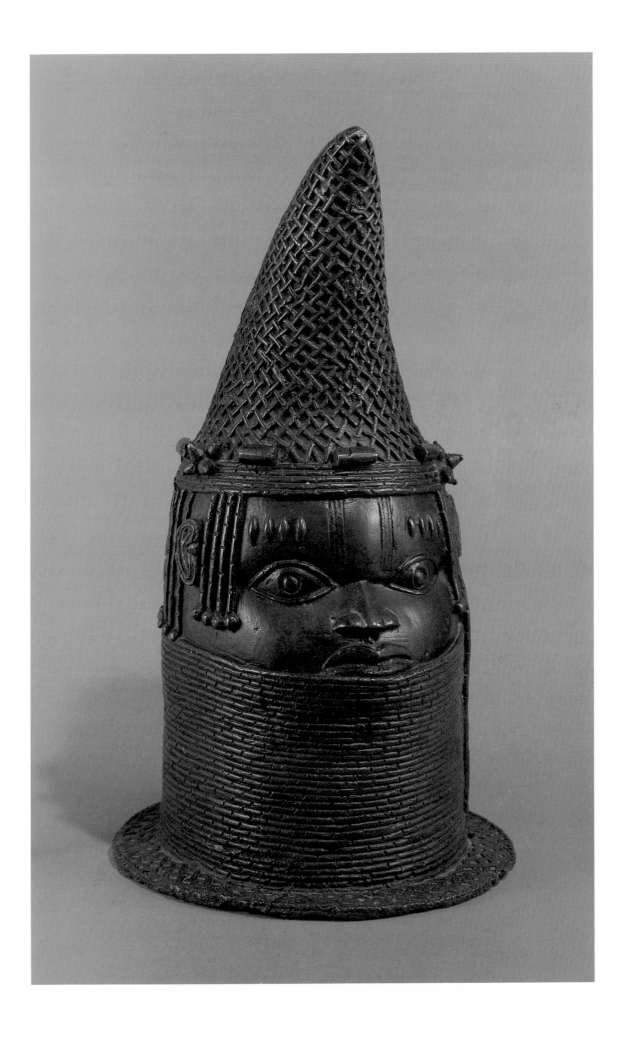

Edo (Bini), Nigeria
Benin City court

111
chief's pendant (*Uhunmwun-ekhue*)
brass, iron
h. 7³/₁₆ in. (18.3 cm.)

19th century (?)

Besides the well-known plaques and altar heads, the British booty of 1897 (cat. no. 109) included bells, gongs, bracelets, vessels, staffs, pendants and a host of other objects in various materials. Cast brass pendants in the form of human or leopard faces (this example with iron eyes) form part of the ceremonial regalia of Edo chiefs and vassal rulers. Only the *Oba* could wear similar pendants carved from ivory (Ben-Amos 1980:75). Such badges of office are provided with eyelets for suspension from the hip. They incorporate positive attributes such as the depiction of coral beads in the headgear and collar of this example. The mudfish making up the collar's lower border is a prevalent Edo symbol usually associated with *Olokun*, deity of the waters, who brings health, wealth and fertility (Ben-Amos 1973:28, 30). The bodies of these mudfish are formed with a plaited rope motif, variations of which are evident throughout West African casting.

exhibited: Indiana University Art Museum, Bloomington, 1980

published: Indiana University Art Museum, Bloomington, 1980, ill. no. 13

Owo subgroup (?), Nigeria

112
bell
brass, iron
h. 5³/₄ in. (14.6 cm.)

19th century (?)

This bell is published in Pitt-Rivers' 1900 catalog (pl. 12, fig. 74) and almost certainly was collected at or near Benin City. However, its style is not Edo; the sparseness of imagery, the absence of surface or border decoration and the concave bottom edges point to an origin outside the capital city area. Presumably the bell was used by the Edo but acquired from elsewhere (Dark 1982:vi, xiii), perhaps among the Yoruba of Owo where Roy Sieber (1982) documented a similarly styled casting (see also Flint Institute of Arts 1970:nos. 72-74; Christie 1978c:lot 192; 1978d:lot 94; Sotheby 1978:lot 47; Kecskési 1982:no. 158). Another bell resembling this one was seen by Paula Ben-Amos (1982) on an ancestral altar at an Edo village near Benin City. Brass pyramidal bells are used ritually in association with altars, where they are rung "to call the ancestors," or worn as part of officials' costumes (Ben-Amos 1980:60-61; Dark 1980:12-13). In former times military personnages wore pyramidal bells as status indicators, ". . . for protection in battle and to announce their victories upon returning home" (Ben-Amos 1980:60). They are depicted suspended from the necks of figures on scores of plaques (cat. no. 109).

published: Pitt-Rivers 1900, pl. 12, fig. 74

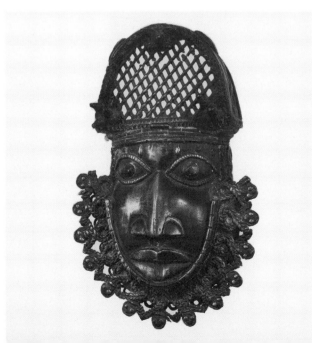

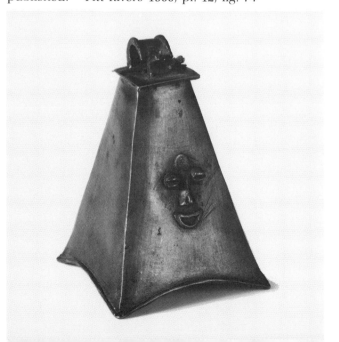

Edo (Bini), Nigeria

113
armlet *(ikoro)*
ivory
h. 5¹/₂ in. (14 cm.)

17th-18th centuries (?)

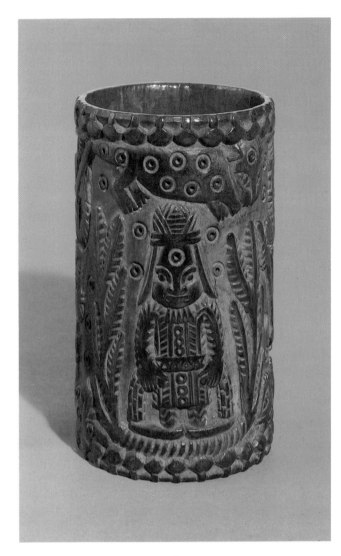

Within the Benin kingdom ivory was a prestige material associated with the *Oba*, and during public ceremonies he wore (and still wears today) armlets and other ornaments of ivory. It is uncertain to whom this example belonged or whether it was used in Benin City. Philip Dark maintains that "all ivory was reserved for the Oba's use or for use in connection with the fulfillment of his functions" (1973:31), and that ". . . armlets carved in ivory are worn by the Oba; those made from bronze are worn by chiefs" (1962:27). However, William Fagg (1970b:24) relates that ivory carvings were commissioned by chiefs throughout the kingdom. Despite the presence of leopards, royal symbols, on this example, the modest nature of its relief carving differs from the considerably more elaborate examples usually identified with the *Oba*. There is no firm evidence for establishing a date of manufacture for this example, although it and armlets similar in imagery and style are usually assigned a date within the 17th-18th centuries (Fairservis 1959:no. 282; Foreman, Foreman and Dark 1960:pl. 53; Leff 1969:no. 178; Fagg 1970b:24-27; Dark 1980:54-55; Ben-Amos 1980:pls. 2, 88-89, 92, 94; Kaplan 1981:fig. 30).

The imagery of this carving is dominated by four human figures: two, on opposite sides of the armlet, are similarly dressed men, each with a sword suspended from a belt and holding an umbrella; the other two, also on opposite sides of the armlet, are identically garbed men holding unidentified objects, possibly beaded whisks (Ben-Amos 1980:pl. 18; 1982). The two sets of figures are facing opposite directions on the vertical axis. The European type garments and what appears to be straight hair probably indicate Europeans, specifically Portuguese. Over the head of each figure is a leopard. The spaces between the human and animal figures are filled with foliage and a circle-and-dot motif. Bordering elements near the rim probably depict beads.

ex-collection: Jay C. Leff

exhibited: Department of Fine Arts,
 Carnegie Institute,
 Pittsburgh, 1959-60
 University Gallery,
 University of Florida,
 Gainesville, 1967
 Museum of Art, Carnegie
 Institute, Pittsburgh,
 1969-70

published: Fairservis 1959, no. 282
 Flam 1967, no. 31
 Leff 1969, no. 178

For centuries elephant ivory has been highly prized by both Africans and Europeans. In this fine old armlet it has been transformed through carving, wear and coloring into a marvelous piece of jewelry. H.E.

Edo (Bini), Nigeria

114
altar head
clay
h. 8⁷/₈ in. (22.6 cm.)

16th-18th centuries

There are only about sixty authentic terra-cotta altar heads in Edo court styles so far identified. They are found on altars of the Benin City brass casters and commemorate Igueghae, who according to oral tradition came from Ife, perhaps in the 14th century, to teach the Edo the art of casting. However, Paula Ben-Amos (1980:15) reports that in the past such heads had wider use ". . . on the royal ancestral altars of the *Ogiso* kings [pre-14th century rulers] and on shrines in Idunmwun Ivibioto, the quarter of the 'sons of soil,' built in *Ogiso* times, and in Idunmwun Ogiefa, the ward guild responsible for purifying the land after the violation of taboos." She further relates that Chief Ihama of the casters' guild claims that those heads with a hole in the top, like this example, supported elephant tusks and were probably used by members of the Ogiso family and related chiefs in the villages (Ben-Amos 1982).

The dating of these heads is a matter of debate. Like this example, most of them are in the relatively naturalistic style of cast heads of the Benin City court, presumed by many authorities to date to the 14th through 16th centuries. Based on stylistic as well as iconographic similarities between the naturalistic clay and metal heads, early 14th to 16th century dates are usually assigned to the terra-cottas (Leuzinger 1963:no. 79; Fagg and Plass 1964:64-65; Willett 1967:figs. 28-29; Fagg 1968:no. 149; Willett 1973:17; Eyo 1977:150-51; Eyo and Willett 1980:no. 78.; de Grunne 1980:250-53; Kaplan 1981:figs. 8-10). However, it is possible that an archaism of style persisted for the clay heads

for a number of centuries. Despite the demands for more elaborate and larger brass items for the court, in part brought about by greater availability of European metal, the casters may have been free from such outside influence when making cult heads. The Eiteljorg head was tested by thermoluminescence, perhaps the only published instance of the test for this type of object (Daybreak Nuclear and Medical Systems, Inc.; Guilford, Conn.; sample 159A1, 1982). The test indicated a date of manufacture between the middle of the 16th and the late 18th centuries, with a mid-17th century date most probable. However, the limitations of thermoluminescence testing without *in situ* soil samples and other control factors, usually unavailable for African sculpture, significantly reduce the probability of an accurate result (Stoneham 1980; cat. nos. 1-2, 35, 77-78).

ex-collection: Robert Plant Armstrong

published: Armstrong 1974, fig. 3

It is always satisfying when scientific tests verify one's judgment of a fine old piece. H.E.

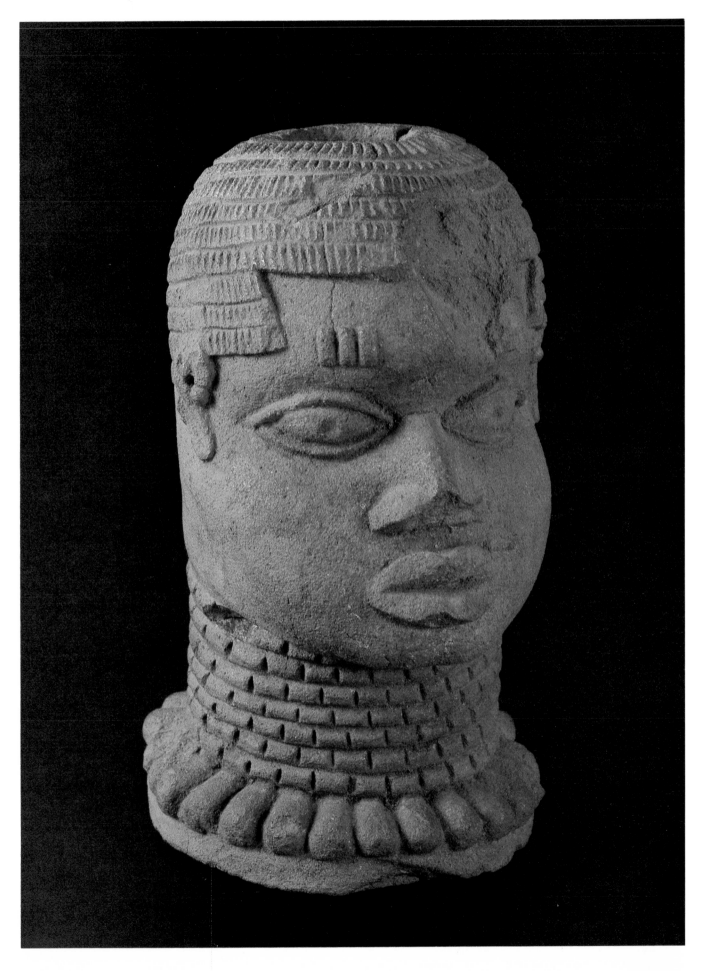

127

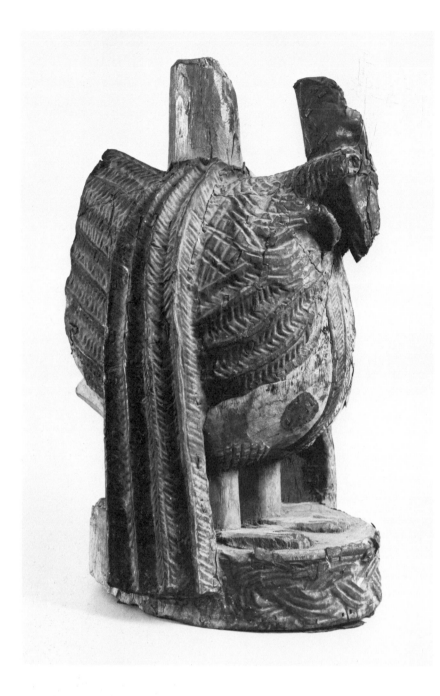

Edo (Bini), Nigeria

115
hen to commemorate chief's mother
wood, brass, iron, cloth
h. 16³/₄ in. (42.5 cm.)

The practice of honoring deceased *Obas* and their mothers with cast brass heads (cat. no. 110) maintained on ancestral altars was paralleled by a similar tradition of commemorating former chiefs and their mothers, respectively, with wooden heads (cat. no. 116) and hens. Hen imagery probably derives from the sacrifice of the fowl to female ancestors and from its symbolism of femininity among the Edo (Ben-Amos in Roy 1979a:no. 92; Ben-Amos 1981:134). Although items of cast brass were the prerogative of royals, embellishment with hammered brass as on this example was permitted for other select individuals. The projecting knob may have supported an ivory tusk or a surrogate in wood or horn. The relief on the base is one variety of the prevalent Edo guilloche motif and in this context may be a kind of trademark of the carver's guild which symbolizes the infinite wisdom of the ancestors (Ben-Amos in Roy 1979a:no. 92).

Edo (Bini), Nigeria

116
head to commemorate chief
(Uhunmwun-elao)
wood, coconut shell
h. 21¹/₈ in. (53.7 cm.)

In the capital city as well as in villages, wooden altar heads commemorate deceased chiefs, and Philip Dark (1973:8) speculates that the practice preceded the similar royal tradition of cast brass heads by as much as four centuries. Paula Ben-Amos (1980:57, 60, 63, pls. 62, 65-66) indicates that in addition to their ancestral aspect, such heads are used by living chiefs as trophies depicting dead enemies and as decorative altar elements. She further relates that they are used on "shrine of the head" altars.

Typical features depicted include coral collar; prominent, upright feather, and coconut shell inlay (not fully extant in this example) indicating forehead scarification and pupils. The hard-edged features of this carving differ from the softer forms of cast royal heads. This illustrates the fact that different sculptural styles sometimes occur within one ethnic group because various specialist groups, in this instance wood-carvers and brass casters, belong to distinct traditions with different materials, tools and techniques.

This piece shows how termite damage and weathering can destroy wood carvings in Africa. Fortunately museums and private collections help acquire and preserve Africa's great heritage of sculpture. H.E.

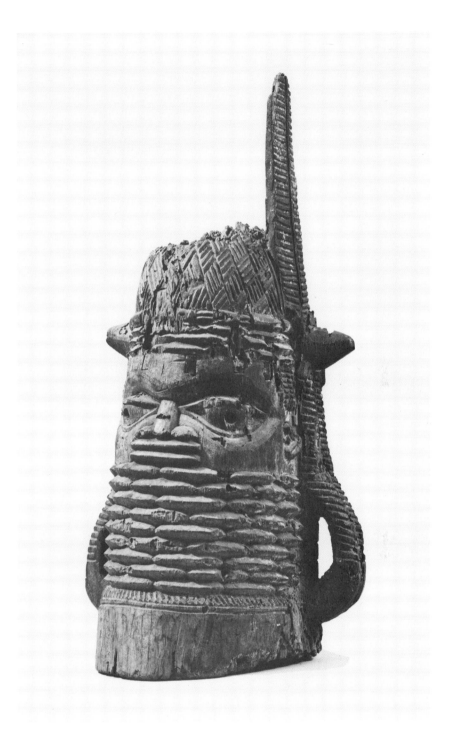

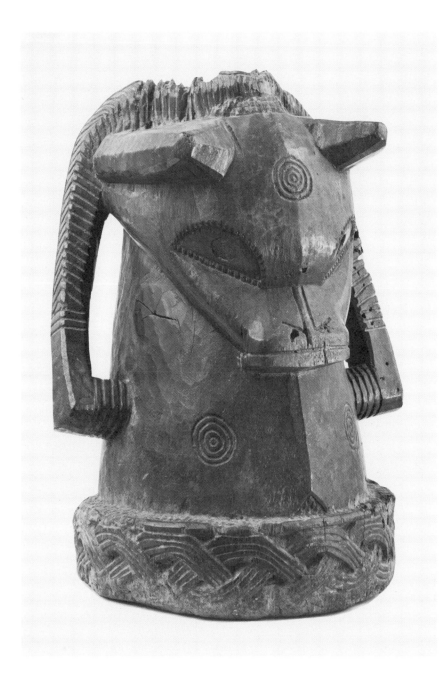

Edo (Bini), Nigeria

117
altar head *(Uhunmwun-ogho)*
wood, coconut shell
h. 13³/4 in. (34.9 cm.)

Ram heads commemorating impor-
tant male ancestors are reported
among the Edo and at the Yoruba
town of Owo. This fine example re-
sembles published heads identified
as Edo (Fagg 1963:pl. 103; Poynor
1978a:pls. 175-76; see also Dark
1973:pl. 56, ills. 120-21), and both
Robin Poynor (1978a:194-227, pls.
34-77; 1978b) and Paula Ben-Amos
(1982) suggest an Edo rather than a
Yoruba origin for this head. There is
a very similar example in the Brody
collection (Celenko 1975:no. 56)
probably by the same carver. Ben-
Amos (1982) relates that such an-
cestral altar heads are generally
found in rural areas outside of
Benin City. The coconut inlay of the
eyes and the vertical slot through
the back of the head have parallels
in human altar heads (cat. no. 116).
The slot may have once held
wooden pegs which served as rat-
tles (Willett and Picton 1967:63) or as
supports for tusks (Dark 1973:36).

*I was instantly impressed with the
commanding presence of this altar-
piece. H.E.*

Edo (Bini), Nigeria
Iyekorhionmwon area (?)

118
face mask for *Ekpo* cult
wood, pigment
h. 10¹/₄ in. (26 cm.)

In contrast to the central authority and cultural influence emanating from the Benin City court are a host of village cults which reflect local autonomy, histories and beliefs. Cult maskers, who embody beings from the spirit world, honor local heroes and deities. They come out during rituals intended to purify and protect a village from disease and other evils.

The masquerades of the *Ekpo* cult, which are found primarily in the Iyekorhionmwon area to the southeast of Benin City, employ wooden headpieces which depict famous ancestors, deities, animals and other characters. This example probably represents a chief because of the depiction of coral beads encompassing the lower portion of the face (Ben-Amos 1980:52-58).

exhibited: Leigh Yawkey Woodson Art
 Museum, Wausau,
 Wisconsin, 1983

published: Aronson 1983, no. 30, fig. 9

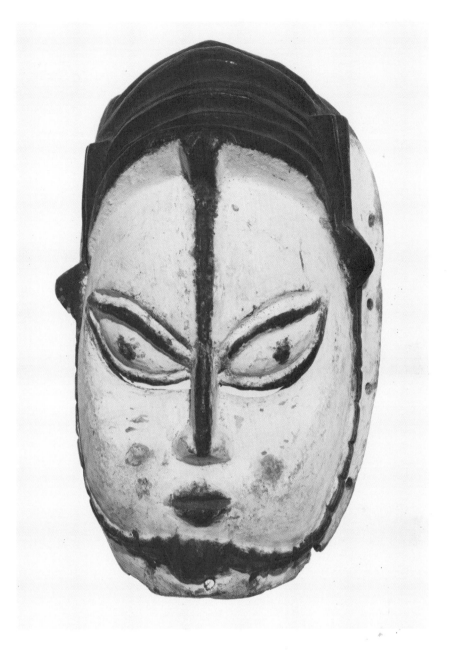

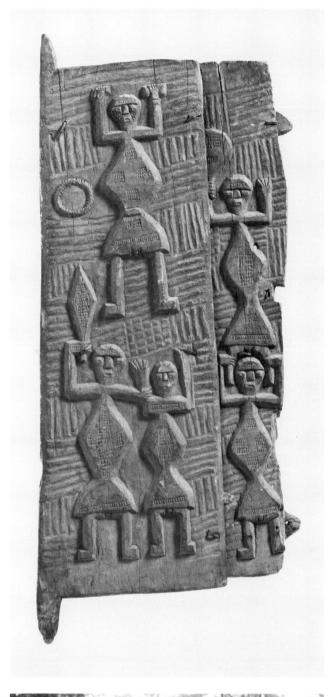

Ishan, Nigeria

119
door *(ekhu/akhu)*
wood, pigment, iron
h. 66³/₈ in. (168.6 cm.)

Carol Ann Lorenz (1982b) reports that figured doors are used on internal entrances in the houses of rules and other men of status (see also Wittmer and Arnett 1978:nos. 80, 82; de la Burde 1972:30, fig. 6). According to Lorenz the relief on this double paneled example is laden with ceremonial and leadership associations. The two figures on the right panel refer to *Ujie*, a funeral ceremony for men of status which can only be depicted on doors of men who have properly buried their fathers. In this panel, the man atop the shoulders of a male friend or relative represents the son of a deceased chief or king. The upper figure holds an *eben*, a ceremonial sword associated with leaders (cat. no. 109), or perhaps a fan. Lorenz' 1980 photograph taken at Uzenema village in Uromi kingdom captures the spirit of jubilation which prevails at *Ujie.* The son of the deceased holds a wooden, rather than a metal *eben.* The freshly cut branch held behind him indicates a recent death rather than a second burial ceremony. On the left panel, the two lower figures depict either an executioner with a prisoner, or a ruler with vanquished enemy. The significance of the upper figure and the circular element next to it is uncertain. The latter possibly refers to a commemorative brass ring like those identified with the Edo and Yoruba (Lorenz 1982a:55-56; 1982b; Vogel 1982).

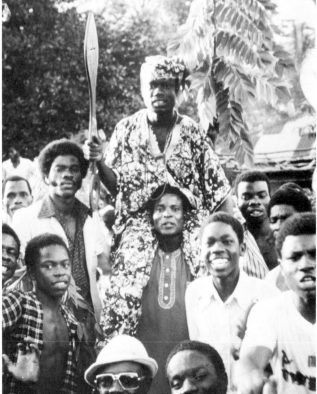

Urhobo, Nigeria

120
janiform male figure *(Eshe)*
wood, incrustation, iron
h. 64⁷/₈ in. (164.8 cm.)

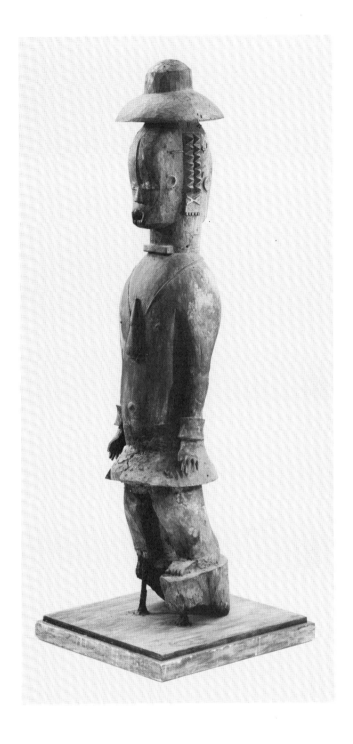

This impressive, almost life-size figure is similar
to those documented by Perkins Foss among the
Urhobo, a southern Edo group living on the
fringes of the Niger River delta. It is probably an
ancestor image *(Eshe)* rather than a spirit image
(Edjo re akare), the other major type of figure.
Eshe, which commemorate real or semi-mythic
ancestors who founded lineages, are placed in
meeting halls of the deceased's clan where they
serve as symbols of ancestral might and authority.
This figure, with typically prominent forehead
and expansive chest, is laden with attributes of
status which include the single neck bead re-
served for rulers, calabash medicine container on
chest, bracelets and hat. The high relief on the
sides of the head depicts coiffure elements (Foss
1976a; 1976b:34-75).

exhibited: Indianapolis Museum of Art, 1976

published: Gilfoy 1976, no. 76, ill.

*Large pieces such as this one form an unrealisti-
cally small percentage of most collections because
of the problems of handling, transport and stor-
age. H.E.*

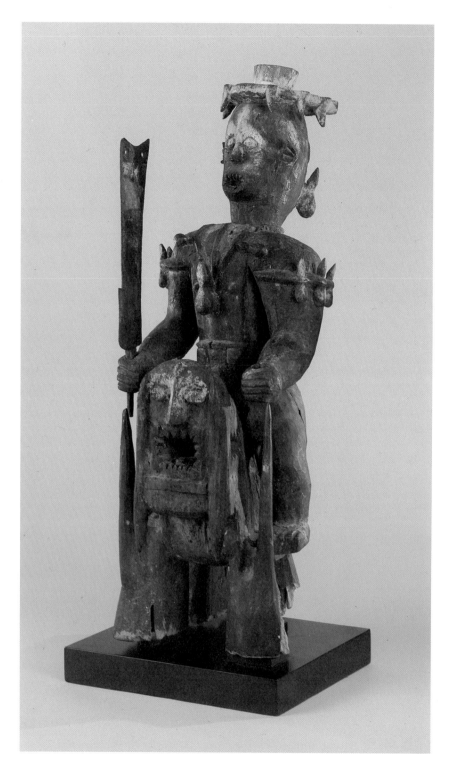

Urhobo (?), Nigeria

121
shrine *(Ivwri)*
wood, pigment, incrustation
h. 27³/₈ in. (69.5 cm.)

Multi-imaged shrines *(Ivwri, Ivri, Iphri, Ejiri, Efiri)* associated with aggression are documented among the Urhobo and Isoko, southern Edo peoples, and among the western Ijo, who probably adopted the concept from their Edo neighbors (Horton 1965:pl. 66; Leis and Murray in Foss 1975:140). These shrines range from small personal carvings to larger assemblages owned by families or lineages which once belonged to famous ancestors. According to Perkins Foss (1975:133-35; 1976b:76-111) these shrines refer to both positive and negative aspects of aggression. They inspire warriors to defend their homeland and protect against enslavement. Conversely, *Ivwri* restrain the excesses of contentious and stubborn individuals. Distinct but related personal shrines associated with a man's right hand are found among the Urhobo *(Obo)*, the Edo of the Benin City area *(Ikegobo)*, the Ishan *(Ikenga, Obo)*, the western Ijo *(Amabra)*, the Igbo *(Ikenga)* and the Igala *(Ikenga)* (Vogel 1974; Rubin 1976b; Foss 1975; 1976b:152-78; Peek 1981).

The core iconic elements of these shrines include a four-legged animal form surmounted by human imagery. The quadruped, which probably refers to a leopard, has an open mouth with rows of exposed teeth. Flanking the mouth are prominent, opposing pairs of upper and lower canines. The mouth, bared teeth and blade-like canines are prime allusions to the aggressive nature of *Ivwri*. At the back of the animal form are three birds, probably of supernatural significance.

Ijo, Nigeria
western area

122
shrine *(Ejiri/Ivwri)*
wood, pigment
h. 26 in. (66 cm.)

The human figure or figures in *Ivwri*,
sometimes full-bodied, vary in their
dress and other attributes. Cat. no.
121 includes a male figure, probably
the original owner of the shrine,
laden with power references. He
wears a warrior's headgear bordered
with wild pig teeth and what is
probably a war belt around his
waist. Medicine vessels are depicted
on the upper arms, back and head;
the most prominent is a chest pen-
dant (cat. no. 120). These figures
usually hold a weapon or other ob-
ject (e.g., trophy head, fan) in each
hand, frequently a cutlass in the
right and spear in the left. Only the
cutlass remains of the separately
carved components once held by
this figure (Foss 1975; 1976a:17, 21;
1976b:112-44). The center figure of
cat. no. 122 wears a pointed hat
identified with "hero spirits" and
their priests (Horton 1965:5-6, 35,
pls. 8, 10). The significance of the
subordinate images held by the cen-
ter figure is uncertain. They may
refer to family members under the
protection of the shrine's owner
(Vogel 1974:12). A very similar shrine,
identified as Ijo, is published in
Wittmer and Arnett 1978 (no. 100).

cat. no. 122
exhibited: Edna Carlsten Gallery,
 University of Wisconsin
 at Stevens Point, 1983

published: Aronson 1983, no. 83, fig 28

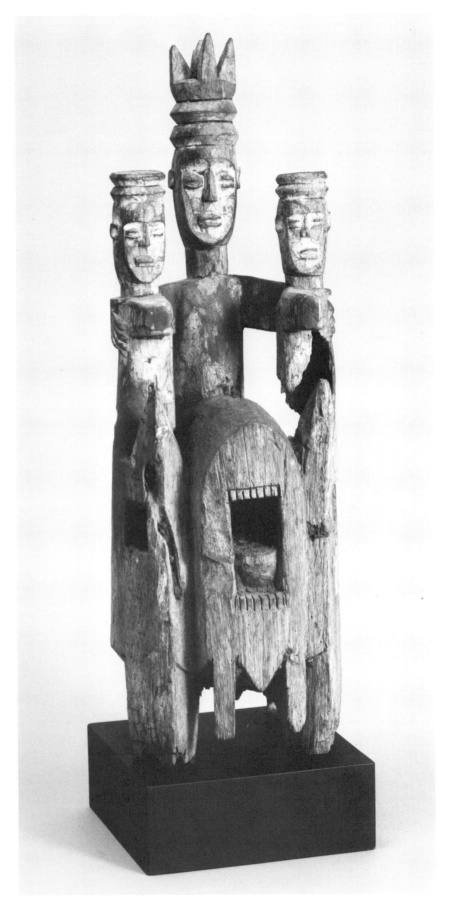

Abua (?), Nigeria

123
cap mask
wood, pigment
l. 61³/₈ in. (155.9 cm.)

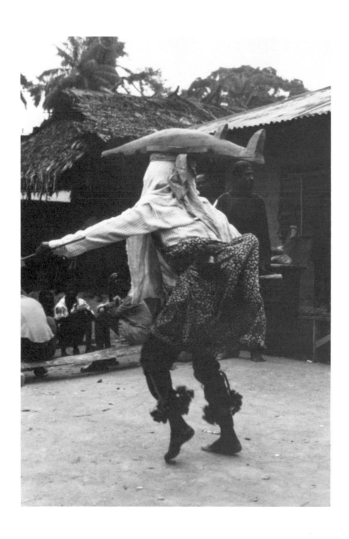

Long headpieces depicting fishes, sharks, pythons and crocodiles are found in both the Niger River delta and Cross River areas (cat. no. 140). Examples related to this headpiece are identified with the Ijo and two peoples north of the eastern Ijo, the Abua and the Ekpahia, an Igbo-related group (Fagg 1963:pls. 120-21; Fagg and Plass 1964:126; Fagg, B. 1965:no. 86; Norton Gallery of Art 1975:no. 137; Kecskési 1982:no. 195; Galerie Wolfgang Ketterer 1983:lot. 106). Some Ijo masks (Horton 1965:pl. 71; Anderson 1982) also share features with this example, and Martha Anderson's 1978 field photograph, which was taken among the Olodiama clan of the central Ijo, illustrates an *oki* (sawfish) masquerader wearing a headpiece similar to this one depicting a shark. The Eiteljorg headpiece, which has separately carved fins, is unusual in its naturalism and streamlined shape. Holes in the upper part of the body probably once supported feathers or other materials.

Among delta peoples, masks with water-related imagery often represent water spirits, and Abua *Onwuema* society masks are so documented. However, Abua masks similar to this one, which are not clearly identified as embodiments of water spirits, are worn by members of the *Egbukele* society whose activities are primarily entertainment. Some Abua claim that this society and its masquerades originated among the Ekpahia (Eyo 1974; Fagg 1963:9).

I have heard that some delta headpieces depicting sharks, fish and other creatures appear to be weaving through the water while the masker is immersed. H.E.

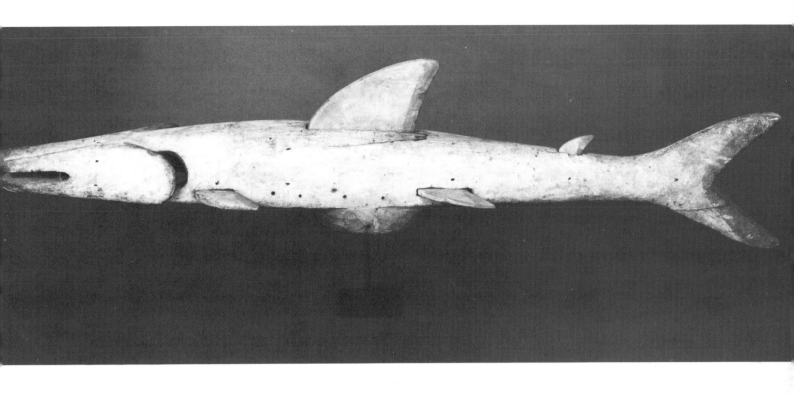

Izi subgroup, Nigeria
area of Abakaliki town

124
masker's garment
cotton, hemp or jute, wool, wood
approx. h. 56 in. (142.3 cm.)

Among the northern Igbo, masquerades of the pervasive men's society, *Mmuo (Mmwo, Mmo, Maw)*, appear during annual festivals, policing activities and funerals. A popular masker is the *Agbogho Mmuo*, literally, "maiden spirit," who wears a brightly colored garment. This outfit was collected in 1981 with its *Agbogho Mmuo* mask near the town of Abakaliki (Robertson 1981). Frank Starkweather (1968:opposite pl. 94) reports that professional tailors specialize in these garments. This one consists of burlap-lined cotton cloth embellished with cotton fabric and wool felt

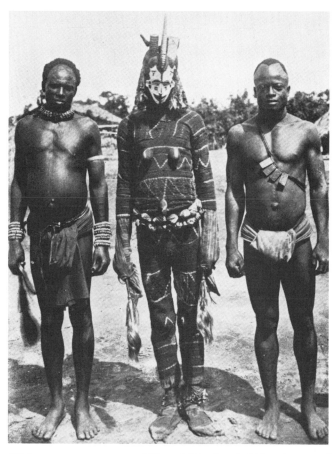

This garment exemplifies Africa's rich heritage of textile arts. H.E.

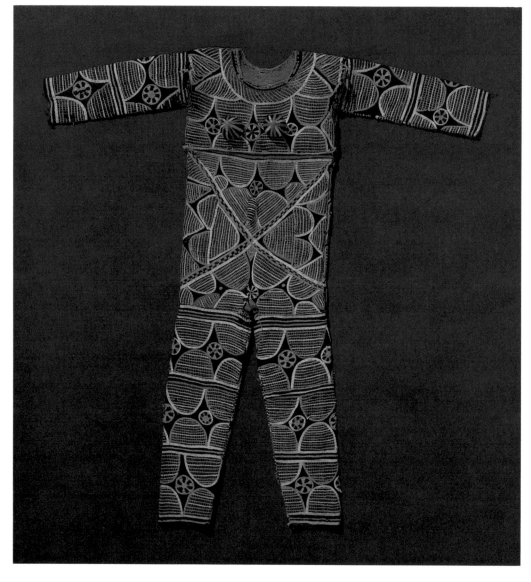

unidentified subgroup, Nigeria
northern area

125
helmet mask *(Agbogho Mmuo)* for *Mmuo* society
wood, pigment, glass
h. 30⁹⁄₁₆ in. (77.7 cm.)

appliqué and wool yarn embroidery. The breasts have wooden cores. Some of the designs are related to painted motifs *(uli)* applied to the face and body. The staged field photograph, published in G. T. Basden's 1921 study of the Igbo (opposite p. 224), illustrates a *Mmuo* masker with attendants.

"Beautiful maiden" masks have whitened, emaciated faces which may connote death or the world of spirits (Basden 1921:236, passim; Starkweather 1968:n.p., pl. 94). The typically light coloring of the faces evokes purity, beneficence, wealth and other positive qualities (Cole in Drewal 1977:no. 42). Elaborate coiffures depict real-life constructions of mirrors, combs, armatures, mastic and other materials. This example, which is missing some of its projecting elements, includes a mirror.

Much of the religious content of *Mmuo* masking has disappeared during this century. The following is Basden's (1921:124) early 20th century description of maskers at a chief's funeral:

> These quaint apparitions, needless to say, are men disguised in grotesque fashion, with their bodies completely enveloped in cloth, and uttering peculiar sounds by means of air instruments fixed between their teeth. To the excited audience these are verily believed to be figures animated by spirits from the underworld. For four consecutive days the programme varies little, and then comes the formal visit to the grave of the deceased chief. The noise and excitement reaches the utmost pitch, all the relatives crying out 'Welcome, welcome to our father,' until, suddenly, firearms are discharged, and the mawafia [maskers] appear escorting the 'spirit' of the dead man from his house, beneath the floor of which his body lies buried.

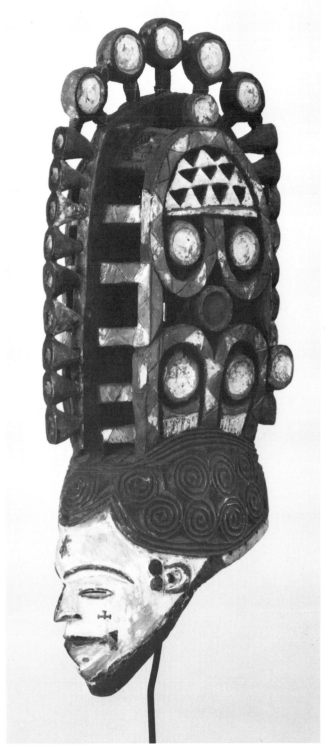

cat. no. 124.
exhibited: Edna Carlsten Gallery,
 University of Wisconsin at
 Stevens Point, 1983
 American Museum of Natural History,
 New York, 1983

published: Aronson 1983, no. 57, cover ill.

cat. no. 125
exhibited: Indianapolis Museum of Art, 1976

published: Gilfoy 1976, no. 46, ill.

The elaborate superstructure of this mask represents traditional coiffures of Igbo women. H.E.

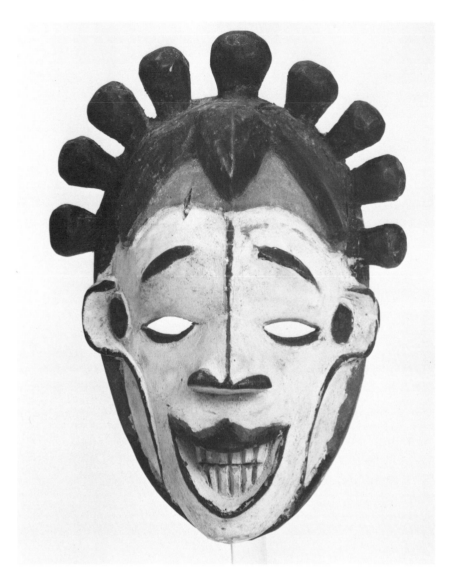

unidentified subgroup, Nigeria
south central area

126
face mask for *Okorosia*
 masquerade
wood, pigment
h. 10¹/₂ in. (26.7 cm.)

The *Okorosia* masquerade, which is found at Owerri, Okigwi, Orlu and other areas within south central Igboland, honors the deity *Owu*. The masquerade consists of over forty different characters who perform daily for almost a month. The characters usually fall into two broad categories, the "good or beautiful" spirits *(Okorosia Nma)*, whose masks, like this one, are white-faced and delicately featured, and the "bad or ugly" spirits *(Okorosia Ojo)* whose blackened masks are distorted and laden with animal attributes. An important feature of the *Okorosia* performances may be the relative aspects of good and evil portrayed by the masked characters and their interaction (Cole 1969:36-38; Murray 1949:cat. nos. 101-105).

exhibited: Indianapolis Museum of
 Art, 1976
 Indianapolis Museum of
 Art at Columbus, 1977
 Edna Carlsten Gallery,
 University of Wisconsin
 at Stevens Point, 1983

published: Gilfoy 1976, no. 47, ill.
 Aronson 1983, no. 52

Izi, Ezza or Ikwo subgroup, Nigeria

127
cap mask
wood, pigment, iron
l. 22¹/₈ in. (56.3 cm.)

A major mask type of the northeastern Igbo is a zoomorphic cap mask whose tusks and trunk-like projection from the forehead (partly broken off of this example) suggest an elephant. Herbert Cole (1970:ill. 67) documents this type of headpiece worn horizontally over the head of an *Obodoenyi* (*enyi*, elephant) masker in the Izi area. However, some features of these masks, especially the noses, appear anthropomorphic. A human face, faces or full figures are often incorporated onto the top of a mask's head. With the exception of Cole's report there is apparently no field data about these masks. However, François Neyt (1979:31-34, 43) indicates their use during annual yam harvest celebrations and at funerals of important chiefs.

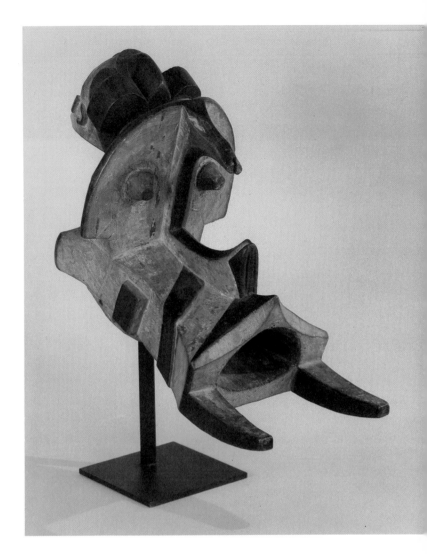

exhibited: Indiana Central University, Indianapolis, 1980

published: Celenko 1980, no. 32

To be fully appreciated this elephant mask must be viewed in the round. H.E.

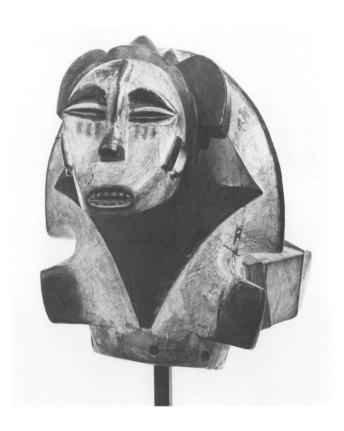

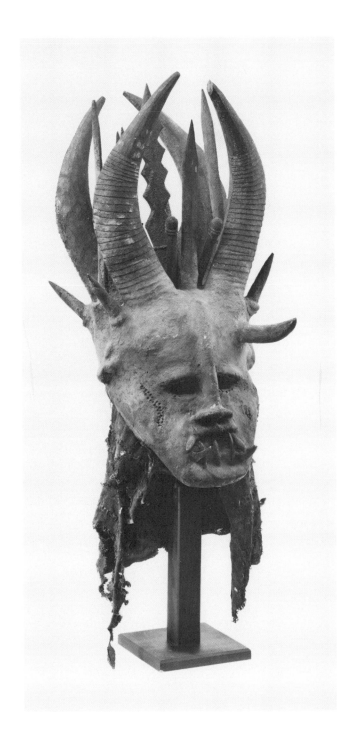

Umueri, Umuigwedo, Anam or Ayamelum subgroup, Nigeria

128
helmet mask *(Odugu Mmuo)*
wood, gum, basketry, metal, cloth, animal teeth
h. excluding cloth: 28¹/₁₆ in. (71.3 cm.)

Some northwestern Igbo as well as some northern Edo, for example the Okpella (Borgatti 1976:27, 29), use massive composite headpieces during funerals. They usually consist of a basketry cap and carved wooden and animal components such as teeth and horns, all embedded in and covered by a black gum which is also used to model the face. The horns and blades projecting from the mask, the brown shaggy costume, a portion of which is attached to this headdress, and the deliberate, menacing gait of the masker express male prowess in war and hunting. A common name for the masker is *Odugu Mmuo,* literally, strong or brave spirit. Although these masks are associated with funerary activities, they do not generally embody souls of the deceased as funerary masks do in some other Igbo areas (Boston 1960).

exhibited: Indiana Central University, Indianapolis, 1980

published: Celenko 1980, no. 31, ill.

This awesome mask, made of basketry, wood, teeth and other elements covered with gum, is a good example of the diverse constructions of some African headpieces. H.E.

Ngwo subgroup (?), Nigeria
northern area

129
head crest
wood, pigment, cloth, iron, fiber
h. 21³/₈ in. (54.3 cm.)

This type of crest is affixed to the wearer's head
by means of basketry or other device and is worn
during activities of a men's society, perhaps the
Mmuo. The whitened face and attenuated fea-
tures indicate a northern Igbo origin (Wittmer
and Arnett 1978:17, 27). Herbert Cole (1982) specu-
lates that the carving is from the Ngwo subgroup
near Enugu.

exhibited: Edna Carlsten Gallery, University of
 Wisconsin at Stevens Point, 1983

published: Aronson 1983, no. 56

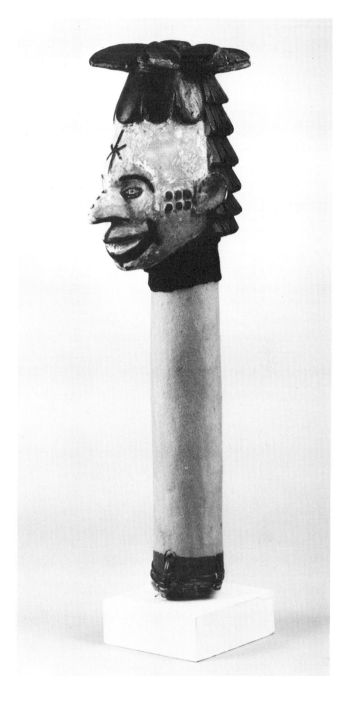

unidentified subgroup, Nigeria

130
food serving dish
wood
l. 14³/₈ in. (36.5 cm.)

Among the Igbo and some other southeastern Nigerian peoples special dishes are used for serving kola nuts and other foods (Talbot 1912:218-19; Fagg, B. 1965:no. 87; Krieger 1969:no. 230; Ottenberg 1975:220, fig. 30; 1981; Wittmer 1977:no. 90; Boston 1977:50; Sieber 1980:192-93). In some areas of West Africa kola nuts are offered to guests, and their social use and stimulant nature are analogous in some ways to coffee drinking in America. A dish similar to this example, identified as an *ocici*, is documented among the Afikpo Igbo (Ottenberg 1975:220, fig. 30). Herbert Cole (1982), who thinks this dish is probably Igbo, indicates that the usual name is *okwa* (dish) *oji* (kola).

The lidded chambers are for palm oil, pepper sauce and perhaps "peanut butter" which are eaten with kola nuts, yam, fish and other foods. These dishes sometimes have a cylindrical kola nut platform and a border depicting cowrie shells, like those on this example. The human faces and what may be ancestral bundles *(ofo)* on the lid suggest a ritual dimension. However, John Boston (1977:50) indicates that there is no ritual significance to kola dishes of this type among the northwest Igbo.

exhibited: Edna Carlsten Gallery, University of
 Wisconsin at Stevens Point, 1983

published: Aronson 1983, no. 67, fig. 23

As elsewhere in the world, some African groups like to impress guests with elaborate serving dishes, H.E.

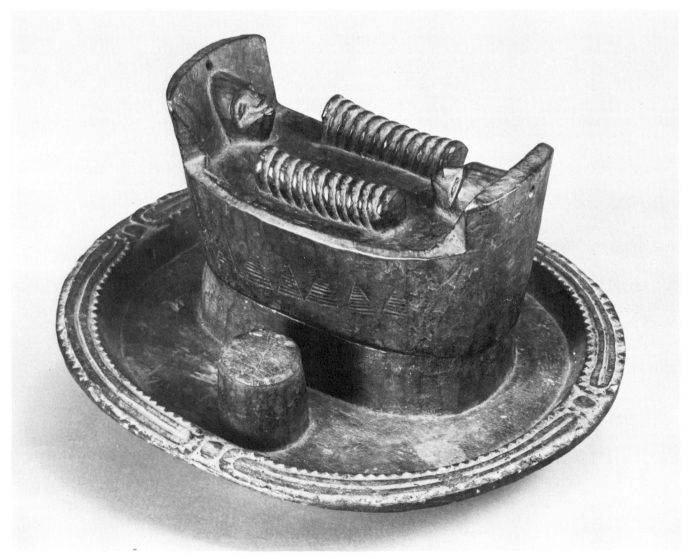

Agulu, Neni, Adazi-Ani or Oreri subgroup,
Nigeria

131
female figure
wood, pigment, iron
h. 50 in. (127 cm.)

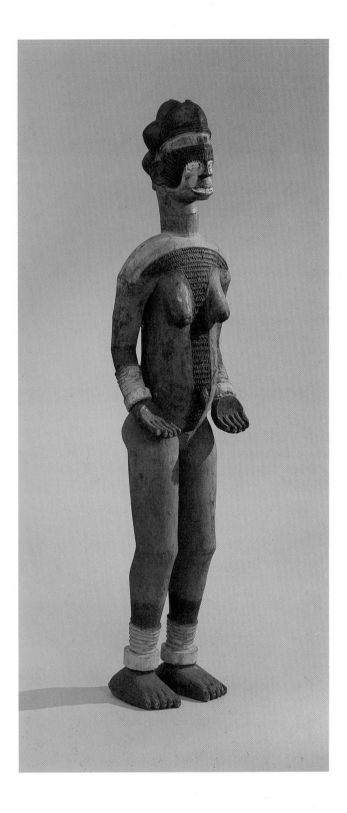

Impressive standing figures of both sexes, sometimes lifesize, are found in various areas of Igboland. Although often described in the literature as ancestor figures, such carvings honor specific deities (Cole 1981). The figures, which are protective, are appealed to during annual ceremonies and other occasions. They are usually kept as a group, and are cared for and ritually attended by priests (Cole 1981). The forehead scarification *(ichi)*, bracelets and anklets allude to wealth and high status. Beads, cloth and other materials are commonly affixed to the figures in their shrines (Cole in Drewal 1977:37). Herbert Cole (in Drewal 1977:37) reports that the characteristic "palms-up gesture conveys a layering of meanings: demand for offerings of honor, recognition and devotion; generosity and openhandedness toward worshipers; and honesty." Cole (1982) attributes this figure to the northern Igbo, perhaps among the Agulu, Neni, Adazi-Ani or Oreri subgroup.

exhibited: Indianapolis Museum of Art, 1976

published: *Saturday Evening Post* 1975, 50, ill.
 Gilfoy 1976, no. 65, ill.

This figure, which seems to be communicating with the viewer, was illustrated in a Saturday Evening Post *article (May/June 1975) about my African collection. H.E.*

Ogoni, Nigeria

132 (bottom)
face mask *(Elu)*
wood, pigment
h. 8¹¹/₁₆ in. (22.1 cm.)

133 (opposite top left)
face mask *(Elu)*
wood, pigment, fiber
h. 8³/₄ in. (22.2 cm.)

134 (opposite top right)
face mask *(Elu)*
wood, pigment, fiber
h. 7⁵/₈ in. (19.4 cm.)

135 (opposite bottom left)
face mask *(Karikpo)*
wood, pigment, fiber
h. 13¹³/₁₆ in. (35 cm.)

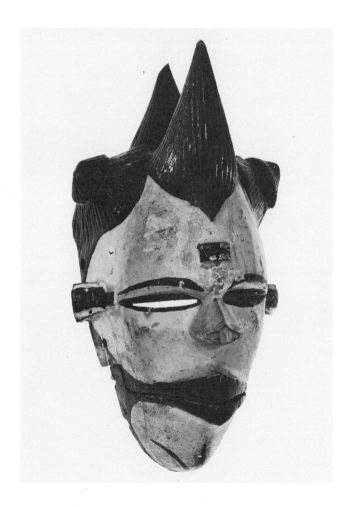

Ogoni, Nigeria

136 (opposite bottom right)
face mask *(Elu)*
wood, pigment, fiber
h. 7³/₁₆ in. (18.3 cm.)

Ogoni masks have stylistic and functional affinities to those of the Ibibio, their culturally related neighbors to the east. Kenneth Murray reports that the Ogoni have numerous men's societies ". . . with social, religious and governmental functions, that use masks at their club meetings, the annual festivals or funerals of members" (1949:nos. 50-54). Lower ranking societies, whose functions are primarily social, use a type of face mask *(Elu)* depicting humans, which is characterized by a diminutive size, delicate, painted features and a hinged lower jaw with wooden teeth inserts. The mouth is manipulated by the masker, whose lip fits in a groove cut on the inside of the lower jaw. The parted hairdos of cat. nos. 133 and 134 exhibit European influences as does the hooked nose of cat. no. 134, a trait sometimes used to portray Caucasians. *Karikpo*, horned masks depicting bovines, goats and antelopes (cat. no. 135), honor local deities, often ancestral, and are used in performances marking the start of the farming season. The *Karikpo* maskers do not actually dance, but rather mime and perform acrobatics (Murray 1949:nos. 79-82).

cat. no. 132
exhibited: Indianapolis Museum of Art, 1976
 Leigh Yawkey Woodson Art Museum,
 Wausau, Wisconsin, 1983

published: Gilfoy 1976, no. 50
 Aronson 1983, no. 34

cat. no. 133
exhibited: Indianapolis Museum of Art, 1976
 Indiana Central University, Indianapolis,
 1980

published: Gilfoy 1976, no. 50
 Celenko 1980, no. 33

Although Ogoni masks are stylistically similar and draw upon a limited range of coiffure, scarification and other details, each has its own unique character. H.E.

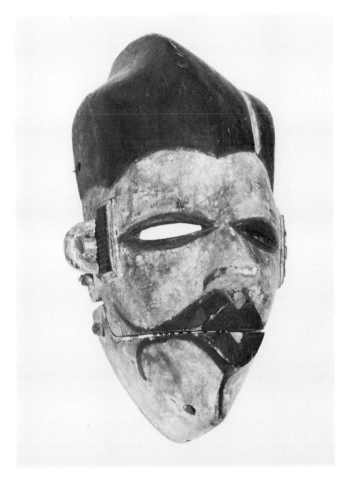

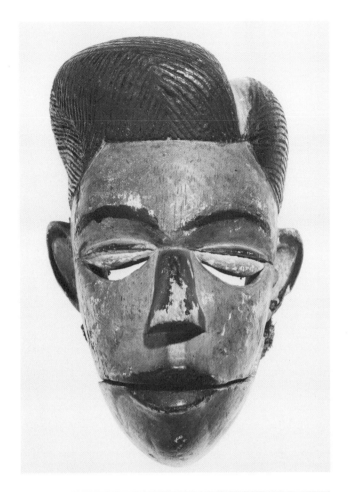

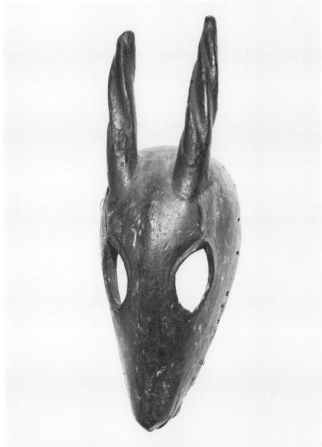

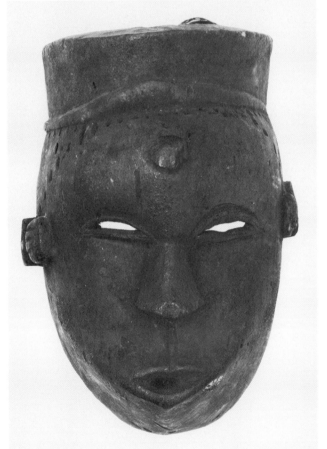

cat. no. 134
exhibited: Indianapolis Museum of Art, 1976
 Indiana Central University, Indianapolis,
 1980

published: Gilfoy 1976, no. 49
 Celenko 1980, no. 34

cat. no. 135
exhibited: Indiana Central University, Indianapolis,
 1980

published: Celenko 1980, no. 37

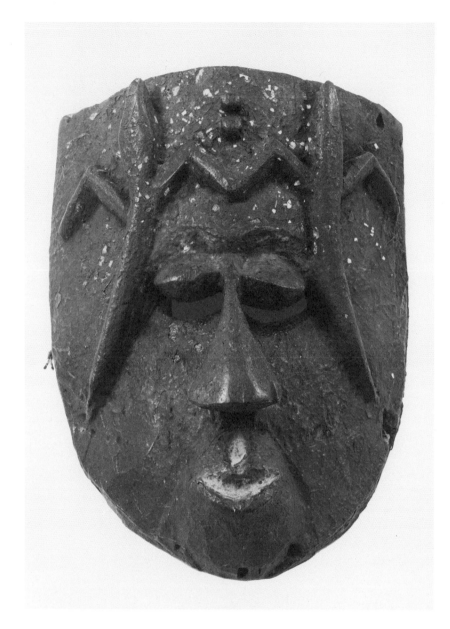

Ibibio, Nigeria

137
face mask for *Idiok Ekpo*
 masker, *Ekpo* society
wood, pigment, incrustation,
 egg shell, fiber
h. 13⁷/₈ in. (35.4 cm.)

Ibibio masks are generally ascribed
to the men's *Ekpo* society whose
functions are ". . . to propitiate the
ancestors for the welfare of the
community, to uphold the power of
the elders and to maintain the so-
cial order" (Murray 1949:nos. 30-48).
Maskers usually fall into two cate-
gories; *Mfon Ekpo*, the "good or
beautiful spirit" of a benevolent an-
cestor who has led a moral life, and
Idiok Ekpo, the "evil or ugly spirit"
of a malevolent ancestor who has
led an immoral life. The masks of
the *Mfon Ekpo* are light colored,
relatively naturalistic and "beauti-
ful," while the *Idiok Ekpo* masks are
blackened, distorted and "ugly."
This carving has the blackened sur-
face, reptilian imagery, turned down
mouth, exaggerated nose and other
features typical of *Idiok Ekpo* masks
(Messenger: 1973:114-23). It is
covered with egg shells and other
evidence of offerings.

Efik (?), Nigeria
lower Cross River, area of Calabar town

138
head crest
wood, skin, pigment, metal, bone, fiber, basketry
w. 32³/₄ in. (83.2 cm.)

The naturalism of the face and the elegant coiffure of this skin-covered crest suggest an origin in Efik country in the vicinity of Calabar (Thompson 1974:177; Nicklin 1978a; 1981a; Blier 1980:6). However, the interchange of carvings, through purchase and trade, within the Cross River area precludes ethnic identification without field collection data. Two similar crests are attributed to an Efik carver, Etim Bassey Ekpenyong, and an Efut carver, Asikpo Edet Okon, from the Calabar area (Friend 1939:100; Nicklin 1978a; 1981a). William Fagg (1977a) comments that the Eiteljorg crest ". . . is known to have been collected between 1915 and 1930 . . . Even without this documentation it would have been firmly dated to the period 1900 to 1930 on the basis of style and condition, being very close in these respects to many pieces in British and German museums and private collections."

The naturalism of Cross River masks and crests is enhanced not only by their skin coverings (cat. no. 139) but by teeth inserts, metal inlaid eyes with pupils; and pigmented eyebrows, temple tattoos and shaved hair patterns on the sides and back of the head. These shaved patterns were worn by women and derive from *Nsibidi* markings, a traditional form of graphic communication (cat. no. 141). The spiral projections issuing from the head, often described as horns, portray one variation of elaborate coiffures formerly affected by some girls in the Cross River area during their "coming-out" ceremonies prior to marriage (Partridge 1905:163-64, fig. 35; Nicklin 1978a; 1981a).

In light of the different uses of headpieces within men's associations in the Cross River area, it is difficult to establish the precise context of a given example. In the past such carvings may have been used by the pervasive leopard spirit cult known variously as *Ekpe*, *Ngbe* or *Egbo* (Talbot 1912:37-48). Keith Nicklin (1978a:68; 1981a:168), commenting on similar crests, reports their use during funerals, initiations and entertainments within the *Nsikpe* and *Ikem* associations. Despite the age of this example it is in relatively fresh condition and may have experienced little use. Nicklin (1981b:174) speculates that the pristine state of some Cross River headpieces in collections outside Nigeria may indicate that they were made for export.

exhibited: Indiana Central University, Indianapolis, 1980

published: Celenko 1980, no. 39, ill.
 Celenko 1981, fig. 7

I was overwhelmed by this crest when I first laid eyes on it, and it is one of the most admired objects in my collection. It is in remarkable condition, considering its age and fragility. H.E.

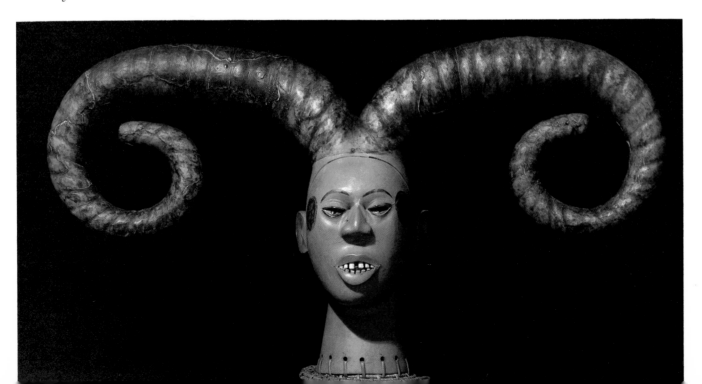

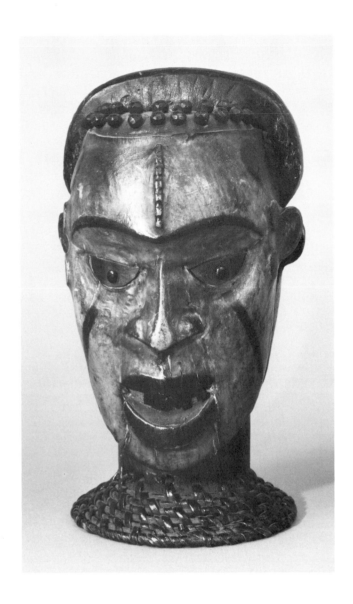

Ejagham (Ekoi) or Efik, Nigeria
lower/middle Cross River

139
janus-faced head crest
wood, skin, pigment, iron, basketry, fiber
h. 10³/₁₆ in. (25.9 cm.)

Like the preceding entry this fine skin-covered crest, which also functioned within a men's association, can be dated to the late 19th or early 20th centuries. William Fagg is of the opinion that it is by the same hand as a well-known headpiece acquired by the British Museum during the first decade of this century (Elisofon and Fagg 1958:147; Fagg 1977b). Janus-faced imagery of this and other headpieces (cat. nos. 141, 142, 146) from the Cross River and neighboring areas is not fully understood. It is plausible to interpret the opposing light and dark faces of this crest, respectively, as female and male, an expression of the polarity of the sexes (Talbot 1912:44; Nicklin 1974:11; Thompson 1974:175).

Fresh or pre-soaked pliable skin, usually antelope, is stretched over the wood and secured with pegs, nails or strings which are later removed. In some instances an adhesive may be used. The skin tightens over the wood as it dries (Nicklin 1974:13-14; 1979:56). Early reports indicate that skulls and heads of slain enemies were worn as dance crests and that human skin was used as a covering for wooden headpieces (Mansfeld 1908:150-51, pls. 17-18; Olderogge and Forman 1969:pl. 86; Talbot 1912:223, 261; 1926 vol. III:789, 829, 850; Brain and Pollock 1871:54; see also Nicklin 1974:8; 1979:56; Eyo 1981). Accordingly a skin sample from this crest and from cat. no. 138 were subjected to rehydration-microscopic analysis. The test of the spiral-coiffured crest (cat no. 138) proved inconclusive. However, the skin from this example was identified as human (Michael R. Zimmerman, M.D., Ph.D., Associate Professor of Pathology, Hahnemann Medical College and Hospital, Philadelphia, 1980).

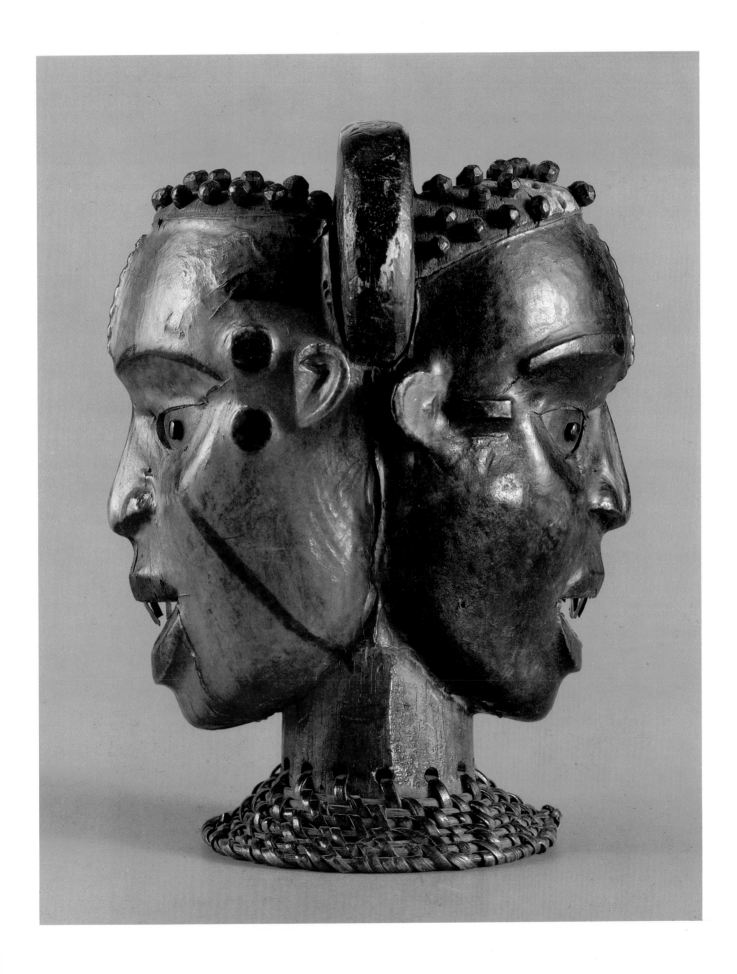

Ejagham (Ekoi) (?), Nigeria/Cameroon
middle Cross River (?)

140
headpiece
wood, pigment, basketry
l. 53¼ in. (135.3 cm.)

This large crocodile headpiece consists of nine separately carved pieces fitted together and set upon a basketry cap. Other elements, perhaps feathers, were inserted into holes in the torso, rear limbs and in the spiral head projections derived from women's coiffures. The surmounting bird may represent the crocodile bird, a plover which feeds on the reptile's insect parasites. The dish on the snout probably held offerings.

In contrast to skin-covered masks and crests from the Cross River area, little is known about this type of headpiece. P. Amuary Talbot, who worked in the area during the early years of this century, reports that crocodiles and other animals play important roles in Ejagham beliefs. For example, it is thought that men become possessed by wild animals such as the crocodile, buffalo and leopard, and that *Nimm*, the primary guardian spirit of women, takes physical form as a snake or crocodile (1912:2, 24, 80, passim). Talbot's field photograph (Talbot 1912:opposite p. 44) and accompanying description document an anti-witchcraft masker *(Ibokk)* of the *Egbo (Ekpe)* society wearing a crocodile crest identical in type to this example at Oban among the Nkukoli (Ekuri), an Ejagham subgroup or Ejagham-related people (Hansford, Bendor-Samuel and Stanford 1976:no. 298):

The image was robed in a long gown of dark blue cloth, daubed with mud from the river bed . . . Over the robes of the image dark-spotted Juju leaves were fastened here and there. On its head it bore a crocodile mask, carved in wood, perhaps a representation of Nimm herself. It was attended by two hunters armed with flint lock guns, a third bore a fishing net, and a fourth a curious earthen trumpet covered with leopard skin. The "image" was supposed to be deaf to human voices, and to hear only those of the bush beasts, save when awakened by the call of the trumpet. Ekuri Ibokk is the great "hunting Juju" [spirit/masquerade] of the Ekoi, and had never before appeared to a European. It is the Juju that is supposed to have the power of "smelling out" all others [witches], and the axe in its jaws is a sign of its special fierceness. (Talbot 1912:45).

exhibited: Indiana Central University, Indianapolis, 1980

published: Celenko 1980, no. 38

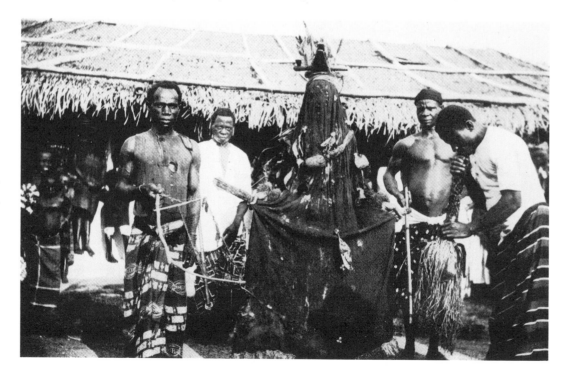

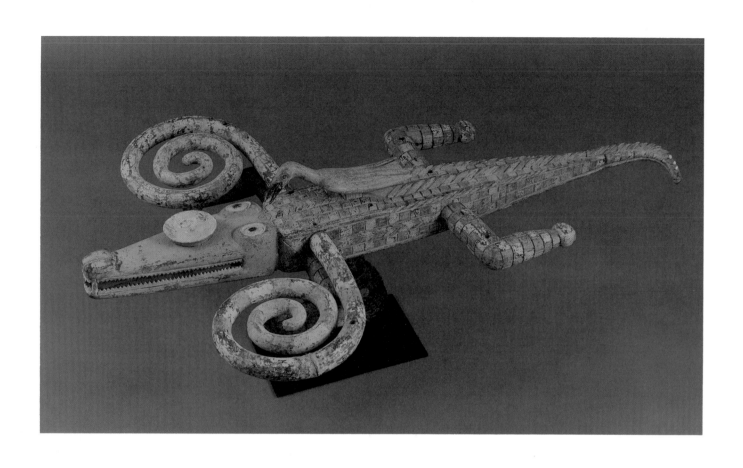

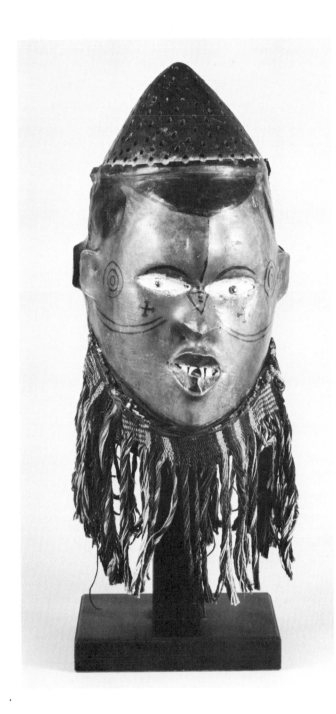

Akparabong (Ekparapong), Nigeria
middle Cross River

141
janus-faced helmet mask
wood, skin, pigment, iron, cloth, fiber
h. excluding cloth: 17³/₈ in. (44.1 cm.)

Helmet masks in this style with bold features are identified with the Akparabong, an Ejagham-related people of the middle Cross River area. They function within the *Nkang*, a warrior association, which in times past accepted only men who had killed a man or a ferocious animal. Porcupine quills, associated with male valor, were originally set into the holes at the top. The metal teeth faithfully depict a widely practiced form of dental mutilation which consists of chipping away the central incisors to create a notch (cat. nos. 138-39; Byström 1954; Thompson 1974:177; Hansford, Bendor-Samuel and Stanford 1976:no. 289a; Eyo 1977:204, 220; Nicklin 1978b; Wittmer and Arnett 1978:78-79).

Like cat. no. 139 the light and dark faces probably depict, respectively, female and male. The female face (left), with more delicate features, displays tattoos derived from *Nsibidi*, an indigenous form of "writing" and mime. Ideographic *Nsibidi* script involves the use of signs, such as a checkerboard pattern to indicate a leopard, or symbols, such as two horizontal, parallel lines to indicate darkness. The cross under each eye of this mask may signify an important verbal command. Placed in sequential order the ideograms are capable of documenting important events and relating extended narratives. In former times *Nsibidi* script was painted on split palm stems as messages, painted on walls, embroidered onto cloths, tattooed on skin and shaved on scalps. The secret aspects of *Nsibidi* script as it related to men's associations are lost today (Talbot 1912:305-309, 447-61; Thompson 1974:177-81).

The skin covering of Cross River headpieces gives them an air of naturalism beyond that of most African wood carvings. H.E.

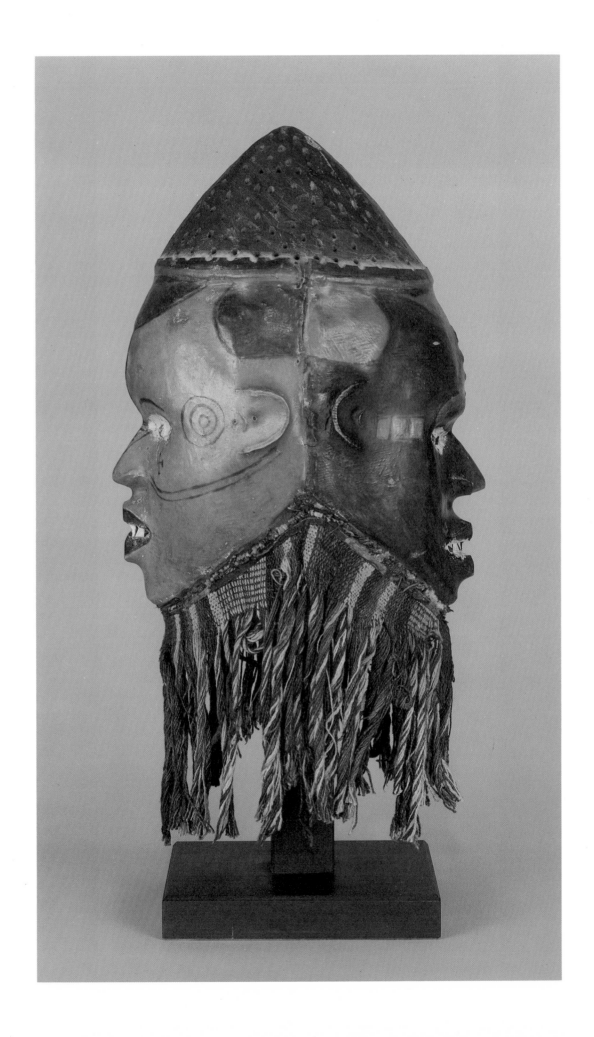

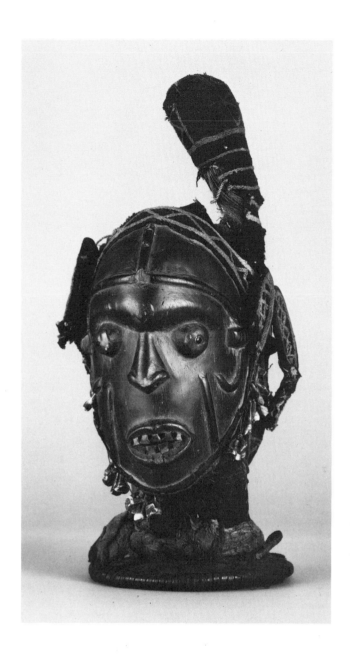

Boki, Nigeria/Cameroon
middle Cross River

142
janus-faced head crest
wood, basketry, cloth, fiber, brass, teeth
h. 15¹/₂ in. (39.4 cm.)

In his discussion of a Boki janus-faced crest in the Ratner collection very similar to this one, Henry Drewal (1977:no. 46) suggests that its restrained style represents an early, distinctly Boki mode different from more recent, apparently Ejagham-influenced styles documented by Keith Nicklin (1974:figs. 11-14, 16-17). (See Krieger and Kutscher 1960:no 63; Fagg 1965:nos. 58-59; 1970a: no. 160; Lommel 1976:no. 197; Wittmer and Arnett 1978:nos. 188-89 for other crests, both with and without skin covering, which may also relate to early Boki styles.) Drewal speculates that such anthropomorphic crests with elaborate hairdos functioned within the important women's association, *Egbebe,* although only men probably wore them (Nicklin 1974:12-15).

Unfortunately the elaborate coiffure of wood, fibers and embroidered cloth is largely missing. Published headpieces with intact coiffures of this type are complex with numerous vertical projections and other embellishments (Leuzinger 1972:O5; Schädler 1973:no. 320; Fagg 1981:no. 18). Drewal suggests that the raised linear patterns, which depict facial scarifications or tattoos, are related to those on *Akwanshi,* the well-known group of old monoliths located near Boki country. These markings and the embroidered designs may derive from *Nsibidi* script (cat. no. 141). The human teeth and perhaps other elements once suspended from the lower part of the faces may imitate an old fashion of embellishing elders' beards as depicted on some *Akwanshi* (Allison 1968:30, pls. 31-33, 36-37, 40-47, 49).

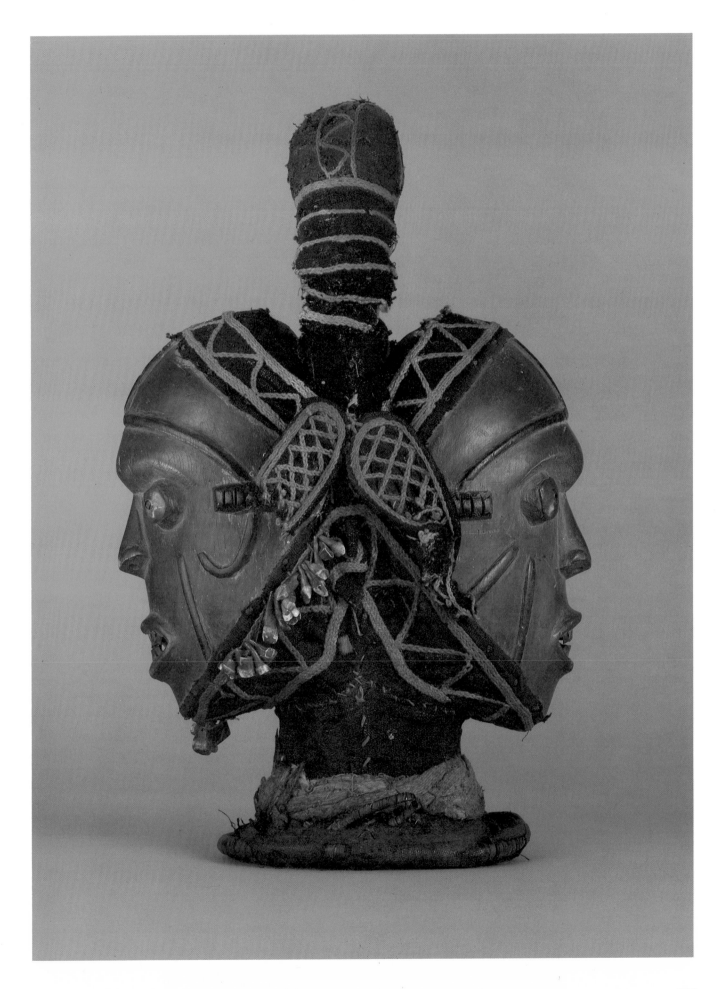

unidentified ethnic group, Cameroon
northwestern Grasslands

143
chair
wood, pigment
h. 32¹/₄ in. (81.9 cm.)

The Cameroon Grasslands is a grassy, mountainous plateau in west central Cameroon, inhabited by peoples who have similar social, political and religious institutions. They also share related sculptural types, motifs and styles. At the head of these hierarchical societies are rulers, variously termed chiefs or kings, responsible for much of the art production within a given group. Only the ruler, members of the royal family and other high ranking individuals have the right to own certain kinds of garments, headgear, furniture and other prestige items.

The size and prominent imagery of this chair indicate a chief's throne, one of the more conspicuous status indicators for Grasslands rulers. However, there is no evidence of the prestigious beadwork or metal sheathing sometimes affixed to important thrones. This example probably comes from the northwestern Grasslands, as it has stylistic affinities with carvings of the Kom, Babanki, Oku and other groups from this area. The chair's termite-ridden, weathered state suggests that it was left unattended after the owner's death. Paul Gebauer (1979:89) reports that a throne of a predecessor was rarely used by a new ruler, but was left exposed to the elements, put in the deceased's grave, placed in storage or given away as a present.

The back of the chair is dominated by a bearded male figure who wears a ruler's crown (cat. no. 150). The figure, which may represent the owner, is flanked by two female attendants. One of these (viewer's left) holds a drinking horn (cat. no. 156); the other attendant holds what appears to be a calabash vessel. The chair was originally supported by six male figures, one of which is completely missing.

Thrones had to be sturdy as well as elaborately carved. Despite considerable weathering, this example testifies to a great feat of carving from a single piece of wood. H.E.

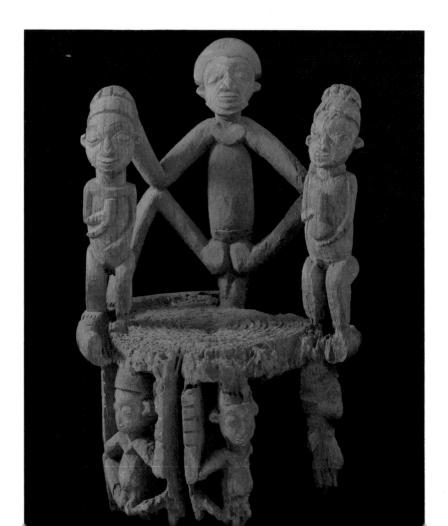

unidentified ethnic group, Cameroon

144
verandah post
wood, pigment, fiber
h. 98¹/₂ in. (250.2 cm.)

One of the most developed architectural carving traditions of sub-Saharan Africa is found in the Grasslands. The genre includes wall panels, roof borders, lintels, door jambs and verandah posts. Such carvings are the prerogative of rulers, their families, retainers and other important individuals. The typical building unit is a square structure made of layers of cane or bamboo latticework covered with mud and surmounted with a thatched roof. Royal compounds, fenced clusters of buildings with sculptural embellishments, are impressive sights.

This openwork verandah post, of uncertain origin, resembles Bamileke and perhaps Nsaw (Wittmer 1980) carving. Also undetermined is whether the post came from an individual's house, a communal house or some other building. All sides bear relief imagery of leadership and fertility symbols: eleven human figures, male and female; two human heads and four spiders. All figures display the characteristic Grasslands gesture of hands to chin; most wear the knitted hat of leadership. Unlike some reliefs this example probably does not relate a narrative or document an historical event. A small portion has been removed from the bottom and perhaps the top of this post, and much of the original black and ocher pigment has weathered away.

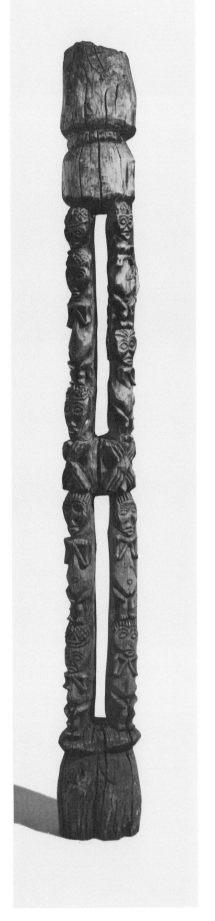

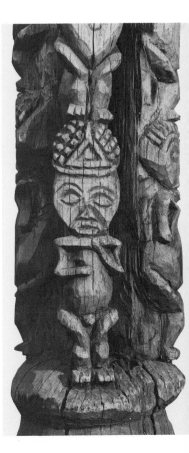

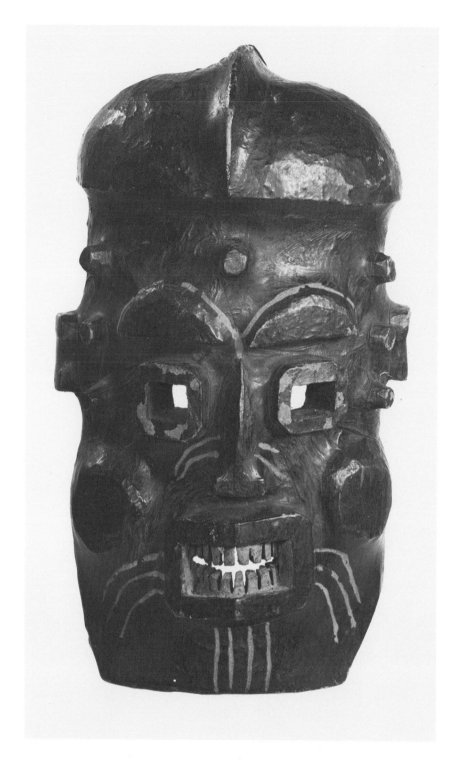

Widekum, Cameroon

145
helmet mask
wood, skin, pigment, fiber
h. 19¹/₄ in. (49 cm.)

The Widekum are a forest group at the western edge of the Cameroon Grasslands. Their masks share aspects with those of the Cross River complex to the west and the Grasslands to the east. The skin covering, temple keloids and expressive features of this example relate to Cross River headpieces, while the boldness and exaggeration of forms, including the puffed cheeks, are characteristic of Grasslands styles. The prominently rimmed eyes and mouth are typical of masks of the Widekum and upper Cross River groups such as the Anyang. However, the angular forms of this example differ from the rounder features of upper Cross River masks (Wittmer 1977:no. 98).

Keith Nicklin (1979:57-58) documents Widekum masks of this type, called *Agwe Chaka* or *Agucha*, worn during funerals conducted by the *Nchibe*, a men's warrior association. The *Nchibe* is apparently related to similar associations of the Cross River area. Other references to Widekum masks relate their function to the *Ekpe* association of the Cross River peoples (Ruel 1969:202, 216, passim; Wittmer 1973:no. 118; Gebauer 1979:M12). However, one documentation of a Widekum mask reports the policing function characteristic of some Grasslands masks (Bascom in Bravmann 1973:no. 38).

exhibited: Indianapolis Museum of Art, 1976

published: Gilfoy 1976, no. 44

Bangwa, Cameroon

146
janus-faced cap mask for "Night Society"
wood, incrustation
h. 10⁷/₈ in. (27.6 cm.)

"Night Society" maskers, like many of those of the Grasslands, derive their authority from both royalty and men's societies. The maskers, whose actions reflect the collective wisdom of a king and community leaders, punish criminals and conduct other social control measures during nocturnal outings. Their wooden headpieces, with exaggerated and distorted features, are intended to help create an awesome, terrifying aura appropriate for a role of enforcement (Brain and Pollock 1971:131-34; Wittmer 1973:no. 105, Northern 1979).

exhibited: Lowe Art Museum, University of Miami, 1973
Indianapolis Museum of Art, 1976

published: Wittmer 1973, no. 105
Gilfoy 1976, no. 37, ill.

The appeal of this headpiece lies in its rugged, bold character. H.E.

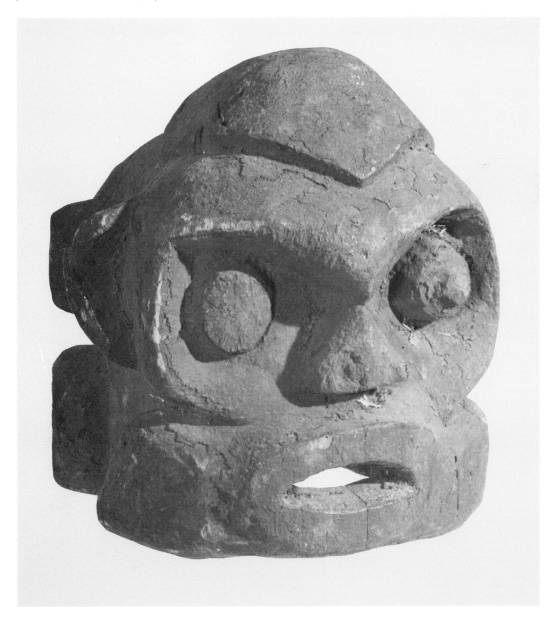

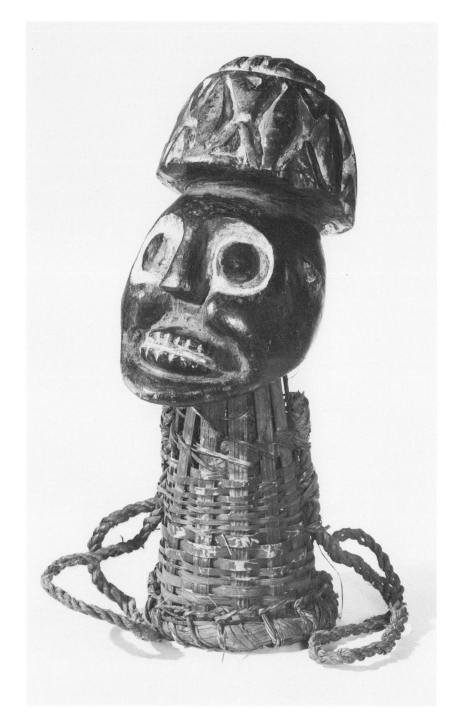

Bamum, Cameroon

147
head crest
wood, pigment, basketry, fiber
h. excluding rope: 23⁹/₁₆ in.
 (59.9 cm.)

The hat portrayed in this mask is covered, in relief, with stylized frogs with vertical, lanceolate bodies flanked by V-shaped legs at each end. Frog imagery, which is related to both fertility and royalty (Northern 1973:34-35; Wittmer 1976:95), is common in Grasslands sculpture along with that of spiders, lizards, leopards, elephants and other animals with symbolic associations. The head crest served as an insignia for the group which owned it and probably appeared during funerals and other occasions with a second masker as a male-female pair. Such crests typically include a prominent fiber assembly (missing in this example) suspended from underneath the carved head, and a basketry support which considerably increases the apparent height of the wearer, who is concealed with a cloth costume. The deeply carved features and round eyes are characteristic of Bamum head crests (Wittmer 1976:94-125, 171, figs. 45-64).

exhibited: Indianapolis Museum of
 Art, 1976
 Indianapolis Museum of
 Art at Columbus, 1977

published: Gilfoy 1976, no. 38, ill.

unidentified ethnic group, Cameroon
western Grasslands

148
cap mask
wood, pigment
l. 16 in. (41.6 cm.)

The snout and bared teeth of this carving suggest the buffalo, which like the elephant and leopard is associated exclusively with royalty. During public performances such zoomorphic masks serve as ". . . icons [which] symbolize and legitimize [royal] authority and power" (Northern 1979:n.p.), and may also have an association with hunters and warriors in support of royalty (Wittmer 1977:26). The triangular forms of the open-work headdress may depict heads of bats, another prevalent Grasslands animal motif (Northern 1973:figs. 29-30; Gebauer 1979:93). The style of this carving, especially its bold, angular forms, indicates an origin among a western Grasslands people (Wittmer 1977:7, passim; 1980). The original white coloring on the teeth and other areas is obscured by soot and coatings of charcoal mixed with vegetable oil.

The animated, expressive features of this mask are its finest qualities. H.E.

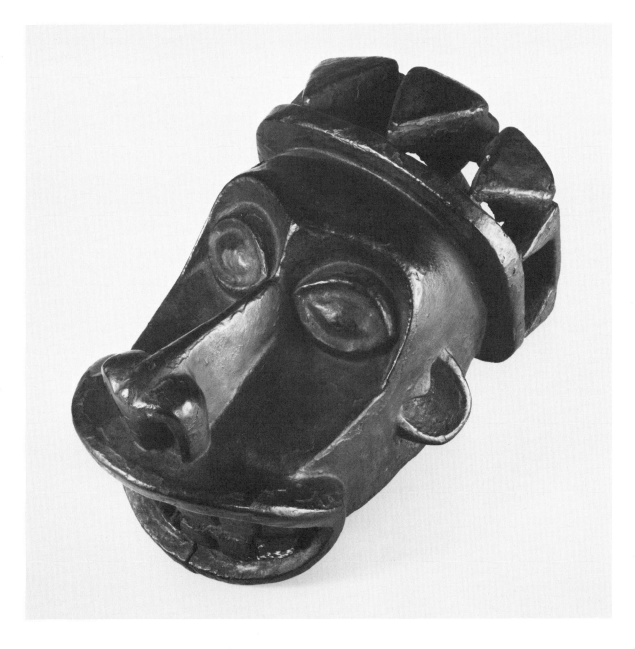

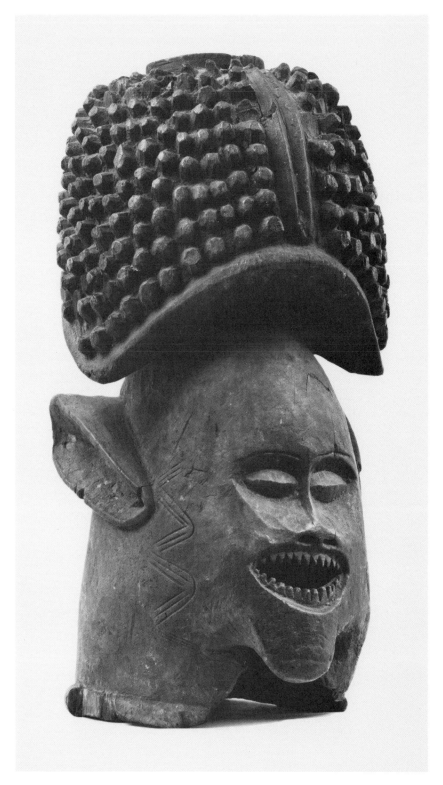

Bamileke (?), Cameroon

149
cap mask
wood, pigment
h. 18¹/₂ in. (47 cm.)

The expressive, attenuated features of this carving suggest an origin among the Bamileke. It has a beard and the knitted, knobbed cap of men of high rank. Incised on the back and on the cheeks are patterns which may relate to *Nsibidi* markings of the neighboring Cross River area. But some of these markings, like the spider and gongs on the back, relate to Grasslands motifs. A circular opening at the top may have held a bundle of feathers or fibers (Gebauer 1979:P16). The significance of two rectangular holes in the back of the mask is uncertain.

unidentified ethnic group,

Cameroon
Northwestern Grasslands

150
cap mask
wood, pigment, brass, fiber, glass,
 cowrie shells, human hair
h. 18³/₁₆ in. (46.6 cm.)

The prestige materials (brass, shells, beads) affixed to this mask indicate that it is a royal headpiece which belonged to a ruler or to the "society of princes" *(Nggiri)*. Royal masks, which are maintained within the palace compound, appear at funerals and installations of rulers and during other rare occasions (Northern 1979:n.d.). Hammered brass covers the face, and rows of cowrie shells and what remain of strung beads embellish the crown and beard. Both the crown, a leadership reference, and the beard are covered with plied human hair. No eyeholes are required since the mask is set atop the head, leaning forward. The style of this example indicates an origin in the northwestern Grasslands, perhaps among the Kom or Oku.

This masterfully carved mask with its royal-associated brass sheathing is certainly one of my prized Cameroon pieces. H.E.

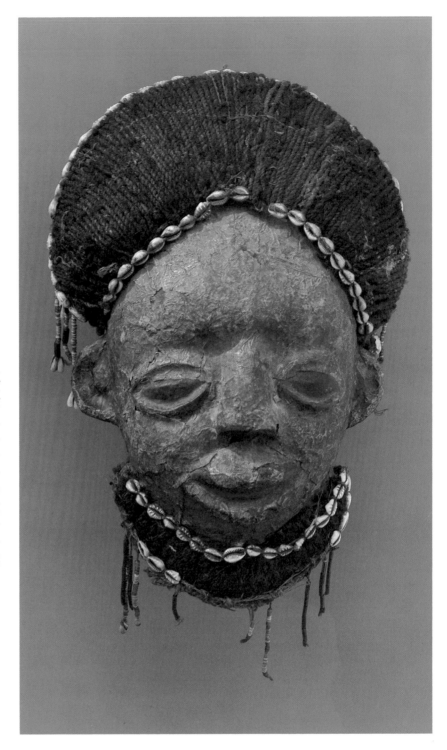

Bamileke (?), Cameroon

helmet mask
151
(front view: opposite left, back view: bottom left)
cotton, plantain fiber (?), glass, wood
approx. h. 32½ in. (82.5 cm.)

Bamileke (?), Cameroon

helmet mask
152
(front view: opposite center, back view: bottom
 center)
cotton, hemp or jute, glass, wool, wood
approx. h. 43 in. (109.2 cm.)

Bamileke (?), Cameroon

helmet mask
153
(front view: opposite right, back view: bottom
 right)
cotton, plantain fiber (?), glass, wool, wood
approx. h. 31¾ in. (80.6 cm.)

Beaded cloth masks with elephant imagery are generally identified as Bamileke, and the majority of documented examples originate from this group. However, these headpieces are also documented among the neighboring Bafut, Bali, Bamum and Bamileke-related Bangwa (Brain and Pollock 1971:100-104, pl. 50, color pl. 7; Northern 1975:17, nos. 4-6, 12-13; Lommel 1976:no. 17). Furthermore, based on Tamara Northern's (1975:116) analysis of examples in the Linden Museum für Länder und Völkerkunde, Stuttgart, stylistic factors alone may not permit ethnic or specific local attribution.

These masks form part of the regalia of certain exclusive societies known as *Kuosi* and *Kemdje* among the Bamileke and *Aka* among the Bangwa. The primary role of these privileged groups, which are under direct control of the paramount ruler *(Fon)* and his council, is to maintain a rigid socio-political hierarchy. This type of mask is worn during funerals of important individuals and during periodic, public assemblies of society members. The large disc ears and the trunk-like panels allude to the elephant, which along with the leopard is a prime symbol of royalty. Northern (1975:117) suggests that the triangle motifs on the masks refer to leopard spots. The masquerad-

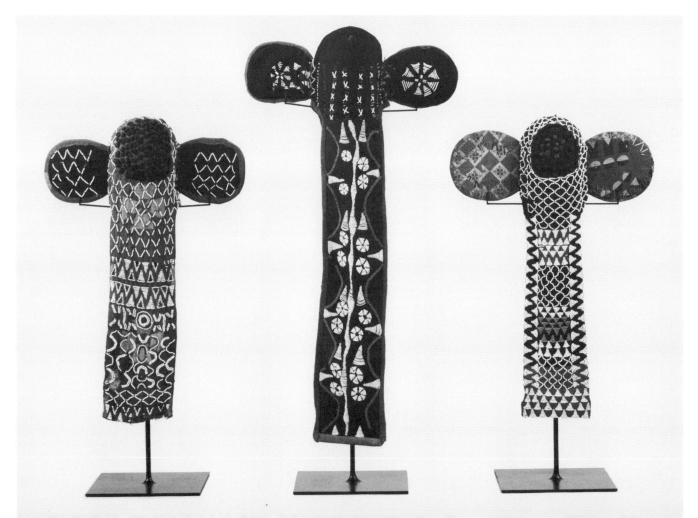

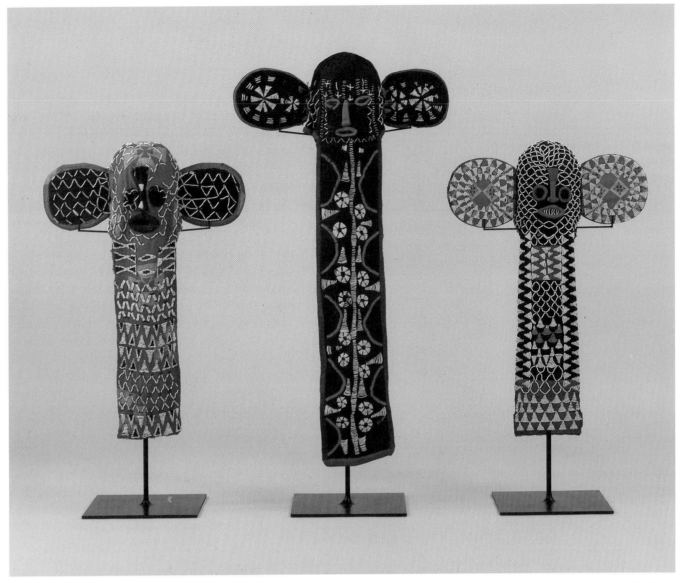

ers also wear garments of blue and white royal cloths, beaded vests and leopard pelts on their backs. Sometimes a beaded or feathered hat, or beaded leopard image surmounts the mask. Cat. nos. 151 and 153 have simulations of knobbed prestige caps (cat. no. 149) on the back of their heads. The lavish use of beads, the royal cloth and the references to the elephant and leopard symbolize the power and wealth of royalty (Albert 1943:56-64, figs. 4b, 8-9; Lecoq 1953:19, 60-61, 188, figs. 24, 26-27; Brain and Pollock 1971:100-104, pl. 50, color pl. 7; Northern 1975:17-22, passim).

The vertical part of these masks consists of cotton cloth lined with local or imported hemp, jute or raffia cloth. The ears, which have a support of wood or fiber covered with cloth, are added, as are the cloth elements which make up the border trim and facial features of cat. nos. 151-52, and the facial features and rectangular panels of cat. no. 153. The geometric beadwork is based predominantly on the repetition of a limited number of designs of solidly beaded triangles or outlined diamonds. Beadwork patterns are usually regular and symmetrical. Even the print of the cloth in cat. nos. 151 and 153 is integrated into the beadwork designs. This is apparent on the front sides of the ears of cat. no. 153, and in the symmetrical placement of crosses on the top of the head and in other areas of cat. no. 151. These crosses, related to Imperial German heraldry, suggest an early date of manufacture for this mask, before or not much later than the First World War in which Germany lost her African territories. Indeed, the style, materials and condition of both cat. nos. 151 and 153 point to an origin early in this century. Both of these masks are constructed primarily of handwoven textiles and have a similar type of bead embroidery stitching. In contrast, cat. no. 152 is composed exclusively of industrially made cloth and has a distinctly different method of stitching.

I am fascinated by the quality and design of the beadwork on these handsome masks, certainly the equal of American Indian beadwork in my collection. H.E.

unidentified ethnic group, Cameroon

154
headdress for dance leader
feathers, fiber, cloth
approx. h. 26 in. (66.1 cm.)

Paul Gebauer (1979:14-15, 111, P23) documents headdresses of this type among the Ndop and Mbem, worn by leaders of dance groups. Gebauer's 1940 photograph taken among the Mbem depicts a village head leading members of the leopard cult in dance (courtesy of the Robert Goldwater Library of Primitive Art, Metropolitan Museum of Art, Bequest of Paul Gebauer, 1977, neg. no. 135/4; see also Gebauer 1979:14-15, M79). Identical type headgear are identified as Bamileke (Northern 1975:121, no. 82) and documented among the Bafut, where they are used by men's societies during funerals (Ritzenthaler and Ritzenthaler 1962:64, 66, 122-23, figs. 30, 61; see also Sieber 1972a:64-65). An interesting feature of these headdresses, which are constructed of dyed feathers set into fiber caps, is that they can be turned inside out for storage, forming compact bundles from which only the longest feathers protrude.

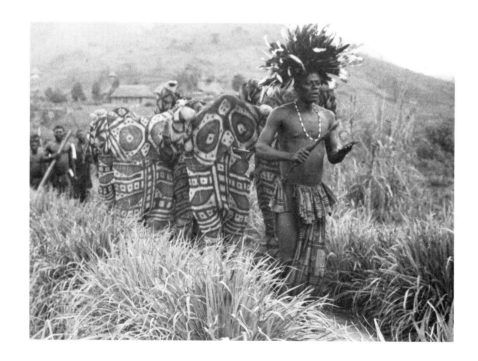

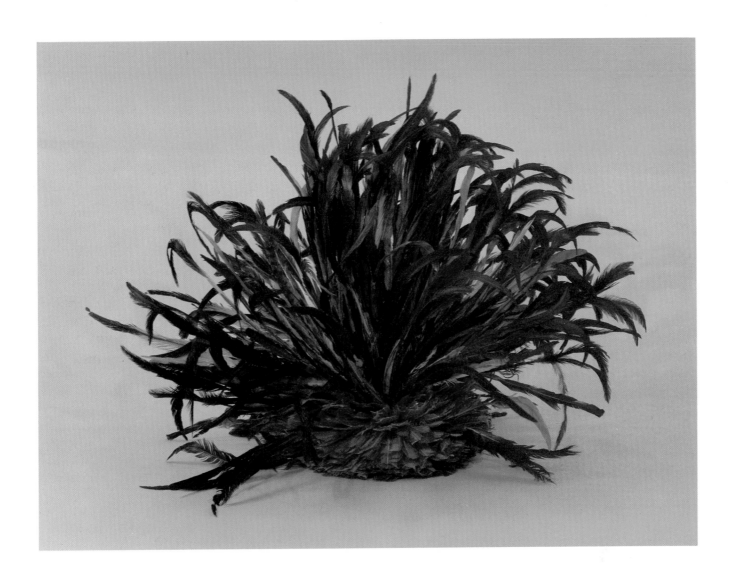

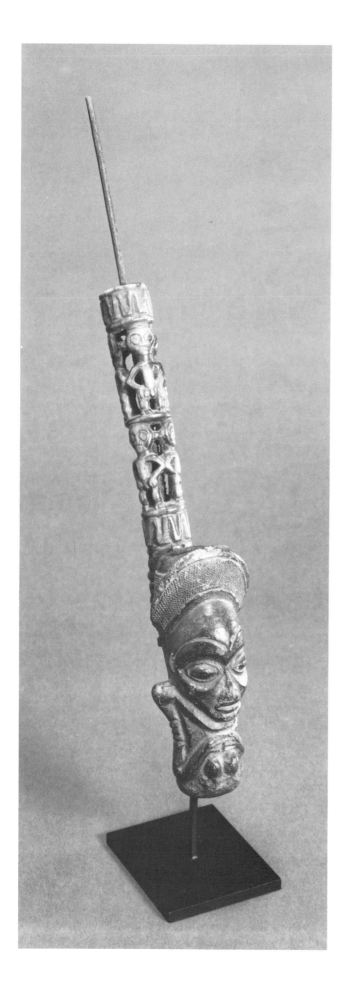

unidentified ethnic group, Cameroon

155
tobacco pipe
clay, iron, ivory, mastic
h. 16^{13}/$_{16}$ in. (42.7 cm.)

The use of tobacco and other American plants was adopted in many areas of Africa after their introduction by Europeans over three centuries ago, and in some areas, where the climate permits, tobacco has become a local crop. In the Cameroon Grasslands pipe smoking developed into a widespread social activity of both sexes. However, since the end of the Second World War the practice has been largely replaced by cigarette smoking (Gebauer 1972; 1979:249). Elaborate pipes such as this example were usually owned by men of status. The imagery reflects, in miniature, subjects and styles prevalent in wood carving. The human figures incorporated into the openwork ivory stem may symbolize fertility and long life (Gebauer 1972:31); the bowl figure may represent a ruler. Male specialists who make clay pipe bowls employ the infrequently documented technique of carving, rather than modeling embellishments on pre-fired, leather-hard clay. This example has affinities with Bamessi pipes which are popular throughout the Grasslands. However, without collection data it is impossible to determine its precise origin because of widespread borrowing of styles and considerable commerce in pipes.

Bamum (?), Cameroon

156
drinking horn
buffalo horn, mastic
l. 9³/₄ in. (24.8 cm.)

Drinking horns, like tobacco pipes, stools, flywhisks, jewelry and other personal items, serve as status symbols in hierarchical Grasslands societies. Men of relatively low status use undecorated buffalo horns and calabash vessels such as those depicted in Paul Gebauer's 1939 photograph taken in the northern Grasslands (courtesy of the Robert Goldwater Library of Primitive Art, Metropolitan Museum of Art, Bequest of Paul Gebauer, 1977, neg. no. 103/34). Horns with relief carving and sometimes cast brass finials are the prerogative of men of wealth and authority. Decorated horns, used primarily for palm wine, are prized possessions and are even carried when traveling (Gebauer 1979:215). The vessels are replete with fertility and leadership imagery drawn from the standard repertory of Grasslands motifs. On this example, below the lip on the inside curve is a figure, probably of a chief, standing on a stylized frog. The balance of relief work, divided into three panels, consists of human images, floral motifs, frogs, spiders and geometric patterns. The carving is closely related in imagery and style to that on an example collected by Gebauer in Bamum country fifty years ago (Gebauer 1979:M46).

EQUATORIAL FOREST

This zone extends from the Atlantic Coast to the Great Lakes (which divide Central and Eastern Africa) and encompasses the forest on both sides' of the equator as well as some grasslands in the north. The inhabitants are agriculturalists and, except in the north, speak Bantu languages which dominate the southern half of the continent. With few exceptions these peoples lack the centralized political institutions and social hierarchies characteristic of some peoples of the neighboring Guinea Coast and Southern Savanna. Consequently there is little art associated with leadership and prestige. Rather, most masks, figures and other figurative carvings function as ritual paraphernalia within associations and cults. Most figure styles are characterized by abstract forms whose flipper-like arms and other conventions sometimes relate to carvings from the Central and Eastern Sudan (cat. nos. 37-38, 204). The heart-shaped face is a prevalent motif (cat. nos. 157, 163, 165-67) whose distribution extends into the Central Sudan (cat. no. 38) and Eastern Guinea Coast.

The Ogowe River region, the Ubangi River-Uele River region and the Eastern region each constitutes a relatively homogeneous sculpture area. In the Ogowe River region, which extends well beyond the Ogowe, protective reliquary images in a wide range of styles (cat. nos. 157-60) form an important category of sculpture. Although not represented in the catalog, headpieces with heart-shaped faces are prevalent.

Both functionally and stylistically the arts of the Ubangi River-Uele River region exhibit two broad traditions. On the one hand the hierarchical, kingship-oriented Zande and Mangbetu produce secular, prestige carvings which are relatively naturalistic (cat. no. 164). Another tradition, more typical of the Equatorial Forest zone, consists of ritual masks and figures in abstract, often minimal forms (e.g., cat. nos. 160, 165-67).

The Eastern region, which extends from west of the Lomani River to the Great Lakes in the east, includes the Lega and a host of lesser-known groups. The Bembe, at the southern periphery of the region, have many cultural features, including masking traditions, similar to forest groups such as the Lega, but their carved figures have affinities with savanna styles to the south. Heart-shaped faces and other conventions which deviate from naturalism typify the region's figurative sculpture.

With respect to the visual arts a good part of the zone is unchartered ground. Little sculpture is reported from two large territories, southwest Central African Republic and a portion of southeast Cameroon, and northeast Congo and adjacent northwest Zaire. The former area is inhabited by Bantu speakers such as the Wute (Bute) and by the Baya, Yangere, Kpere and other groups who speak Adamawa-Eastern languages. The latter area is occupied primarily by peoples of the extensive Mongo cluster, which includes the Mongo proper, the Ntomba, Konda, Booli and other groups who apparently lack significant figurative carving traditions (Vansina 1966:90-91). Other Mongoid peoples such as the Ndengese and Tetela of the Southern Savanna zone and the Mbole and Yelwa to the east are part of recognized sculpture-producing regions.

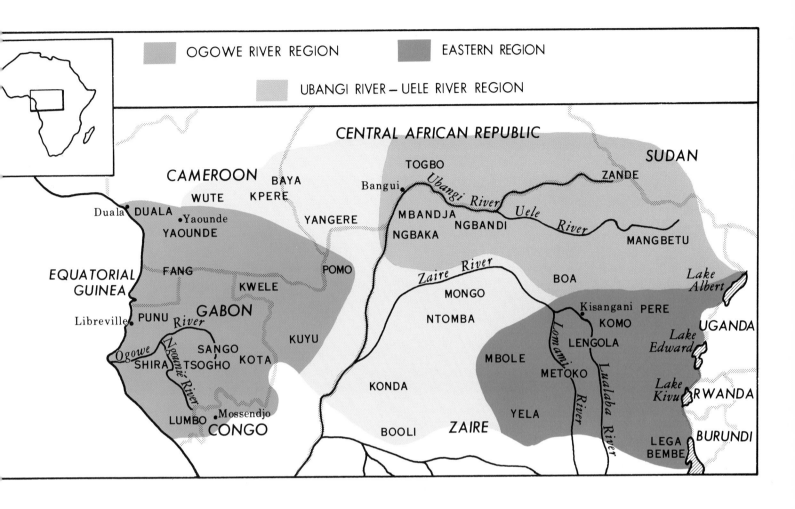

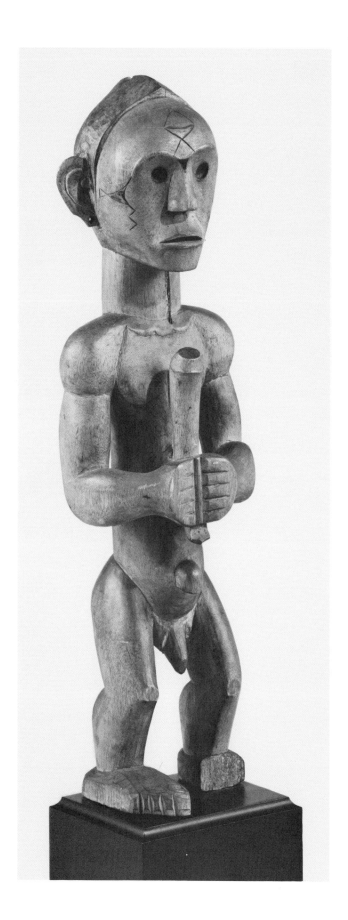

Fang, Cameroon
Ngumba or Mabea subgroup

157
male reliquary figure for *Bieri* cult
wood
h. 17¹/₈ in. (43.5 cm.)

19th century

The Fang are a conglomerate of related groups distributed throughout southwestern Cameroon, Equatorial Guinea and northwestern Gabon. Until the early part of this century they maintained a pervasive ancestral cult *(Bieri)*. Skulls and bones of important clan members, which were the focal point of the cult, were kept in a cylindrical bark container surmounted by a wooden head or figure. These images, identified as *nlo Byeri, eyima Bieri* and *mwan Bian* (Perrois 1972:132; Fernandez 1973:197), were both evocations of ancestors and apotropaic devices for the reliquaries. Reliquaries of great chiefs could contain as many as a score of skulls although the usual number was much lower. Initiated males consulted the reliquaries for aid and protection before all important activities such as war, resettlement, marriage and travel. Access was strictly forbidden to women and children. Reliquaries were also used in initiations and other ritual activities (Perrois 1972:131-39; 1979:40-46).

Fang, Gabon
Betsi or Nzaman subgroup

158
female reliquary figure for _Bieri_ cult
wood, pigment, fiber
h. 9¼ in. (23.5 cm.)

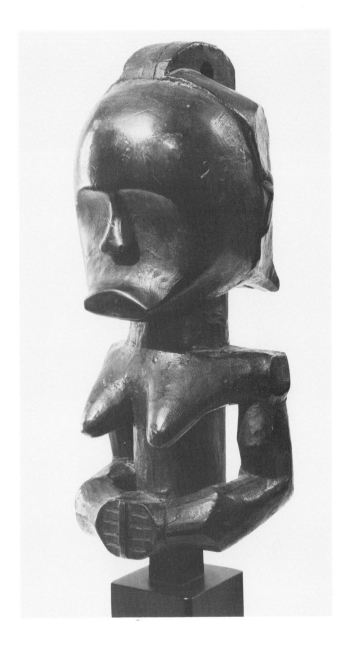

Cat. no. 157 belongs to a group of light colored figures collected in southern Cameroon late in the last century (Preston n.d.:no. 7) and bears an 1897 accession date of the dealer W. D. Webster. Its style is most similar to that of the Ngumba and Mabea subgroups (Krieger 1965:no. 191; Perrois 1972:69-70; 1979:56-64; Lommel 1976:nos. 88, 89; Preston n.d.:no. 7). Antelope horns such as the one depicted with this figure serve as medicine containers or whistles. The cruciform pattern on the forehead relates to scarification and tattoo bird tail motifs recorded among the Fang early this century by Günter Tessmann (1913 vol. I:258-64, ill. 216-17).

Cat no. 158, which has been cut off below the waist, probably comes from the Betsi or Nzaman subgroup (Perrois 1972:245-55; 1979:ill. 59-62, 65). Its lustrous black surface, bulbous head and protruding mouth are typical of Fang figures. The head is surmounted by a type of crested coiffure or fiber headpiece formerly worn by the Fang (Tessmann 1913 vol. I:175-77, ill. 119).

cat. no. 157
ex-collection: W. D. Webster

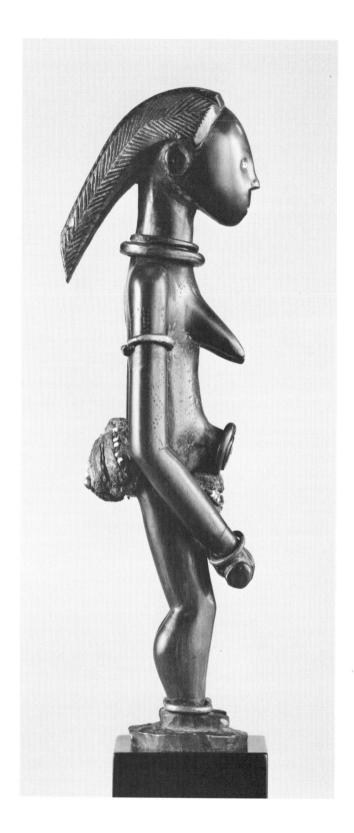

exhibited: Indiana Central University, Indianapolis,
 1980

published: Celenko 1980, no. 41, ill.
 Celenko 1981, fig. 11

Fang (?), Gabon/Equatorial Guinea

159
female figure
wood, fiber, glass, brass
h. 9³/₄ in. (24.8 cm.)

The questionable attribution of this masterful carving rests largely on its similarity to a figure of approximately the same size published as Fang on at least three occasions (Portier and Poncetton 1956:pl. XX, fig. 26; Fagg and Plass 1964:145; Perrois 1972:290). Louis Perrois (1972:290) identifies the published figure as a Fang work, possibly from the Okak subgroup of Equatorial Guinea. The figure is somewhat more stoutly proportioned than the Eiteljorg example. Otherwise the two carvings have much in common, including similar breast, coiffure and facial styles; tiny glass beads as eyes; identical stances with what appear to be batons held in front; and abdominal projections encircled by brass rings. However, there are apparently no field collection data for the published figure. Furthermore, the Eiteljorg carving in particular, with its delicate, attenuated forms and slender proportions bears little relationship to the known corpus of Fang statuary. Three other published figures in the Barnes Foundation (Guillaume and Munro 1954:fig. 13; Perrois 1972:191), the New Orleans Museum of Art (Fagaly 1980:158) and the Museum für Völkerkunde München (Kecskési 1982:no. 291) identified as Fang but apparently without field documentation have coiffures similar to this figure. Also, the inverted U-shaped patterns above the breasts and on the back of the Eiteljorg figure resemble scarification and tattoo motifs recorded among the Fang by Günter Tessmann (1913 vol. I:ill. 215). The cylindrical base is unusual for Fang reliquary figures; its irregular bottom surface suggests that it was cut from a larger object, perhaps a staff.

Few of the many authorities familiar with this figure are comfortable with a Fang attribution. Other suggestions of the carving's origin have focused on three areas, the Ovimbundu or related Angolan people, southeastern Zaire near Lake Tanganyika, and an area between Gabon and the mouth of the Zaire River. Radiographs of the abdominal protrusion reveal the absence of foreign, medicinal substances which would have suggested a relationship with the Lower Zaire River region.

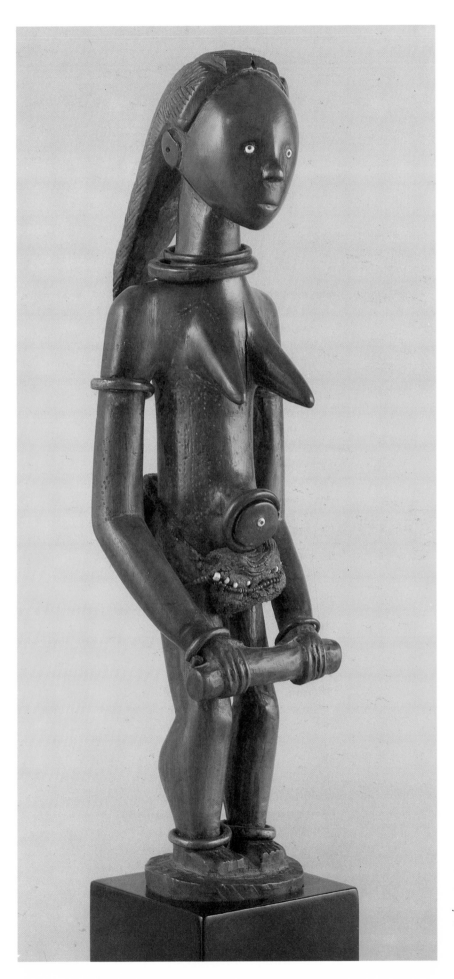

This jewel of a carving has to be one of my favorite African pieces, and I had to put it on the front of the dust jacket. The refined form, the understated tension of the posture and the marvelous surface make it a masterpiece. H.E.

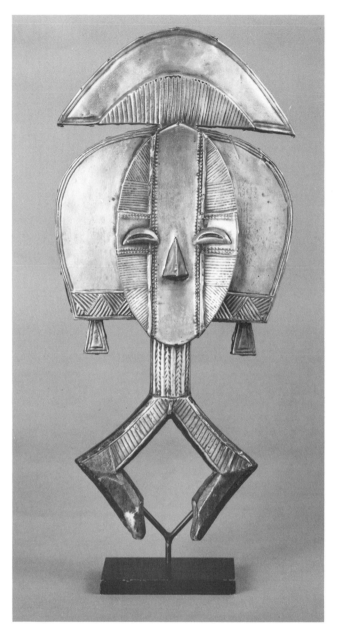

exhibited: Ancienne Douane, Strasbourg, France,
1967-68
Musée de l'Impression, Mulhouse,
France, 1968
Indiana Central University, Indianapolis,
1980

published: Haddouf 1967, no. 273, pl. 49
Chaffin 1973, ill. no. 26
Chaffin and Chaffin 1979, piece 99, ill.
Celenko 1980, no. 42, ill.

*Like many artists during the early years of this
century, Picasso was an admirer of African
sculpture. Indeed, some of Picasso's paintings
from the first decade of the century borrow di-
rectly from Kota reliquary figures such as this one.
H.E.*

Kota, Congo/Gabon
southern area
Mindumu or Mindassa subgroup

160
reliquary image *(ngulu/nguru)*
wood, copper, brass, iron
h. 20¼ in. (51.4 cm.)

Kota is a blanket term for a cluster of related
groups living in Gabon and parts of neighboring
Congo. Their reliquary images probably represent
the most sophisticated tradition of metal appli-
qué in sub-Saharan Africa and were among the
earliest African sculptures to influence European
artists during the early years of this century. This
example comes from the Mindumu or Mindassa
subgroup in southeastern Gabon and southwest-
ern Congo and may specifically originate from the
area of Mossendjo town in Congo (Chaffin
1973:38, 42, ill. no. 26; Chaffin and Chaffin 1979:10,
194-95, 279-80; Andersson 1953:figs.37b, 38;
1974:pl. 2, figs. 15-17, 22, 27).

Kota figures represent founding ancestors and in
former times were placed as guardians on bas-
ketry, bark or fiber containers which held the
skulls and other bones of prominent family an-
cestors. Such ancestor assemblages, called *mbulu
ngulu/nguru,* literally, reliquary container with
figure, served as protection against witchcraft and
provided a means of appealing to the spirit world
for aid. Figures were sometimes removed from
their reliquaries and carried about during ini-
tiations and other rituals (Siroto 1968; Chaffin
1973:14; Perrois 1978; 1981; Fagg 1981:no. 33).

Although Kota figures fulfill a function similar to
reliquary carvings of the neighboring Fang (cat.
nos. 157-59) and other Ogowe River peoples, their
two-dimensional, abstract, metal appliqué forms
are distinctive. Most consist of an oval face
flanked and surmounted by projecting elements
which probably derive from coiffures, and by a
diamond shaped "body" support, which in this
example is not fully extant. The valued cuprous
metals affixed to Kota figures are appropriate to
honor the most revered ancestors. Such metals
were available from Europeans by the 16th cen-
tury, although copper may have been imported
from African sources earlier (Siroto 1968:86; Per-
rois 1978:141; 1979:146-48).

unidentified ethnic group, Gabon/Congo

161
female figure
wood, pigment
h. 10⁹/₁₆ in. (26.8 cm.)

Figures of the Punu, Lumbo, Shira, Sango and other peoples in the area of the Ngounié River, a southern tributary of the Ogowe, constitute a related carving complex whose styles have not been adequately identified. The broad face, prominently arched eyebrows, diamond-shaped scarification pattern and kaolin coating of this example, which has been cut off above the feet, are also characteristic of the area's masks. The significance and use of these figures are uncertain. They are probably associated with ancestors, possibly serving a role similar to Fang reliquary figures. Differently styled, ancestor-associated figures among the neighboring Tsogo function within the *Bwiti* cult (Millot 1961; Fagg 1970a:no. 74; Perrois 1979:214-35, 256-61, 295; Roy 1979a:no. 129).

published: Celenko 1981, fig. 4

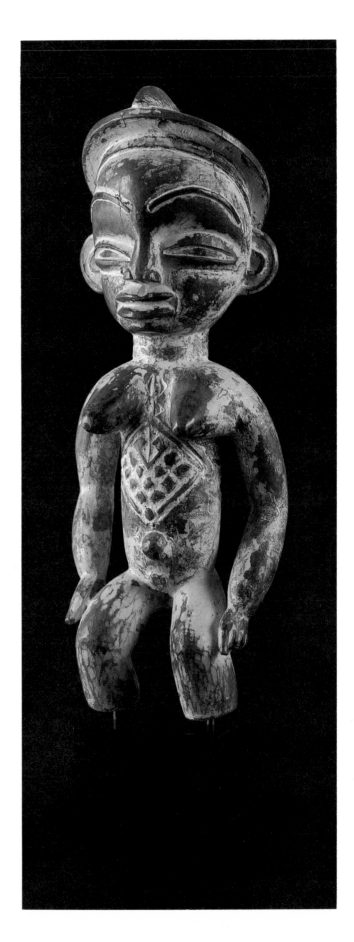

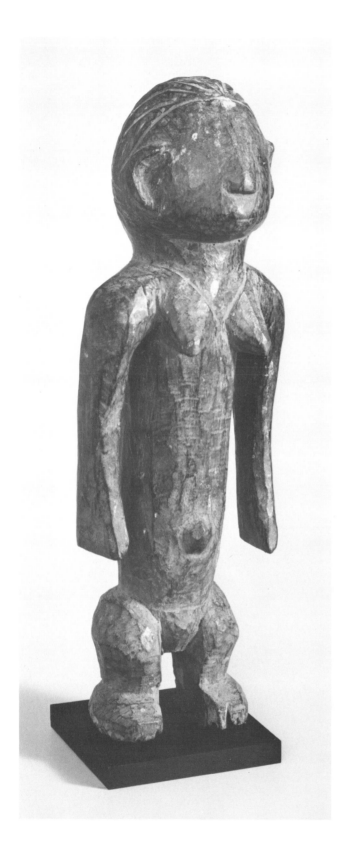

Ngbaka or Ngbandi, Zaire/Congo/Central African Republic

162
female figure
wood, iron
h. 13¹/₈ in. (33.4 cm.)

Wood carvings of the Mbandja, Togbo, Ngbaka, Ngbandi, Zande and other peoples inhabiting the region of the Ubangi and Uele Rivers exhibit a simplification of form and lack of naturalism associated with the Sudanic zone to the north, from which some of these groups may originally have come. Since the region has been little studied and because of the similarity of styles it is difficult to establish the ethnic origin of a carving without collection data. Further complicating this problem is the diversity of styles within each group. This may be partly due to nonspecialist carvers in some areas who probably also account for the uneven quality of much of the area's sculpture. This relatively naturalistic figure with a very worn face is probably of Ngbaka or Ngbandi origin. Such figures, which embody spirits of recent or mythical ancestors, are reported to be used in initiations and divination (Burssens 1958a:51, figs. 2-5, 13-14; 1958b:136-38, 169; Van Geluwe 1967:60; Cornet 1971:no. 177).

Zande, Zaire/Central African Republic/Sudan

163
male figure *(Yanda, Nazeze* **type) for** *Mani*
 society
wood, fiber, feathers
h. 8^{11}/$_{16}$ in. (22.1 cm.)

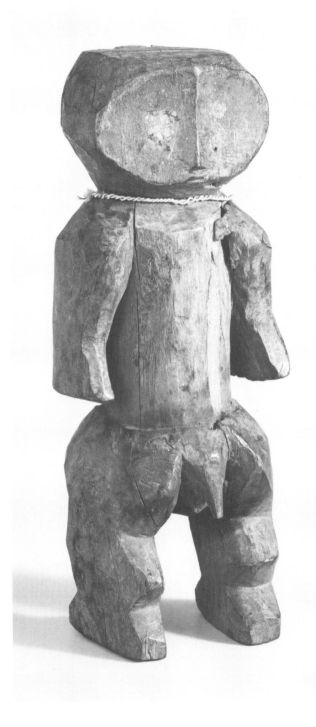

Zande figures vary greatly in style and are among
the more minimal and abstract in Africa, some-
times reduced to limbless torsos with simplified
heads. Variations of a heart-shaped face, here
rendered as two depressed facets divided by a
center ridge, are conventions found throughout
the Equatorial Forest zone (cat. nos. 157, 165-67)
and parts of the Eastern Guinea Coast and the
Central Sudan (cat. no. 38). The flipper-like arms
and zigzag legs are other features which relate
Zande figures to the broader carving complex of
the Equatorial Forest and the Central Sudan (cat.
nos. 37-38).

Most Zande figures belong to a broad category
known as *Yanda* which includes human and ani-
mal images in wood, stone or baked clay. Wooden
anthropomorphic figures with arms, like this
example, are called *Nazeze. Yanda* figures embody
protective spirits and are kept in special huts
where they are consulted on various communal
and individual concerns. For example, they are
appealed to for protection against sickness and
enemies, for fertility and in the settlement of dis-
putes (Burssens 1962:218-23; Cornet 1971:301-10).

exhibited: Indianapolis Museum of Art, 1976
 Indianapolis Museum of Art at
 Columbus, 1977

published: Gilfoy 1976, no. 71, ill.

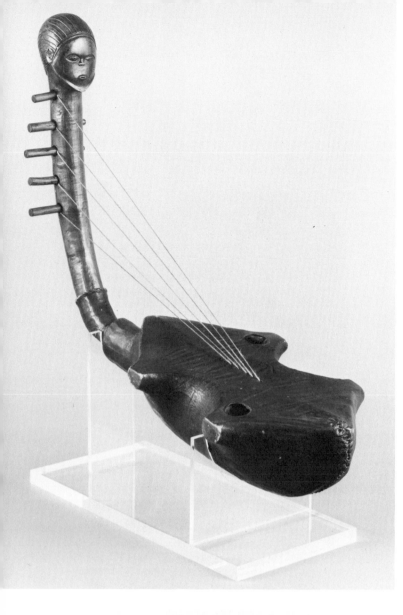

Zande, Zaire/Central African Republic/Sudan

164
harp
wood, skin, fiber, iron
l. 25⅝ in. (65.1 cm.)

A distinct type of harp with a single curved neck and an elongated sound box with two circular openings is a cultural feature shared by the Mangbetu and other peoples with whom the Zande interacted during their expansion southward in the 19th century. As with this example the neck often includes an anthropomorphic finial whose significance is not fully understood. The original strings were made of vegetable fiber or animal sinew and were tuned with the neck pegs.

Such harps are used primarily by itinerant musicians as accompaniment to singing or reciting. They are not normally used in conjunction with dancing or as part of an instrumental group. In some instances harps may have served as status indicators for highly born individuals (Laurenty 1960:179-83).

During an excursion through Zande territory in 1870 Georg Schweinfurth was visited by a "minstrel" who performed with a harp identical in type to this one. The event was recorded by the accompanying illustration and commentary:

> As the darkness came on, our camp was enlivened by the appearance of the grotesque figure of a singer, who came with a huge bunch of feathers in his hat, and these, as he wagged his head to the time of his music, became all entangled with the braids of his hair. . . . Their instrument is the local guitar, the thin jingling of which accords perfectly well with the nasal humming of the minstrel's recitative (Schweinfurth 1874 vol. 1:445-46).

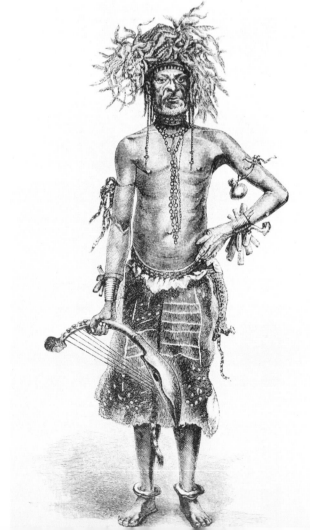

Metoko, Zaire

165
figure for *Bukota* association
wood, pigment
h. 25⁷/₈ in. (65.7 cm.)

In contrast to Lega carvings (cat. nos. 166-67) those of the Metoko, Lengola, Mbole, Komo, Pere and other culturally and historically related peoples of the Eastern region are less well known. Metoko figures vary considerably in style; but heart-shaped faces and abstracted, often elongated anatomical elements are consistent features. In this example, of uncertain gender, the rhythmic repetition of angular forms exemplifies the dramatic sculptural configurations of some carving traditions of the Equatorial Forest zone. Metoko figures of the pervasive *Bukota* association are used during funerals, circumcision rites, initiations and peace-making activities (Biebuyck 1976; 1977:52-55). This example may have ancestral associations (Neyt 1981:38-39, fig. II.15).

published: Neyt 1981, fig. II.15

The angular, faceted construction of this figure and the sculpturally successful multiple views are similar to the approaches to the human form undertaken by Cubists in the early twentieth century. H.E.

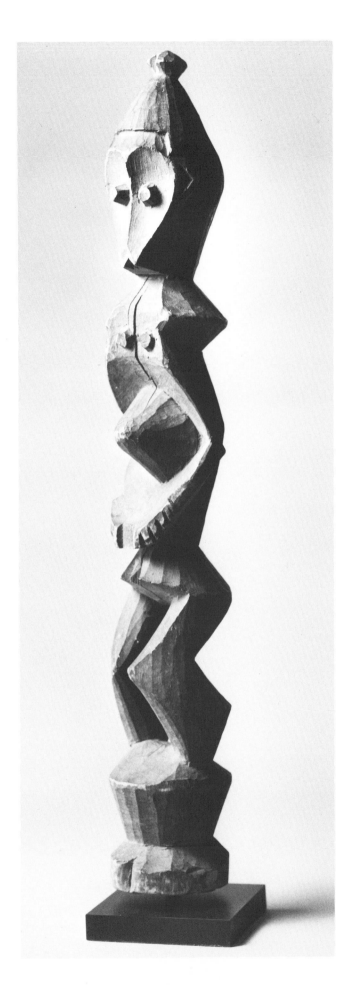

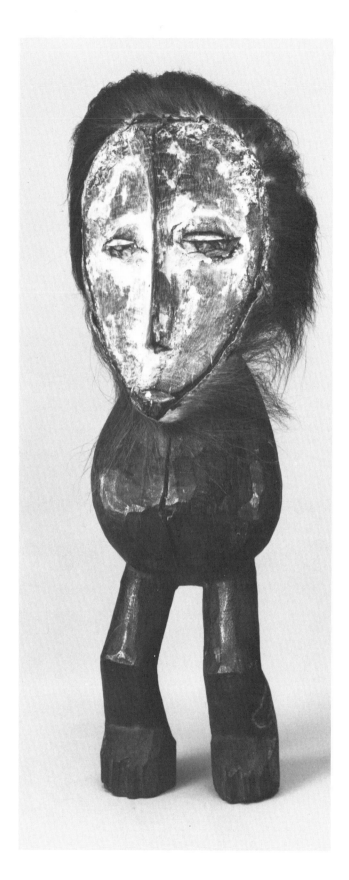

Lega, Zaire

166
figure for _Bwami_ association
wood, pigment, fur, iron
h. 12⁵/₈ in. (32.1 cm.)

Almost all Lega figures and masks function within the _Bwami_, a pervasive association with political, social, economic and religious ramifications. This figure was probably owned by a member of the association's highest grade, _Lutumbo Lwa Kindi_, and functioned primarily during initiations. Anthropomorphic and zoomorphic carvings depict a host of characters, each with an associated aphorism relating to _Bwami_ ethics. It is usually impossible to identify the meaning of a figure from its form alone. However, this example belongs to a morphological type consistently linked with the character _Kakulu Ka Mpito_, "The Great-Old-One with the black hat of monkey hide, who died a bad death because of his pregnant adulterous wife or because of his lack of circumspection" (Biebuyck 1973:218). In addition to their role as icons associated with aphorisms, these figures are also prestige objects, insignia of _Bwami_ rank and symbols of family continuity, since figures pass from generation to generation (Biebuyck 1973:160-81, 214-21, pl. 69).

Lega, Zaire

167
**face mask (*Lukwakongo*) for *Bwami*
 association**
wood, pigment, fiber
h. 10¹/₈ in. (25.7 cm.)

Lukwakongo masks are owned by men who be-
long to the association's second highest grade of
the *Bwami, Lutumbo Lwa Yananio.* Such masks
indicate rank and are worn or displayed in a
variety of ways during rituals. In essence, a mask
symbolizes a man's male ancestry; descriptions of
a mask as "a semblance of man," "the skull of a
dead one" or "the skull of my father" reveal its
ancestral aspect. There are a host of other mean-
ings relating to people, animals or concepts
which these carvings can evoke (Biebuyck
1973:210-13, passim, pls. 60-62).

Daniel Biebuyck's field photograph illustrates ini-
tiates of the *Lutumbo Lwa Yananio* grade during
the *Nkunda* rite approaching the initiation house
in squatting postures. The man on the left has his
personal *Lukwakongo* mask attached to his hat as
a display of status; the initiate on the right wears
an *Idimu* mask on the back of his head (Biebuyck
1982).

This mask is missing the characteristic fiber
beard, and much of the white kaolin coating has
been worn away by handling. It was collected in
1960 by Dr. Nicholas De Kùn at Kambondo village
(Baker 1977). The whitened, depressed, heart-
shaped face represents the easternmost exten-
sion of this motif, found in many areas of the
Equatorial Forest zone.

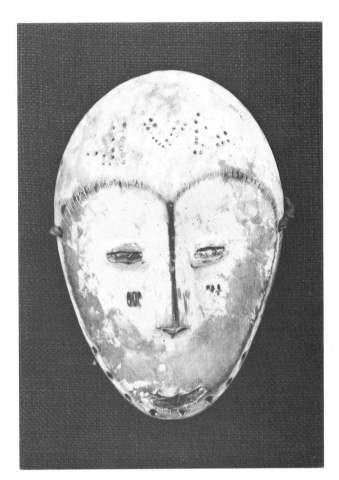

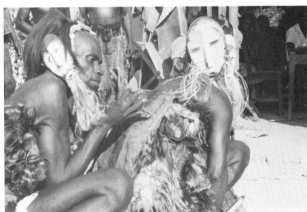

ex-collection: Herbert Baker

exhibited: William Rockhill Nelson Gallery and
 Atkins Museum of Fine Arts, Kansas
 City, 1966
 Expo '67, Montreal, 1967
 Museum of Primitive Art, New York,
 1969-70
 Los Angeles County Museum of Art, 1974
 Indianapolis Museum of Art, 1977-78
 Indiana Central University, Indianapolis,
 1980

published: Museum of Primitive Art, New York, 1969,
 no. 36
 Celenko 1980, no. 49, ill.

I love the classic simplicity of this Lega mask. H.E.

SOUTHERN SAVANNA

The Southern Savanna lies south of the Equatorial Forest zone, extending from the Atlantic Coast to the East African Lakes. The physical environment and socio-political institutions broadly parallel those of the Sudan, Africa's great "Northern Savanna." The term Southern "Savanna" is somewhat of a misnomer since peoples like the Vili, Yombe, Bembe, Kuba and Ndengese live exclusively or primarily in forested rather than grasslands areas. Political organization is generally small-scale in the form of minor chiefdoms, although in the past there existed powerful states such as Kongo (14th-18th centuries), Kuba (17th-19th centuries), Luba (16th-19th centuries) and Lunda (16th-19th centuries). Arabs and Europeans introduced foreign cultural elements, including Islam and Christianity, providing new ideas, object-types and materials which affected the arts.

The concept of the Southern Savanna as a distinct zone of sculpture with stylistic, typal and functional features different from those of neighboring territories, may have first been published by Roy Sieber and Arnold Rubin (1968:120). The regional groupings used here are modifications of Frans Olbrechts' (1959) division of the former Belgian Congo, now Zaire, into style provinces (Maesen 1950; Sieber and Rubin 1968; Cornet 1971; 1978; Bascom 1973; Rubin 1976a; Roy 1979a; Neyt 1981). Relationships of sculptural forms and functions are the basis of the present scheme, however, cultural and historical factors also unify each of the five regions.

The Lower Zaire River region encompasses "Kongo" peoples such as the Yombe, Bwende and Bembe, clustered around the mouth of the great river, as well as the Teke. Figures and personal prestige items are the predominant sculptural forms; masks are relatively rare. Figures carrying magical/medicinal substances (cat. nos. 169-74, 176) constitute an important category of carving, as they do in varying degrees in other Southern Savanna regions. The most notable feature of the region's figurative styles is a frequently occurring naturalism, a trait not fully exemplified by the catalog entries.

In contrast to the relative naturalism of the Lower Zaire River region, carving styles of the Kwango River-Kwilu River region often exhibit anatomical exaggerations and distortions. Magic/medicine figures (cat. nos. 177-79) are common, but polychromed masks (cat. nos. 181-84) used in male initiations are perhaps the most distinguishing aspect of the region's carving.

For centuries most populations of the Kasai River-Sankuru River region have been politically and culturally influenced by peoples of the Kuba complex, notably the Bushoong. Due to the hierarchical nature of Kuba societies there is a profusion of personal prestige items such as cups (cat. nos. 187-88, 190), headrests (cat. no. 189), pipes, cosmetic boxes and textiles. Figures are not prevalent except among the Ndengese and Lulula, groups peripheral to the Kuba complex in the northern and southern parts of the region. Polychromed masks embellished with prestige materials (cat. nos. 185-86) are a major category of sculpture. Carvings from this region have an underlying naturalism modified by stylistic conventions.

The Eastern region, extending from the area of the Sankuru River in the east to the area of Lakes Tanganyika and Mweru in the west, is known for a variety of carvings, including magic/power figures (cat. nos. 191-92), ancestral images (cat. no. 196), figured prestige objects (cat. nos. 193, 195, 197-98), and masks (cat. no. 194). Figures of the Luba, Hemba and related peoples exhibit a sophisticated integration of anatomical forms abstracted to a series of curves.

The arts of the Southern region are exemplified by carvings of the Chokwe, who due to expansionist activities during the last century, are broadly distributed in Angola, western Zambia and south central Zaire. Chokwe carvings exhibit relationships with those of the Lunda, Lwena, Songo, Ovimbundu and other groups with whom they interacted, and the similarity of many of the region's styles is largely due to Chokwe influence. The region's sculpture includes masks (cat. nos. 199-200, 203), free-standing figures and a wide variety of prestige items such as chairs, combs, staffs, tobacco mortars (cat. no. 201) and spears (cat. no. 202) with skillfully rendered, refined forms. Diagnostic features of Chokwe and related styles are bent-knee postures, exaggerated limbs and prominent, lenticular eyes.

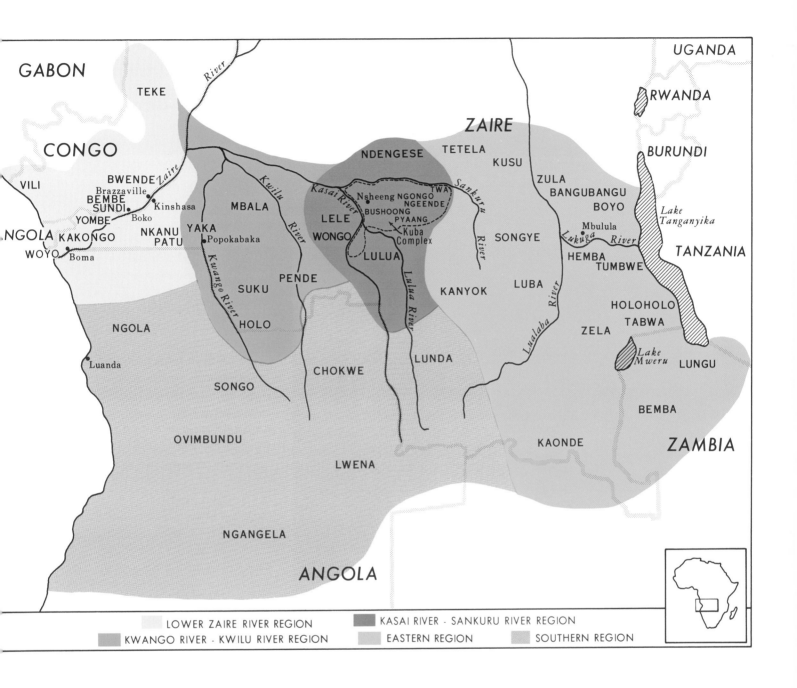

GABON

CONGO

VILI

TEKE

River

ZAIRE

BWENDE
Zaire
BEMBE Brazzaville
SUNDI •Boko •Kinshasa
YOMBE
NGOLA KAKONGO NKANU
WOYO •Boma PATU
YAKA
•Popokabaka

MBALA

Kwilu

Kwango River

SUKU

HOLO

NGOLA

•Luanda

SONGO

OVIMBUNDU

River PENDE

CHOKWE

LWENA

NGANGELA

ANGOLA

NDENGESE TETELA
KUSU
Kasai River Nsheeng NGONGO TWA
BUSHOONG NGEENDE *Sankuru*
LELE PYAANG
WONGO Kuba *River*
Complex
LULUA
Lulua River
KANYOK

LUNDA

ZAIRE

ZULA
BANGUBANGU
BOYO
Lake
Tanganyika
SONGYE
Lukuga *River*
HEMBA
LUBA TUMBWE
Lualaba River
HOLOHOLO
ZELA TABWA
Lake
Mweru LUNGU
BEMBA
KAONDE

UGANDA

RWANDA

BURUNDI

TANZANIA

Mbulula

ZAMBIA

LOWER ZAIRE RIVER REGION KASAI RIVER - SANKURU RIVER REGION
KWANGO RIVER - KWILU RIVER REGION EASTERN REGION SOUTHERN REGION

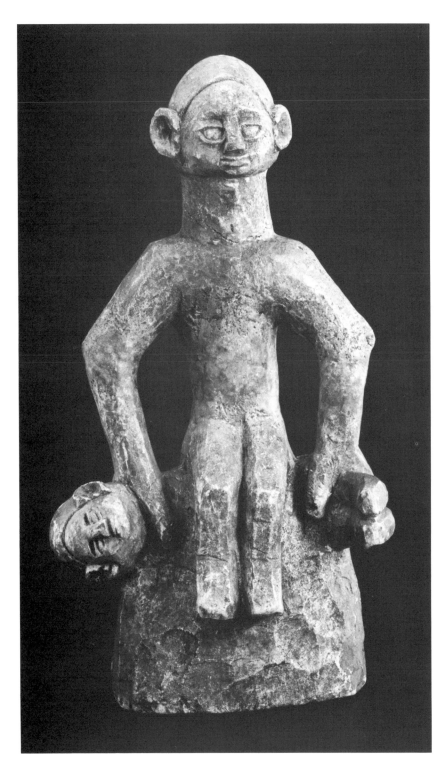

Kakongo (?), Zaire

168
figure group
 (*Ntadi/Tumba/Kinyongo*)
stone
h. 15³/₄ in. (40 cm.)

19th century (?)

In some areas of the Lower Zaire River Region stone images were formerly placed on the graves of important persons. These figures are carved from soft steatite and are often found in damaged condition. This carving was broken into four pieces before its repair and probably originates from an area to the immediate north of the Zaire River near the town of Boma in Kakongo country (Boone 1973:70-75, passim). Joseph Cornet (1981a:213-16) rejects the early dates once given to these figures. He reports that they were made up to about fifty years ago, but that no data exist to indicate they were made before the 19th century.

The imagery of these carvings expresses "proverbial wisdom or spiritual concerns" (Thompson 1981:97). This example is similar to published carvings identified as executioners (Verly 1955:62-64, fig. 11; African Sculpture Unlimited 1981:n.p.; Thompson 1981:99-100, fig. 67, no. 56). However, unlike these, the upper figure of this example does not hold a knife to the head of the lower figure and does not wear the hat of status which in the published examples probably signifies a royal executioner. In more general terms this figure group may allude to defeat and subjugation.

Stone figures are relatively rare in Africa and most are damaged. This piece has been repaired but is complete. H.E.

Yombe (?), Zaire/Congo/Angola

169
chief's scepter
ivory
h. 7⁷/₈ in. (20 cm.)

Living near the mouth of the Zaire River is a complex of peoples collectively referred to as Kongo. Unfortunately, the substyles of this sculpturally rich area, which encompasses such peoples as the Yombe, Bwende, Woyo, Vili, Sundi and Bembe, have not been fully sorted out. Iconographically and stylistically this scepter is similar to examples in the Barbier-Müller collection (Leiris and Delange 1968:ill. 169; Savary 1978:no. 48), the Kerchache collection (Leuzinger 1972:S17), the Prince Sadruddin Aga Khan collection (Sotheby 1983b:lot. 51), the George Ortiz collection (Sotheby 1978:lot. 58), and the Bronson collection (Cornet 1978:no. 13), the latter identified as Yombe. The crowned chief sits on the head of a female figure. The tip of the tusk, which included the bottom half of the female figure, is broken off. In his left hand the chief carries a scepter. His other hand holds a sacred, hallucinogenic plant, which he chews. Pieces of the plant were spat on assemblies during some ceremonies. The magical/medicinal bundle is missing from the top of this carving (Cornet 1978:nos. 12-14; Neyt 1981:90-94).

published: Neyt 1981, fig. V.11

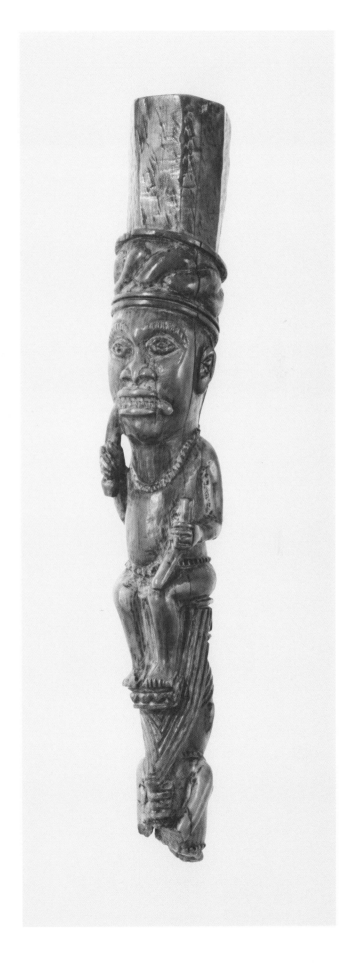

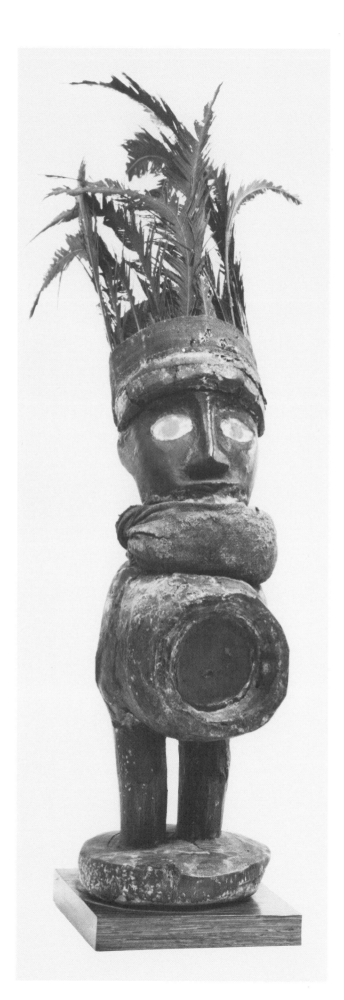

Yombe (?), Zaire/Congo/Angola

170
standing figure *(Nkisi/Nduda)*
wood, glass, cloth, resin, feathers, pigment, metal
h. excluding feathers: 8¹/₈ in. (20.6 cm.)

So-called "fetish" or "magical" figures like this one are found throughout the Lower Zaire River region and among other groups to the east. A universal feature of these figures is their ineffectiveness without the application of magical/medicinal substances by a ritual specialist, known as *nganga* among some peoples. Once a figure has been charged with these substances it is often referred to as *Nkisi;* among the Yombe, who probably made this example, it can also be known as *Nduda.* Clients request these ritual specialists, who often employ *Nkisi,* for a variety of reasons, for example, as protection against thieves or illness, to insure successful hunting, fishing or farming, or to cause harm to an enemy. These images are limited to a specific function which can, however, change over time (Van Wing 1941:86-90; Volavkova 1972:52-54; Cornet 1978: nos. 1-2, 34; Van Geluwe 1978b:158).

A radiograph of this figure reveals hidden accumulations in the top of the head, within the cloth neck ring and within the mirrored torso box, the walls of which are resin. These radiopaque substances, which appear white in the X-ray photograph, probably include resin, fragments of bones, teeth, claws or horns, and perhaps pieces of metal. Screws which secure the figure to the supporting base and the glass inlays in the eyes also appear as white. The relatively radiolucent wood appears as gray, while the feathers surmounting the head have been completely "burned out" during the radiographic process. While heads of *Nkisi* type images are noted for their naturalism, torsos, as revealed in this radiograph, are often minimally carved. (Radiograph taken on T.F.I. Hotshot: Kodak Industrex AA film; 32kV, 3mA, 3 min.; Conservation Department, Indianapolis Museum of Art, 1978).

exhibited: Indianapolis Museum of Art, 1977-78

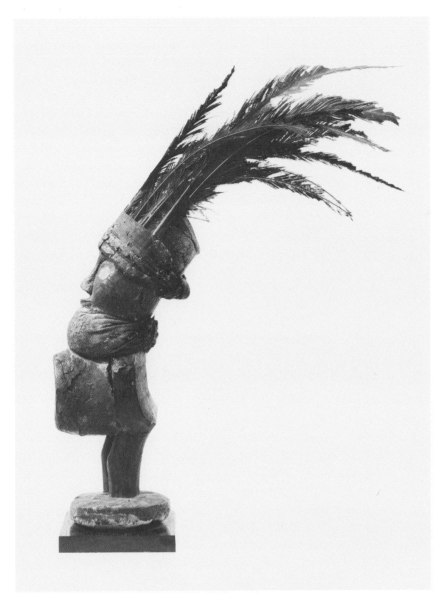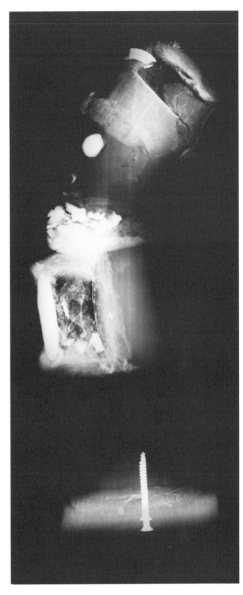

Bwende or Sundi (?), Zaire/Congo

171
male figure *(Nkisi Nkondi)*
wood, iron, medicinal substances
h. 24 in. (61 cm.)

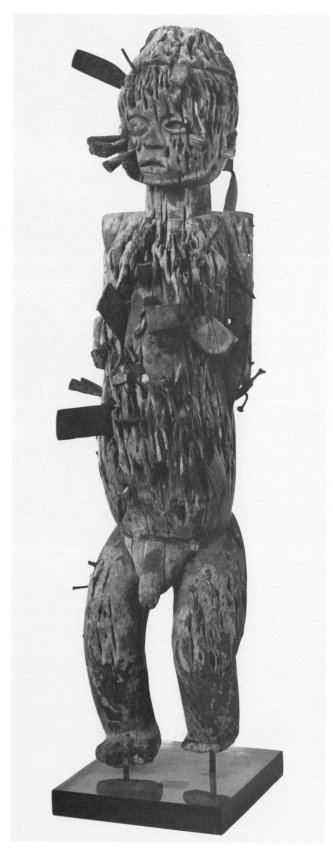

Minkisi Minkondi (sing. *Nkisi Nkondi*), commonly referred to as "nail fetishes," belong to the broader category of *Nkisi* figures prevalent in the Lower Zaire River region and Kwango River-Kwilu River region. Such figures are used by ritual specialists, known as *nganga* in many areas, on behalf of clients. These objects must be activated with medicinal/magical substances, Nkisi, in conjunction with other rituals in order to be efficacious. Residue of such substances is evident on the head of this example. Furthermore, the iron blades and nails, other manifestations of *Nkisi*, identify it as a *Nkisi Nkondi*. The term *Nkondi* has a number of interpretations (Lehuard 1980:106, 109), among which is its relationship to the verb *konda*, to hunt. "Minkisi n'kondi, like seasoned hunters, lurk in ambush for liars, thieves, adulterers, for all sorts of persons who might undermine societal structure" (Thompson 1978a:211). Most of the approximately four hundred original iron inserts have eroded away, fallen out or been removed from this example. The presence of a handful of wooden inserts hints that this figure dates from an early period when wooden, thorn and bone elements were driven into *Minkisi Minkondi* (Thompson 1978a:211-12). Since these figures could be used for a variety of purposes, for example, to establish guilt, to cure illness, to destroy thieves or other evil-doers, or to validate important covenants such as treaties, ascertaining the function of a particular figure without field data presents a problem. However, Robert Thompson (1978a:216-18; Lehuard 1980:182-91) has attempted to relate the various kinds of inserts with particular functions. Following his speculations, the predominance of blade forms in a figure, as in this example, may indicate a role in the settlement of important disputes such as treaties between towns (Van Geluwe 1978a; Thompson 1978a; Lehuard 1980:101-250).

The origin of this carving is uncertain. A similarly styled female figure (K.E. Laman collection) is published as Sundi (Lindbolm 1945:fig. 4). However, Raoul Lehuard (1979; 1980:pl. 82) attributes it to the Bwende (possibly from the area of Boko just north of the Zaire River in Congo) based on the flexed legs, full abdomen, arms held close to the chest, and head and headdress shape.

exhibited: Indianapolis Museum of Art, 1977-78

published: Celenko 1980, no. 44, ill.
 Lehuard 1980, pl. 82

Yombe, Zaire/Congo/Angola

172
female figure with child *(Phemba)*
wood, brass, glass
h. 13³/₈ in. (34 cm.)

Maternal images form an important class of figures from this region. Unfortunately there is limited reliable information about them. The varied interpretations of the generic term for such images, *Phemba*, relate to human fertility and its association with rebirth from the world of the dead. The images may symbolize human fertility through an idealized, high status woman with her child. Some *Phemba* are used by ritual specialists, and an old field report by Léo Bittremieux indicates that one was used by a great diviner. *Phemba* which include magical/medicinal substances probably function similarly to the region's *Nkisi/Nkondi* figures (cat. nos. 170-71; Maesen 1969:pl. 1; Lehuard 1977:45-46, 63-64, 74-78, 83-86, 104-110; Van Geluwe 1978c).

These carvings are laden with prestige references, for example, the depiction of brass anklets and actual brass earrings on this figure, and it is likely that some *Phemba* are generalized images of chiefs' wives. The projecting headdresses of many figures probably depict caps or coiffures of chiefs or other important persons (Lehuard 1977:54-56; Cornet 1978:no. 7). *Phemba* are usually supported by plinths and often have cross-legged, forward-thrusting postures. Inlaid eyes, chest bands and bold scarification patterns are also typical. Although the mouth of this example is atypically unnaturalistic for Yombe styles, its headdress, scarification and overall style identify it as a Yombe work (Lehuard 1979).

exhibited: Indianapolis Museum of Art, 1977-78

The mother-and-child motif symbolizes mother love and continuity of generations throughout the world. H.E.

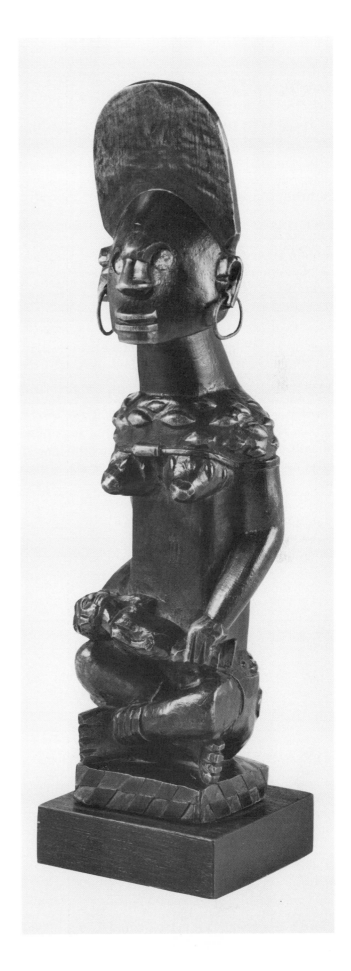

Bembe, Congo

173
male figure (left)
wood, ceramic
h. 5⁷/₈ in (14.9 cm.)

Bembe, Congo

174
female figure with child (right)
wood, ceramic, iron
h. 8¹/₄ in. (21 cm.)

Bembe wood figures are characteristically small, with well-worn patinations, inlaid eyes and extensive torso scarifications. They always have a hole in the anal area into which *Mukuyu*, sacred substances, can be inserted. The *Mukuyu*, which is believed to embody ancestral spirits, is applied by a diviner *(nganga)*. Without *Mukuyu* the images have no religious significance. The figures which have *Mukuyu* receive offerings and can benefit or bring harm to an individual according to his actions (Börrisson in Söderberg 1975:14). Male figures normally hold power and leadership attributes such as knives, staffs, guns and powder flasks; female figures are commonly depicted with palms up or with hands touching the torso. Maternal images are rare.

cat. no. 173
exhibited: Indianapolis Museum of Art, 1977-78

cat. no. 174
exhibited: Fondation pour la Recherche en
 Endocrinologie Sexuelle et l'Etude de
 la Reproduction Humaine/La Société
 Générale de Banque, Brussels, 1977
 Indianapolis Museum of Art, 1977-78
 Indiana Central University, Indianapolis,
 1980

published: Fondation pour la Recherche en
 Endocrinologie Sexuelle et l'Etude de
 la Reproduction Humaine/La Société
 Générale de Banque 1977, no. 42, ill.
 Celenko 1980, no. 43

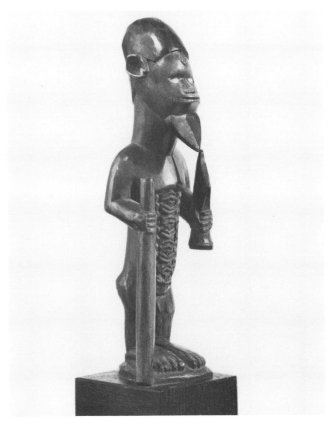

I love these beautifully carved small figures. Their aesthetic sophistication belies the impression most people have of "primitive" art. H.E.

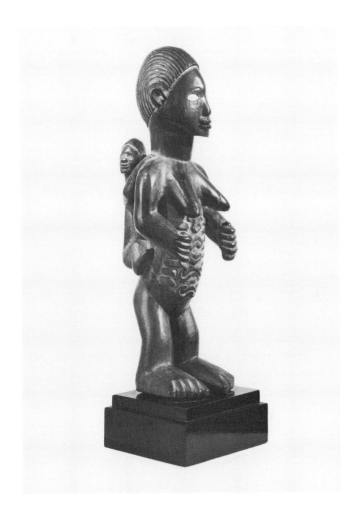

Vili (?), Congo/Gabon

175
ritual skull
simian skull, basketry, earth, pigment, claw
l. 7⁷/₈ in. (20 cm.)

Interest in the skull as a ritual object seems to be more prevalent within an area extending from eastern Nigeria to the mouth of the Zaire River than anywhere else in Africa. Overmodeled and embellished simian skulls such as this one are usually attributed to the Vili or more northerly, equatorial forest groups such as the Lumbo and Kwele (Millot 1961:74, fig. 5; Perrois 1979:295; Siroto 1972:65-66; Rivière 1975:138). Although the significance of this object is uncertain, it is possible that it served as a ritual device intended to harness the spirits of bush animals. Radiographic analyses of this and another example in the Eiteljorg collection reveal the presence of small radiopaque objects, perhaps of ritual import, placed within each skull before it was enveloped with earth and basketry.

exhibited: Indianapolis Museum of Art, 1976

published: Gilfoy 1976, no. 100

In my Oceanic collection there are also human skulls that were used for ritual purposes. H.E.

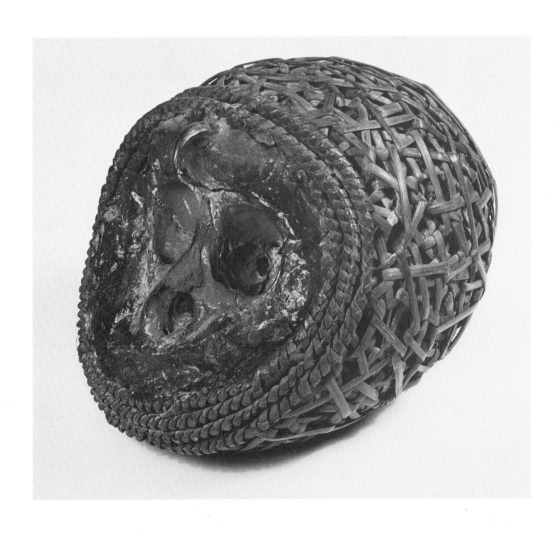

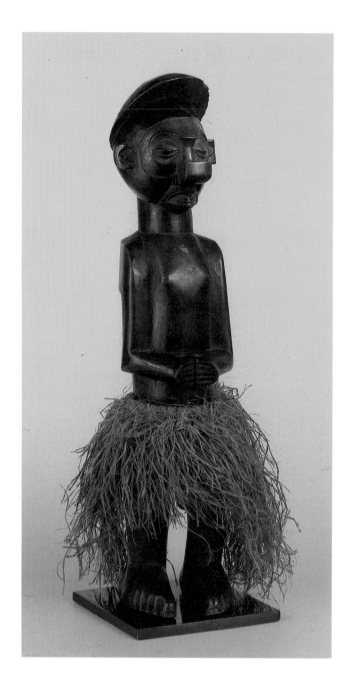

Nkanu (?), Zaire/Angola

176
male figure *(Nkisi)*
wood, fiber
h. 18⁷/₈ in. (48 cm.)

Carving styles of the Nkanu, Patu and other peoples (Boone 1973:157-60, 166-67, passim) of the easternmost Kongo complex have been strongly influenced by the Yaka, as evidenced in this figure by the recessed face and upturned nose. However, according to Arthur Bourgeois (1982), compared to Yaka styles the greater naturalism and more sharply rendered, rounded and compact forms of this figure place its origin among the Nkanu or other eastern Kongo group. Medicine bundles may once have been affixed to the figure; the hands have holes, perhaps for this purpose. Charged with magical/medicinal substances, this figure would have served as a *Nkisi* for a *nganga*, or ritual specialist, on behalf of clients. Such figures are used for a wide variety of specific functions, for example, to aid in childbirth, to cure an illness, to produce a good harvest or as protection against thievery (Van Wing 1941:86-90).

exhibited: Indiana Central University, Indianapolis, 1980

published: Celenko 1980, no. 45
Celenko 1981, fig. 16

This strong and rugged figure is accentuated by its angular, upturned nose. H.E.

Mbala, Zaire

177
drummer
wood, pigment, skin, fiber, brass, iron
h. 20³/₁₆ in. (51.3 cm.)

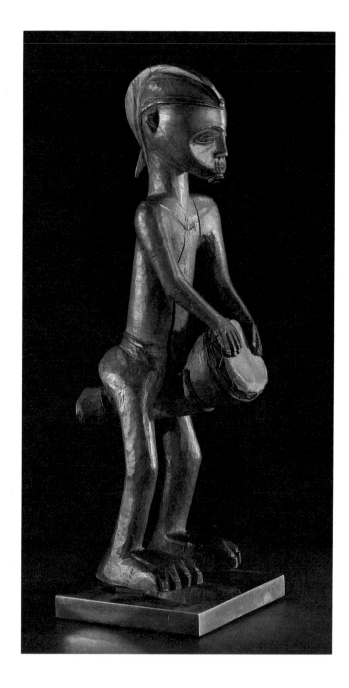

Musicians are a favorite theme for Mbala carvers. Such carvings are used at the installation of chiefs as symbols of power (Information and Documentation Center of Belgian Congo and Ruanda-Urundi 1950:ills. 17-18; Van Geluwe 1967:32, no. 7.3; Maesen 1969:pl. 15; Leuzinger 1972:T2; Cornet 1981b). However, early writers on the Mbala discuss, but do not illustrate, medicine-imbued figures used by specialists on behalf of clients for success in hunting, healing and other specific purposes (Torday and Joyce 1905:419-20; Pierpont 1932:199-204). Such a function relates to similarly used figures among the neighboring Yaka (cat. nos. 178-79) who have culturally influenced the Mbala. The incorporation of a small cavity in the anal area of this carving suggests that it relates to the broader complex of Southern Savanna magic/medicine figures. Material enclosed within the hollow drum, which is covered with animal skin, may also be medicinal, or perhaps included for its audible potential since the carving serves as a rattle when shaken. The figure is said to have been collected by missionaries in 1932. Its animated posture, facial features and crested coiffure are typical of Mbala carving.

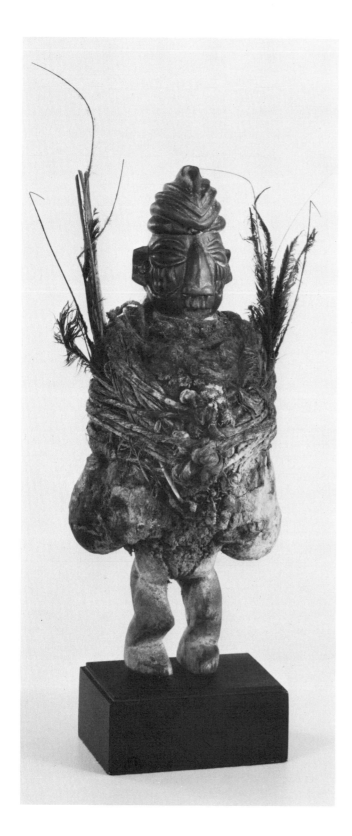

Yaka, Zaire
northern area

178
female figure (*Kiteki, Mpungu type*)
wood, pigment, fiber, feathers, brass, earth,
 incrustation, medicinal substances
h. of wood carving: 10⁵/₈ in. (27 cm.)

The Yaka use a variety of protective figures known generically as *Biteki* (sing., *Kiteki*). *Biteki* derive their power from medicinal substances, *Nkisi*, applied by a ritual specialist, *nganga*. These charms, which are kept in houses or ritual huts, protect property, cure illness and assure the well-being of future generations.

Cat. no. 178 is a type of *Kiteki* called *Mpungu* which serves as a personal charm discarded after its owner dies. It functions primarily to protect the owner from enemies and other harm. Such figures are characterized by a large *Nkisi* bundle which envelops the torso. The bundles are typically bound with fiber cords and include elements from wild animals, certain plants, minerals and cartridge shells, a number of which are embedded in this example (Bourgeois 1982).

Yaka, Zaire
northern area

179
male figure *(Kiteki)*
wood, iron
h. 8¹⁵/₁₆ in. (22.8 cm.)

Cat. no. 179 probably belonged to a lineage, rather than an individual, and would have been handed down from generation to generation (Bourgeois 1982). Small cavities in the torso and head probably once contained medicinal substances. The surface, which has been polished, may have also once carried *Nkisi*. According to Arthur Bourgeois (1982) this figure resembles the earliest group of Yaka carvings collected around the turn of the century (for example, see Krieger 1965:no. 256). Typical Yaka features of this example include the outlined face, prominent nose, globular eyes, hands-to-chest gesture and bent-knee stance.

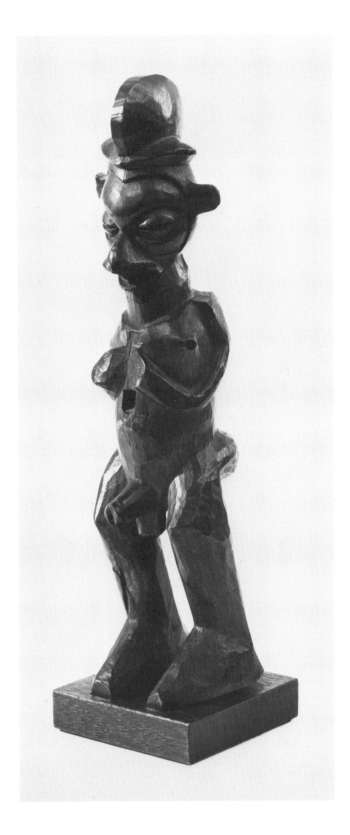

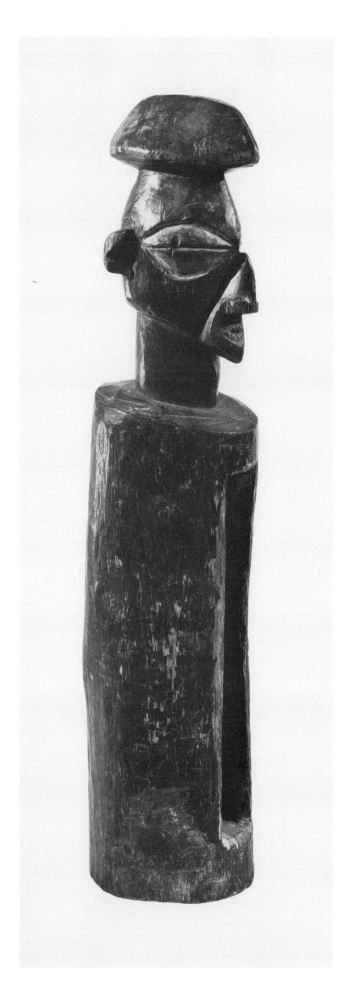

Yaka, Zaire
northern area

180
diviner's instrument (*mukoko ngombo*)
wood, pigment, medicinal residue
h. 16¼ in. (41.3 cm.)

Portable slit drums serve as badges of office for the most revered class of diviners, the *nganga ngombo*, ritual specialists who are sought out to cure illness and counter the negative forces of witchcraft. A *mukoko ngombo* is used by a diviner as a drum to signal his or her arrival into an area, as a stool when consulting clients and as a vessel to prepare medicine (Cornet 1975:no. 36; Bourgeois 1982). Near the opening this carving is worn from beating by a drum stick, and the cavity is coated with a medicinal substance. Arthur Bourgeois' 1976 field photograph, taken in the Popokabaka area of northern Yakaland, depicts a diviner with her *mukoko ngombo.*

Yaka, Zaire
area of Popokabaka town (?)

181
helmet mask for *Nkanda* rite
wood, pigment, cloth, fiber
h. approx. 22¹/₂ in. (57.2 cm.)

Yaka masks appear during festivities which celebrate the "coming out" of young men from the initiation camp (*Nkanda*). This example is a lower ranking *Ndemba* or *Miondo* type. Masks do not depict spirits or ancestors; rather they should be regarded as ". . . charms of good reception used almost as dance wands and worn on the head or held before the face only momentarily . . ." (Bourgeois 1982). The field photograph, published in Plancquaert's 1930 monograph on the Yaka (fig. 38), depicts fully costumed initiates with their masks. *Nkanda* masks used to be burned at the end of initiations, but today they are kept to be rented or sold (Plancquaert 1930:112-15; Bourgeois 1982). Unlike an increasing number of African sculptural traditions those of the Yaka are still viable.

This variety of mask typically includes a carved lower portion with projecting handle, a cloth-fiber superstructure which incorporates a variety of motifs and a prominent collar of raffia. The antennae-like elements of this example may be related to a chief's headdress. The "tear streaks" under the eyes are said to symbolize the initiates' suffering. The upturned nose, perhaps the most diagnostic feature of Yaka carving, may be no more than decorative or may refer to bird, elephant or phallic symbols (Devisch 1972:155; Bourgeois 1979:62; 1982).

exhibited: Indianapolis Museum of Art, 1977-78

Pende, Zaire
eastern Pende

182
helmet mask (below)
wood, pigment, fiber
h. 17¹⁵/₁₆ in. (45.6 cm.)

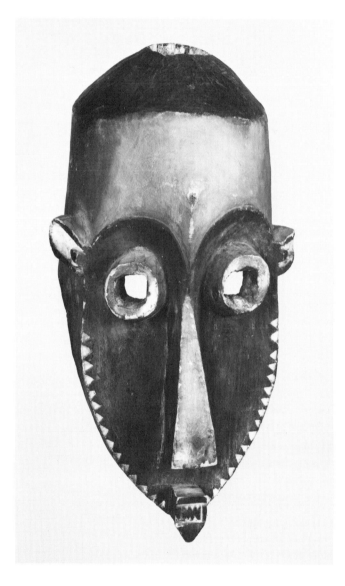

cat. no. 182
exhibited: Indianapolis Museum of Art, 1977-78

cat no. 183
published: Celenko 1981, fig. 14

These three masks from the same ethnic group are completely different in shape yet similar in their geometric detail. H.E.

Masks of the eastern or Kasai Pende differ from those of the western Pende in their greater stylization and incorporation of linear, geometric designs. Red, black and white polychrome and rows of small incised, painted triangles are typical of the eastern group. Masks embody ancestral forces and serve as intermediaries with the spirit world. Maskers perform during such significant communal events as ceremonies terminating the initiations of youths, installments of chiefs, agricultural rites and village relocations (Van Geluwe 1978d).

Kindombolo masks (cat. no. 183) of varying forms are found among both the eastern and western Pende (de Sousberghe 1958:38, 55-56, figs. 57, 85). Eastern masks are characterized as sorcerers (Cornet 1978:no. 74) and tricksters (Janzen and Kauenhoven-Janzen 1975:46). Small holes in the cheeks of some of these masks may mimic the effects of smallpox (Van Geluwe 1967:33). Like many Pende masks the *Kindombolo* may have a host of functions. Their use is documented in periodic village renewal rituals related to the planting of millet (Janzen and Kauenhoven-Janzen 1975:44, 46) and in a ritual to assure successful childbirth (Bastin in de Sousberghe 1958:56). Feathers and fibers may have once been affixed to this mask. Stylistic interaction of the eastern Pende with the Kuba, Lele, Wongo, Chokwe and other nearby peoples is not uncommon, and the hairline on this mask is similar to those of Kuba carvings.

The *Panya Ngombe* mask (cat. no. 184) is characterized by exaggerated width and frequently includes laterally projecting ears or panels. Masks of this type and replicas without eye openings are mounted on doors and lintels of chiefs' compounds as emblems of office (de Sousberghe 1958:63-64, figs. 78, 219). A field report documents a *Panya Ngombe* masker who implanted ancestral bundles, *mahamba*, around a chief's compound; it appeared with another masker, *Pakasa*, the buffalo, which it symbolically killed with a knife (Souris in de Sousberghe 1958:61-62, 68, fig. 78). The *Panya Ngombe* is also documented during the initiations of youths (Janzen and Kauenhoven-Janzen 1975:44).

The identity of the helmet mask (cat. no. 182) is uncertain. It relates in some aspects to *Phumba A Mfumu* masks, which are reserved for chiefly activities (de Sousberghe 1958:61-62; Janzen and Kauenhoven-Janzen 1975:44, 47; Cornet 1975:no. 45).

Pende, Zaire
eastern Pende

183
face mask (*Kindombolo*) (right)
wood, pigment
h. 9¼ in. (23.5 cm.)

Pende, Zaire
eastern Pende

184
face mask (*Panya Ngombe*) (below)
wood, pigment
w. 18¾ in. (47.6 cm.)

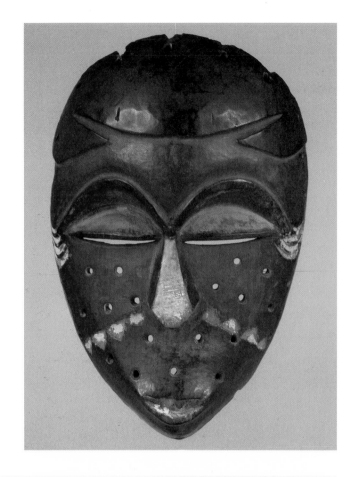

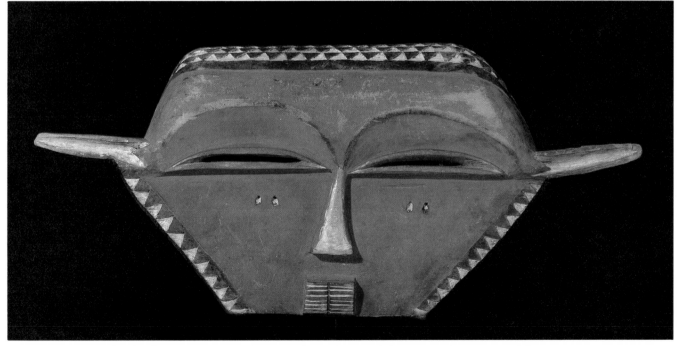

Kuba complex, Zaire
Ngeende (?)

185
helmet mask
wood, pigment, fiber, basketry, glass,
 cowrie shells, brass, iron
l. 16¹/₂ in. (41.9 cm.)

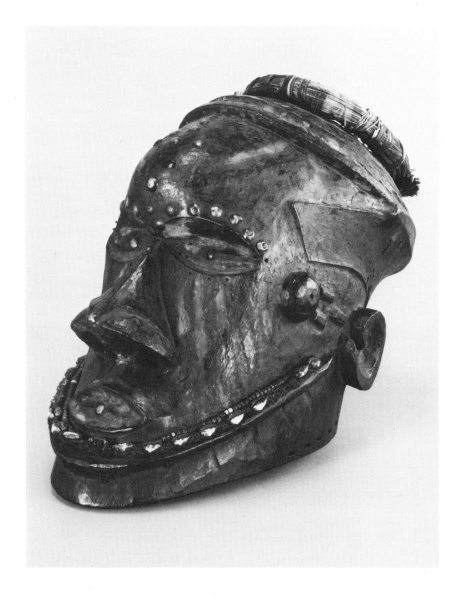

The term Kuba refers to a complex of peoples situated between and near the confluence of the Kasai and Sankuru Rivers. The unity of these groups, which include the Bushoong, Ngeende, Pyaang, Ngongo, Twa and other peoples, is the result of political domination by the Bushoong, whose kings ruled the area until the early years of this century. Due to Bushoong political hegemony these peoples share similar prestige arts and masking traditions (Cornet 1971:120, 123; Vansina 1978:3-11). Unfortunately attribution of an object to a particular group presents a problem because of mutual influences and because substyles within the Kuba complex are not yet adequately identified.

Writings about Kuba masking have focused on three Bushoong mask types, *Mwaash A Mbooy*, *Bwoom* and *Ngaady A Mwaash*, which appear during initiations and funerals and present the myths of the royal founding of the Bushoong kingdom. However, there are a host of other mask types among the Bushoong and other groups which are not well documented. The identity of these two examples is uncertain; it is likely that they were worn during initiations, funerals or entertainments (Van Geluwe 1967:36; Cornet 1971:138, 141; 1975:76-77, 82-89, 92-95; 1978:194-219; 1982:249-78; Vansina 1978:215-17; Neyt 1981:159-69). Cat. no. 185 may be a variant of the *Bwoom* mask with its boldness of form, surface embellishment with prestige materials (in this example painted designs, metal tacks, cowrie shells and glass beads) and viewing holes under the nose (Van Geluwe 1967:36; Cornet 1971:138, 141; 1978:nos. 109-111; 1982:264-70; Neyt 1981:161-64). Cat. no. 186 relates to the *Pwoom Itok* entertainment mask with its stylized face with projecting eyes surrounded by small holes. However, the horn-like elements, whose

Kuba complex, Zaire
unidentified ethnic group

186
face mask
wood, pigment, cloth, fiber,
 cowrie shells
h. of wood carving: 10³/₄ in.
 (27.4 cm.)

significance is uncertain, preclude a
firm identification. The cloth con-
struction on top of the carving is
common in Kuba face masks, and
feathers indicating high status may
also once have been attached there
(Cornet 1975:no. 59; 1978:no. 112;
Neyt 1981:163-64, 169).

cat. no. 186
exhibited: Indianapolis Museum of
 Art, 1977-78

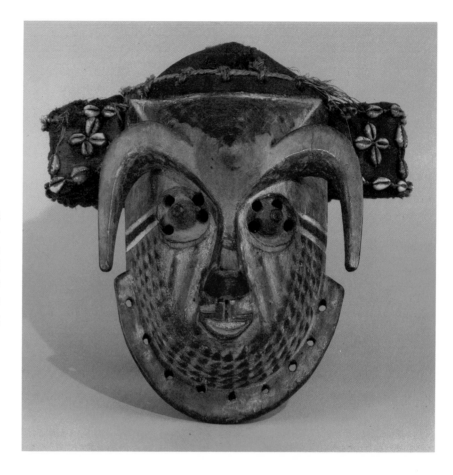

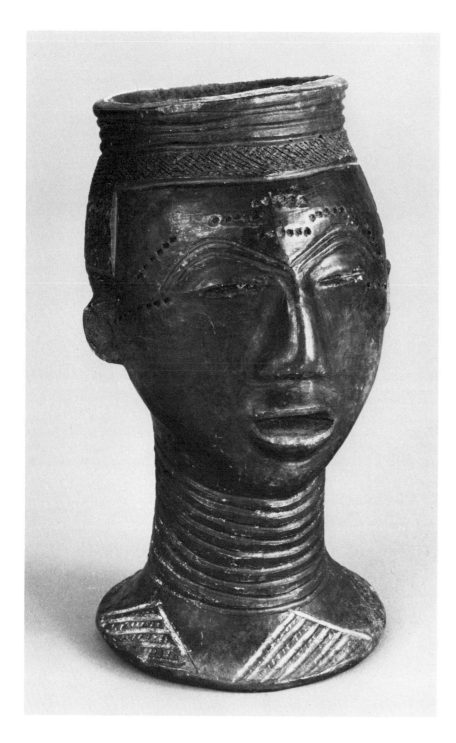

Kuba complex, Zaire
unidentified ethnic group

187
cup
clay, pigment
h. 6³/4 in. (17.1 cm.)

The peoples of the Kuba complex are famous for their elaborately carved wine cups, cosmetic boxes, tobacco pipes, combs and other personal items, which in addition to their utilitarian nature serve as prestige objects. Wine cups in the form of human heads are not uncommon and few examples are without some geometric surface patterns which resemble designs of textile embroidery and beadwork. Cat. no. 188, with female genitals and characteristic Kuba facial features, is a particularly fine example with a well-worn, lustrous reddish-brown patination. Its old style coiffure with prominent lateral projections is a type reserved for high-ranking men as well as chiefs' wives and women pregnant for the first time (Torday and Joyce 1910:168-69, 280-82, passim; Torday 1925:100, ills. 1-2). The hairlines depicted on both of these cups and on the Kuba masks (cat. nos. 185-86) result from shaving and are frequently found on anthropomorphic objects. Cat. no. 187, which was collected over half a century ago (White 1923-26), is unusual, being of clay. The additive medium dictates a softer treatment of forms than is apparent in the more hard-edged, sharply delineated features characteristic of Kuba wood carving. Jan Vansina (1978:218) speculates that cups and other objects, originally made of clay and basketry, were later translated into wooden form with the advent of Bushoong-oriented court art. How-

Kuba complex, Zaire
unidentified ethnic group

186
face mask
wood, pigment, cloth, fiber,
 cowrie shells
h. of wood carving: 10³/₄ in.
 (27.4 cm.)

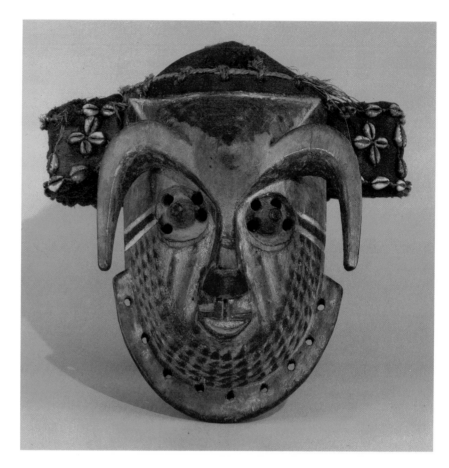

significance is uncertain, preclude a
firm identification. The cloth con-
struction on top of the carving is
common in Kuba face masks, and
feathers indicating high status may
also once have been attached there
(Cornet 1975:no. 59; 1978:no. 112;
Neyt 1981:163-64, 169).

cat. no. 186
exhibited: Indianapolis Museum of
 Art, 1977-78

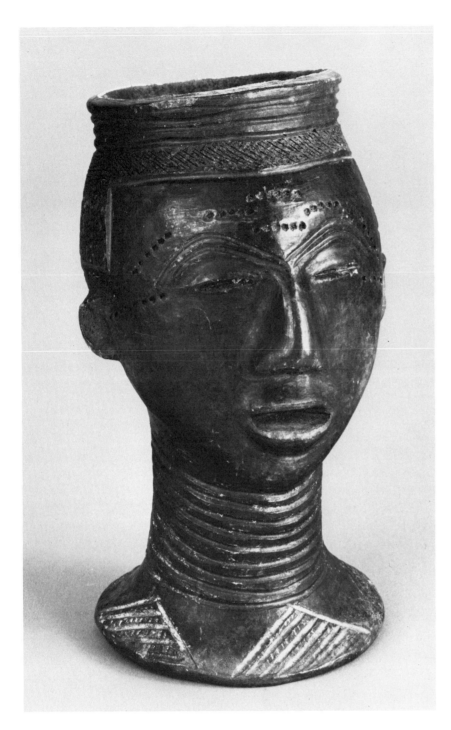

Kuba complex, Zaire
unidentified ethnic group

187
cup
clay, pigment
h. 6³/₄ in. (17.1 cm.)

The peoples of the Kuba complex are famous for their elaborately carved wine cups, cosmetic boxes, tobacco pipes, combs and other personal items, which in addition to their utilitarian nature serve as prestige objects. Wine cups in the form of human heads are not uncommon and few examples are without some geometric surface patterns which resemble designs of textile embroidery and beadwork. Cat. no. 188, with female genitals and characteristic Kuba features, is a particularly fine example with a well-worn, lustrous reddish-brown patination. Its old style coiffure with prominent lateral projections is a type reserved for high-ranking men as well as chiefs' wives and women pregnant for the first time (Torday and Joyce 1910:168-69, 280-82, passim; Torday 1925:100, ills. 1-2). The hairlines depicted on both of these cups and on the Kuba masks (cat. nos. 185-86) result from shaving and are frequently found on anthropomorphic objects. Cat. no. 187, which was collected over half a century ago (White 1923-26), is unusual, being of clay. The additive medium dictates a softer treatment of forms than is apparent in the more hard-edged, sharply delineated features characteristic of Kuba wood carving. Jan Vansina (1978:218) speculates that cups and other objects, originally made of clay and basketry, were later translated into wooden form with the advent of Bushoong-oriented court art. How-

Kuba complex, Zaire
unidentified ethnic group

188
cup
wood, iron
h. 9³/4 in. (24.8 cm.)

ever, the assumption that most of
the wine cups, cosmetic boxes and
other such items originate from the
Bushoong court at Nsheeng should
be questioned since Kuba styles
have not been adequately identified
(Vansina 1978:217-218).

cat. no. 187
exhibited: Indianapolis Museum of
 Art, 1977-78

cat. no. 188
exhibited: Indianapolis Museum of
 Art, 1977-78

published: Celenko 1981, fig. 15

*This is a very handsome example
from my cup collection. It has a
lovely rich patina that shows years of
care and use. H.E.*

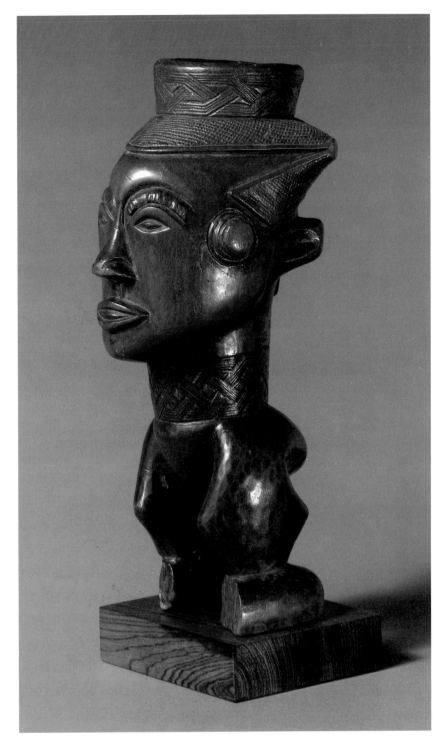

Kuba complex, Zaire
Twa (Tshwa/Cwa)

189
headrest
wood
l. 10⁵/₈ in. (27 cm.)

The Twa are a people of pygmy stock who live among Mongo peoples, the Kuba and other Bantu groups of Central Africa. Because of acculturation and intermarriage the Twa have come culturally and physically to resemble these groups (Murdock 1959:48-51; Boone 1961:20, 74; 1973:173, 176-77; Cornet 1975:94; Vansina 1978:4-9; Gillon 1979:118; Neyt 1981:152). Among the Kuba they ". . . have an official representative at the court of the

. . . king, . . . who serves as an intermediary to present the king with tributes from the hunt" (Cornet 1975:94). The very few published examples of Twa carving include at least two masks copied from a Kuba type (Cornet 1975:no. 70; 1978:no. 106). Other published carvings from the Kuba-ized Twa include two headrests very similar to this one (Christie 1978b:161; Gillon 1979:fig. 148). All three include pairs of half-figures in janus orientation, and at least one other headrest besides this one is embellished with Kuba-like incisings on the top. This carving probably depicts females, since the other published examples each portray a female and a male with a prominent penis.

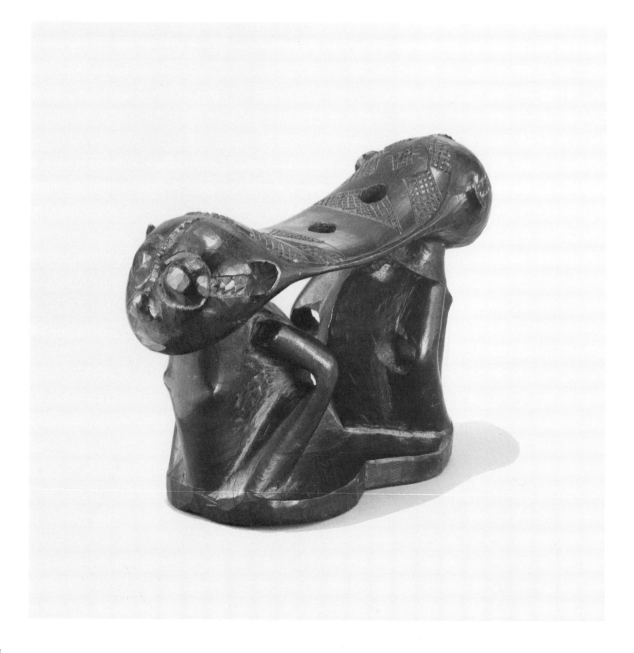

Wongo, Zaire

190
drinking vessel
wood, pigment, iron, fiber
h. 10⅝ in. (27 cm.)

Wongo carvings are typified by full-bodied, bulbous features. Influence from the nearby Kuba complex is suggested in this example by the hairline and eye conventions. This female figure vessel was confiscated by Belgian officials in 1923, shortly after which it was acquired by Major John N. White, an American missionary. Such vessels are usually identified as men's prestige cups for drinking palm wine. However, White's field notes (1923-26) indicate that the mouth of the cup was once covered with locally made cloth, and fibers are still evident beneath one of the three iron tacks near the rim. A cloth covering suggests that the vessel had greater significance than a wine cup. Although the accuracy of White's observations is questionable, he further indicates that the carving had an ancestral significance. Lajos Boglár (in Bodrogi 1968:pl. 163) identifies a similar carving collected by Emil Torday as a poison cup.

exhibited: Indianapolis Museum of Art, 1977-78

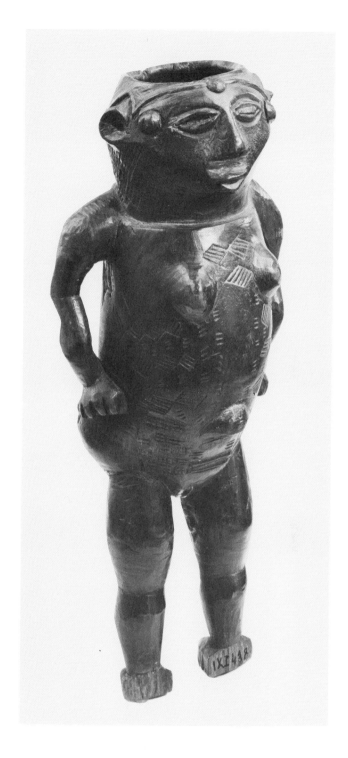

Songye, Zaire

191
male figure
wood, pigment
h. 4⁷/₈ in. (12.4 cm.)

Figures bearing accumulations of magical, power and prestige materials, sometimes referred to as "fetishes," are prevalent among the Songye. Cat. no. 192 probably served as a protective device for an individual or group, perhaps an entire community. Such figures are the focus of periodic rituals and function to combat witchcraft and to promote fertility and general well-being (Cornet 1971:238-47; 1978:nos. 158-61).

According to a scheme proposed by Arnold Rubin, this type of figure is classified as a "power" figure which is ". . . activated through the transfer and concentration of essential qualities in the form of a wide range of attributes derived from a variety of sources. The objective of these procedures is the organization and exploitation of the qualities inherent in such attributes for the benefit of an individual or group" (1974:13-14). "Power" elements in this example include pelts, animal horn and magical substances apparent in some areas. Other elements, which Rubin terms "display," play a secondary role. They include prestige materials such as the metal appliqué on the head of this example and enhance the attractiveness and value of an object without necessarily increasing its effectiveness (Rubin 1974).

The miniature (cat. no. 191) which was acquired by the missionary Major John C. White (1923-26) over half a century ago, probably functioned as an amulet. Such personal images are viewed as protection and insurance of success in life. Like large Songye figures these carvings are also provided with magical substances, which in this figure may have been in the head cavity (Neyt 1981:262). Unlike larger figures, whose forms are usually concealed by accumulations of foreign materials, small figures like this relatively naturalistic one reveal the large head with jutting jaw, short legs and hands on prominent abdomen characteristic of Songye styles.

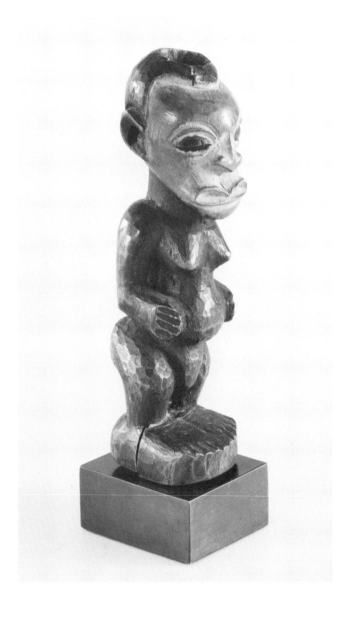

cat. no. 191
exhibited: Indianapolis Museum of Art, 1977-78

cat. no. 192
ex-collection: Paul Tishman

exhibited: Musée de l'Homme, Paris, 1966
 Israel Museum, Jerusalem, 1967
 Los Angeles County Museum of Art,
 1968-69
 Virginia Museum, Richmond, 1970

published: Musée de l'Homme 1966, no. 109
 Israel Museum 1967, no. 178
 Sieber and Rubin 1968, no. 156, ill.

Songye, Zaire

192
male figure
wood, metals, hide, fur, horn,
 gourd, medicinal substances
h. excluding lower fur: 16³/₄ in.
 (42.6 cm.)

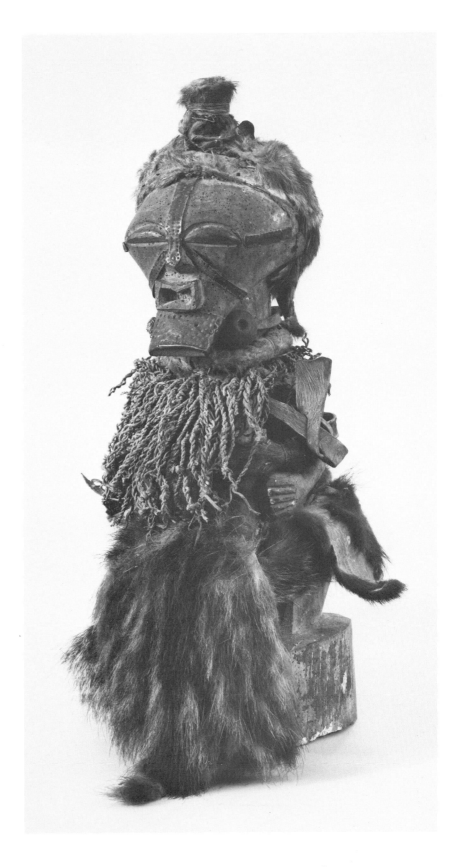

*The American Indian medicine man used a
medicine bundle to practice his magical powers.
His bundle, like this figure, contained many little
strange objects with spiritual or social signi-
ficance. H.E.*

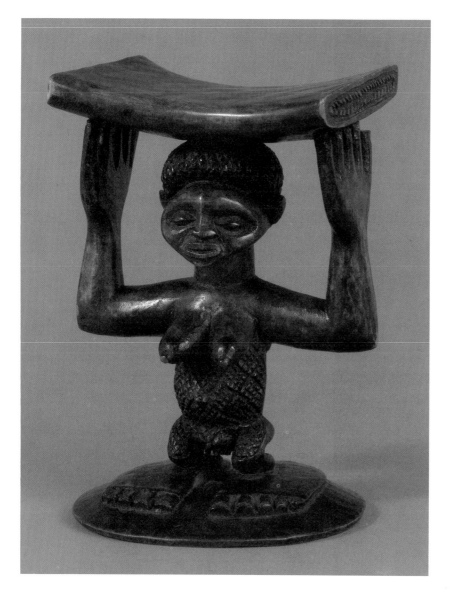

Kanyok (Bena Kanioka), Zaire

193
headrest
wood
h. 6³/4 in. (17.2 cm.)

Kanyok carvings are relatively rare; most examples are prestige objects such as tobacco pipes, staffs, combs, cups, stools and headrests. In some areas of Africa headrests are used by one or both sexes as a support while resting or sleeping in order to maintain elaborate coiffures. The exaggerated size of the hands and feet, which lends an air of monumentality to this miniature, is a Kanyok stylistic trait that relates to carvings of the Luba, to whom the Kanyok are culturally related, and to those of the Chokwe, who settled in the area during the last century.

exhibited: Indianapolis Museum of
 Art, 1977-78

published: Celenko 1980, no. 47, ill.
 Celenko 1981, fig. 18

I can't believe it would be comfortable, but it is certainly a charming miniature work of art. H.E.

Luba(?), Zaire

194
face mask for *Kifwebe* society
wood, pigment, feathers, fiber, basketry, shells
h. of wooden mask: 14¹/4 in. (36.2 cm.)

Kifwebe masks of disparate styles are documented among and attributed to both the Luba and Songye. This example is cautiously assigned a Luba origin based largely on similar white-faced masks published recently by Joseph Cornet (1975:nos. 82-83; 1978:nos. 155-56) and François Neyt (1981:246-53). However, other published masks similar to this one are identified as Songye, and the confused state of available information regarding these carvings does not permit a confident ethnic attribution of any but the most typical examples (Merriam 1978; Roy 1979a:nos. 174, 182-83; Ezra 1981). A feature shared by these carvings is a surface covered with parallel grooves. A prominent rounded forehead and protruding angular nose and mouth are characteristic. Information about these masks is sketchy. They are associated with the *Kifwebe* society and are reported to appear during public entertainments, funerals, installations and other occasions.

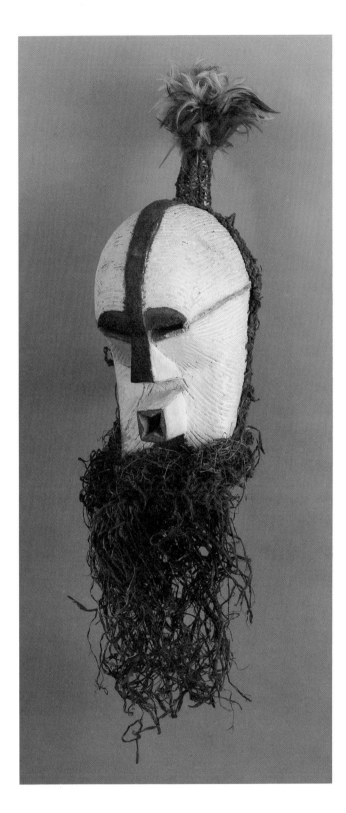

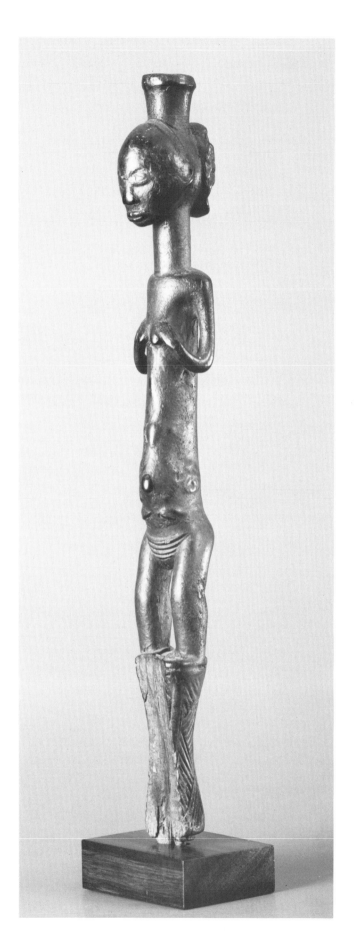

Luba (?), Zaire

195
female figure from staff or spear
wood, metal, incrustation
h. 16¹/₄ in. (41.3 cm.)

François Neyt (1980) attributes this carving to an area between the towns of Kiambi and Kabalo south of the Lukuga River, an eastern tributary of the Lualaba, and further identifies it as a "Luba-Hemba" work. However, it is unclear from the literature, particularly Olga Boone's thorough survey of the region (1961:vii, 43-45, 85, 115, 145, 156, 215, 258, 263; Murdock 1959:294; Biebuyck 1978:19-21, 98-102) and even Neyt's own writings (1977:18, 38; 1981:232-86), whether the awkward designation "Luba-Hemba" refers to a genuine ethnic group or to a conglomerate of peoples of varying cultural affinities with the Luba and Hemba, who border the area south of the Lukuga River.

This figure was part of a staff or ceremonial spear which probably served as a symbol of authority for a family or village chief (Neyt and Strycker 1975:48). Such staffs and spears are characterized by decorative incisings, metal embellishments and in some instances figurative elements, which may be ancestral (Cornet 1971:210). Radiographs reveal fragments of metal implants in the coiffure and other areas of the head, which were probably decorative in their original state. The typically rounded forms of this area's carvings are in this example further softened by a thick but smooth incrustation which obscures some of the facial features and torso scarification.

published: Celenko 1981, fig. 17

Hemba, Zaire
Niembo chiefdom, area of Mbulula town

196
male figure *(Singiti)*
wood, incrustation, fiber, glass
h. excluding fiber garment: 30 in. (76.2 cm.)

Until recently the sophisticated and now highly acclaimed carvings of the Hemba were little known outside Africa, and it has only been within the past decade that Hemba carving has been isolated as a cluster of styles distinct from earlier identified and more widely known Luba styles. François Neyt (1980) attributes this figure, which recalls some 19th century figures, to the Mbulula area of the Niembo chiefdom north of the Lukuga River (Neyt 1977:60-85, 88-89, 166-71). In this area ancestral images are called *Singiti.* They commemorate important men and are kept in special huts of principal families, serving as genealogical references and as foci for ancestor worship (Neyt and Strycker 1975:10, 16; Neyt 1977:480-83; 1978).

Common to a number of Hemba substyles are stylized beards and elaborate coiffures terminating in cruciform patterns at the back. The prestige coiffure imitates an actual practice of building up the hair with oil, powder and false hair upon a raffia support. A diadem marks the highly shaved hairline. The lustrous black surface results from application of river mud, animal blood, palm oil and other substances, and years of handling.

exhibited: Indianapolis Museum of Art, 1977-78

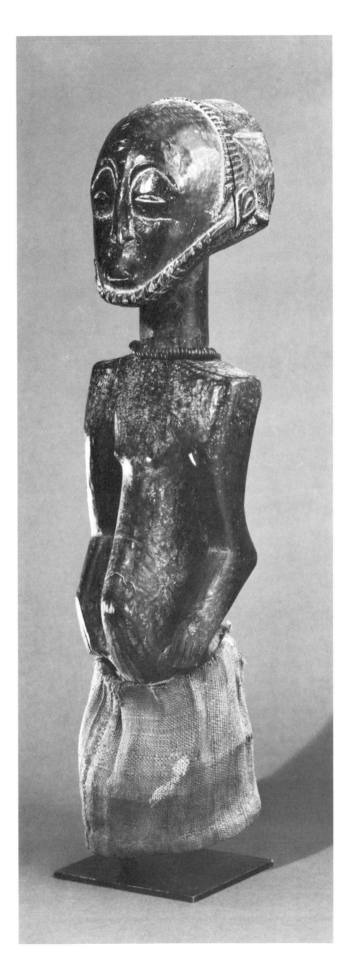

Zela (?), Zaire

197
stool
wood
h. 15¹/₁₆ in. (38.3 cm.)

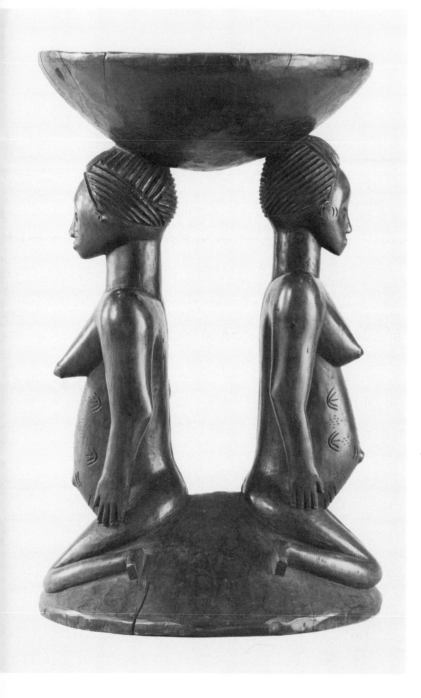

Louis de Strycker (1979) attributes this fine carving to the Zela, a little-studied, Luba-related group located south of the Hemba and east of the Luba (Boone 1961:247-51). It was published in 1947, while still in the collection of the Musée Léopold II, as Bazela (Zela) or Bashila (Shila) (Waldecker 1947:5, fig. 10), eastern neighbors of the Zela. Two other stools (Parke-Bernet 1966:lots 86-87), formerly in the Helena Rubinstein collection, each with two caryatids similar in style to these, are attributed to the Bazala subtribe of the Baluba. However, there is apparently no ethnic group identified as Bazala or Zala from this part of Africa (Murdock 1959; Boone 1961). Another carving in a related style, a kneeling female with raised hands in the Barbier-Müller collection (Savary 1978:no. 64), is tentatively identified as Holoholo, a group living over one hundred miles northeast of the Zela (Boone 1961:50-52).

In this region figurative stools are reserved for important individuals such as chiefs. They are status indicators, especially on public occasions, for example, when a chief settles disputes. Most of the supporting images are female and may commemorate owners' wives or perhaps ancestors (Flam 1971; Neyt and Strycker 1975:40-48; Neyt 1981:237-38). However, the specific meaning and function of this and the following entry, both from groups whose arts are not well documented, are uncertain.

ex-collection: Musée Léopold II, Lubumbashi
 Shaba, Zaire

exhibited: Indianapolis Museum of Art, 1977-78
 Indiana Central University, Indianapolis,
 1980

published: Waldecker 1947, fig. 10
 Celenko 1980, no. 48
 Celenko 1981, fig. 2

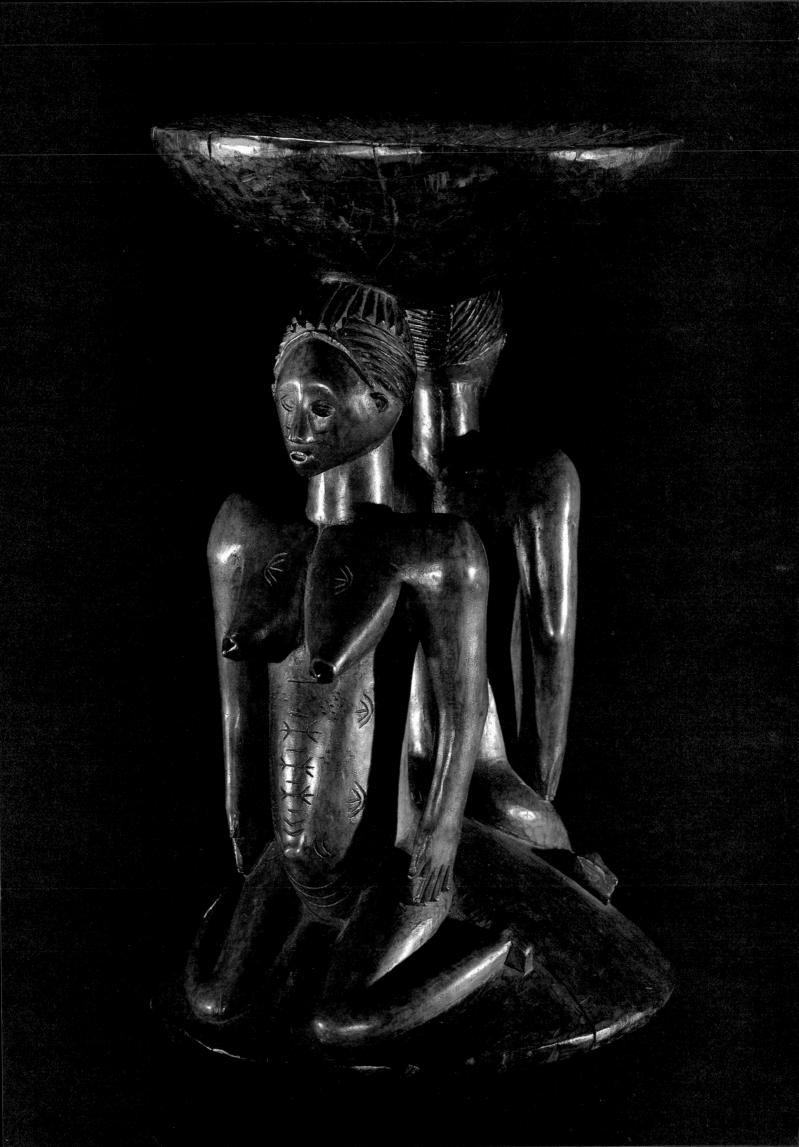

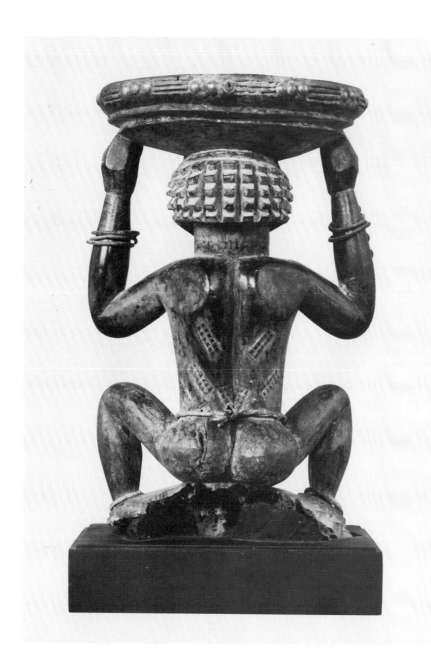

Bangubangu or Zula (?), Zaire

198
stool
wood, pigment, cloth, brass, iron
h. 17 in. (43.2 cm.)

This prestige stool originates from the Bangubangu, Zula or some other group living near and among the northern extensions of the Luba and Hemba (Boone 1961:5-11, 42-50, passim). François Neyt (1980) attributes it and a similar one to the Zula (1977:fig. 93, 473-74, passim). Three published caryatid stools, from the Museum Rietberg der Stadt Zürich (Leuzinger 1963:no. 199), the Museum für Völkerkunde Leipzig (Germann 1958:pl. 21), and a German private collection (Schädler 1973:no. 514), have many stylistic features identical to this one, and it is likely that all four come from the same school of carvers. The Zürich piece, with abdominal scarifications identical to those on this example, is identified as Bangubangu, eastern Luba, Manyema area; the other stools are simply identified as eastern Luba and Luba (cat. no. 197).

exhibited: Indianapolis Museum of
Art, 1977-78

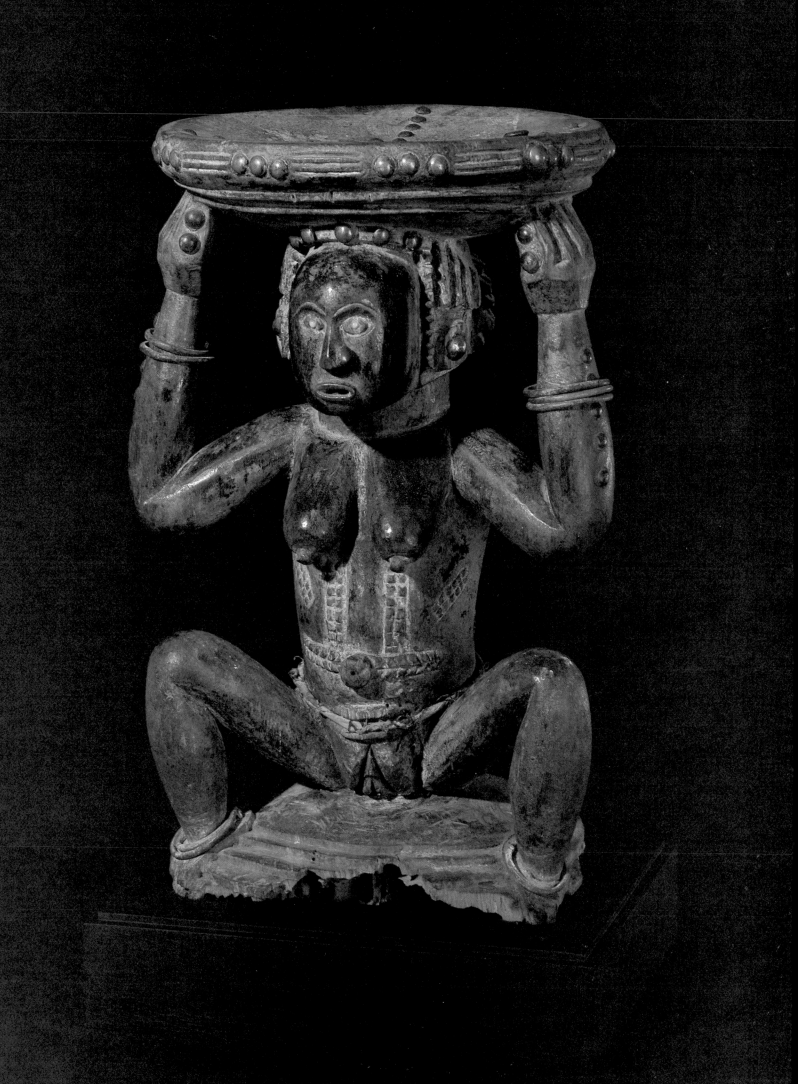

Chokwe, Angola/Zaire

199
face mask for *Cihongo* masker
wood, pigment, fiber, feathers, brass
h. of wood carving: 8¹/₂ in. (21.7 cm.)

Chokwe masks of wood, as opposed to those of barkcloth, have lost much of their former sacred, ancestral import, and today are worn primarily for secular entertainment. These examples depict two common masked personages. The male mask (cat. no. 199), with prominent beard, represents *Cihongo*, the powerful and wealthy man; the female mask (cat no. 200), with more delicate features, represents *Mwana Pwo*, the beautiful young woman (Bastin 1968:63-64; 1982:86-91). The latter is attributed by Marie-Louise Bastin (1979) to the Chokwe located between the Kwilu and Kasai

Rivers of northeastern Angola and neighboring parts of Zaire. It is atypical because the coiffure is part of the wood, forming a variety of helmet mask. Fibers, animal hair and other materials are usually affixed to these headpieces, and the maskers wear netted garments, which on the *Mwana Pwo* are fitted with wooden breasts. Both carvings depict Chokwe facial markings. The cruciform *(cingelyengelye)* on the forehead of the male mask may derive from Christian sources. The female example bears the "tear" motif *(masoji)* below the eyes, chevrons *(tukone)* on the cheeks, parallel lines *(mipila)* on the temples and a vertical mark *(kangongo)* on the front of the nose (Bastin 1961:74, 147-53, passim; 1979).

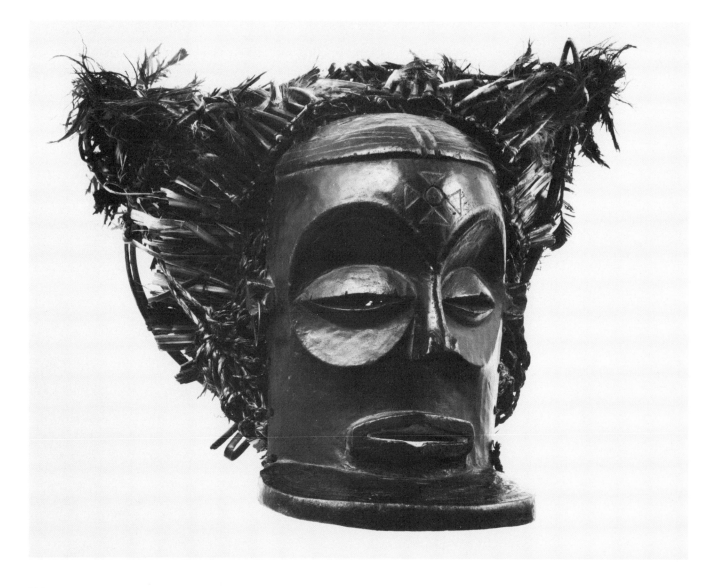

Chokwe, Angola/Zaire

200
**helmet mask for *Mwana
 Pwo* masker**
wood, pigment, fiber, metal
h. 11¹³/₁₆ in. (30.1 cm.)

cat. no. 200
exhibited: Indianapolis Museum
 of Art, 1976, 1977-78
 Indianapolis Museum
 of Art at Columbus, 1977

published: Gilfoy 1976, no. 52, ill.
 Celenko 1981, fig. 13

*Both female and male masks are
worn by men for their dance cere-
monies. H.E.*

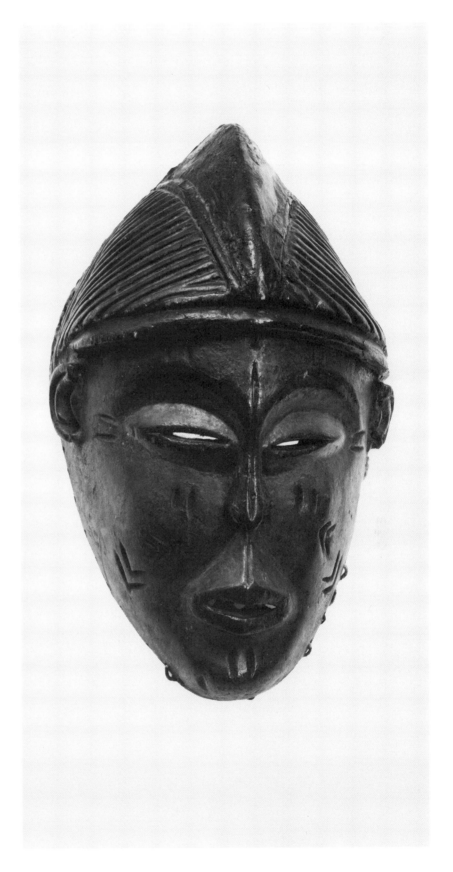

Chokwe, Angola/Zaire

201 (below)
tobacco mortar
wood, leather, metal
h. 5¼ in. (13.3 cm.)

Chokwe figurative carving is frequently incorporated into prestige items such as stools, chairs, staffs, combs and tobacco mortars. This mortar is very worn from years of handling, and the colonial coins on the leather strap were minted over half a century ago. The carving probably dates from at least the early part of this century. Such mortars are used both to grind and store snuff (Bastin 1961:316-18; 1982:ills. 135-48). The bent-legged stance, jutting jaw and prominent, lanceolate eyes typify Chokwe styles.

Tobacco, first introduced by Europeans centuries ago, created a demand for pipes, mortars and other tobacco-related items. This old snuff mortar shows considerable wear. H.E.

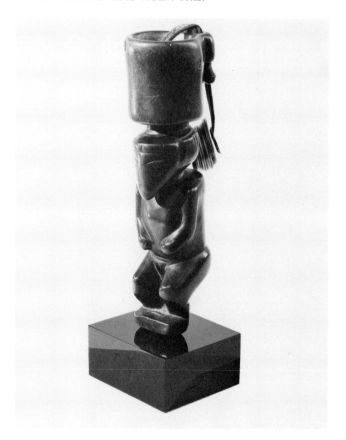

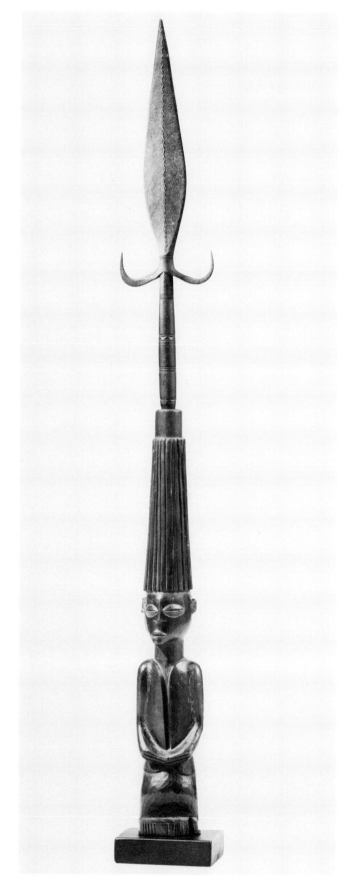

Chokwe, Angola/Zaire

202 (left)
spear *(mukuba)* top
wood, brass, iron, pigment
h. 23³/₈ in. (59.4 cm.)

Figured spears, which derive from functional weapons, serve exclusively as status indicators and prestige objects for important men (Bastin 1961:302-304). The male figure, who wears a European type coat, originally constituted the upper portion of a full length shaft. The zigzag design running the length of the blade belongs to a class of motif called *mahenga* and derives from patterns in scarification and paint applied to women's abdomens and buttocks (Bastin 1961:57, 74, 95-98; 1982:ills. 130-34). A piece of wood from the head's right side, which was broken off, has been carefully repaired in a traditional manner with a series of tiny brass staples.

Chokwe, Angola/Zaire

203 (below)
face mask *(Ngulu)*
wood, pigment
l. 12 in. (30.5 cm.)

Ngulu (pig) masks are used in entertainment dances and sometimes accompany the *Mwana Pwo* (cat. no. 200). The masker, who views through the snout, sometimes assumes a four-legged posture and scratches and rummages the earth in imitation of a pig. *Ngulu* headpieces could not have been initiated before the introduction of the animal into the area by Europeans in recent times (Cornet 1975:no. 80; Bastin 1979; 1982:91-92, ill. 31). The minimal nature of this carving differs from the greater detail usually associated with Chokwe masks.

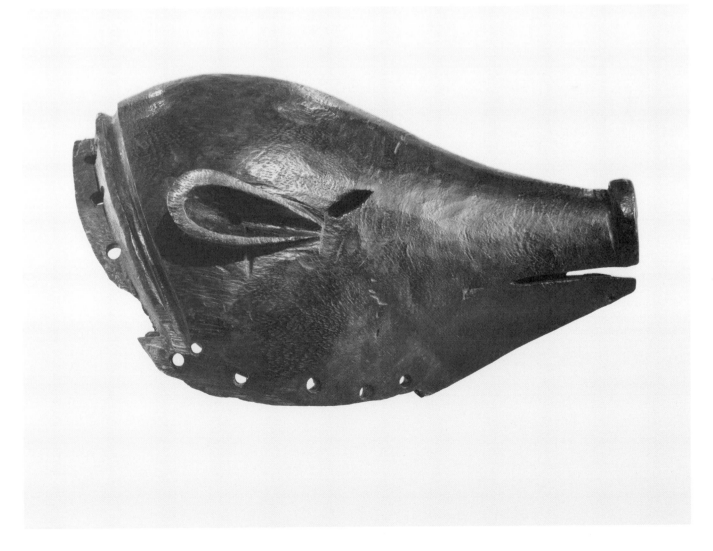

EASTERN SUDAN, EASTERN AND SOUTHERN AFRICA

Physically and culturally the Eastern Sudan is in some ways an extension of the Western and Central Sudan (pp. 12-13). It is diversely populated with both farmers and herders of Negroid, Caucasoid or Negroid-Caucasoid stock, most of whom speak Nilo-Saharan or Afro-Asiatic languages. The border between the Sudan and Eastern Africa delineated here is marked by a transition from lowlands to the highlands of Ethiopia and Kenya, and a shift from agriculture to pastoralism. In former times the black state of Kush (8th century B.C.-4th century A.D.), at the northern periphery of the region, was a dominant power which served as a two-way conduit between the Mediterranean world and sub-Saharan Africa. The sophisticated arts of the Kushites, which derive largely from Egypt, contrast dramatically with the region's few documented figurative traditions, which consist of abstract, often elongated forms. Sculpture-producing groups are primarily Negroid and Negroid-Caucasoid agriculturalists who for the most part resisted Islam.

Relative to the wealth of sculpture in the western and central parts of the continent, eastern and southern Africa have little in the way of figurative carving and casting. This paucity, which has discouraged attempts to subdivide this vast territory into art regions, is probably due in large measure to the high incidence of pastoralism, and in the north and on the east coast, to the influence of Islam, with its prohibition against representational art. The most widespread visual arts are ornamentation of the body, dress, and portable items such as containers, headrests, and weapons, with beads, paint, hide and other embellishments. Notable traditions of the past include the religious arts of the Caucasoid peoples of the Christian states of Ethiopia (4th-20th centuries); the nonfigurative, decorative arts of the Islamic, Arab-African Swahili culture along the east coast; and the rock paintings and engravings of the Bushmen of Southern Africa, who have been largely displaced by Bantu-speaking Negroes and Europeans within the past five hundred years. Madagascar, the large island off the southeast coast of the continent, was first peopled by Indonesians about two thousand years ago, and despite more recent arrivals of Africans, as well as other peoples, the arts and other cultural features of the island are essentially non-African.

EASTERN SUDAN

EASTERN AND SOUTHERN AFRICA

unidentified ethnic group, Sudan (?)

204
female figure
wood
h. 20⁷/₈ in. (53.1 cm.)

Although the ethnic origin of this carving is un-
certain (Hartwig 1979), its rigid posture and sim-
plified, unnaturalistic forms are similar to figure
styles of the Bari, Belanda, Bongo and other
peoples of the Eastern Sudan. Despite the ab-
sence of the elongated proportions so typical of
the region's "pole styles," it has stylistic features,
especially the projecting ovoid ears and rounded
forms, in common with grave figures documented
among or attributed to the Bongo, a small agricul-
tural group located in the far south of the
present-day nation of Sudan (Schweinfurth 1874
vol. I:284-87; 1875:pl. VIII, figs. 5, 7; Seligman
1917; Seligman and Seligman 1932:fig. 31, pl. XLIX;
Kronenberg and Kronenberg 1960:pls. XL-XLIII,
XLV-XLVI; Christie 1978c:lot. 181; Gillon 1979:ill.
178; Fagg 1981:no. 59; Bradley 1982:no. 10). How-
ever, it is not inconceivable that this figure origi-
nated farther south (Hartwig 1979), perhaps
among the Kerebe (Kerewe) or some other Tan-
zanian group (Kroll 1933; Holý 1967:18-22, pls.
33-34, 54; Hartwig 1969a; 1969b; 1978:figs. 9-10).

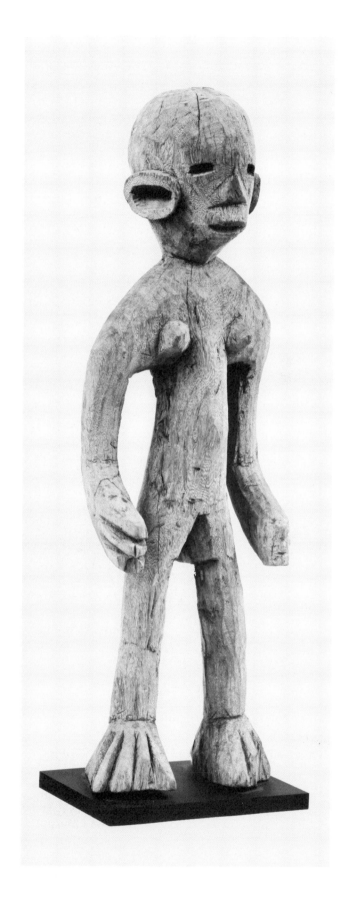

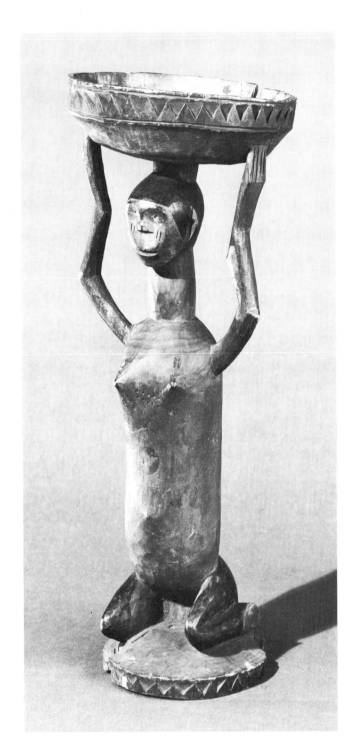

unidentified ethnic group, Tanzania

205
figure
wood
h. 21¹¹/₁₆ in. (55.1 cm.)

The elongated torso and the cursory treatment of the attenuated arms of this figure supporting a bowl are recurring stylistic elements of sculpture of Eastern Africa. However, aside from carvings of a handful of groups such as the Makonde, Zaramo and Mijikenda peoples confident ethnic identification of undocumented sculptures from Eastern Africa is impossible due to the paucity both of long-standing carving traditions and of field studies (Hartwig 1978; 1979). A handful of published carvings identified as Tanzanian works from the Zegura (Zigula) (Gillon 1979:fig. 197), Zaramo (Gunn 1962:pl. XIII, fig. 5; Fagg 1965:no. 119; Robbins 1966:pl. 344), Sukuma (Holý 1967:pl. 34; Delange 1974:ill. 177), Pare (Hartwig 1978:fig. 1) and Nyamwezi (Holý 1967:pl. 36) share stylistic features with this figure. Other characteristics, not typical of eastern Africa, suggest that it originated near Lake Tanganyika, where influence from the great carving traditions of southeastern Zaire is sometimes evident. These include use of a figurative support, the kneeling posture and the heart-shaped face (Burt 1981). Despite what appear to be breasts, the sex of the figure is uncertain since a plug (broken off) inserted in the crotch may have served as a penis. The eyes were probably once inlaid.

Makonde, Mozambique

206
helmet mask for *Mapiko* masker
wood, pigment, human hair, wax,
 iron, fiber
l. 10⁵/₈ in. (27 cm.)

Makonde masks and figures repre-
sent the most widely recognized
figurative carving tradition of East-
ern Africa. Masks are worn by
Mapiko masqueraders who play a
central role in the initiations of
young men into adulthood. Masks
are also associated with some activ-
ities of female initiations. Maskers
are said to represent the dead and
during public performances serve as
a means of social control by satiriz-
ing anti-social behavior. Although
the Makonde, a farming people, are
distributed on both sides of the
Tanzania-Mozambique border, hel-
met masks like this one originate
from Mozambique, while the usually
less naturalistic face masks come
from the Tanzanian Makonde. The
naturalism of Makonde helmet
masks is heightened by the use of
human hair, and by the realistic
depiction of filed teeth and scar-
ification. Helmet masks are worn
at a forward tilt with the open
mouth serving as a viewing hole.
The masker is concealed by a spe-
cial tightly fitting costume which
includes a rope corset laden with
bells (Dias 1961:31, 46, 57-60; Dias
and Dias 1964:56-81; 1970:159-217,
391-95, passim; Dick-Read 1964:56-
66; Korabiewicz 1966:24-25, ills.
75-81; Holý 1967:29-30, pls. 69-76,
86-101).

The expressive naturalism of this
mask is enhanced by the addition of
human hair clippings for the beard,
eyebrows and hair. H.E.

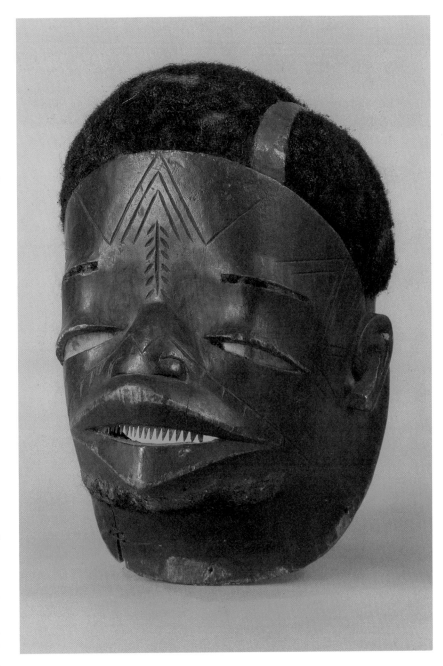

Mijikenda complex, Kenya
Chonyi, Jibana, Kambe, Ribe or Rabai

207 (opposite left)
commemorative post (Kigango)
wood, metal
h. 70⁹/₁₆ in. (179.3 cm.)

Mijikenda complex, Kenya
Giriama (?)

208 (opposite right)
commemorative post (Kigango)
wood, plaster, pigment
h. 71¹/₈ in. (180.6 cm.)

The Mijikenda peoples (Giriama, Kauma, Chonyi, Jibana, Kambe, Ribe, Rabai, Duruma, Digo) are agriculturalists living along the coast of Kenya. All but the two most southerly groups, the Islamized Duruma and Digo, erect memorial posts in human form. *Vigango* (sing., *Kigango*) commemorate deceased elders of the *Chama Cha Gohu* male association, and are among the tallest and most elaborate type of post. The field photograph, taken by Ernie Wolfe III in Msumarini area of Giriama country in 1978, illustrates a *Kigango* along with a *Kibao*, about half the height of the *Kigango*, and ten small, uncarved *Koma*. *Vibao* (sing., *Kibao*), smaller and less intricate than *Vigango*, are second generation commemorative posts erected to replace abandoned *Vigango* when a new village is established. The short, unworked *Koma* commemorate wives and brothers of association members (Hollis 1909; Barrett

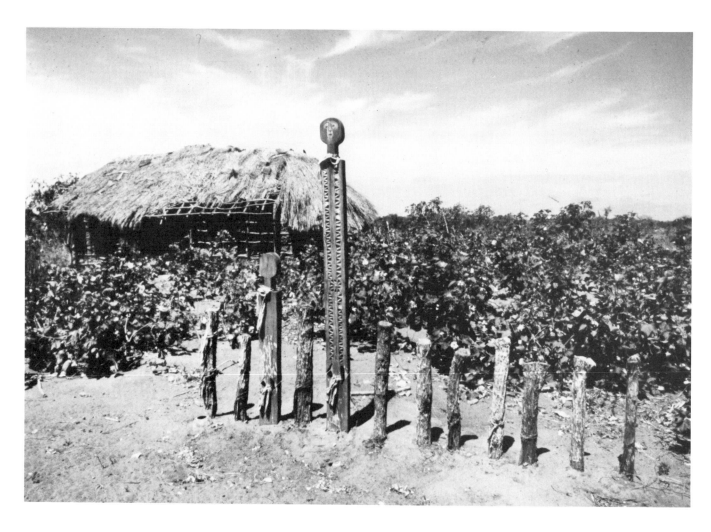

1911:23-25; Wolfe 1979:25-29; Brown 1980: Parkin 1981). Important ancestors must be appeased with *Vigango* and sacrifices lest their spirits cause harm. The posts serve as a means of communication between the living and ancestors, who are appealed to during times of illness, drought and other troubles. *Vigango* are not normally positioned over graves (Wolfe 1979:29; 1980; Parkin 1981:1), although some writers do report the practice (Hollis 1909; Barrett 1911:23; Adamson 1967:285-325; Siroto 1979:105-108; Brown 1980:36-37). Commemorative carvings with similar functions but different styles are found among other peoples such as the Zaramo of Tanzania, the Konso of Ethiopia and the Antandroy and Mahafaly of Madagascar. These may represent the remnants of once pervasive traditions which predate Islamic influence (Siroto 1979:110-12; Sieber 1981:13-19).

Most *Vigango* are minimally anthropomorphic with disc-like heads. These examples have earth-impacted bases from being implanted in the ground. A limited repertory of geometric motifs, mostly triangular, are carved into the front and sometimes the back surfaces, as on these examples. These motifs may have been inspired by Swahili decorative elements (Siroto 1979:110-12; Brown 1980:37, 39; Sieber 1981:16-19). The depressions of surface designs are commonly inlaid with pigmented plaster or latex, which in many extant examples, like cat. no. 207, has completely fallen out or eroded away. In some cases the significance of the geometric motifs may be no more than decorative. However, some patterns probably signify anatomical elements (breasts, navels, waists, spines, ribs), clothing, body decoration or diseases which caused the deaths of commemorated individuals (Siroto 1979:109; Wolfe 1979:28-29; Brown 1980:37-38). Ernie Wolfe III (1980) provides the following identifications of the markings on these two examples. The waists are indicated by lateral notches on the lower part of the posts. The circular motifs on both carvings may refer to breasts or navels, while the vertical rows of triangles on both front surfaces and on the back surface of cat. no. 207 probably depict, respectively, ribs and spine. The cross configuration of triangles on both sides of the upper "torso" of cat. no. 208 may signify an elder's death from tuberculosis. Coins, which connote wealth, are frequently used to indicate eyes; those affixed to cat. no. 207 are dated 1935 and 1942.

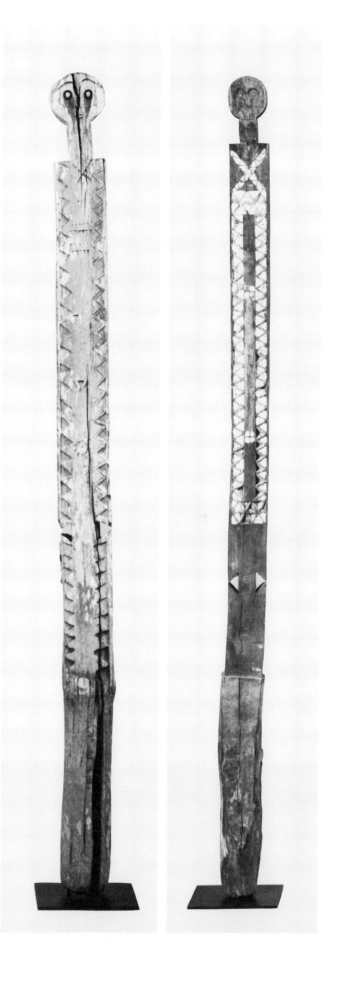

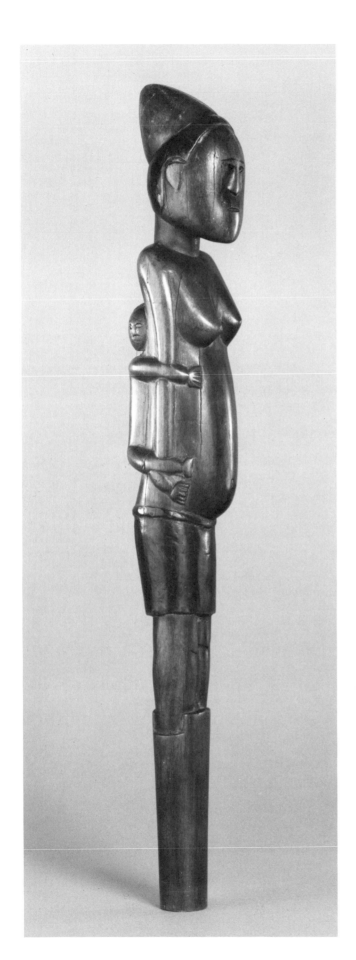

Zulu (?), South Africa

209
finial of staff *(udlwedlwe)*
wood
h. 13¹/₂ in. (34.3 cm.); h. of figure: 10⁵/₈ in. (27 cm.)

19th century (?)

Carving styles of the Zulu and other groups of the Nguni complex, and of peoples influenced by them during their 19th century incursions throughout much of southeastern Africa, are not adequately identified. In the absence of field collection data, as is the case with these examples, attributions must be tentative (Holý 1967:36-37; pls. 130-39; Gillon 1979:ill. 212-14; Mack 1981). A combination of style elements in these carvings suggests an origin among the Zulu of Natal (Conner 1982). These features include pyro-engraved details such as the hair, cylindrical necks abruptly intersecting with heads and shoulders, spherical heads with moderately jutting jaws, minimal facial detail with triangular noses, and in cat. no. 209 elongated torso and arms.

These carvings are probably *udlwedlwe*, prestige staffs-walking sticks reserved for elders of both sexes (Doke and Vilakazi 1958:164; Nymbezi and Nxumalo 1966:102). The themes depicted on these finials, mother and child and man with dog are uncommon. The woman depicted in cat. no. 209 wears a married woman's headdress and hide skirt (Krige 1950:372, 376-77). A mother and child group and two single figure staff finials stylistically similar to this example are published in an 1897 sales catalog (Webster 1897:nos. 77-78, 80), and it is plausible that cat. no. 209 also dates

Zulu (?), South Africa

210
staff *(udlwedlwe)*
wood
h. 52¹/₂ in. (133.3 cm.); h. of human figure: 6³/₈ in.
 (16.2 cm.)

to the 19th century. Four other finials, two
mother and child groups (Rubin 1977:front cover;
Museum of Mankind, London, Wellcome coll., no.
968557/1954 AF 23) and two single female figures
(Museum of Mankind, London, Wellcome coll.,
no number/1954 AF 23; Sotheby 1983*a*:lot 103) are
iconographically and stylistically very close to
cat. no. 209, and it is likely that all of the
aforementioned carvings have the same origin.
The canine imagery of cat. no. 210 probably
alludes to the importance of dogs in hunting, an
important male activity (Krige 1950:203-207), and
suggests that the staff belonged to a man, who
may be depicted in this finial. The figure lacks the
headring of senior men often found in depictions
of males.

cat. no. 209
exhibited: Creative Arts Department, Purdue
 University, West Lafayette, Indiana,
 1982

published: Conner and Pelrine 1983, no. 36b, ill. 32

The Zulu, once renowned warriors, also create
such delicate figures as these. H.E.

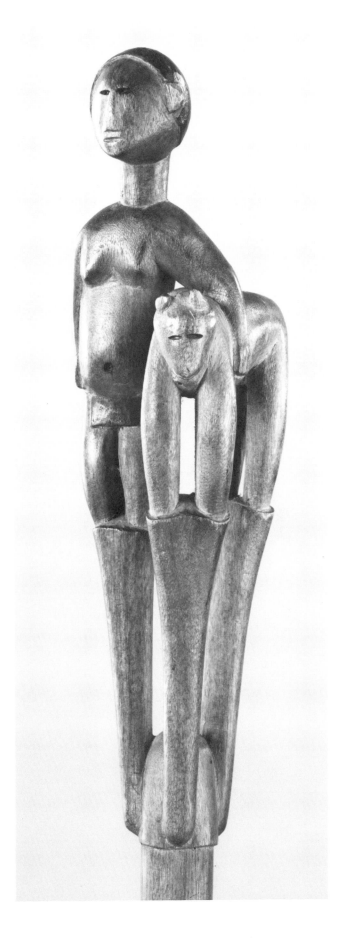

REFERENCES CITED

Adams, Monni
1982 *Designs for Living: Symbolic Communication in African Art.* Cambridge, Massachusetts: Carpenter Center for the Visual Arts, Harvard University.

Adamson, Joy
1967 *The Peoples of Kenya.* New York: Harcourt, Brace & World, Inc.

African Arts
1980 Advertisement, Jan Baum-Iris Silverman Gallery 13(3):17.

African Sculpture Unlimited
1981 *Stone Ntadi Sculpture of Bas-Zaire.* Translated and adapted by Fred Benson from *Pierres Sculptées du Bas-Zaire* by Joseph Cornet, 1978. New York: African Sculpture Unlimited.

Albert, André
1943 *Au Cameroun Français Bandjoun.* Montréal: Les Editions de l'Arbre.

Allen, Van Nes
1939 *I Found Africa.* Indianapolis: Bobbs-Merrill Co.

Allison, Phillip
1968 *African Stone Sculpture.* New York: Frederick A. Praeger.

Anderson, Martha
1982 Personal communication.

Andersson, Efraim
1953 *Contribution à l'Ethnographie des Kuta I.* Studia Ethnographica Upsaliensia, 6. Uppsala: Almquist & Wiksells Boktryckeri AB.
1974 *Contribution á l'Ethnographie des Kuta II.* Studia Ethnographica Upsaliensia, 38. Uppsala: Almquist & Wiksells Boktryckeri.

Armstrong, Robert Plant
1974 My Collection. *African Arts* 7(3):38-45.
1981 *The Powers of Presence: Consciousness, Myth, and Affecting Presence.* Philadelphia: University of Pennsylvania Press.

Arnoldi, Mary Jo
1976 *Bamana and Bozo Puppetry of the Segou Region Youth Societies.* West Lafayette, Indiana: Department of Creative Arts, Purdue University.
1982 Personal communication.

Aronson, Lisa
1983 *Nigerian Art and Communication.* Wausau, Wisconsin: Leigh Yawkey Woodson Art Museum and Stevens Point: Edna Carlsten Gallery, University of Wisconsin.

Atmore, Anthony and Stacey, Gillian
1979 *Black Kingdoms, Black Peoples: The West African Heritage.* New York: G.P. Putnam's Sons.

Baker, Herbert
1977 Personal communication.

Balandier, Georges and Maquet, Jacques
1974 *Dictionary of Black African Civilization.* Translated by Lady (Mariska Caroline) Peck, Bettina Wadia, and Peninah Neimark. New York: Leon Amiel.

Baldwin, Hannah
1978 Senegalese Folk Jewelry: Form, Technique and Origins. Unpublished paper.

Barrett, W. E. H.
1911 Notes on the Customs and Beliefs of the Wa-Giriama, etc., British East Africa. *Journal of the Royal Anthropological Institute of Great Britain and Ireland* 41:20-39.

Bascom, William
1969a *The Yoruba of Southwestern Nigeria.* New York: Holt, Rinehart and Winston.
1969b *Ifa Divination: Communication between Gods and Men in West Africa.* Bloomington: Indiana University Press.
1973 *African Art in Cultural Perspective.* New York: W. W. Norton and Co., Inc.

Basden, G.T.
1921 *Among the Ibos of Nigeria.* London: Seeley Service & Co. Ltd. Reprinted, London: Frank Cass & Co. Ltd., 1966.

Bastin, Marie-Louise
1961 *Art Décoratif Tshokwe.* Subsidios Para a História, Arqueologia, e Etnografia dos Povos da Lunda, no. 55. Lisbon: Museu do Dundo.
1968 Arts of the Angolan Peoples, Part I. *African Arts* 2(1):41-43, 47, 63-64.
1979 Personal communication.
1982 *La Sculpture Tshokwe.* English translation by J. B. Donne. Meudon, France: Alain and Françoise Chaffin.

Baumann, Hermann, ed.
1975 *Die Völker Afrikas und ihre Traditionellen Kulturen.* 2 vols. Wiesbaden: Franz Steiner Verlag GMBH.

Baumann, Hermann and Westermann, D.
1948 *Les Peuplades et les Civilisations de l'Afrique.* Translated by L. Homburger. Paris: Payot.

Beier, Ulli
1958 Sango Shrine of the Timi of Ede. *Black Orpheus* 4:30-35.
1982 *Yoruba Beaded Crowns: Sacred Regalia of the Olokuku of Okuku.* London: Ethnographica Ltd.

Ben-Amos, Paula
1973 Symbolism in Olokun Mud Art. *African Arts* 6(4):28-31, 95.
1980 *The Art of Benin.* New York: Thames & Hudson.
1981 Rooster. In *For Spirits and Kings: African Art from the Paul and Ruth Tishman Collection.* Susan Vogel, ed. cat. no. 77, p. 134. New York: Metropolitan Museum of Art.
1982 Personal communication.

Bernatzig, Hugo Adolph
1944 *Im Reich der Bidyogo.* Innsbruck: Kommissionsverlag Österreichische Verlagsanstalt.

Biebuyck, Daniel P.
1973 *Lega Culture: Art, Initiation and Moral Philosophy Among a Central African People.* Berkeley: University of California Press.
1976 Sculpture from the Eastern Zaïre Forest Regions. *African Arts* 9(2):8-15, 79-80.
1977 Sculpture from the Eastern Zaïre Forest Regions: Metoko, Lengola, and Komo. *African Arts* 10(2):52-58.
1978 Review of *La Grande Statuaire Hemba du Zaire* by Françoise Neyt. *African Arts* 12(1):19-21, 98-102.
1982 Personal communication.

Bird, Charles
1974 *The Songs of Seydou Camara: Kambili.* Translated with Mamadou Koita and Bourama Soumaoro. Occasional Papers in Mande Studies, vol. 1. Bloomington: African Studies Center, Indiana University.
1979 Personal communication.

Blier, Suzanne Preston
1980 *Africa's Cross River: Art of the Nigerian-Cameroon Border Redefined.* New York: L. Kahan Gallery, Inc.

Bodrogi, Tibor
1968 *Art in Africa.* New York: McGraw-Hill Book Co.

Boone, Olga
1961 *Carte Ethnique du Congo, Quart Sud-Est.* Annales, série in-8, Sciences Humaines, 37. Tervuren: Musée Royal de l'Afrique Centrale.
1973 *Carte Ethnique de la'République du Zaire, Quart Sud-Ouest.* Annales, série in-8, Sciences Humaines, 78. Tervuren: Musée Royal de l'Afrique Centrale.

Borgatti, Jean M.
1976 Okpella Masking Traditions. *African Arts* 9(4):24-32, 90-91.

Boston, John S.
1960 Some Northern Ibo Masquerades. *Journal of the Royal Anthropological Institute of Great Britain and Ireland* 90(1):54-65.
1977 *Ikenga Figures Among the North-West Igbo and the Igala.* London: Ethnographica Ltd. and Lagos: Federal Department of Antiquities.

Bourgeois, Arthur P.
1979 *Nkanda Related Sculpture of the Yaka and Suku of Southwestern Zaire.* Ph.D. dissertation, Indiana University.
1982 Personal communication.

Bradley, Douglas E.
1982 *Traditional African Sculpture from the Britt Family Collection.* Notre Dame, Indiana: Snite Museum of Art, O'Shaughnessy Galleries, University of Notre Dame.

Brain, Robert and Pollock, Adam
1971 *Bangwa Funerary Sculpture.* Toronto: University of Toronto Press.

Bravmann, René A.
1970 *West African Sculpture.* Index of Art in the Pacific Northwest, number 1. Seattle: University of Washington Press.
1973 *Open Frontiers: The Mobility of Art in Black Africa.* Index of Art in the Pacific Northwest, number 5. Seattle: University of Washington Press.
1974 *Islam and Tribal Art in West Africa.* African Studies Series, 11. Cambridge, England: Cambridge University Press.

Brink, James T.
1981 Antelope Headdress *(Chi Wara).* In *For Spirits and Kings: African Art from the Paul and Ruth Tishman Collection.* Susan Vogel, ed. cat. no. 8, pp. 24-25. New York: Metropolitan Museum of Art.

Brown, Jean Lucas
1980 Miji Kenda Grave and Memorial Sculptures. *African Arts* 13(4):36-39, 88.

Burssens, Herman
1958a Sculptuur in Ngbandi-Stijl een Bijdrage Tot de Studie van de Plastiek van Noord-Kongo. *Kongo-Oversee* 24(1-2):1-51.
1958b *Les Peuplades de l'entre Congo-Ubangi (Ngbandi, Ngbaka, Mbandja, Ngombe et Gens d'Eau).* Sciences de l'Homme Monographies Ethnographiques, vol. 4. Tervuren: Musée Royal du Congo Belge.
1962 *Yanda-Beelden en Mani-sekte bij de Azande (Centraal-Afrika).* Sciences Humaines, no. 4. Tervuren: Musée Royal de l'Afrique Centrale.

Burt, Eugene C.
1981 Personal communication.
Byström, Knut
1954 Notes on the Ekparabong Clan. *Orientalia Suecana* 3:3-26.
Carroll, Kevin
1967 *Yoruba Religious Carvings*. London: Geoffrey Chapman Ltd.
Celenko, Theodore
1975 *African Art from the Collection of Julian and Irma Brody*. Catalog notes. Des Moines, Iowa: Des Moines Art Center.
1980 *Selections from the Harrison Eiteljorg Collection of African Art*. Indianapolis: Leah Ransburg Art Gallery, Indiana Central University.
1981 The Harrison Eiteljorg Collection. *African Arts* 14(3):32-42, 89-90.
Chaffin, Alain
1973 Art Kota. *Arts d'Afrique Noire* 5:12-43.
Chaffin, Alain and Chaffin, Françoise
[1979] *L'Art Kota: Les Figures de Reliquaire*. English translation by Carlos E. Garcia. Meudon, France: By the Authors.
Christie, Manson & Woods Ltd.
1976 *Tribal Art and Ethnography from Africa, the Americas and the Pacific*. London, sale of October 12.
1978a *Important Tribal Art*. London, sale of June 13.
1978b *African Art from the Collection of the Late Josef Mueller of Solothurn, Switzerland*. London, sale of June 13.
1978c *Tribal Art and Ethnography from Asia, the Americas, Africa and the Pacific*. London, sale of July 25.
1978d *African and Tribal Arts*. New York, sale of October 13.
1979a *Tribal Art from the Collection of the Late Josef Mueller Part II*. London, sale of May 20.
1979b *Important Tribal Art*. London, sale of June 19.
Cole, Herbert M.
1969 Art as a Verb in Iboland. *African Arts* 3(1):34-41, 88.
1970 *African Arts of Transformation*. Santa Barbara: Art Galleries, University of California.
1981 Mother and Child. In *For Spirits and Kings: African Art from the Paul and Ruth Tishman Collection*. Susan Vogel, ed. cat. no. 85, pp. 146-48. New York: Metropolitan Museum of Art.
1982 Personal communication.
Cole, Herbert M. and Ross, Doran H.
1977 *The Arts of Ghana*. Los Angeles: Museum of Cultural History, University of California.
Conner, Michael W.
1982 Personal communication.
Conner, Michael W. and Pelrine, Diane
1983 *The Geometric Vision: Arts of the Zulu*. West Lafayette, Indiana: Purdue University Galleries and Bloomington: African Studies Program, Indiana University.
Cornet, Joseph
1971 *Art of Africa: Treasures from the Congo*. Translated by Barbara Thompson. London: Phaidon Press Ltd.
1975 *Art from Zaïre: 100 Masterworks from the National Collection/L'Art du Zaïre: 100 Chefs-d'oeuvre de la Collection Nationale*. Translated by Irwin Hersey. New York: African-American Institute.

1978 *A Survey of Zairian Art: The Bronson Collection*. Raleigh: North Carolina Museum of Art.
1981a Kongo Stone Funerary Sculpture. In *The Four Moments of the Sun: Kongo Art in Two Worlds*. Robert Farris Thompson and Joseph Cornet. pp. 211-19. Washington: National Gallery of Art.
1981b Drummer. In *For Spirits and Kings: African Art from the Paul and Ruth Tishman Collection*. Susan Vogel, ed. cat. no. 138, p. 226. New York: Metropolitan Museum of Art.
1982 *Art Royal Kuba*. Milan: Edizioni Sipiel.
Dark, Phillip J. C.
1962 *The Art of Benin: A Catalogue of an Exhibition of the A. W. F. Fuller and Chicago Natural History Museum*. Chicago: Natural History Museum.
1973 *An Introduction to Benin Art and Technology*. London: Oxford University Press.
1975 Benin Bronze Heads: Styles and Chronology. In *African Images: Essays in African Iconology*. Boston University Papers on Africa, vol. 6. Daniel F. McCall and Edna G. Bay, eds. pp. 25-103. New York: Africana Publishing Co.
1980 *Catalogue of a Collection of Benin Works of Art*. Sotheby Parke Bernet, sale of June 16. London: Sotheby Parke Bernet & Co.
1982 *An Illustrated Catalogue of Benin Art*. Boston: G.K. Hall & Co.
de Grunne, Bernard
1980 *Terres Cuites Anciennes de l'Ouest Africain/Ancient Terracottas from West Africa*. English translation by Claire W. Enders. Publications d'Histoire de l'Art et d'Archéologie de l'Université Catholique de Louvain, 22. Louvain-la-Neuve, Belgium: Institut Supérieur d'Archéologie et d'Histoire de l'Art, Collège Erasme.
de Grunne, Bernard and Preston, George Nelson
1981 *Ancient Terra Cotta of Mali and Ghana*. New York: African-American Institute.
de la Burde, Roger
1972 Ancestral Ram's Heads of the Edo-Speaking Peoples. *African Arts* 6(1):29-34, 88.
1973 The Ijebu-Ekine Cult. *African Arts* 7(1):28-33, 92.
Delange, Jacqueline
1974 *The Art and Peoples of Black Africa*. Translated by Carol F. Jopling. New York: E. P. Dutton.
DeMott, Barbara
1982 *Dogon Masks: A Structural Study of Form and Meaning*. Studies in the Fine Arts: Iconography, 4. Ann Arbor, Michigan: UMI Research Press.
Dennis, Benjamin G.
1972 *The Gbandes: A People of the Liberian Hinterland*. Chicago: Nelson-Hall Co.
de Sousberghe, Léon
1958 *L'Art Pende*. Beaux-Arts 9(2). Brussels: Académie Royale de Belgique.
Devisch, Renaat
1972 Signification Socio-Culturelle des Masques chez les Yaka. *Boletim Instituto de Investigação Cientifica de Angola* 9(2):151-76.
Dias, A. Jorge
1961 *Portuguese Contribution to Cultural Anthropology*. Johannesburg: Witwatersrand University Press.

Dias, A. Jorge and Dias, Margot
1964 *Os Macondes de Moçambique, Vol. 2: Cultura Material*. Lisbon, Portugal: Junta de Investigações do Ultramar.
1970 *Os Macondes de Moçambique, Vol. 3: Vida Social e Ritual*. Lisbon, Portugal: Junta de Investigações do Ultramar.
Dick-Read, Robert
1964 *Sanamu: Adventures in Search of African Art*. New York: E. P. Dutton & Co. Inc.
Dittmer, Kunz
1966 *Kunst und Handwerk in Westafrika*. Wegweiser zur Völkerkunde, no. 8. Hamburg: Hamburgisches Museum für Völkerkunde und Vorgeschichte.
Doke, C. M. and Vilakazi, B. W.
1958 *Zulu-English Dictionary*. Johannesburg: Witwatersrand University Press.
Donald Morris Gallery
1971 *African Art*. Detroit: Donald Morris Gallery.
Drewal, Henry John
1974a Gelede Masquerade: Imagery and Motif. *African Arts* 7(4):8-19, 62-63, 95-96.
1974b Efe: Voiced Power and Pageantry. *African Arts* 7(2):26-29, 58-66, 82-83.
1977 *Traditional Art of the Nigerian Peoples: The Milton D. Ratner Family Collection*. Washington, D. C.: Museum of African Art.
1978 The Arts of Egungun among Yoruba Peoples. *African Arts* 11(3):18-19, 97-98.
1980a *African Artistry: Technique and Aesthetics in Yoruba Sculpture*. Atlanta: High Museum of Art.
1980b Personal communication.
1981a Staff (*Edan Oshugbo*). In *For Spirits and Kings: African Art from the Paul and Ruth Tishman Collection*. Susan Vogel, ed. cat. no. 45, pp. 90-91. New York: Metropolitan Museum of Art.
1981b Mask (Gelede). In *For Spirits and Kings: African Art from the Paul and Ruth Tishman Collection*. Susan Vogel, ed. cat. no. 62, p. 115. New York: Metropolitan Museum of Art.
1981c Personal communication.
Drewal, Henry John and Drewal, Margaret Thompson
1983 *Gelede: Art and Female Power among the Yoruba*. Bloomington: Indiana University Press.
Drewal, Margaret Thompson
1977 Projections from the Top in Yoruba Art. *African Arts* 11(1):43-49, 91.
Drewal, Margaret Thompson and Drewal, Henry John
1978 More Powerful Than Each Other: An Egbado Classification of Egungun. *African Arts* 11(3):28-39, 98-99.
Eberl-Elber, Ralph
1937 *Sierra Leone*. Berlin: Verlag die Heimbücherei.
Egharevba, Jacob
1968 *A Short History of Benin*. 4th ed. Ibadan, Nigeria: Ibadan University Press. 1st ed. Lagos: CMS Bookshop, 1934.
Elisofon, Eliot and Fagg, William
1958 *The Sculpture of Africa*. New York: Praeger.
Eyo, Ekpo
1974 Abua Masquerades. *African Arts* 7(2):52-55.
1977 *Two Thousand Years: Nigerian Art*. Lagos: Federal Department of Antiquities.

1981 Headdress. In *For Spirits and Kings: African Art from the Paul and Ruth Tishman Collection.* Susan Vogel, ed. cat. no. 98, p. 167. New York: Metropolitan Musem of Art.

Eyo, Ekpo and Willett, Frank
1980 *Treasures of Ancient Nigeria.* New York: Alfred A. Knopf, Inc.

Ezra, Kate
1981 Mask. In *For Spirits and Kings: African Art from the Paul and Ruth Tishman Collection,* Susan Vogel, ed. cat. no. 132, p. 218. New York: Metropolitan Museum of Art.

Fagaly, William A.
1978 African Art at the New Orleans Museum of Art. *African Arts* 11(4):20-27, 94.
1980 Standing Male Figure for a Reliquary *(bieri).* In *Handbook of the Collection.* Betty N. McDermott, ed. p. 158. New Orleans: New Orleans Museum of Art.

Fagg, Bernard
1965 *Art from the Guinea Coast.* n.p.: Pitt Rivers Museum, University of Oxford.

Fagg, William
1951 De l'Art des Yoruba. *L'Art Nègre. Présence Africaine* 10-11:103-35.
1952 Notes on Some West African Americana. *Man* 52(165):119-22.
1963 *Nigerian Images.* New York: Praeger.
1965 *Tribes and Forms in African Art.* New York: Tudor Publishing Co.
1968 *African Tribal Images: The Katherine White Reswick Collection.* Cleveland: Cleveland Museum of Art.
1970a *African Sculpture.* Washington, D.C.: International Exhibits Foundation.
1970b *Divine Kingship in Africa.* London: British Museum.
1975 Unpublished note.
1977a Unpublished note.
1977b Unpublished note.
1979 Personal communication.
1980 *Masques d'Afrique dans les Collections du Musée Barbier-Müller.* n.p.: Editions Fernand Nathan/L.E.P.
1981 *African Majesty: From Grassland and Forest.* Toronto: Art Gallery of Ontario.

Fagg, William and Plass, Margaret
1964 *African Sculpture: an Anthology.* London: Studio Vista Ltd.

Fairservis, Walter A., Jr.
1959 *Exotic Art from Ancient and Primitive Civilizations: Collection of Jay C. Leff.* Pittsburgh: Carnegie Institute.

Fernandez, James
1973 The Exposition and Imposition of Order: Artistic Expression in Fang Culture. In *The Traditional Artist in African Societies.* Warren L. d'Azevedo, ed. pp. 194-217. Bloomington: Indiana University Press.

Fischer, Eberhard
1978 Dan Forest Spirits: Masks in Dan Villages. *African Arts* 11(2):16-23, 94.
1981a Female Figure. In *For Spirits and Kings: African Art from the Paul and Ruth Tishman Collection.* Susan Vogel, ed. cat. no. 34, pp. 71, 73. New York: Metropolitan Museum of Art.
1981b The Western Guinea Coast: A Short Introduction to a West-African Art Province. *Critica d'Arte Africana* n.s.:46(178):50-65.

Fischer, Eberhard and Himmelheber, Hans
1976 *Die Kunst der Dan.* Zürich: Museum Rietberg.

Flam, Jack D.
1967 *African Tribal Art from the Jay C. Leff Collection.* Gainesville: University of Florida.
1971 The Symbolic Structure of Baluba Caryatid Stools. *African Arts* 4(2):54-59, 80.

Flint Institute of Arts
1970 *The Art of Black Africa.* Flint, Michigan: Flint Institute of Arts, DeWaters Art Center.

Fondation pour la Recherche en Endocrinologie Sexuelle et l'Etude de la Reproduction Humaine, La Société Générale de Banque/Stichting voor het Onderzoek van de Geslachtsendocrinologie en de Studie van de Voorplanting van de Mens, Generale Bankmaatschappij.
1977 *La Maternité dans les Arts Premiers/Het Moederschap in de Primitieve Kunsten.* Brussels.

Foreman, W., Foreman, B. and Dark, Phillip J. C.
1960 *Benin Art.* London: Paul Hamlyn.

Foss, Perkins
1975 Images of Aggression: *Ivwri* Sculpture of the Urhobo. In *African Images: Essays in African Iconology.* Boston University Papers on Africa, vol. 6. Daniel F. McCall and Edna G. Bay, eds. pp. 133-43. New York: Africana Publishing Co.
1976a Urhobo Statuary for Spirits and Ancestors. *African Arts* 9(4):12-23, 89-90.
1976b The Arts of the Urhobo Peoples of Southern Nigeria. Ph.D. dissertation, Yale University.
1980 *Nigerian Splendor.* Hanover, New Hampshire: Dartmouth College Museum & Galleries.

Fraser, Douglas
1974 The Legendary Ancestor Tradition in West African Art. In *African Art as Philosophy.* Douglas Fraser, ed. pp. 38-54. New York: Interbook.

Friend, Donald
1939 Masks. *Nigeria* 18:100-104.

Froelich, J. C.
1954 *La Tribu Konkomba du Nord Togo.* Mémoires de l'Institut Français d'Afrique Noire, no. 37. Dakar: l'Institut Français d'Afrique Noire.

Fry, Phillip
1970 Essai sur la Statuaire Mumuye. *Objets et Mondes* 10(1):3-28.

Gaisseau, Pierre-Dominique
1954 *Sacred Forest: Magic and Secret Rites in French Guinea.* Translated by Stephen Becker. New York: Alfred A. Knopf.

Galerie Wolfgang Ketterer
1983 *Afrika-Ozeanien.* Munich, sale of April 30, number 69.

Gallois-Duquette, Danielle
1976 Informations sur les Arts Plastiques des Bidyogo. *Arts d'Afrique Noire* 18:26-43.
1978 Personnage Assis sur un Siège *Iran*/Seated *Iran* Figure. In *Vingt-Cinq Sculptures Africaines/Twenty-Five African Sculptures.* Jacqueline Fry, ed. cat. no. 9, pp. 89-96. Ottawa: Galerie National du Canada/National Gallery of Canada.
1979 Women, Power and Initiation in the Bissagos Islands. *African Arts* 12(3):31-34, 93.

1981 Ox Mask (Dugn'be). In *For Spirits and Kings: African Art from the Paul and Ruth Tishman Collection.* Susan Vogel, ed. cat. no. 25, p. 57. New York: Metropolitan Museum of Art.

Gant, Jean
1981 Personal communication.

Garrard, Timothy F.
1983 A Corpus of 15th to 17th Century Akan Brass-Castings. In *Akan Transformations: Problems in Ghanaian Art History.* Monograph series, no. 21. Doran H. Ross and Timothy F. Garrard, eds. pp. 30-53. Los Angeles: Museum of Cultural History, UCLA.

Gebauer, Paul
1972 Cameroon Tobacco Pipes. *African Arts* 5(2):28-35.
1979 *Art of Cameroon.* Portland, Oregon: Portland Art Museum and New York: Metropolitan Museum of Art.

Gerbrands, A. A.
1957 *Art as an Element of Culture, especially in Negro-Africa.* Mededelingen van het Rijksmuseum voor Volkenkunde, no. 12. Leiden: E. J. Brill.

Germann, Paul
1958 Negerplastiken aus dem Museum für Völkerkunde zu Leipzig. In *Beiträge zur Afrikanischen Kunst,* pp. 34-59. Berlin: Akademie-Verlag.

Gessain, Robert
1963a Mission au Sénégal 1962. *Objets et Mondes* 3(2):153-62.
1963b Sénégal Oriental 1963. *Objets et Mondes* 3(4):317-28.
1968 Sénégal Oriental 1967. *Objets et Mondes* 8(2):145-58.

Gilfoy, Peggy Stoltz
1976 *African Art from the Harrison Eiteljorg Collection.* Indianapolis: Indianapolis Museum of Art.

Gilliland, William McKinley
1961 The Yoruba Cult of Egungun. Unpublished M.A. thesis, The Kennedy School Missions, Hartford, Connecticut.

Gillon, Werner
1979 *Collecting African Art.* London: Cassell Ltd.

Glaze, Anita J.
1981a *Art and Death in a Senufo Village.* Bloomington: Indiana University Press.
1981b Staff for a Champion Cultivator. In *For Spirits and Kings: African Art from the Paul and Ruth Tishman Collection.* Susan Vogel, ed. cat. no. 23, pp. 48-49. New York: Metropolitan Museum of Art.
1982 Personal communication.

Goldwater, Robert
1960 *Bambara Sculpture from the Western Sudan.* New York: Museum of Primitive Art.
1964 *Senufo Sculpture from West Africa.* New York: Museum of Primitive Art.

Goody, Jack R.
1962 *Death, Property and the Ancestors: A Study of the Mortuary Customs of the LoDagaa of West Africa.* Stanford, California: Stanford University Press.

Greenberg, Joseph H.
1966 *The Languages of Africa.* Bloomington: Indiana University Press.

Griaule, Marcel
 1963 *Masques Dogons*. 2nd ed. Travaux et Mémoires de l'Institut d'Ethnologie 33. Paris: Musée de l'Homme. 1st ed., Paris: Institut d'Ethnologie, 1938.
Guillaume, Paul and Munro, Thomas
 1954 *Primitive Negro Sculpture*. 1st ed. 1926. Reprinted, New York: Hacker Art Books, 1968.
Guimiot, Phillip and Van de Velde, L.
 1977 *Arts Premiers d'Afrique Noire/Oerkunsten van Zwart Afrika*. Brussels: Studio 44.
Gunn, Harold D.
 [1962] *A Handbook of the African Collections of the Commercial Museum*. Philadelphia: Philadelphia Commercial Museum.
Haddouf, Erica
 1967 *Art Nègre*. Strasbourg, France: Ancienne Douane and Mulhouse, France: Musée de l'Impression.
Hansford, Keir, Bendor-Samuel, John and Stanford, Ron
 1976 *An Index of Nigerian Languages*. Studies in Nigerian Languages, no. 5. Accra North, Ghana: Summer Institute of Linguistics.
Harley, George W.
 1941 *Notes on the Poro in Liberia*. Papers of the Peabody Museum of American Archaeology and Ethnology, Harvard University, 19(2). Cambridge, Massachusetts: Peabody Museum. Reprinted, New York: Kraus Reprint Corporation, 1968.
Hartwig, Gerald
 1969a A Historical Perspective of Kerebe Sculpturing — Tanzania. *Tribus* 18:85-102.
 1969b The Role of Plastic Art Traditions in Tanzania. *Baessler-Archiv* 17:25-40.
 1978 Sculpture in East Africa. *African Arts* 11(4):62-65, 96.
 1979 Personal communication.
Hemholz, Robert C.
 1972 Traditional Bijago Statuary. *African Arts* 6(1):52-57, 88.
Herold, Erich
 1967 *The Art of Africa: Tribal Masks from the Náprstek Museum, Prague*. London: Paul Hamlyn Ltd.
Herron Museum of Art
 1965 *Art of Africa*. Indianapolis: Herron Museum of Art.
Herskovits, Melville J.
 1945 *Background of African Art*. Denver: Denver Art Museum.
Herzog, George
 1975 Personal communication.
Himmelheber, Hans
 1963 Die Masken der Guéré im Rahmen der Kunst des Oberen Cavally-Gebietes. *Zeitschrift für Ethnologie* 88(1):216-33.
 1966a Figuren und Schnitztechnik bei den Lobi, Elfenbeinküste. *Tribus* 15:63-87.
 1966b Masken der Guéré II. *Zeitschrift für Ethnologie* 91(1):100-108.
 1972 Gold-Plated Objects of Baule Notables. In *African Art and Leadership*. Douglas Fraser and Herbert M. Cole, eds. pp. 185-208. Madison: University of Wisconsin Press.
Hinckley, Priscilla
 1980 *The Sowo Mask: Symbol of Sisterhood*. Working papers, no. 40. Boston University: African Studies Center.

Holas, Bohumil
 1960 *Cultures Matérielles de la Côte d'Ivoire*. Paris: Presses Universitaires de France.
 1967 *Arts Traditionnels de la Côte d'Ivoire*. n.p.
 1968 *L'Image du Monde Bété*. Paris: Presses Universitaires de France.
 1969a *Masques Ivoiriens*. n.p.:C.S.H.
 1969b Sculptures Ivoiriennes. n.p.:C.S.H.
Hollis, A. Claude
 1909 A Note on the Graves of the Wa-Nyika. *Man* 9(85):145.
Holsoe, Svend E.
 1979 *A Standardization of Liberian Ethnic Nomenclature*. Liberian Studies Research Working Paper, no. 6. Philadelphia: Institute for Liberian Studies.
Holý, Ladislav
 1967 *The Art of Africa: Masks and Figures from Eastern and Southern Africa*. Translated by Till Gottheiner. London: Paul Hamlyn Ltd.
Hommel, William L.
 1974 *Art of the Mende*. Baltimore: University of Maryland Art Gallery.
 1978 Moisi, A Mende Sculptor. *African Directions*, Spring, pp. 9-12.
 1980 Personal communication.
Horton, Robin
 1965 *Kalabari Sculpture*. Lagos: Department of Antiquities.
Houlberg, Marilyn Hammersley
 1973 Ibeji Images of the Yoruba. *African Arts* 7(1):20-27, 91-92.
 1978 Notes on Egungun Masquerades among the Oyo Yoruba. *African Arts* 11(3):56-61, 99.
 1981 Pair of Figures. In *For Spirits and Kings: African Art from the Paul and Ruth Tishman Collection*. Susan Vogel, ed. cat. no. 57, p. 107. New York: Metropolitan Museum of Art.
Huet, Michael
 1978 *The Dance, Art and Ritual of Africa*. New York: Pantheon Books.
Imperato, Pascal J.
 1970 The Dance of the Tyi Wara. *African Arts* 4(1):8-13, 71-80.
 1972 Door Locks of the Bamana of Mali. *African Arts* 5(3):52-56, 84.
Indiana University Art Museum
 1980 *Royal Benin*. Exhibition checklist. Bloomington: Indiana University Art Museum.
Information and Documentation Center of Belgian Congo and Ruanda-Urundi.
 1950 *The Arts in Belgian Congo and Ruanda-Urundi*. Translated by Stephanie Chandler. Brussels.
Israel Museum
 1967 *Masterpieces of African Art: Tishman Collection*. Jerusalem: Israel Museum.
Janzen, John M. and Kauenhoven-Janzen, Reinhild
 1975 Pende Masks in Kauffman Museum. *African Arts* 8(4):44-47.
Johnson, Samuel
 1921 *The History of the Yorubas*. London: Routledge & Kegan Paul Ltd. Reprinted, Westport, Connecticut: Negro Universities Press, 1970.
Kamer, Henri
 1973 *Haute-Volta*. Brussels: Studio 44-Passage 44.
Kaplan, Flora S., ed.
 1981 *Images of Power: Art of the Royal Court of Benin*. New York: New York University.

Kecskési, Maria
 1982 *Kunst aus dem Alten Afrika*. Sammlungen aus dem Staatlichen Museum für Völkerkunde München, vol. 2. Innsbruck: Pinguin-Verlag.
Kitnick, Barry A.
 1980 Personal communication.
Kjersmeier, Carl
 1935-38 *Centres de Style de la Sculpture Nègre Africaine*. 4 vols. Paris: A. Morancé and Copenhagen: Illums Bog-Afdeling & Fischers. Reprinted, New York: Hacker Art Books, 1967.
Korabiewicz, Wacław
 1966 *African Art in Polish Collections*. Warsaw: Polonia Publishing House.
Krieger, Kurt
 1965 *Westafrikanische Plastik I*. Berlin: Museum für Völkerkunde.
 1969 *Westafrikanische Plastik II*. Berlin: Museum für Völkerkunde.
Krieger, Kurt and Kutscher, Gerdt
 1960 *Westafrikanische Masken*. Berlin: Museum für Völkerkunde.
Krige, Eileen
 1950 *The Social System of the Zulus*. Pietermaritzburg: Shuter & Shooter.
Kroll, Hubert
 1933 Plastische Menschendarstellungen von der Insel Ukerewe im Victoria-See. *Ethnologische Anzeiger* 3(3):142-44.
Kronenberg, A. and Kronenberg, W.
 1960 Wood Carvings in South Western Sudan. *Kush* 8:274-81.
Labouret, Henri
 1931 *Les Tribus du Rameau Lobi*. Travaux et Memoires de l'Institut d'Ethnologie, 15. Paris: Institut d'Ethnologie.
Lamp, Frederick
 1978 Frogs into Princes: The Temne Rabai Initiation. *African Arts* 11(2):38-49, 94-95.
 1979 *African Art of the West Atlantic Coast: Transition in Form and Content*. New York: L. Kahan Gallery, Inc.
 1980 Personal communication.
Laude, Jean
 1971 *The Arts of Black Africa*. Translated by Jean Decock. Berkeley: University of California Press.
Laurenty, J. S.
 1960 *Les Cordophones du Congo Belge et du Ruanda-Urundi*. Sciences de l'Homme, vol. 2. Tervuren: Musée Royal du Congo Belge.
Lawal, Babatunde
 1970 Yoruba *Sango* Sculpture in Historical Retrospect. Ph.D. dissertation, Indiana University.
 1981 Staff for Shango (*Oshe Shango*). In *For Spirits and Kings: African Art from the Paul and Ruth Tishman Collection*. Susan Vogel, ed. cat. no. 46, p. 92. New York: Metropolitan Museum of Art.
Lecoq, Raymond
 1953 *Les Bamiléké*. Paris: Présence Africaine.
Leff, Jay C.
 1969 *The Art of Black Africa: Collection of Jay C. Leff*. Catalog notes. Pittsburgh: Carnegie Institute.
Lehuard, Raoul
 1977 *Les Phemba du Mayombe*. Arnouville, France: Arts d'Afrique Noire.
 1979 Personal communication.
 1980 *Fétiches à Clous du Bas-Zaire*. Arnouville, France: Arts d'Afrique Noire.

Leiris, Michel and Delange, Jacqueline
1968 *African Art*. Translated by Michael Ross. New York: Golden Press.
Le Moal, Guy
1980 *Les Bobo: Nature et Fonction des Masques*. Travaux et Documents de l'Orstom, no. 121. Paris: ORSTOM.
Leuzinger, Elsy
1960 *Africa: The Art of Negro Peoples*. Translated by Ann E. Keep. New York: Crown Publishers, Inc.
1963 *Afrikanische Skulpturen/African Sculpture*. English translation by Ann E. Keep. Zürich: Museum Rietberg.
1972 *The Art of Black Africa*. Translated by R. A. Wilson. Greenwich, Connecticut: New York Graphic Society Ltd.
Lindblom, Karl Gerhard
1945 *Nose Ornaments in Africa*. Smärre Meddelanden, no. 2, Stockholm: Statens Ethnografiska Museum.
Lommel, Andreas
1976 *Africanische Kunst*. Munich: Staatliches Museum für Völkerkunde.
Lorenz, Carol Ann
1982a Lower Niger Bronze Bells: Form, Iconography and Function. In *The Art of Metal in Africa*. Marie-Thérèse Brincard, ed. pp. 52-60. New York: African-American Institute.
1982b Personal communication.
McIntosh, Roderick J. and McIntosh, Susan Keech
1979 Terracotta Statuettes from Mali. *African Arts* 12(2):51-53, 91.
McIntosh, Susan Keech and McIntosh, Roderick J.
1980 Jenné-Jeno: An Ancient African City. *Archaeology* 33(1):8-14.
McNaughton, Patrick R.
1975 *Iron: Art of the Blacksmith in Western Sudan*. West Lafayette, Indiana: Department of Creative Arts, Purdue University.
1979 *Secret Sculptures of Komo: Art and Power in Bamana (Bambara) Initiation Associations*. Working Papers in the Traditional Arts, no. 4. Philadelphia: Institute for the Study of Human Issues.
Mack, B. J.
1981 Male Figure. In *For Spirits and Kings: African Art from the Paul and Ruth Tishman Collection*. Susan Vogel, ed. cat. no. 149, pp. 241-42. New York: Metropolitan Museum of Art.
Maes, Joseph
1921 *Guide Ethnographique du Musée du Congo Belge*. Brussels: Goemaere.
Maes, Joseph and Boone, Olga
1935 *Les Peuplades du Congo Belge*. Monographies Idéologiques, série 2, vol. 1. Tervuren: Musée du Congo Belge.
Maesen, Albert
1950 Traditional Sculpture in Belgian Congo. In *The Arts in Belgian Congo and Ruanda-Urundi*. Translated by Stephanie Chandler. pp. 9-33. Brussels: Information and Documentation Center of Belgian Congo and Ruanda-Urundi.
1969 *Ubangu, Art du Congo au Musée Royal du Congo Belge*. 2nd ed. Tervuren: Musée Royal de l'Afrique Centrale. 1st ed. Tervuren: Musée Royal de l'Afrique Centrale, 1960.
1972 *Vijfentwintig Afrikaanse Kunstvoorwerpen*. Tervuren: De Vrienden van hat Koninklijk Museum voor Midden-Afrika.

1982 Personal communication.
Mansfeld, Alfred
1908 *Urwald-Dokumente: Vier Jahre unter den Crossflussnegern Kameruns*. Berlin: Dietrich Reimer.
Mato, Daniel
1975 *Icon and Symbol: The Cult of the Ancestor in African Art*. Bloomfield Hills, Michigan: Cranbrook Academy of Art/Museum.
Merriam, Alan P.
1978 Kifwebe and Other Masked and Unmasked Societies Among the Basongye. *Africa-Tervuren* 24(3-4):57-73, 89-101.
Messenger, John C.
1973 The Role of the Carver in Anang Society. In *The Traditional Artist in African Societies*. Warren L. d'Azevedo, ed. pp. 101-27. Bloomington: Indiana University Press.
Meyer, Piet
1981a *Kunst und Religion der Lobi*. Zurich: Museum Rietberg.
1981b Pair of Figures. In *For Spirits and Kings: African Art from the Paul and Ruth Tishman Collection*. Susan Vogel, ed. cat. no. 13, pp. 30-32. New York: Metropolitan Museum of Art.
1981c Personal communication.
Millot, Jacques
1961 De Pointe-Noire au Pays Tsogo. *Objets et Mondes* 1(3-4):65-80.
Mullen, Christine
n.d. Unpublished notes.
Murdock, George Peter
1959 *Africa: Its People and Their Culture History*. New York: McGraw-Hill Book Co.
Murray, K. C.
1949 *Masks and Headdresses of Nigeria*. London: Zwemmer Gallery.
Musée de l'Homme
1966 *Arts Connus et Méconnus de L'Afrique Noire: Collection Paul Tishman*. Paris: Musée de l'Homme.
Museum of African Art
1979 *Traditional Sculpture from Upper Volta*. Washington, D.C.: Museum of African Art, Smithsonian Institution.
Museum of Primitive Art
1964 *African Sculpture from the Collection of Jay C. Leff*. New York: Museum of Primitive Art.
1969 *The Herbert Baker Collection*. New York: Museum of Primitive Art.
Newton, Douglas
1978 *The Nelson A. Rockefeller Collection: Masterpieces of Primitive Art*. New York: Alfred A. Knopf.
Neyt, François
1977 *La Grande Statuaire Hemba du Zaïre*. Publications d'Histoire de l'Art et d'Archéologie de l'Université Catholique de Louvain, 12. Louvain-la-Neuve, Belgium: Institut Supérieur d'Archéologie et d'Histoire de l'Art.
1978 Effigie d'Ancêtre/Ancestor Effigy. In *Vingt-Cinq Sculptures Africaines/Twenty-Five African Sculptures*. Jacqueline Fry, ed. cat. no. 23, pp. 163-68. Ottawa: Galerie National du Canada/National Gallery of Canada.
1979 Masque-Eléphant et Statuaire des Igbo. *Arts d'Afrique Noire* 32:29-45.
1980 Personal communication.

1981 *Arts Traditionnels et Histoire au Zaïre/Traditional Arts and History of Zaïre*. Publications d'Histoire de l'Art et d'Archéologie de l'Université Catholique de Louvain, 29. Brussels: Société d'Arts Primitifs, Institut Supérieur d'Archéologie et d'Histoire de l'Art.
Neyt, François and Stryker, Louis de
1975 *Approche des Arts Hemba*. Villiers-le-Bel, France: Arts d'Afrique Noire.
Nicklin, Keith
1974 Nigerian Skin-Covered Masks. *African Arts* 7(3):8-15, 67-68, 92.
1978a Haut Masque, Portrait de Femme/Cap Mask Portraying a Woman. In *Vingt-cinq Sculptures Africaines/Twenty-five African Sculptures*. Jacqueline Fry, ed. cat. no. 5, pp. 66-71. Ottawa: Galerie National du Canada/National Gallery of Canada.
1978b Masque-cloche à Trois Visages/Helmet Mask with Three Faces. In *Vingt-cinq Sculptures Africaines/Twenty-five African Sculptures*. Jacqueline Fry, ed. cat. no. 6, pp. 72-77. Ottawa: Galerie National du Canada/National Gallery of Canada.
1979 Skin-Covered Masks of Cameroon. *African Arts* 12(2):54-59, 91.
1981a Headdress. In *For Spirits and Kings: African Art from the Paul and Ruth Tishman Collection*. Susan Vogel, ed. cat. no. 99, pp. 167-68. New York: Metropolitan Museum of Art.
1981b Four-Faced Helmet Mask. In *For Spirits and Kings: African Art from the Paul and Ruth Tishman Collection*. Susan Vogel, ed. cat. no. 103, pp. 173-74. New York: Metropolitan Museum of Art.
Nigerian Museum
n.d. *Guide to the Nigerian Museum*. Lagos: Museum of Nigerian Antiquities, Traditional Art and Ethnography.
Northern, Tamara
1973 *Royal Art of Cameroon*. Hanover, New Hampshire: Hopkins Center Art Galleries, Dartmouth College.
1975 *The Sign of the Leopard: Beaded Art of Cameroon*. Storrs, Connecticut: William Benton Museum of Art, University of Connecticut.
1979 *Splendor and Secrecy: Art of the Cameroon Grasslands*. New York: Pace Primitive and Ancient Art.
Northern, Tamara and Goldwater, Robert
1969 Africa. In *Art of Oceania, Africa, and the Americas from the Museum of Primitive Art*. n.p. New York: Metropolitan Museum of Art.
Norton Gallery of Art
1975 *African Art: Nature, Man and Vital Force, From the Collection of H. B. Green and Family*. West Palm Beach, Florida: Norton Gallery of Art.
Nymbezi, Sibusiso and Nxumalo, O. E. H.
1966 *Inqolobane Yesizwe*. Pietermaritzburg: Shuter and Shooter.
Olbrechts, Frans M.
1959 *Les Arts Plastiques du Congo Belge*. Brussels: Editions Erasme, S.A.
Olderogge, Dimitry and Forman, Werner
1969 *The Art of Africa: Negro Art*. London: Paul Hamlyn Ltd.
Ottenberg, Simon
1975 *Masked Rituals of Afikpo: The Context of African Art*. Seattle: University of Washington Press.

1981 Personal communication.
Parke-Bernet Galleries, Inc.
1966 *The Helena Rubenstein Collection: African and Oceanic Art*. New York, sale of October 15, number 2460.
Parkin, David
1981 Introduction. In *Vigango: The Commemorative Sculpture of the Mijikenda of Kenya*. David Parkin, Roy Sieber, and Ernie Wolfe III, pp. 1-7. Bloomington: African Studies Program, Indiana University.
Partridge, Charles
1905 *Cross River Natives*. London: Hutchinson and Co.
Paudrat, Jean-Louis
1978 Text. In *The Dance, Art and Ritual of Africa* by Michael Huet. New York: Pantheon Books.
Paulme, Denise
1962a *African Sculpture*. Translated by Michael Ross. New York: Viking Press.
1962b *Une Société de Côte d'Ivoire Hier et Aujourd'hui: les Bété*. Paris: Mouton & Co.
Peek, Phillip M.
1981 Figure *(Ivri)*. In *For Spirits and Kings: African Art from the Paul and Ruth Tishman Collection*. Susan Vogel, ed. cat. no. 81, pp. 140-43. New York: Metropolitan Museum of Art.
Pemberton, John III
1980 *Yoruba Beadwork: Art of Nigeria*. Catalog notes. New York: Rizzoli.
1982 Catalog notes. In *Yoruba Sculpture of West Africa*. Bryce Holcombe, ed. New York: Alfred A. Knopf.
Perani, Judith
1978 Personal communication.
Perrois, Louis
1972 *La Statuaire Fan: Gabon*. Mémoires O.R.S.T.O.M., 59. Paris.
1978 Figure de Reliquaire *Bwete/Bwete* Reliquary Figure. In *Vingt-Cinq Sculptures Africaines/Twenty-five African Sculptures*. Jacqueline Fry, ed. cat. no. 18, 138-41. Ottawa: Galerie National du Canada/National Gallery of Canada.
1979 *Arts du Gabon: Les Arts Plastiques du Bassin de l'Ogooué*. Arnouville, France: Arts d'Afrique Noire and Paris: O.R.S.T.O.M.
1981 Janus Reliquary Figure. In *For Spirits and Kings: African Art from the Paul and Ruth Tishman Collection*. Susan Vogel, ed. cat. no. 118, pp. 199-201. New York: Metropolitan Museum of Art.
Phillips, Ruth B.
1980 The Iconography of the Mende Sowei Mask. *Ethnologische Zeitschrift Zürich* 1:113-32.
Picton, John
1981 Female Figure with Calabash *(Arugba)*. In *For Spirits and Kings: African Art from the Paul and Ruth Tishman Collection*. Susan Vogel, ed. cat. no. 69, p. 125. New York: Metropolitan Museum of Art.
Pierpont, J. de
1932 Les Bambala. *Congo: Revue Générale de la Colonie Belge* 2:185-205.
Pitt-Rivers, Lane Fox
1900 *Antique Works of Art from Benin*. London: Harrison and Sons. Reprinted, New York: Hacker Art Books, 1971.

Plancquaert, M.
1930 *Les Sociétés Secrètes chez les Bayaka*. Louvain, Belgium: J. Kuyl-Otto.
Portier, A. and Poncetton, F.
1956 *Les Arts Sauvages Afrique*. Paris: Editions Albert Morancé.
Poynor, Robin
1978a The Ancestral Arts of Owo, Nigeria. Ph.D. dissertation, Indiana University.
1978b Personal communication.
Preston, George Nelson
n.d. *African Sculpture: Rare and Familiar Forms from the Anspach Collection*. Potsdam, New York: Brainerd Hall Art Gallery, State University College at Potsdam.
1970 *The Innovative African Sculptor*. Ithaca, New York: Ithaca College Museum of Art.
1981 Head. In *For Spirits and Kings: African Art from the Paul and Ruth Tishman Collection*. Susan Vogel, ed. cat. no. 41, p. 81. New York: Metropolitan Museum of Art.
Quinn, Charlotte A.
1978 African Art at the Naprstek Museum. *African Arts* 11(4):58-61, 96.
Richards, Josephus V.O.
1970 Factors of Limitation in the Art Forms of the Bundu Society of the Mende of Sierra Leone. Ph.D. dissertation, Northwestern University.
Ritzenthaler, Robert and Ritzenthaler, Pat
1962 *Cameroons Village: An Ethnography of the Bafut*. Publications in Anthropology, 8. Milwaukee: Milwaukee Public Museum.
Rivière, Marceau
1975 *Les Chefs-d'Oeuvre Africains des Collections Privées Françaises*. Paris: Editions PHILBI.
Robbins, Warren M.
1966 *African Art in American Collections/L'Art Africain dans les Collections Américaines*. French translation by Richard Walters. New York: Frederick A. Praeger.
Robertson, Eric
1983 Personal communication.
Rood, Armistead P.
1969 Bété Masked Dance: A View from Within. *African Arts* 7(3):37-43, 76.
Ross, Doran H.
1983 Personal communication.
Roth, Ling H.
1903 *Great Benin: Its Customs, Art and Horrors*. Halifax, England: F. King & Sons.
Roy, Christopher D.
1979a *African Sculpture: The Stanley Collection*. Iowa City: University of Iowa Museum of Art.
1979b Mossi Masks and Crests. Ph.D. dissertation, Indiana University.
1981 Personal communication.
Rubin, Arnold
1969 The Arts of the Jukun-Speaking Peoples of Northern Nigeria. Ph.D. dissertation, Indiana University.
1974 *African Accumulative Sculpture: Power and Display*. New York: Pace Gallery.
1976a *The Sculptor's Eye: The African Art Collection of Mr. and Mrs. Chaim Gross*. Washington, D.C.: Museum of African Art.
1976b *Figurative Sculptures of the Niger River Delta*. Los Angeles: Gallery K, Inc.
1977 *Mother and Child in African Art*. Los Angeles: Jan Baum-Iris Silverman Gallery.

1978 Personnage Debout/Standing Figure. In *Vingt-Cinq Sculptures Africaines/Twenty-Five African Sculptures*. Jacqueline Fry, ed. cat. no. 11, pp. 105-108. Ottawa: Galerie National du Canada/National Gallery of Canada.
1981 Figure; Figure. In *For Spirits and Kings: African Art from the Paul and Ruth Tishman Collection*. Susan Vogel, ed. cat. nos. 91-92, pp. 155-58. New York: Metropolitan Museum of Art.
Ruel, Malcom
1969 *Leopards and Leaders: Constitutional Politics Among a Cross River People*. London: Tavistock Publications.
Saturday Evening Post
1975 Treasures of African Art: A Portfolio from the Private Collection of Harrison R. [sic] Eiteljorg. 247(4):50-53.
Savary, Claude
1978 *Sculptures d'Afrique*. Geneva: Collection Barbier-Müller.
Schädler, Karl Ferdinand
1973 *Afrikanische Kunst in Deutschen Privatsammlungen/African Art in Private German Collections/L'Art Africain dans les Collections Privées Allemandes*. Munich: Münchner Buchgewerbehaus GmbH.
Schiltz, Marc
1978 Egungun Masquerades in Iganna. *African Arts* 11(3):48-55, 100.
Schwab, George
1947 *Tribes of the Liberian Hinterland*. Papers of the Peabody Museum of American Archaeology and Ethnology, Harvard University, 31. Cambridge, Massachusetts: Peabody Museum.
Schwartz, Nancy Beth A.
1976 *Mambilla: Art and Material Culture*. Publications in Primitive Art, 4. Milwaukee: Milwaukee Public Museum.
Schweinfurth, Georg
1874 *The Heart of Africa*. Translated by Ellen E. Frewer. 2 vols. New York: Harper & Brothers, Publishers.
1875 *Artes Africanae. Abbildungen und Beschreibungen von Erzeugnissen des Kunstfleisses Centralafrikanischer Völker/Illustrations and Descriptions of Productions of the Industrial Arts of Central African Tribes*. Leipzig: F. A. Brockhaus and London: Sampson Low, Marsten, Low, and Searle.
Seligman, C. G.
1917 A Bongo Funerary Figure. *Man* 17(67):97-98.
Seligman, C. G. and Seligman, Brenda Z.
1932 *Pagan Tribes of the Nilotic Sudan*. London: George Routledge & Sons Ltd.
Sieber, Roy
1961 *Sculpture of Northern Nigeria*. New York: Museum of Primitive Art.
1972a *African Textiles and Decorative Arts*. New York: Museum of Modern Art.
1972b Kwahu Terracottas, Oral Traditions and Ghanaian History. In *African Art and Leadership*. Douglas Fraser and Herbert Cole, eds. pp. 173-83. Madison: University of Wisconsin Press.
1973 Art and History in Ghana. In *Primitive Art and Society*. Anthony Forge, ed. pp. 70-96. London: Oxford University Press.

1978 Review of *The Arts of Ghana*, by Herbert M. Cole and Doran H. Ross. *African Arts* 11(3):9-11, 13-14.

1980 *African Furniture and Household Objects*. New York: American Federation of Arts and Bloomington: Indiana University Press.

1981 A Note on History and Style. In *Vigango: The Commemorative Sculpture of the Mijikenda of Kenya*. David Parkin, Roy Sieber, and Ernie Wolfe III, pp. 9-19. Bloomington: African Studies Program, Indiana University.

1982 Personal communication.

Sieber, Roy and Celenko, Theodore
1977 Rayons X et Art Africain. *Arts d'Afrique Noire* 21:16-28.

Sieber, Roy and Rubin, Arnold
1968 *Sculpture of Black Africa: The Paul Tishman Collection*. Los Angeles: Los Angeles County Museum.

Siegmann, William C.
1977 *Rock of the Ancestors*. Suakoko, Liberia: Africana Museum, Cuttington University College.

1981 Personal communication.

Siroto, Leon
1968 The Face of the Bwiti. *African Arts* 1(3):22-27, 86-89.

1972 *Gon: A Mask Used in Competition for Leadership Among the Bakwele*. In *African Art and Leadership*. Douglas Fraser and Herbert Cole, eds., pp. 57-78. Madison: University of Wisconsin Press.

1976 *African Spirit Images and Identities*. New York: Pace Primitive and Ancient Art.

1979 A *Kigangu* Figure from Kenya. *Bulletin of the Detroit Institute of Arts* 57(3):105-13.

Skougstad, Norman
1978 *Traditional Sculpture from Upper Volta*. New York: African-American Institute.

Söderberg, Bertil
1975 Les Figures d'Ancêtres chez les Babembé, part 2. *Arts d'Afrique Noire* 14:14-37.

Sotheby Parke Bernet, Inc.
1978 *The George Ortiz Collection of African and Oceanic Works of Art*. London, sale of June 29.

1980 *African and Oceanic Art*. New York, sale of April 22, number 4363.

1983a *Catalogue of Pre-Columbian, Central American, North American Indian, Eskimo, Oceanic and African Works of Art*. London, sale of March 22.

1983b *Prince Sadruddin Aga Khan Collection of African Art*. London, sale of June 27.

Starkweather, Frank
1968 *Traditional Igbo Art: 1966*. Ann Arbor: Museum of Art, University of Michigan.

Stoll, Mareidi and Stoll, Gert
1980 *Ibeji: Zwillingsfiguren der Yoruba/Ibeji: Twin Figures of the Yoruba*. English translation by Donald Arthur, Munich:n.p.

Stoneham, Doreen
1980 Quelques Datations par Thermoluminescence de Terres Cuites du Delta Intérieur du Niger/Some Thermoluminescence Datings of Terracottas from the Inland Delta of the Niger (Mali). In *Terres Cuites Anciennes de l'Ouest Africain/Ancient Terracottas from West Africa* by Bernard de Grunne. pp. 276-82. English translation by Claire W. Enders. Publications d'Histoire de l'Art et d'Archéologie de l'Université Catholique de Louvain 22. Louvain-la-Neuve, Belgium: Institut Supérieur d'Archéologie et d'Histoire de l'Art Collège Erasme.

Stryker, Louis de
1979 Personal communication.

Sydow, Eckart von
1954 *Afrikanische Plastik*. New York: George Wittenborn, Inc.

Talbot, P. Amaury
1912 *In the Shadow of the Bush*. London: William Heinemann.

1926 *The Peoples of Southern Nigeria*. 4 vols. London: Oxford University Press. Reprinted, London: Frank Cass & Co. Ltd., 1969.

Tauxier, L.
1924 *Nègres Gouro et Gagou*. Paris: Librairie Orientaliste Paul Geuthner.

Temple, O.
1919 *Notes on the Tribes, Provinces, Emirates and States of the Northern Provinces of Nigeria*. C. L. Temple, ed. Capetown: Argus Co. 2nd ed., London: Frank Cass & Co. Ltd., 1965.

Tessmann, Günter
1913 *Die Pangwe*. 2 vols. Berlin: Ernst Wasmuth A.-G.

Thompson, Robert Farris
1971 *Black Gods and Kings: Yoruba Art at UCLA*. Occasional Papers, 2. Los Angeles: University of California, Los Angeles; Museum and Laboratories of Ethnic Arts and Technology.

1972 The Sign of the Divine King: Yoruba Bead-Embroidered Crowns with Veil and Bird Decorations. In *African Art and Leadership*. Douglas Fraser and Herbert Cole, eds. pp. 227-60. Madison: University of Wisconsin Press.

1974 *African Art in Motion: Icon and Act in the Katherine Coryton White Collection*. Los Angeles: University of California Press.

1978a The Grand Detroit *N'kondi*. *Bulletin of the Detroit Institute of Arts* 56(4):206-21.

1978b Masque *Gelede*/Gelede Mask. In *Vingt-Cinq Sculptures Africaines/Twenty-Five African Sculptures*. Jacqueline Fry, ed. cat. no. 4, 58-65. Ottawa: Galerie National du Canada/National Gallery of Canada.

1979 Personal communication.

1980 Personal communication.

1981 Kongo Civilization and Kongo Art. In *The Four Moments of the Sun: Kongo Art in Two Worlds*. Robert Farris Thompson and Joseph Cornet. pp. 34-140. Washington: National Gallery of Art.

Torday, Emil
1925 *On the Trial of the Bushongo*. London: Seeley, Service & Co., Ltd.

Torday, Emil and Joyce, T. A.
1905 Notes on the Ethnography of the Ba-Mbala. *Journal of the Royal Anthropological Institute of Great Britain and Ireland* 35:398-426.

1910 Notes *Ethnographiques sur les Peuples Communément Appelés Bakuba, Ainsi que sur les Peuplades Apparentées. Les Bushongo*. Annales du Musée du Congo Belge, Ethnographie, Anthropologie 2(1). Tervuren: Musée Royal du Congo Belge.

Van de Velde-Caremans, Maria
1976 Some Aspects of the Wood Sculpture of the Central Northern Igala. *Africana Gandensia* 1:118-59.

Van Geluwe, Huguette
1967 *Art of the Congo*. Catalog notes. Minneapolis: Walker Art Center.

1978a Personnage Féminin à Clous *Nkondi*/Nkondi Female Figure with Nails. In *Vingt-Cinq Sculptures Africaines/Twenty-Five African Sculptures*. Jacqueline Fry, ed. cat. no. 21, pp. 152-56. Ottawa: Galerie National du Canada/National Gallery of Canada.

1978b Figure Magique *Nduda*/Nduda Magic Figure. In *Vingt-Cinq Sculptures Africaines/Twenty-Five African Sculptures*. Jacqueline Fry, ed. cat. no. 22, pp. 157-62. Ottawa: Galerie National du Canada/National Gallery of Canada.

1978c Mère à l'Enfant *Phemba*/Phemba Mother with Child. In *Vingt-Cinq Sculptures Africaines/Twenty-Five African Sculptures*. Jacqueline Fry, ed. cat. no. 20, pp. 146-51. Ottawa: Galerie National du Canada/National Gallery of Canada.

1978d Personal communication.

Vansina, Jan
1966 *Introduction a l'Ethnographie du Congo*. Brussels: Editions Universitaires du Congo.

1978 *The Children of Woot: A History of the Kuba Peoples*. Madison: University of Wisconsin Press.

Van Wing, J.
1941 Bakongo Magic. *Journal of the Royal Anthropological Institute of Great Britain and Ireland* 51:85-97.

Verly, Robert
1955 La Statuaire de Pierre du Bas-Congo (Bamboma-Mussurongo). *Zaire* 9(5):451-528.

Vogel, Susan Mullin
1973 People of Wood: Baule Figure Sculpture. *Art Journal* 33(1):23-26.

1974 *Gods of Fortune: The Cult of the Hand in Nigeria*. New York: Museum of Primitive Art.

1977 Baule Art as the Expression of a World View. Ph.D. dissertation, New York University.

1978 Personal communication.

1979 Personal communication.

1980 Personal communication.

1981a Female Figure. In *For Spirits and Kings: African Art from the Paul and Ruth Tishman Collection*. Susan Vogel, ed. cat. no. 35, p. 73. New York: Metropolitan Museum of Art.

1981b Male Figure. In *For Spirits and Kings: African Art from the Paul and Ruth Tishman Collection*. Susan Vogel, ed. cat. no. 94, pp. 159-61. New York: Metropolitan Museum of Art.

1982 Nigerian Bronze Rings. In *The Art of Metal in Africa*. Marie-Thérèse Brincard, ed. pp. 61-62. New York: African-American Institute.

Volavkova, Zdenka
1972 Nkisi figures of the Lower Congo. *African Arts* 5(2):52-59, 84.

Wahlman, Maude Southwell
1979 *Ceremonial Art of West Africa: From the Victor DuBois Collection*. East Lansing: Kresge Art Center Gallery and African Studies Center, Michigan State University.
1980 *Traditional Art of West Africa: Selections from the Victor DuBois Collection*. Waterville, Maine: Colby College Museum of Art.

Waldecker, Burkhart
1947 Introduction à l'Art Décoratif Congolais. *Le Congo Illustré* 109:3-6.

Warren, Dennis M.
1976 Bono Shrine Art. *African Arts* 9(2):28-34, 80.

Wassing, René S.
1968 *African Art: Its Background and Traditions*. New York: Harry N. Abrams, Inc.

Webster, W. D.
1897 *Illustrated Catalogue of Ethnographic Specimens, European and Eastern Arms and Armour, Prehistoric and Other Curiosities*, nos. 11 to 17. Bicester, Oxon, England: Oxford House.

Werner, O.
1970 Metallurgische Untersuchungen der Benin-Bronzen des Museums für Völkerkunde Berlin. *Baessler-Archiv*. Neue Folge 18:71-153.

Werner, O. and Willett, F.
1975 The Composition of Brasses from Ife and Benin. *Archaeometry* 17(2):141-56.

Wescott, Joan
1962 The Sculpture and Myths of Eshu-Elegba, The Yoruba Trickster: Definition and Interpretation in Yoruba Iconography. *Africa* 32:336-53.

White, John C.
1923-26 Unpublished notes.

Willett, Frank
1967 *Ife in the History of West African Sculpture*. New York: McGraw-Hill Book Co.
1973 The Benin Museum Collection. *African Arts* 6(4):8-17, 94.
1981 The Analysis of Nigerian Copper Alloys: Retrospect and Prospect. *Critica d'Arte Africana*, n.s., 46(178):35-49.

Willett, Frank and Picton, John
1967 On the Identification of Individual Carvers: A Study of Ancestor Shrine Carvings From Owo, Nigeria. *Man*, n.s., 2(1):62-70.

Wittmer, Marcilene K.
1973 *Images of Authority: From Benin to Gabon*. Miami: Lowe Art Museum, University of Miami.
1976 Bamum Village Masks. Ph.D. dissertation, Indiana University.
1977 *Cameroon: An Exhibition from the Collection of William and Robert Arnett*. Charlotte, North Carolina: Mint Museum.
1980 Personal communication.

Wittmer, Marcilene K. and Arnett, William
1978 *Three Rivers of Nigeria*. Atlanta: High Museum of Art.

Wolfe, Ernie III
1979 *An Introduction to the Arts of Kenya*. Washington, D.C.: Museum of African Art, Smithsonian Institution.
1980 Personal communication.

Zahan, Dominique
1974 *The Bambara*. Leiden: E. J. Brill.
1980 *Antilopes du Soleil: Arts et Rites Agraires d'Afrique Noire*. Vienna: Edition A. Schendl.
1981 Antelope Headdress: Male (*Chi Wara*); Antelope Headdress: Female (*Chi Wara*). In *For Spirits and Kings: African Art from the Paul and Ruth Tishman Collection*. Susan Vogel, ed. cat. nos. 6-7, pp. 22-24. New York: Metroplitan Museum of Art.

Zwernemann, Jürgen
1962 Zur Figürlichen Plastik der Bwa. *Tribus* 11:149-52.